BIRD DECOYS
OF NORTH AMERICA

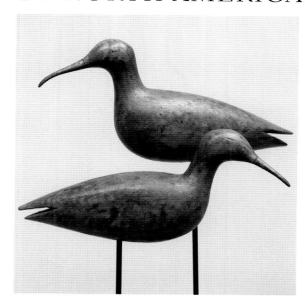

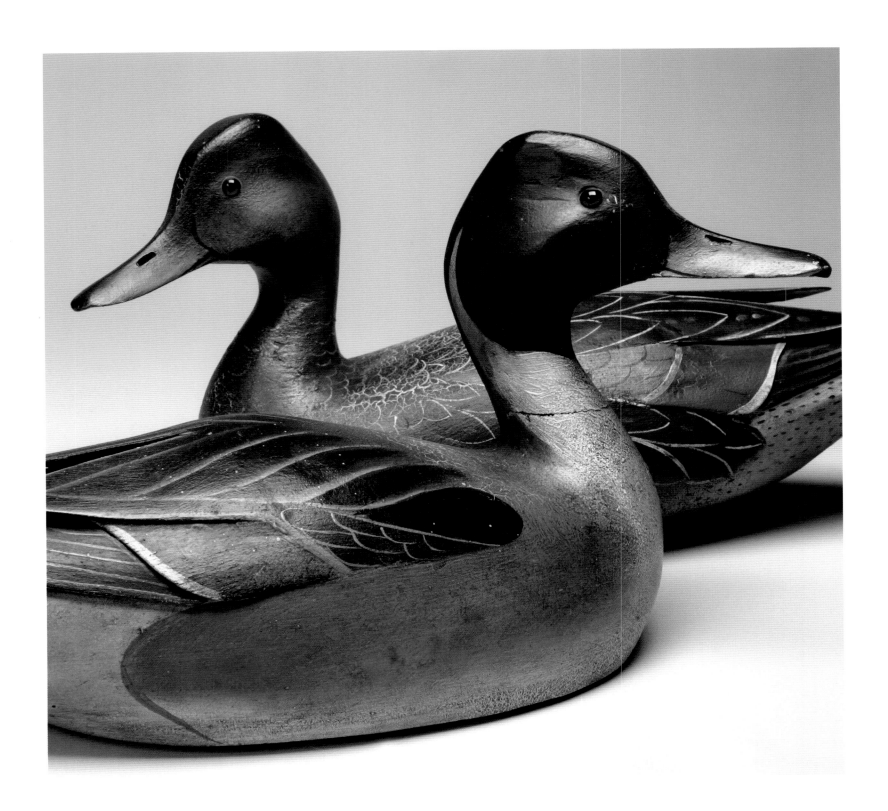

BIRD DECOYS
OF NORTH AMERICA

Nature, History, and Art

ROBERT SHAW

STERLING

New York / London
www.sterlingpublishing.com

STERLING and the distinctive Sterling logo are registered trademarks of
Sterling Publishing Co., Inc.

Library of Congress Cataloging-in-Publication Data
Shaw, Robert.
 Bird decoys of North America : nature, history, and art / by Robert Shaw.
 p. cm.
 Includes bibliographical references and index.
 ISBN 978-1-4027-4772-4
 1. Wildlife wood-carving--North America. 2. Decoys (Hunting)--North
America. 3. Birds in art. I. Title.
 NK9704.S49 2010
 745.593'60973--dc22

 2010013451

10 9 8 7 6 5 4 3 2 1

Published by Sterling Publishing Co., Inc.
387 Park Avenue South, New York, NY 10016
Copyright © 2010 Robert Shaw
Distributed in Canada by Sterling Publishing
c/o Canadian Manda Group, 165 Dufferin Street
Toronto, Ontario, Canada M6K 3H6
Distributed in the United Kingdom by GMC Distribution Services
Castle Place, 166 High Street, Lewes, East Sussex, England BN7 1XU
Distributed in Australia by Capricorn Link (Australia) Pty. Ltd.
P.O. Box 704, Windsor, NSW 2756, Australia

Book Design: Rachel Maloney, Amy Henderson

Printed in China
All rights reserved

Sterling ISBN 978-1-4027-4772-4

For information about custom editions, special sales, premium and
corporate purchases, please contact Sterling Special Sales
Department at 800-805-5489 or specialsales@sterlingpublishing.com.

FRONTISPIECE: *Pair of Pintails (detail)*. **Lemuel and Stephen Ward. c. 1935.
Crisfield, Maryland. Collection of Ron Gard.**

OPPOSITE: *Common Tern*. **Hand-colored lithograph by John T.
Bowen after John James Audubon for *The Birds of America*, First Octavo
edition. 1840–44. Philadelphia.**

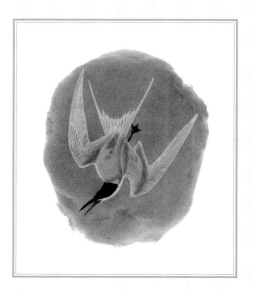

Dedicated to the memory of my mother,
Ruth Hubbard Shaw, who taught me to love birds
when I was a very little boy.

Contents

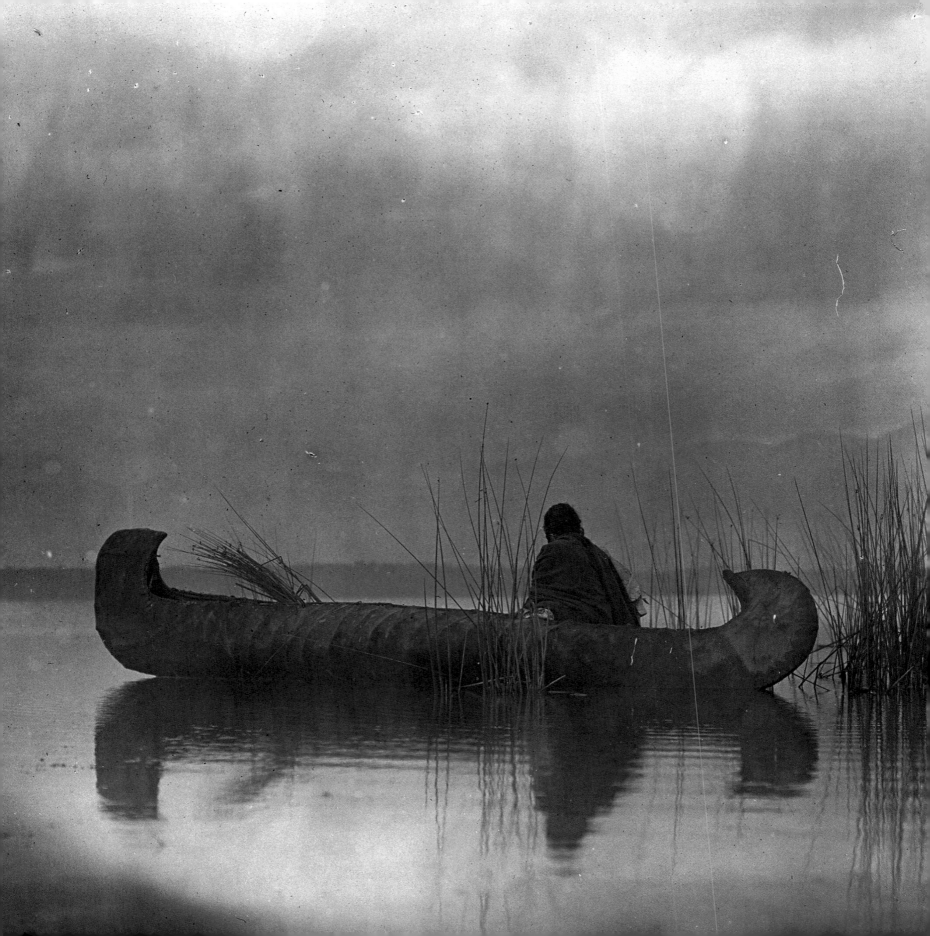

North American Decoys: Totems of the Hunt

Decoys, man-made representations of wild birds intended to deceive wildfowl and lure them within range of hunters' guns, are a uniquely North American invention. Originally intended as tools, decoys also can be seen today as both art objects and historical documents, evocations of North America's natural bounty and our evolving relationship to the land and the creatures we share it with. The greatest wildfowl hunt in the history of the world took place on this continent between the end of the Civil War and the end of World War I, and decoys were essential tools of that hunt. By the time it was brought to an end by federal legislation, millions of birds had been killed, thousands of acres of habitat had been destroyed, and a number of species teetered on the brink of oblivion. Decoys representing more than sixty species of American wildfowl have been identified, encompassing thirty different types of ducks and geese, nineteen shorebird species, and a variety of other game and plume birds, including swans, pigeons, doves, herons, egrets, gulls, terns, crows, owls, and loons. Two of the species represented—the Labrador duck and passenger pigeon—are known to be extinct, while a third, the Eskimo curlew, is widely believed to have passed into history as well. Surviving decoys tell the story of our devastating and almost unbelievable slaughter of wild birds during that era. But they also speak to the move toward conservation and sensible management that those excesses provoked and finally brought into being. And, the ameliorative and positive responses to past mistakes that were first taken in the late nineteenth and early twentieth centuries continue to protect and preserve wild birds and their habitats today.

The concept of the decoy was developed by Native Americans, who were crafting and using decoys at least a thousand years before the European discovery of the New World, and decoys have been

**Kutenai duck hunter.
Photograph by
Edward S. Curtis.**
Decoys were used by Native Americans centuries before the European discovery of North America.

essential tools for every hunter since. Decoys as we think of them today are therefore a confluence of Native American ingenuity and Anglo-American craftsmanship, and they are the only major folk art form that originated in North America. They emerged in response to the incredible abundance of wild-fowl in early America and hunters' desire to exploit wild birds as a commercial and recreational resource. Hundreds of thousands of decoys were carved between 1840, when commercial hunting of wildfowl began in earnest, and 1950, by which time handmade wooden decoys had largely been replaced by counterfeit birds mass produced from plastic and other synthetics.

Joel Barber, the father of decoy collecting and the author of the seminal book *Wild Fowl Decoys*, painted an evocative picture of the first Native American decoy maker trying out what Barber called his "swell idea." Paralleling surviving examples found in the Smithsonian's Museum of the American Indian, the decoys he was testing were made of tied reeds and painted to resemble the plumage of canvasback ducks, the most delicious of American wildfowl.

> The wild-fowl of North America were moving southward. Wisps of snipe had come and gone again. Wild geese passed leisurely in the sky. Over the estuary waterfowl hovered as smoke clings to the sea.
> Off shore a few yards, a group of reeded Canvas-backs rode crazily at anchor. Mooring lines of twisted grass pitched downward through waving tendrils to stone anchors on wild celery bottom.

Pre-White Man Canvasback. **Watercolor on paper. Joel Barber. Joel Barber Collection, The Shelburne Museum. 1927.**
This depiction is of one of the Native American decoys found in the Lovelock Cave in Nevada, carbon dated to at least 1000 BCE.

Behind a flimsy screen of dried grass, the red-skinned inventor shivered in the cold. The idea was launched—to live or die—nebulous, but potent as rum.

Time passed. More time—then the great deception raised its head. Nature was to serve a new master. Instinct to foregather, buried deep in the hearts of wild waterfowl, was to meet disaster.

In the distance a swiftly moving flock of birds faltered in the sky. The false Canvas-backs rolled and pitched dully on the water. The Indian crouched lower in the reeds. Tapping in his breast was a gift to posterity—"expectancy!" It touched his hair in the back, rippled across his jaw-bone and down his spine. His knee sank deeper in the matted grass.

Events followed swiftly. The leading birds swung shorewards toward the false ducks on the water; oncoming trailers followed, telescoping and banking on the turn. There was no disorder. Like magic the line of hurtling birds straightened, gathered speed, drove headlong in and set their wings to half.

They were over the group on the water.

On shore a bow-string twanged!—then again! And again!

For a moment there was hurried confusion; then bending sharply on stiff wings the visitors fled.

The false Canvas-backs on their stone anchors held steadily into the wind, even at birth intrepid and inscrutable. Beyond them, drifting slowly leeward, two white breasts sprawled loosely in the sea.

It began to snow. In the distance the forest was turning a deeper blue. To right and left the sloping shore was merging with water. In his trampled nest the lone inventor stood black against the waving marsh.

And then it came—the long drawn yell of Indian victory; victory for generations of fowlers to come. The echo of that great idea still vibrates along the migratory paths of all American waterfowl.

Wild ducks had decoyed; were to decoy for evermore. They were never to know and never to understand. For that was a thousand years ago.

Native Americans created many varieties of decoys. Some, like the reed canvasbacks Barber described, were carefully crafted, but the majority were ephemeral tools, improvised in the field from materials at hand. Indians skinned birds they had killed and mounted them on floats or sticks, shaped mud or placed a small stone on top of a larger oblong rock to suggest the head and body of a resting duck, or created crudely shaped but effective wooden forms, often using suggestively shaped tree branches or roots for the heads and necks. European settlers observed Indian decoys and hunting methods, but found most of them unsatisfactory because they were so impermanent. They wanted more durable tools that could be reused season after season, and they employed the woodworking skills they had brought from Europe to achieve that goal. Sometime in the late 1700s, Americans began carving birds from blocks of wood that they then painted to mimic plumage patterns, and the decoy as we know it, the handcrafted wooden bird, came into being.

Red-breasted Merganser.
Roger Williams. c. 1800–20. Sheepshead Bay, Long Island, New York. The Gene & Linda Kangas Collection of American & International Folk Art.
The head of this early primitive was shaped from a tree root. Roger Williams's (c. 1770–1840) decoys, some of which have the initials "RW" carved into their bottoms, are among the earliest known. His brother Nathaniel also carved.

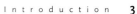

Wooden decoys have always been made in two basic forms: floaters and stickups. Floating lures were made to represent many species of swimming game birds, including all types of ducks and geese as well as swans, gulls, and loons. Stickups, which were mounted on wooden sticks that could be pushed into beach sand or mud, primarily represented wading birds such as curlews, plovers, sandpipers, and herons, although a few carvers made standing ducks and geese for use in marshes and fields, and some also crafted stickups representing gulls, terns, and other species.

The bodies of floating lures were carved either from a single piece of wood or from two pieces that were hollowed out and joined together with nails or dowels. Hollow lures were lighter and easier to carry than solid-bodied ones, an important consideration for a hunter who had to lug decoys any distance. More than a few early decoy carvers were boatbuilders as well, and the idea of hollow lures may have come from their experience in that realm. Like small boats, hollow decoys floated higher in the water than solid blocks. Unless they were intended for use in extremely calm water, solid metal weights were usually attached to the bottom of floating lures to provide ballast and balance them in the water; another weight tied to a lead line at the bird's breast was often added as an anchor to keep it from drifting away from the gunner's hiding place and other decoys in the rig. A few professional carvers branded their birds or attached weights stamped with their names, but the vast majority of

COUNTERCLOCKWISE FROM LEFT: *Brant.* c. 1900. *Bluebill (Scaup) Drake.* c. 1900. *Green-winged Teal Drake.* c. 1920. *Yellowlegs.* c. 1900. *Black-bellied Plover.* c. 1900. Joseph Whiting Lincoln. Accord, Massachusetts. Ex-collection James M. McCleery, M.D. Photograph courtesy the Houston Museum of Natural Science, Houston, Texas.
Lincoln was a professional decoy maker who crafted both floaters and stickups. He carved very few teal and scaup.

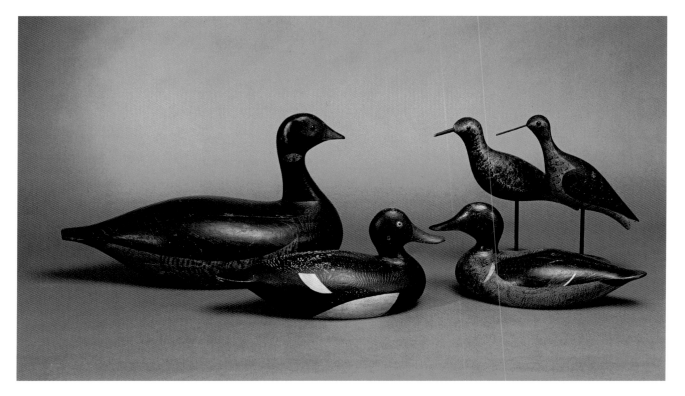

brands found on working decoys are those of the owners, applied after the birds were purchased for identification in the field.

Although a few carvers laboriously carved both head and body from a single block of wood, in most cases the decoy's head was carved separately and attached to the body, usually with nails, a screw, or a dowel. Heads, necks, and tails were the thinnest and therefore most vulnerable parts of any working decoy, easily damaged in use. To address the problem, a few ingenious carvers created birds with detachable heads that could be removed when not in use and carried separately. One masterful but still unidentified Massachusetts carver, for example, attached the heads of his geese and shorebirds with mortised dovetail joints so they could be easily slipped on and off. Another made a rig of geese with interlocking brass plates at the base of their necks and the top of a neck seat on the body, which were then joined by a metal pin.

After the head and body were joined, the carver would apply paint to imitate the plumage of the intended species. Some simply painted broad abstract outlines of the bird's basic plumage colors and pattern, while others went to great lengths to imitate the texture of feathering by swirling colors together and drawing fine toothed feathering combs or actual feathers through wet paint. Some even daubed the paint like a pointillist with the tip of a brush or a chewed matchstick. Like boats, decoys used in saltwater needed to be touched up or repainted on a regular basis, so the majority of Atlantic coast carvers kept their patterns simple, as did someone making a large rig. Freshwater was far kinder to paint than saltwater, so the most highly detailed painted plumage is found on decoys that were made to be used inland as well as those mimicking shorebirds, which were not exposed to water at all.

Decoys were made and used in groups called rigs, which were intended to give the effect of a gathering of wildfowl. Depending on the region, water conditions, and species sought, a hunter's rig could include anywhere from a handful of birds to several hundred. A gunner seeking black ducks in New England or shorebirds along the Atlantic coast would need to make or buy only ten or twelve decoys, whereas a market gunner setting out a battery rig on the Susquehanna Flats might use four or five hundred. Carvers who were making large rigs rarely bothered with detail. To be effective as tools, decoys had to fool passing birds long enough to bring them in for a closer look or, in some situations, to hold them on the water long enough for hunters to approach them.

Birds see differently than humans. Sight is by far a bird's dominant sense, the equivalent of a dog's or deer's sense of smell. Indeed, the vision of a wild bird is more acute than that of any other

Detachable Dovetailed Head of a Canada Goose. Maker unknown. c. 1890. North Shore of Massachusetts. Private collection. Photograph courtesy Sotheby's, Inc. This represents an ingenious solution to transporting a large, high-headed decoy, thereby avoiding breakage. The same unidentified artisan also made shorebirds with similar detachable heads.

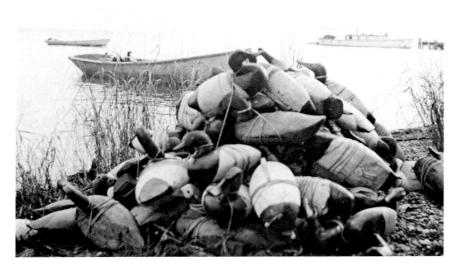

Rig of decoys piled on the waterfront. c. 1900. Susquehanna Flats region, Upper Chesapeake Bay, Maryland.
Upper Chesapeake Bay gunners were known to use as many as five hundred decoys in a rig.

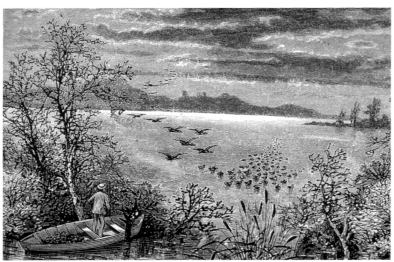

Standing Hunter in His Boat. **Engraving. c. 1870.**
American hunters were careful observers of their prey.

vertebrate. The large eyes of wildfowl, placed on opposite sides of their heads, work independently and give them an extremely wide field of vision, allowing them to take in a nearly 360-degree perspective without moving their heads. However, according to David Sibley, the author of *The Sibley Guide to Bird Life and Behavior*, "birds' eyes are so large relative to their skulls that there is no room left to rotate them, as mammals can; birds must turn their heads frequently to align their field of view." Although their vision is largely monocular, birds also have extremely good color vision and can see both near and faraway objects in equally sharp focus. In photographic terms, birds' eyes are in effect wide-angle lenses that are also capable of enormous depth of field.

As H. Albert Hochbaum, the author of *Travels and Traditions of Waterfowl*, sums it up, "It is impossible, with our binocular vision and narrow visual field, to imagine how the world appears to a duck." But while most hunters and decoy makers did not have knowledge of the science of avian sight, they understood it intuitively. Decoys were made as much for avian eyes as human ones, which is why they are deeper and more faithful representations of living birds than the vast majority of today's often photographically detailed decorative competition carvings. They were meant to be seen from a distance, sending a message out to birds flying above that all was well below, and it was perfectly safe to join the wooden flock bobbing at anchor in the water. The most effective examples were carefully observed symbols of the birds they sought to attract rather than detailed imitations of their appearance to the human eye. Exacting realism was rarely required or even desirable; what was needed was actually subtler—a lure that could convey the essence of a bird's plumage, form, and attitude at a glance and thereby fool a living bird.

Working decoys were totems of the hunt. Carvers and hunters had to know their prey well to be successful, and the lures they created and used bound them in close relationship with the wild birds they sought. They spent hours observing game birds in the wild, trying to understand their habits and preferences, and noting their changing plumages and migratory patterns, and they brought the accumulated knowledge of different species' appearances and behaviors back to the crucible of the carving bench. Although the lures they created were intended to be deadly tools, they also, paradoxically, speak volumes on their makers' and users' empathetic, if not sympathetic, identification with the hunted and of their respect for the birds' natural beauty, intelligence, and abilities.

The wetlands, rivers, lakes, and seacoasts of the United States and Canada presented hunters with a wide variety of water conditions and locally prevalent species. Each major hunting area—from the Canadian Maritimes to South Carolina, from Toronto Harbour to the bayous of Louisiana, and beyond—produced its own distinctive forms. Everywhere wild birds were hunted, carvers followed regional models for decoys that had evolved over generations of trial and error by local hunters. These regional differences are distinctive and easily identified by an experienced eye. A black duck decoy intended for use at the mouth of the Housatonic River, for example, looks nothing like a bird of the same species made to float on Lake St. Clair, and a pintail from San Francisco Bay bears little

Black Ducks. LEFT: **John Henry Downes. c. 1875. Smith Island, Virginia.** RIGHT: **A member of the Doughty family. c. 1880. Cobb's Island, Virginia. Courtesy Collectable Old Decoys.** Sophisticated elegance of line meets folksy power of mass in these two very different Virginia black ducks. Unlike most Southern carvers, John Henry Downes hollowed the bodies of his decoys. Cobb and Smith are barrier islands off the Eastern Shore of Virginia near Cape Charles.

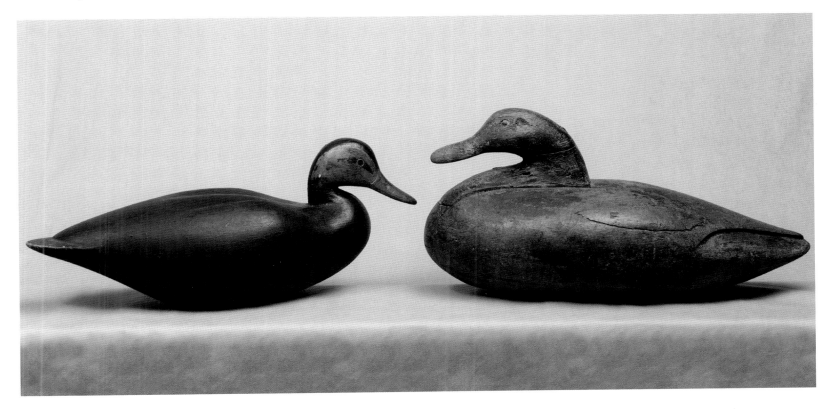

resemblance to one from the Chesapeake. Working within established local traditions, individual carvers developed their own styles as well, and the combination of regional norms and individual creativity is perhaps the most fascinating aspect of the decoy. Variations of form, paint patterns, construction methods, and other details abound—some subtle, some obvious. Decoys from some regions conform to a particular set of parameters, while other regions are filled with anomalies and strongly individual approaches. Some regions had dominant nineteenth-century master carvers who set standards that younger carvers followed closely, while other areas produced a number of distinctly different carving styles. Some regions elicited highly sophisticated and detailed carving and painting, while others were dominated by boldly sculptural lures with simple paint patterns.

If Native Americans were the inventors of the decoy, it was the market gunners of the nineteenth century, professional hunters who sold the wildfowl they killed to wholesale game distributors, who were the fathers of the wooden bird. They dealt in bulk, and their deadly profession demanded large numbers of sturdy, good-quality decoys. In turn, their need for quality tools enabled the supporting profession of decoy carving to flourish. Many of the market hunters doubled as carvers, crafting the decoys they needed during the off-season, when they were not out hunting, fishing, or following other waterside pursuits. But all over the United States and Canada, wherever wild birds were hunted and sold to city markets that supplied restaurants and the public with wild game, professional carvers also hung out their shingles and carved birds for local gunners. Whatever the needs of market hunters, local carvers were there to supply it.

Advances in weaponry and transportation helped make hunting more deadly and more profitable over the course of the nineteenth century. By the 1850s, railroads were spreading through the wide-open prairies, opening vast areas of the American interior to settlement and development. The approach was unprecedented, as noted by the Scottish traveler James Stirling after his visit to the United States from 1856 to 1857:

> The development of the country by means of a railway is such that what was yesterday waste land is to-day a valuable district. There is thus action and reaction: the railway improves the land; the improvement pays for the railway . . . there is nothing in history to compare with this seven-league progress of civilization. For the first time in the world we see a highly civilized people spreading itself over a vast untenanted solitude, and at one wave of its wand converting the wilderness into a cultivated and fruitful region.

The divisions of the Civil War enabled further expansion of the railway system in the Northern states. The Pacific Railroad Acts of 1862 and 1864 granted enormous privileges to companies that could build a transcontinental railway and feeder lines, including rights of way, rights to enormous amounts of land on either side of the tracks, rights to the use of local stone and timber all along the routes, and

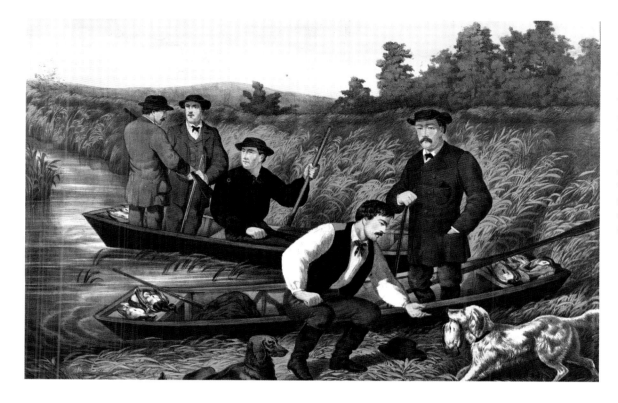

Scenes—Wild Duck Shooting.
Hand-colored lithograph.
Published by Currier & Ives,
c. 1870. New York.
Currier & Ives were
the most successful
American lithographers
of the nineteenth century,
producing more than one
million prints of some 7,500
different images between
1835 and 1907. Hunting
scenes like this one were
among their most popular
categories.

some $60 million in government loans, nearly half of the needed capital. Northern railway companies began the project in 1863. They were soon in a race to grab as much land as possible, and ties joining east and west were joined by the famed "golden spike" on May 10, 1869.

The Civil War also brought major advances in guns, the most important of which were repeating rifles, breech-loading guns capable of firing a number of shots in quick succession. The pioneering Spencer and Henry repeating rifles introduced during the war were further refined by Winchester and inventor John Browning in the 1870s and 1880s. In 1878, Daniel LeFever in Syracuse, New York, introduced the first hammerless shotgun, and in 1883 he patented the first automatic hammerless shotgun. In 1887, Winchester introduced the first successful repeating shotgun, the Model 1887 Lever Action Repeating Shotgun, which loaded a fresh cartridge from an internal magazine instead of needing to be cracked open to reload. In 1893, John Browning, who had worked on the Model 1887 for Winchester, produced the first pump-action shotgun, and in 1900, he patented the Browning Auto-5, the first semiautomatic shotgun.

With weapons like these in hand and railroads connecting formerly remote hunting areas with major cities, hunters could kill hundreds of birds a day and ship fresh game to city markets before it spoiled. There were virtually no hunting restrictions, so professional market hunters could kill at will to

meet the growing public demand for wild birds of all kinds. The range of species that were hunted for food was astonishing—not just ducks, geese, pheasants, grouse, woodcocks, and other game birds, but also shorebirds of all kinds, from curlews to sandpipers, as well as swans, doves, pigeons, robins, and even red-winged blackbirds. Eggs of many species were also gathered and sold, both for food and for the collections of natural history buffs, as were the feathers of terns, gulls, herons, egrets, and other plume birds and the down of eiders and Labrador ducks. The feathers were sold to the bustling millinery trade, which used them to festoon women's hats on both sides of the Atlantic. Every fashionable woman of the age wore hats, the bigger and more elaborate the better, and feathers and plumes were among the most popular and common adornments. Feathers from wood ducks and mallards were also popular, as were the feathers, wings, and even whole skins of colorful songbirds, including jays, orioles, flickers, snow buntings, and cedar waxwings.

In addition to the pressure from professional hunters, wildfowl of many kinds were also pursued by "sports," a new class of wealthy capitalists who rode the rails to beautifully appointed private clubs and hunting resorts all over the United States and Canada. They expected and could afford the best accommodations, weapons, and tools, and a host of clubs and resorts actively competed for their business, offering guide services, fine dining, and lavishly appointed rooms. Some of the most refined decoys extant today were used or commissioned by men who belonged to clubs like the Long Point Shooting Club, situated on a thirty-mile-long sand spit that juts out from the Ontario side of Lake Erie; the Woodmont Rod and Gun Club, located north of Washington, D.C.; and the Currituck Shooting Club, built in 1857 on the Outer Banks of North Carolina. The membership and guest lists of these

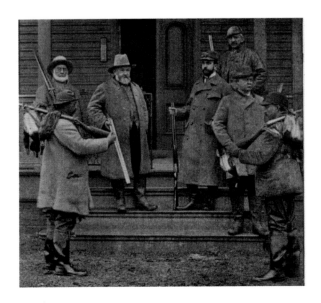

President Benjamin Harrison with duck hunting party. c. 1890. Like many of his peers, Harrison was an avid duck hunter.

establishments read like a who's who of the late Victorian era. Long Point, for example, was frequented by J. P. Morgan, members of the Cabot family of Boston, and British royalty. Presidents James Garfield, Chester Arthur, Grover Cleveland, and Benjamin Harrison all shot at the Woodmont. And the aptly named George Bird Grinnell, the editor of *Field and Forest* magazine, founder of the Audubon Society, and author of *American Duck Shooting*, gunned at the Currituck Club, alongside Daniel Giraud Elliott, author of *The Wild Fowl of North America*, and members of the Havemeyer family of New York, whose patriarch, Henry O. Havemeyer, ran the American Sugar Refining Company. (His daughter, Electra Havemeyer Webb, would later found the Shelburne Museum in Vermont and display some of the decoys used at the club.) "Dinner at Currituck Club is always a feast," wrote Frederick G. Havemeyer II in *Duck Shooting Along the Atlantic Tidewater*. "The table groans with Hunger Creek oysters, Teal and red wine. You eat until you cannot swallow another morsel, then you stand with your back to the fire and

take part in the talk of shooting, past and present. Talk of bluebird weather, no'theasters, driving snowstorms. Talk of blinds, rigs, record bags, guns, ammunition and decoys. And most of all—talk of birds."

The demand for decoys grew to the point that by the late 1800s, several companies began to offer birds by mail order. The George Peterson Decoy Company, the first of a series of decoy manufactures to operate in Detroit, led the way in 1873. Mason Decoy Factory, which opened its doors in 1896, was the largest and most successful of these operations. Like its competitors, Mason was a small cottage industry, with different crews assigned to different parts of the decoy-making process. Originally, all of Mason's decoys were entirely hand crafted, but after the turn of the century, the company installed lathes, on which heads and bodies were roughed out, while other crews worked on finishing the carving, painting the birds, and adding weights and other rigging. On completion, Mason decoys were packed a dozen to a crate and shipped to sportsmen all over the United States and Canada. A Mason Decoy Factory price list, printed around 1905, offers a range of graded models priced from $4 to $12 a dozen, approximately the equivalent of $100–300 in today's economy. Another entrepreneur, Harvey A. Stevens, who ran a mail order company with his brothers in upstate New York, offered his high quality birds for $10 a dozen in the 1880s. Hundreds of individual carvers were also making decoys, and, like Mason, Stevens's, and other so-called decoy "factories," many of the better-known professionals took orders from hunters and sporting goods stores near and far. Decoys were migrating almost as widely as their wild counterparts, traveling north and south, east and west, all over the continent.

A few carvers teamed with painters, taking an approach similar to the "factories" by splitting up the basic tasks of creating decoys to improve both their products and productivity. In Illinois, for example, the husband and wife team of Robert and Catherine Elliston started a regional tradition followed by Charles and Edna Perdew and Bert and Millie Graves; he did all the carving, while she brought her talents with the brush to the highly detailed paint patterns favored by local hunters. Elliston's letterhead billed him as a "manufacturer" of decoys and hunting boats with a "factory" located in Henry, Illinois, but as was the case with Harvey Stevens's operation, his business was in reality a cottage industry, with just him and Catherine at work, perhaps aided by a young Charles Perdew. Both Catherine Elliston, who outlived her husband by almost forty years, and Edna Perdew also painted birds carved by other men in Illinois.

TOP: **Front cover of Mason's Decoy Factory catalog. c. 1905.** Mason was the largest commercial decoy maker of its time, and the company's lures, which were sold by mail order, have been found all over North America.

ABOVE: **Robert Elliston's letterhead. c. 1890.** Elliston was the leading professional decoy maker in the Midwest in the late nineteenth and early twentieth centuries. Although he and his wife produced their decoys entirely by hand, he advertised himself as a manufacturer who had a factory.

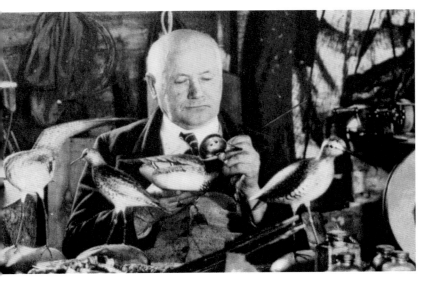

**Elmer Crowell in his shop.
c. 1930.**
Crowell and his son Cleon
were full-time professional
bird carvers who made a
wide variety of decoys and
ornamental carvings over
the years. The Crowells were
pioneers in the transition
from hunting decoys to
decorative bird carving.

As the nineteenth century wore on, many duck, plume, and shore-bird species declined drastically in number. Intense hunting pressure was surely to blame, but the spread of civilization and the attendant destruction of habitat played at least as big a part as the hunters did. The killing of plume birds in particular fueled the efforts of early conservationists, who found that the plight of such attractive birds as the common tern and great white egret resonated with the public. Public awareness of the killing grew as the nineteenth century came to an end, and local and federal government began to feel enormous pressure for change. Beginning in the 1890s, a few states passed laws restricting hunting, but it became clear that federal action was needed to provide uniform protection to endangered species. Legislation outlawing the interstate sale of migratory birds was passed by the United States Congress in 1916 and ratified in 1918. The Migratory Bird Treaty Act of 1918 implemented a 1916 convention between the United States and Great Britain (representing Canada). It regulated and protected North American migratory birds throughout their range, making it illegal to hunt, sell, or otherwise disturb any species unless otherwise sanctioned by the government.

The new laws brought the age of the market gunners to a close and also profoundly affected the business of decoy carvers who had supplied them with the tools of their trade. Mason Decoy Factory closed its doors in 1924, and many individual carvers supplemented income from their carving by oystering, fishing, boatbuilding, or painting, or moved on to other lines of work. Some of the most talented and imaginative carvers, such as Gus Wilson, George Boyd, Joseph Lincoln, Charles and Edna Perdew, Elmer Crowell and his son and partner Cleon, Ira Hudson, and Steve and Lem Ward, reacted to the changing marketplace by adding decorative and/or miniature carvings to their repertoires, works that appealed especially to the eyes of women and other nonhunters. Lincoln, for example, made perfectly proportioned miniature versions of his decoys, which he called "toys," while the Crowells, who advertised their business as "The Songless Aviary," sold miniature standing songbirds, shorebirds, and ducks and geese in sets of twenty-five species each to local schools, who used them to teach bird identification. And, in addition to the gunning decoys they continued to produce, the Crowells also made life-size decorative carvings of everything from standing ducks and shorebirds to chickadees and fish. Boyd also made miniatures, and the Perdews and Wards carved full-size decoratives of a wide variety of species. Hudson and Wilson created expressive flying and standing birds with inserted, outstretched wings, and Wilson carved a handful of enormous tigers for his own amusement—one of them seven feet from its nose to the tip of its tail—that have long been recognized as being among the great masterpieces of American folk sculpture.

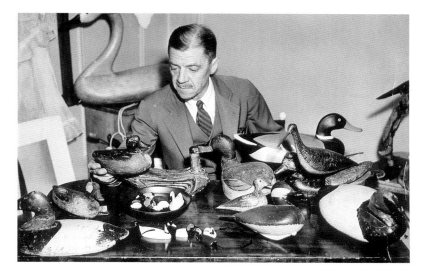

Although sportsmen had long put decoys on mantelpieces in their clubhouses and dens, the first real collector of decoys was the aforementioned Joel Barber, an urbane New York architect and nonhunter who in 1918 happened upon an old merganser decoy in a Long Island boathouse and brought it home. The bird cast a spell on him, and he soon recognized decoys as a uniquely American art form he called "floating sculpture." He became obsessed with the art and history of wooden birds, and, since he could find little written information about them, he began collecting stories and decoys from carvers, baymen, and hunters up and down the East Coast, from Nova Scotia to North Carolina. He also befriended contemporary carvers such as Charles "Shang" Wheeler, Bob McGaw, Joe Lincoln, and Ted Mulliken; painted watercolors and schematic architectural construction drawings of decoys he had collected and borrowed; and even took up decoy carving himself. In 1923, he organized the first decoy carving competition ever held, where a pair of mallards by Wheeler won the grand prize; exhibited parts of his collection at Abercrombie and Fitch in New York; and loaned birds to important early folk art exhibitions organized by the pioneering curator and author Holger Cahill at the Newark Museum and the Museum of Modern Art. When *Wild Fowl Decoys* was published in 1934, he explained:

> My book is like an island, a single gesture in the midst of unrelated activities. . . . My own collection has a singular if personal importance. To me, it represents the rise and fall of American wildfowl. Yet the origins and development of decoys has remained in persistent obscurity. . . . No one has ever bothered about them as I have, perhaps no one ever thought about it. But it is my wish that the decoy ducks of American duck shooting have a pedigree of their own. For this reason I became collector and historian.

Barber was a lonely figure in the 1920s and '30s, but other intrepid souls, most notably William J. Mackey Jr., folk art dealer Adele Earnest, and Dr. George Ross Starr, all of whom would later author their own books on decoys, had begun collecting before Barber's death in 1952. By the time of his passing, the historic wooden decoys he so passionately championed were also fading into history. World War II brought enormous technological changes to the world, and, after the war, the introduction of inexpensive but durable mass-produced decoys, molded from plastic and other synthetics, sounded the death knell for the old-time hand carvers who were still at work. Their ranks were thinning, too. Elmer Crowell died the same year as Barber. James Holly had passed earlier

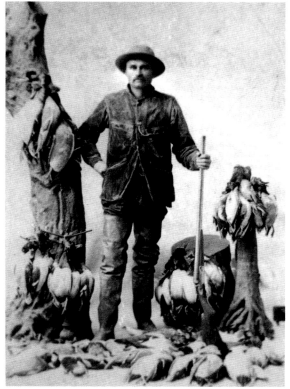

TOP: **Joel Barber exhibiting part of his collection in New York. c. 1930.**
Barber was the first person to collect decoys, and his 1934 book, *Wild Fowl Decoys,* was the first book published on the subject.

ABOVE: **Charles Schoenheider Sr. c. 1900.**
Schoenheider (1884–1944) was a Peoria, Illinois, market gunner and an outstanding decoy maker.

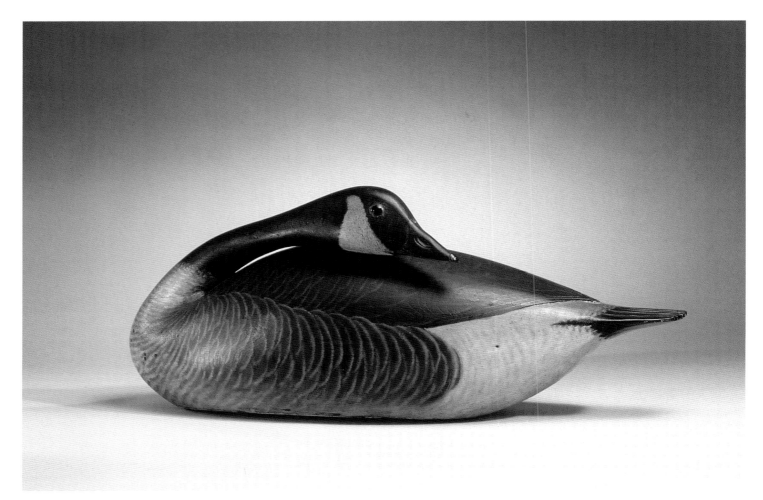

Canada Goose. **A. Elmer Crowell. 1917. East Harwich, Massachusetts. Ex-collection James M. McCleery, M.D. Photograph courtesy the Houston Museum of Natural Science, Houston, Texas.** This unique sleeping goose is one of three extraordinary ornamental geese that Crowell made for Harry V. Long, a Cohasset, Massachusetts, businessman who was one of his major early patrons. This bird, which could conceivably have been gunned over, although neither Crowell nor Long intended it for use, carries Crowell's oval brand.

in 1935, Joe Lincoln in 1938, George Boyd in 1941, Rowley Horner in 1942, Charles Schoenheider Sr. in 1944, Nicole Vidacovitch in 1945, Charles Bergman in 1946, and George Huey in 1947. Shang Wheeler, David K. Nichol, and Ira Hudson all died in 1949. Gus Wilson was gone in 1950, John R. Wells in 1953, Charles Walker in 1954, Bert Graves in 1956, and Keyes Chadwick in 1958. The list goes on and on. The birds and hunting grounds were diminished, regulated, and managed; the great camps were shuttered; and the demand for handmade decoys was gone with the men who had supplied it. The era of the wooden bird was over.

A remarkable number of early working decoys survived to tell the story, however, and interest in the old birds grew as the time of their use faded. Joel Barber's collection was acquired in 1954 by Electra Webb's Shelburne Museum in Vermont and inspired many early collectors in the 1950s and '60s, as interest in historic decoys grew and collectors began to network. With Barber's birds as its nucleus, Shelburne's collection remains the largest and finest on public display in the world to this

day. The small group of collectors active in the 1960s has continued to grow steadily over the years, and their passion has added many volumes to the research Barber began in the 1920s. Thousands of decoys are in private and museum collections today, offering a window into a lost world of American birds and hunting. Decoys are now among the most avidly sought of all American folk arts, and birds that originally traded hands for pennies regularly cross the auction block, where in recent years more than a few have brought prices ranging well into six figures. The auction of the legendary collection of Dr. James M. McCleery brought more than $11 million in 2000, and two carvings by Elmer Crowell, one of them originally part of the McCleery collection, sold privately for $1.1 million each in 2007. Values show no sign of going anywhere but up in the years to come.

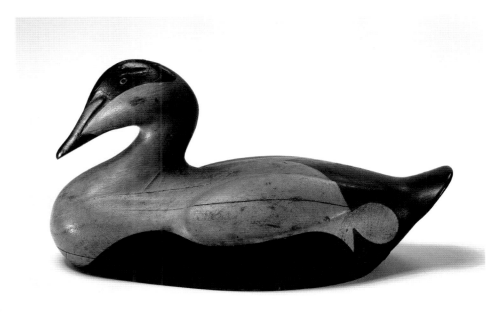

Eider Drake. **Augustus Aaron Wilson. c. 1900. South Portland, Maine. Private collection. Photograph courtesy Sotheby's, Inc.** This is one of Wilson's most powerful and sculpturally detailed birds, with relief-carved wings. Unlike the vast majority of Wilson's work, it is also hollow, with a bottom board attached with iron nails. New York dealer and collector Steve Miller, who owned this bird for many years, called it "the best piece of folk sculpture I have owned" and kept it at the foot of his bed so that he could see it when he awoke each morning.

Impressive as the dollar signs are, however, they are ultimately irrelevant and can serve only to distract from the real historical and artistic value of the objects themselves. As the former *New York Times* chief art critic Hilton Kramer has observed, "No amount of money is worth a great work of art," and the best decoys are great works of art indeed. Although they were created as humble tools, they can be appreciated on many levels today—as works of sculptural art, as examples of American craftsmanship and ingenuity, as compelling portraits of living and extinct species, and as pieces of American history that resonate with the story of North American wildfowl and wildfowling. The masters of the decoy rank among the finest American bird artists of all time, alongside the likes of Alexander Wilson, John James Audubon, Titian Peale, Louis Agassiz Fuertes, and Frank Benson. Few bird portraits are as compelling as a Bowman shorebird, as powerful as a Gus Wilson eider, or as elegantly poised as a Lothrop Holmes merganser. Few works of American craft are as well made as a turn-of-the-century Crowell decoy or as clever as a Schoenheider ice duck. Few historical objects are as poignant as a shot-scarred old Chesapeake Bay canvasback or a nineteenth-century Nantucket Eskimo curlew. As was Joel Barber's wish, the best old decoys are now recognized as significant works of American art and important relics of our history. The aura of these totems of the hunt draws us into the world in which they were made and used, conjuring visions of an American past that we can only wonder at. The best of the old decoys put us in touch with men who admired and understood wild birds enough to somehow capture their living spirit in carved and painted wood. Like the birds they were made to deceive, their mystery endures, and we can only marvel at the beauty they embody and freely offer to us.

The Hunted

Great Auk. Hand-colored aquatint, etching, and line engraving by Robert Havell Jr. after John James Audubon for *The Birds of America*. 1827–38. London. The penguinlike great auk was the first North American bird driven to extinction by hunters.

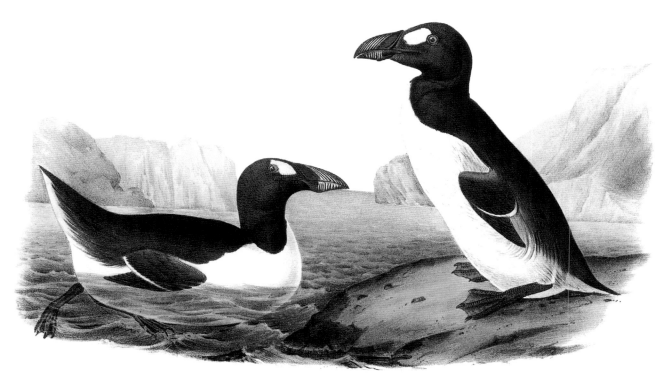

CHAPTER 1

Wildfowl in Early America

For centuries before the European discovery and colonization of America, the continent's skies, forests, and waters teemed with almost unimaginable legions of wildfowl. Untold millions of birds roamed freely across the continent, with little impact from the proportionately small number of Native Americans who hunted them with homemade traps and weapons made from stone, wood, and feathers. Huge, flightless penguins called great auks swam and nested along the North Atlantic Coast, and beautiful bicolored Labrador ducks were found as far south as Virginia. Passenger pigeons flew in flocks of incomprehensible size, sweeping everything before them as they passed, and trumpeter swans, loudly honking their clarion calls, ranged across the continent. Ducks and geese of all kinds migrated north and south in enormous numbers, taking advantage of an estimated 200 million acres of wetlands in what would become the United States, as well as the millions more in the

yet uncharted and unclaimed future provinces of Canada. Shorebirds, too, migrated by the millions, swarming beaches and mud flats so densely they sometimes obscured the very ground beneath them from view. The only checks and balances were those enforced by Nature herself, by the variables of weather and climate and the time-honored rituals of inter-species competition and predation.

European explorers and the settlers who followed them across the Atlantic were astonished at the abundance of nature they encountered when they first arrived in the New World. Coming from lands that had been controlled and managed by humans for centuries, they were totally unprepared for America's vast wildernesses and the seemingly limitless bounty of its natural resources. Migrating birds passed above their ships in the dark, their cries heard all night long. The shores were crowded with birds, as were the dense, virgin, old-growth forests that stretched as far as the eye could see and exploration could penetrate. Flights of Eskimo curlew and golden plover blackened the skies of early New England, and untold numbers of canvasback ducks fed upon vast shallow water fields of wild celery on the Susquehanna Flats and Chesapeake Bay. Huge flocks of wild turkeys and heath hens roamed the forests of the East, exotic green and orange Carolina parakeets flew though the swamps and bottomlands of the Southeast, and millions upon millions of migrating ducks, geese, and shorebirds ranged over the vast, unbroken stretches of Midwestern prairie grasslands on their way to nest and breed in the wild lands far to the north.

Early naturalists such as William Bartram, Mark Catesby, Alexander Wilson, and John James Audubon were more scientifically aware of what they observed and experienced but no less amazed. "The multitudes of Wild Pigeons in our woods are astonishing," Audubon wrote early in the nineteenth century. He continued:

> Indeed, after having viewed them so often, and under so many circumstances, I even now feel inclined to pause, and assure myself that what I am going to relate is fact. Yet I have seen it all, and that too in the company of persons who, like myself, were struck with amazement.
>
> In the autumn of 1813, I left my house at Henderson, on the banks of the Ohio, on my way to Louisville. In passing over the Barrens a few miles beyond Hardensburgh, I observed the Pigeons flying from north-east to south-west, in greater numbers than I thought I had ever seen them before, and feeling an inclination to count the flocks that might pass within the reach of my eye in one hour, I dismounted, seated myself on an eminence, and began to mark with my pencil,

The Haunts of the Wild Swan (Carroll Island—Chesapeake Bay). Hand-colored lithograph. Published by Currier & Ives. c. 1872.

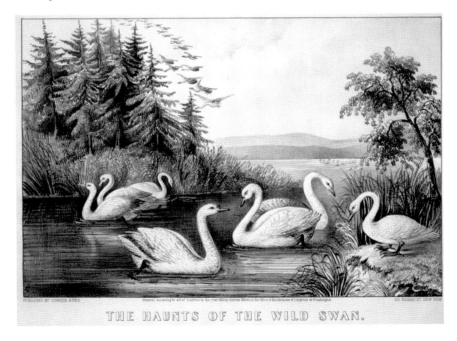

THE HAUNTS OF THE WILD SWAN.

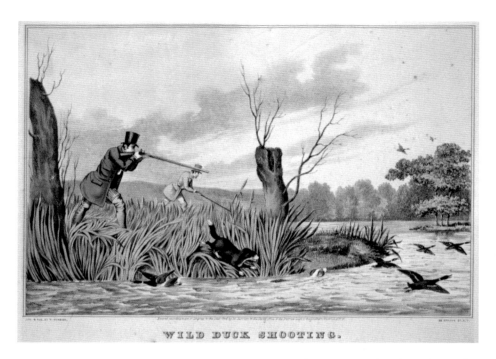

Wild Duck Shooting. Hand-colored lithograph. Published by N. Currier. c. 1846.

making a dot for every flock that passed. In a short time finding the task which I had undertaken impracticable, as the birds poured in countless multitudes, I rose, and counting the dots then put down, found that 163 had been made in twenty-one minutes. I travelled on, and still met more the farther I proceeded. The air was literally filled with Pigeons; the light of noon-day was obscured as by an eclipse, the dung fell in spots, not unlike melting flakes of snow; and the continued buzz of wings had a tendency to lull my senses to repose.

Europeans upset the balances that had held North America's land, flora, and fauna in ecological stability for millennia. They brought new technologies and sophisticated new weapons to the New World, along with a religious and economic mind-set that allowed them to see the natural world as something apart from themselves, a resource to be conquered and exploited for profit. Unlike the Native Americans they encountered, who lived on the land and whose religions embraced the natural world as a sacred gift demanding respect and honor, Europeans staked claims of ownership over the land and everything that inhabited it. They sought mastery, not communion, and the results of that conflict would be disastrous.

The impact of the new masters on America's land was immediate, and would soon be immense, altering the face of the land and its wildfowl forever. The speed of changes wrought on the land and its flora and fauna was staggering. The great auk, hunted relentlessly for its flesh and eggs since the 1500s, was in danger by the late 1700s, and the last nesting pair was killed in 1844. The Labrador duck was rare by Audubon's time and extinct by 1875—he never saw a live one and painted his portrait of the species in the 1830s from specimens sent to him by others. As Alfred Newton noted in his 1896 *Dictionary of Birds*, "This bird . . . used to breed on rocky islets, where it was safe from the depredations of foxes and other carnivorous quadrupeds. This safety was, however, unavailing when man began yearly to visit its breeding haunts, and, not content with plundering its nests, mercilessly to shoot the birds. Most of such islets are, of course, easily ransacked and depopulated. Having no asylum to turn to . . . its fate is easily understood." The heath hen was extirpated from the American mainland by the 1870s as well, with only a small population surviving on the isolated island of Martha's Vineyard, off the coast of Massachusetts. By 1900, all but a tiny fraction of the old-growth forest had been cut at least once, and the passenger pigeon, which had depended on the nuts and fruits of that forest, was gone

from the wild. Dozens of other species—not just birds like the heath hen, passenger pigeon, and Carolina parakeet but also bison, gray wolves, pronghorn sheep, bowhead whales, grizzly bears, and even deer—were near extinction as well, victims of overhunting and ongoing habitat destruction. Tens of thousands of acres of wetlands had been drained and turned over to agricultural use, and most of the prairie grasslands had also been plowed under. Migrating birds reeled under the impact of lost breeding grounds and migratory food sources and the constant toll of unrestricted, year-round hunting. Naturalists despaired for the future, seeing nothing but more destruction and devastation in the years ahead. The historical dead end of extinction loomed, what the (Martha's) *Vineyard Gazette* described as "Something more than death, or rather, a different kind of death." Mourning the passing of the heath hen, the paper continued, "There is no survivor, there is no future, there is no life to be recreated in the form again. We are looking upon the uttermost finality which can be written, glimpsing the darkness which will not know another day of light. We are in touch with the reality of extinction."

Pied Duck [Labrador Duck]. **Hand-colored lithograph by John T. Bowen after John James Audubon for** *The Birds of America,* **First Octavo edition. 1840–44. Philadelphia.** The beautiful bicolored "pied duck" was another early casualty of American hunters.

Pied Duck
1.Male 2.Female

The Conservation Movement, which began in the late nineteenth century, was born from such dark truths and visions, and state and federal governments, acting under intense pressure from an aroused and angry public, finally stepped in to protect what was left of the wild. For a few unlucky species, it was too late, and they passed into the black hole of extinction, their existence remembered only in human writings and depictions, museum mounts, and, in the cases of the Labrador duck and passenger pigeon, in a few wooden decoys representing the species. But most of the birds that were hunted survived—some just barely, some with relative ease. None can ever regain their historic abundance. The world our birds once inhabited is gone, but they remain to remind us of how precious they are and of our continuing responsibility for their survival.

Wild Duck Shooting: On the Wing. Hand-colored lithograph. Published by Currier & Ives. c. 1870. New York.

Migration

The instinctive urge to migrate is wired into the genes of most birds. The behavior evolved over the millennia as an unlikely but highly successful survival tool, a means of ensuring ample supplies of food for birds and their young throughout the course of the year. Migratory birds are true citizens of the globe, wanderers who travel considerable distances over the course of the year to take advantage of seasonally abundant food and daylight and to avoid extreme weather and food shortages. Migratory birds, which include most geese, ducks, and shorebirds, are built for movement, with hollow, lightweight bones, streamlined bodies, and powerful wings that can move them through the air at sustained speeds and over distances unmatched by any terrestrial species. Some species are year-round residents of particular places or travel just a few hundred miles, but many fly thousands of miles in what is called return migration, moving from one destination to another and back again, usually with stopovers along the way to rest and refuel.

For early hunters, migration was the central fact of bird behavior, a biannual ritual that, while not well understood, could be depended upon as surely as the changing of the seasons. Anyone paying attention knew roughly when different species could be expected to arrive in their region and anticipate their appearance and length of stay with some degree of certainty. That knowledge was local and based on years of observation, and it was passed from generation to generation and hunter to hunter. Chesapeake Bay hunters knew from long experience when canvasbacks would come in to feed on the vast beds of wild celery that grew there, Midwesterners knew when they could find Canada and snow geese in the cut-over cornfields, and Cape Cod gunners knew when to be on the lookout for flocks of golden plover and Eskimo curlew. Then as now, every geographical region of the United States and Canada had its own set of resident and migratory species and its own seasonal expectations, and hunters were finely tuned to the nuances of the year's changes and how they affected the birds they sought.

Migration routes and distances vary enormously from species to species. Some fly north and south over the same path, while others travel elliptical routes that lead them over

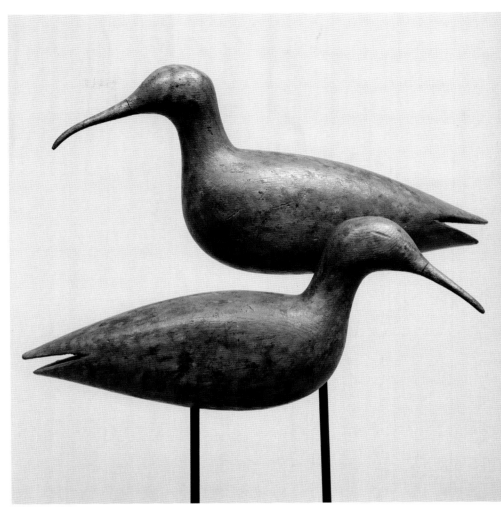

entirely different parts of the continent in spring and fall. Some migrate over land or follow coastlines, while others fly far out to sea, traveling hundreds or even thousands of miles over open ocean. Many "American" species only pass through the continental United States and populated areas of Canada on their way to and from far-flung destinations or spend just a few months of the year on North American shores and waters before heading away again. Most wildfowl found in North America migrate north to breed, following or anticipating the advance of spring weather in the northern hemisphere, and return south to warmer grounds as weather cools and food becomes scarcer in the fall. Breeding in the North also gives the birds access to the long daylight hours of midyear, allowing them more time to search for food for their young. Generally speaking, the farther north a bird breeds in the spring, the farther south it travels in the fall. Many species, especially shorebirds, living below the equator in the fall effectively turn the seasons on their heads, traveling from fall to spring and back again as the planet turns on its

Pair of Eskimo Curlews. **Maker unknown. c. 1875. Nantucket, Massachusetts. Courtesy Collectable Old Decoys.** Eskimo curlews, which are believed to be extinct, migrated between Patagonia and the Arctic Circle each year. Their journey was among the longest distances traveled by any species. These accurately carved decoys are half the size of a long-billed curlew and are also painted in the species' distinctive cinnamon-colored plumage.

axis. Geocentrically, such southern haunts are called "wintering" grounds, but that does not really reflect the birds' or the season's reality, just our own. Terns and shorebirds like the golden plover are among the champion long-distance migrators, flying from Tierra del Fuego at the tip of South America, then north beyond the Arctic Circle to breed, thereby enjoying the almost constant daylight of midsummer near the poles for a considerable portion of the year.

While the fact of migration was understood in earlier times, migration routes were little understood until the 1930s, when extensive bird banding unlocked the basic mysteries of where and when birds traveled and by what path. American birders as early as John James Audubon had banded birds to study their movements, but data was scanty and inconclusive in the nineteenth century. Not until the 1930s were biologists, using data gathered through banding, able to map four massive north–south pathways in North America—the Atlantic, Mississippi, Central, and Pacific flyways, which were named for their general geographic locations. Migratory movements have proved far more complex than once thought, however, and the flyway concept is now considered oversimplified and outdated, although it continues to be useful as a wildfowl management tool. Decades of banding and other tracking methods have mapped the travels of many species and enabled conservationists to better understand their habits and needs.

The how of bird migration is also finally unraveling before the eyes of science, and the complexities and sophistication of avian navigation are proving especially fascinating. It is now clear that migration is triggered by sensitivity to changing daily photoperiods, the length of daylight relative to night. Navigation is guided by a variety of directional cues, including the sun, star patterns, the earth's magnetic field, and, most importantly, polarized light patterns observable in the sky at dawn and sundown. Researchers at Virginia Tech recently proved that songbirds coordinate their magnetic compass systems based on observation of polarized light patterns. According to a university press release about the research, migratory songbirds were found to average the sunrise and sunset intersections of a certain band of polarized light with the horizon to find the geographic north–south axis, thereby "providing a reference that is independent of time of year and latitude. The birds then use this geographic reference to calibrate their other compass systems." Mysteries still remain, and some may never be solved, but wildfowl migration is better understood today and more deeply studied than at any time in history, a fact that benefits both the birds and those who care for and about them.

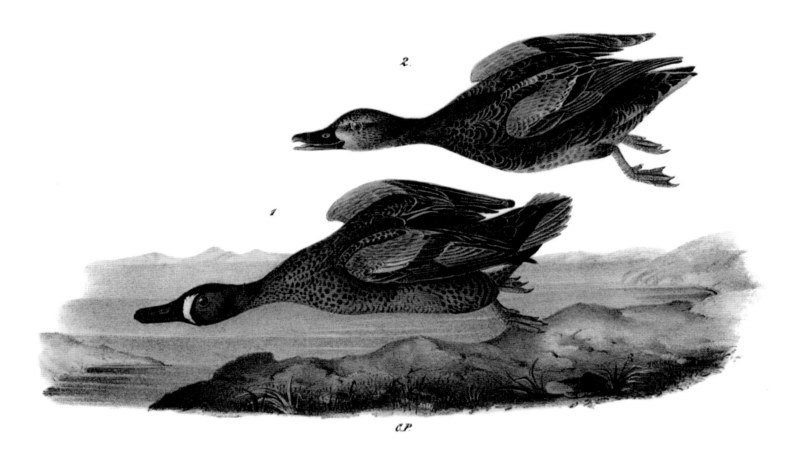

2.

1.

C.P.

Blue-winged Teal

1. Male 2. Female

Blue-winged Teal. Hand-colored aquatint, etching, and line engraving by Robert Havell Jr. after John James Audubon for *The Birds of America.* 1827–38. London. Blue-winged teal are long-distance migrators that breed across central and northern portions of the United States and Canada and winter in Central and South America. They are among the last ducks to migrate north in spring and one of the first to return south in the fall. They are fast flyers that can cover tremendous distances in a short time; according to the Cornell Lab of Ornithology, one individual banded in Alberta was shot in Venezuela just one month later.

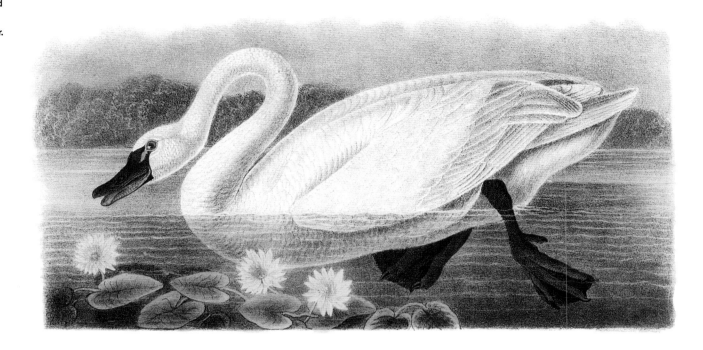

Tundra Swan. Hand-colored aquatint, etching, and line engraving by Robert Havell Jr. after John James Audubon for *The Birds of America.* 1827–38. London.

CHAPTER 3

Swans and Geese

Swans, geese, and ducks are all members of the family Anatidae, which includes 147 species that are found in aquatic habitats worldwide. Like their smaller cousins, swans and geese have long bodies, broad, flat bills with round tips, and webbed feet, and males are typically larger than females. Swans, which are bigger than geese, also have proportionally larger feet and longer necks. Unlike most ducks, both sexes of swans and geese share similar plumage year round.

Swans and geese are primarily herbivores that feed by tipping up or grazing, just as dabbling ducks do. Both swans and geese also feed on land, although geese are much better suited for walking and often graze on grasses and in farmers' fields. Due to their size, swans and geese usually have to run on water to gain momentum before they can take off, a habit they share with the diving ducks. They are gregarious birds that feed and travel in large flocks and are perhaps best known for the loud and distinctive calls they make during flight.

TRUMPETER AND TUNDRA SWANS

The trumpeter swan (*Cygnus buccinator*), named for its loud, deep, hornlike call, which can be heard from more than a mile away, is the world's largest swan and the largest of North America's native waterfowl. A magnificent, long-necked bird, it averages five feet in length with an eighty-inch wingspan, typically weighing in at around twenty-three pounds. Males, which are called cobs, can weigh as much as thirty-five pounds and stand four feet tall. They feed almost exclusively on underwater plants, using their long necks to reach deeper than any other duck or goose can.

Once called the whistling swan for its call, the tundra swan (*Cygnus columbianus*) is America's most common native swan. It is markedly smaller than the trumpeter, averaging fifty inches long with a sixty-six-inch wingspan and a typical weight of a little over fourteen pounds. In the field, it can be difficult to distinguish from the trumpeter; the calls that gave both birds their names provide the clearest means of identification.

The tundra swan breeds in Arctic wetlands and migrates across land to spend the winter in estuaries along the East and West Coasts. Both trumpeter and tundra swans mate for life, forming lasting pair bonds at an early age. The trumpeter is particularly long-lived, sometimes passing twenty-five years in the wild.

The trumpeter was once widespread, but it was decimated by early fur traders, who trafficked in its skins and feathers, as well as by nineteenth-century feather hunters. In 1828, more than nine thousand skins were sold in London alone, where they were used to make ladies' powder puffs. Young "cygnet" swans were much prized as table birds, and swan eggs were also in demand among Victorian naturalists. Writing in 1912, Massachusetts state ornithologist E. H. Forbush summed up the situation this way:

> The trumpeter has succumbed to incessant persecution in all parts of its range, and its total extinction is now only a matter of years . . . A swan seen at any time of year is the signal for every man with a gun to pursue it. The breeding swans of the United States have been extirpated, and the bird is pursued, even in its farthest northern haunts, by the natives, who capture it in summer, when it has molted its primaries and is unable to fly. The swan lives to a great age. The old birds are about as tough and unfit for food as an old horse. Only the younger are savory, and the gunners might well have spared the adult birds, but it was "sport" to kill them and fashion called for swan's down. The large size of the bird and its conspicuousness have served . . . to make it a shining mark, and the trumpetings that were once heard over the breadth of a great continent . . . will soon be heard no more. In the ages to come, . . . they will be locked in the silence of the past.

Swan. **Attributed to John "Daddy" Holly. c. 1870. Havre de Grace, Maryland. Private collection. Photograph courtesy Stephen O'Brien Jr. Fine Arts, LLC.**
Daddy Holly (1818–92) was the patriarch of a family of outstanding decoy carvers who supplied hunters along the head of the Chesapeake Bay. Remarkably, both the keel and paint on this majestic decoy are original.

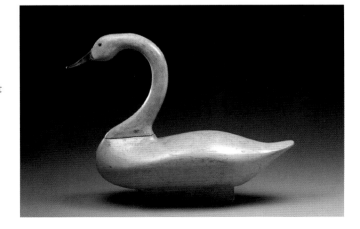

Thankfully, Forbush's dire predictions for the trumpeter did not come true. Conservation laws saved the species from extinction, but by the mid-1930s, fewer than one hundred were known to exist. The trumpeter has made a successful comeback, but the species has recovered only a small portion of its former cross-continental distribution and will probably always be but a shadow of its former presence.

CANADA GOOSE

The Canada goose (*Branta canadensis*) is North America's most widely distributed goose. These geese are perhaps the most familiar fall migrants, and their calls and V-shaped flying formations are symbols of the changing of the seasons throughout the northern United States and southern Canada. Some birds do not migrate, and the species today breeds in every Canadian province and all forty-eight continental United States. The majority of Canada geese, however, still nest in Alaska and Canada, while their winter grounds can range as far south as the Gulf Coast and northern Mexico.

Like swans, Canada geese are monogamous, mating for life with partners they usually choose when they are two or three years old. They vary enormously in size, with geographically separate populations ranging from twenty-five to forty-five inches in length and two and a half to nearly ten pounds in weight. One of those populations, the smaller cackling goose, has recently been recognized as a separate species and designated as *Branta hutchinsii*.

Canada geese have been eagerly sought by hunters since time immemorial, prized for their substantial size and excellent meat, and respected for the sport they provide in the field.

Canada Goose. Joseph Whiting Lincoln. c. 1910. Accord, Massachusetts. Private collection. Photograph courtesy Stephen O'Brien Jr. Fine Arts, LLC. The neck and head of this goose are set forward in a belligerent pose.

Despite their almost domestic status in many areas today, wild geese are extremely wary and intelligent birds. As Charles Hallock put it in his 1877 *Sportsman's Gazeteer and General Guide*, "'As silly as a goose' is an expression which . . . has long gone out of favor with those gunners who have given much time or attention to the pursuit of these birds, for they are certainly the shyest and least easily imposed upon of any of our wildfowl."

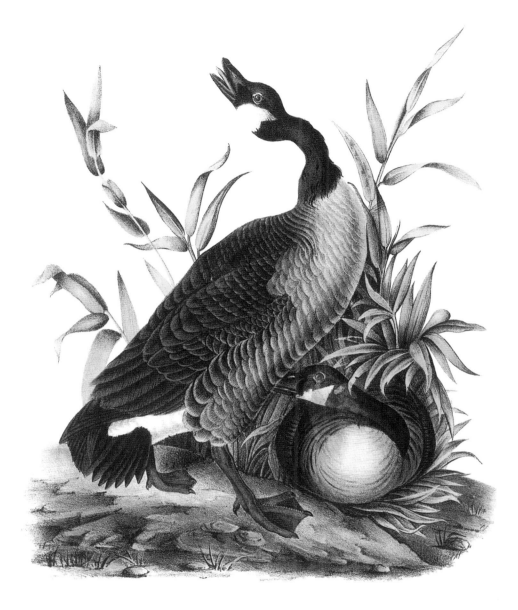

Canada Goose. Hand-colored aquatint, etching, and line engraving by Robert Havell Jr. after John James Audubon for *The Birds of America.* 1827–38. London.

SNOW GOOSE

Although their plumage makes them look completely different, the pure white snow goose and its dark blue color morph, the so-called blue goose, are actually a single species (*Chen caerulescens*). The white and blue color morphs were considered separate species until 1983. The blue morph is controlled by a single gene that is partially dominant over white; the union of a pure dark goose with a white goose

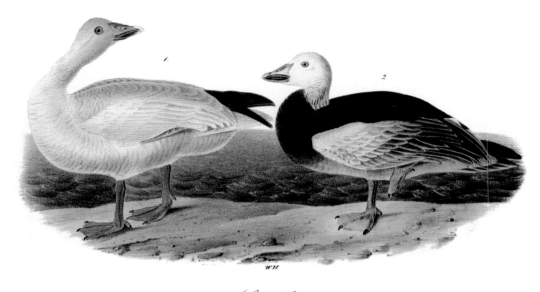

Snow Goose. Hand-colored lithograph by John T. Bowen after John James Audubon for *The Birds of America*, First Octavo edition. 1840–44. Philadelphia.

Snow Goose.
1. Adult male 2. Young Female

produces only dark offspring, and mating white geese can produce only white offspring, while pairs of dark geese produce primarily dark offspring, but can have white chicks too.

Whatever their color, snow geese are stocky, medium-size geese, averaging between twenty-eight and thirty-one inches in length and weighing from a little over five pounds to more than seven. The species breeds across the Canadian Arctic, migrating north and south along all four major flyways in huge, high-flying flocks that can number into the tens of thousands.

"The spectacle of a flock of these white geese flying is a very beautiful one," the early conservationist George Bird Grinnell declared in his book *American Duck Shooting* (1901). He continued:

Sometimes they perform beautiful evolutions on the wing, and it is seen at a distance like so many snowflakes being whirled hither and thither on the wind. Scarcely less beautiful is the sight which may be seen in the Rocky Mountain region during the migration. As one rides along under the warm October sun he may have his attention attracted by sweet, faint, distant sounds, interrupted at first, and the gradually coming near and clearer, yet still only a murmur; from above, before, behind and all around, faintly sweet and musically discordant, always softened by distance, like the sounds of far-off harps, of sweet bells jangled, of the distant baying of mellow-voiced hounds. Looking up into the sky above him he sees the serene blue on high, flecked with tiny white moving shapes, which seem like snowflakes drifting lazily across the azure sky; and down to earth, falling,

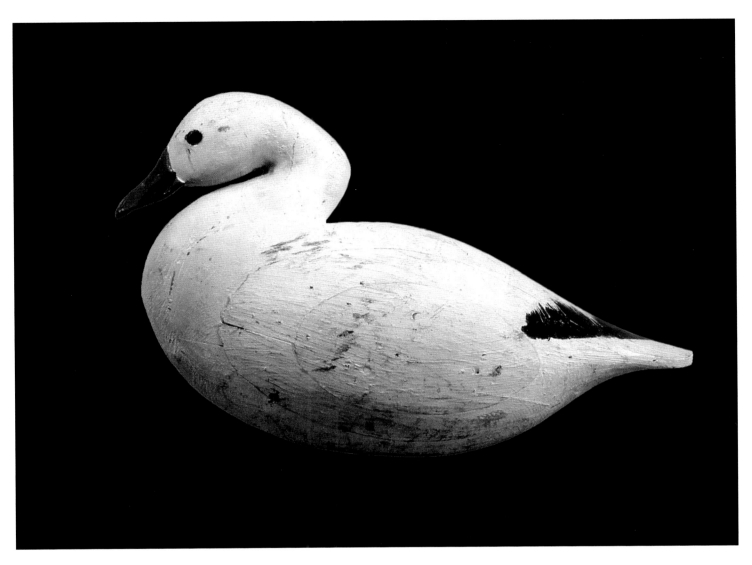

falling, falling, come the musical cries of the little wavies [the Indian name for snow geese] that are journeying toward the south land.

Snow geese congregate in large numbers on their wintering grounds, along southern portions of the Atlantic and Pacific coasts, and from southern Nebraska, Iowa, and Illinois south to the Gulf Coast and Mexico. They forage in shallow marshes and water-soaked fields, where they grub for underground rhizomes, tubers, and roots and graze on aquatic plants, wild and cultivated grasses, and grains. Not unlike the domestic geese they resemble, they prefer to feed on land and often forage for leftover corn and grain found in the harvested fields.

Snow Goose. **John Tax. c. 1917. West Union, Minnesota. Private collection. Photograph courtesy The Gene & Linda Kangas Collection of American & International Folk Art.** Only two Tax snow goose decoys with nestling heads are known. Tax made standing Canada and snow geese that were used for field shooting.

BRANT

Brant (*Branta bernicla*) are small, darkly colored, short-necked geese, averaging twenty-five inches in length and weighing a little over three pounds. Brant breed in the Arctic, mainly in Alaska and Canada's Northwest Territories. They winter along the Atlantic and Pacific coasts, from Massachusetts to North Carolina in the East, with particularly heavy concentrations in New Jersey, and from Alaska to Baja in the West. West Coast brant have darker bellies than their East Coast cousins, and were for many years considered a separate species, called "black brant."

Unlike other geese, brant are highly selective feeders whose preferred food is eelgrass (*Zostera marina*), a flowering underwater plant that plays a major role in the ecosystems of protected coastal waters. The species' dependence on eelgrass is such that it suffered devastating population declines when eelgrass beds along the Atlantic were hit by a blight in the 1930s. Both the grass and the brant recovered, although the cause of the disease was not discovered until 1997. Since then, up-and-down cycles have continued in both populations over the years. Brant survived in part by adapting their feeding habits, moving their preference to a seaweed called sea lettuce.

Brant Goose [Brant]. Hand-colored lithograph by John T. Bowen after John James Audubon for *The Birds of America*, First Octavo edition. 1840–44. Philadelphia.

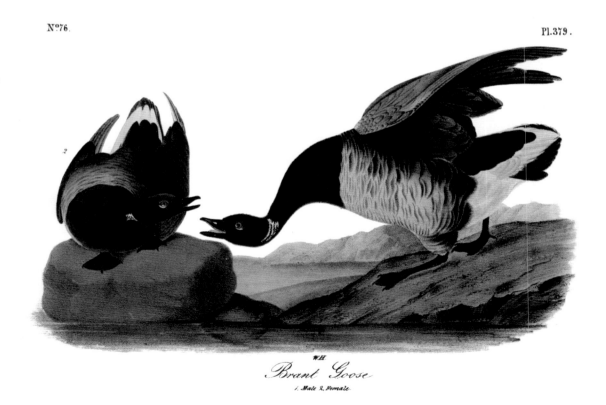

N°76.

Pl.379.

Brant Goose

1. Male 2. Female.

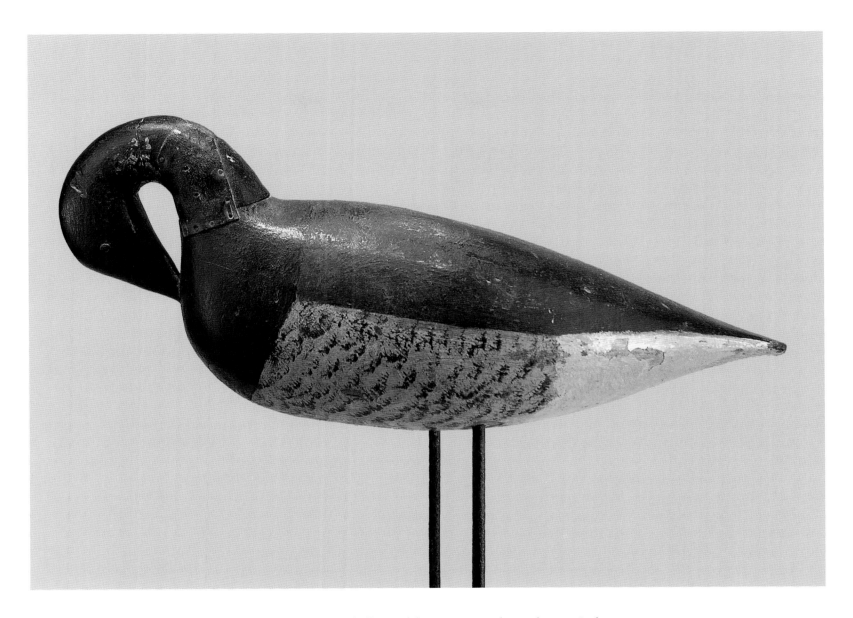

Brant, which winter in heavy concentrations in shallow tidal waters, were hunted extensively along both the Atlantic and Pacific coasts during the nineteenth and early twentieth centuries. Unlike geese, brant are an unsuspicious species and are easily domesticated. Many were used as live decoys by New England hunters, a practice that was eventually banned because it was too effective in luring wild birds within the range of gunners.

Brant. John Ramsey. c. 1900. Summerside, Prince Edward Island. The Gene & Linda Kangas Collection of American & International Folk Art.

This solid-bodied standing front preener has an in-use metal patch to the neck and two metal rods for legs. Many Prince Edward Island carvers made standing decoys.

Mallard Duck. Hand-colored aquatint, etching, and line engraving by Robert Havell Jr. after John James Audubon for *The Birds of America.* 1827–38. London.

CHAPTER 4

Dabbling Ducks

Dabbling ducks, named for their habit of nibbling at food at, or just below, the water's surface, are primarily freshwater birds most often found in shallow marshes, ponds, and rivers. They also often "tip up," dipping head down into the water with their feet in the air as they feed. Because their feet are closer to the center of their bodies than diving ducks, they can also feed on land, walking or running with relative ease. Dabblers feed by filtering invertebrates and vegetable matter through lamellae, flexible plates that line the edges of their bills and are similar in texture and function to whale baleen. Dabblers take off directly from water without a running start and are also distinguished by their brightly colored, iridescent wing patches, called speculums.

MALLARD

The mallard (*Anas platyrhynchos*) is the most familiar and widely distributed of all dabbling ducks and the ancestor of almost all domestic ducks. A highly adaptable omnivore, it thrives in a wide variety of habitats, breeding from California, north to Alaska, and across Canada's Central Plains to the East Coast, wintering all over the United States and southern Canada, and as far north as it can find reliably open water. The species is also extremely tolerant of humans, and, like the Canada goose, is often found today in the midst of parks, golf courses, and other public places. It was far and away the most abundant duck in North America during colonial days, and it remains so today, although its numbers are much reduced from their historic sizes.

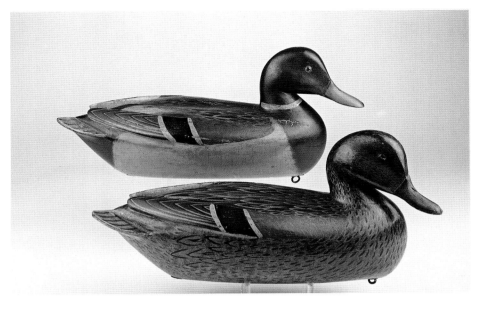

Pair of Mallards. **Charles Perdew. c. 1944. Henry, Illinois. Collection of Joe and Donna Tonelli.** Note the "sleepy" eye on the hen of this raised-winged pair, which represents Charlie Perdew at the top of his game. They were among a dozen mallards he crafted for "Sacci" Saccaro of the Mud Lake Gun Club, who had provided him with saw blades during World War II.

The drake mallard's distinctive breeding plumage—an iridescent dark green head and rusty red breast, separated by a band of white contrasting with a gray back, white underparts, blue speculum, and short, uncurled black tail—is the image that comes to mind when most people think of ducks. In contrast, the hen and nonbreeding males are drab brown with dark bodies and light heads. The female's orange-and-black bill distinguishes it from the nonbreeding male, whose bill is always solid orange. They are the largest and heaviest of dabbling ducks, averaging twenty-three inches long and weighing a little under two and a half pounds.

The mallard has been a prized table bird among North American hunters for centuries, and it was hard hit by market gunners in the nineteenth and early twentieth centuries. Audubon, who observed that the species in Florida was so numerous that they blackened the sky, described a single slave who killed between 50 and 120 mallards a day to supply the plantation's kitchen, and a report of the 1893–94 season at Big Lake, Arkansas, estimated that 120,000 ducks were sent to market from that spot alone. Hundreds of thousands were also killed for their colorful feathers. It's no mystery why populations of the species were reported to be down as much as 90 percent in the early 1900s. Happily, the mallard's resilient and adaptable nature allowed it to recover quickly after protective legislation was put in place, and today, with its population stable and well managed, it is once again the most hunted of all American ducks.

AMERICAN BLACK DUCK

The American black duck (*Anas rubripes*), so named because it is found only in North America, is a predominantly Eastern species, rarely found west of the Mississippi River. It prefers coastal salt marshes, but also frequents freshwater ponds, marshes, and other waters so long as adequate cover is present. Black ducks breed throughout eastern Canada, from Hudson Bay south through Ontario, Quebec, and the Maritimes. They winter from the southern edges of their breeding grounds on either side of the Canadian border south to Mississippi, Alabama, and northern Florida. The greatest concentration of these birds is found in New England and Nova Scotia.

Unlike the mallard, its close relative with whom it often interbreeds, the black duck is extremely wary and avoids all contact with humans. Charles Hallock advised fellow hunters in 1877 that "stratagem is the only recourse, if we hope to be successful. They are rarely to be found in great numbers, except when congregated in salt water, five to ten being an average flock started from pond and feeding ground." He continues, "During severe winters, when every sheet of water is bound in with a thick covering of ice, the Black Duck are driven to warm spring holes where the water never freezes, and hunters often take large bags by concealing themselves near such places."

Dusky Duck [American Black Duck]. Hand-colored lithograph by John T. Bowen after John James Audubon for *The Birds of America*, **First Octavo edition. 1840–44. Philadelphia.**
Audubon often used common, rather than proper, names of the birds he portrayed. The American black duck was also called "black mallard" in earlier times.

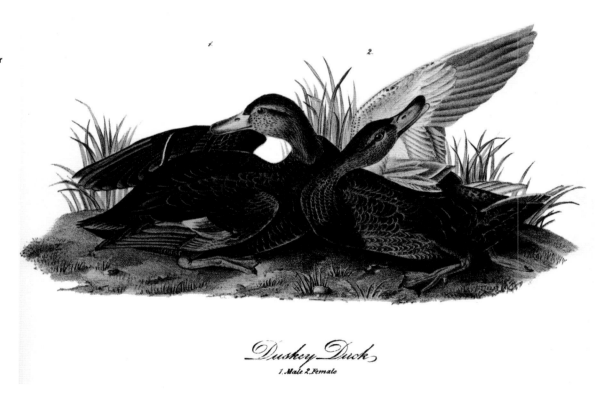

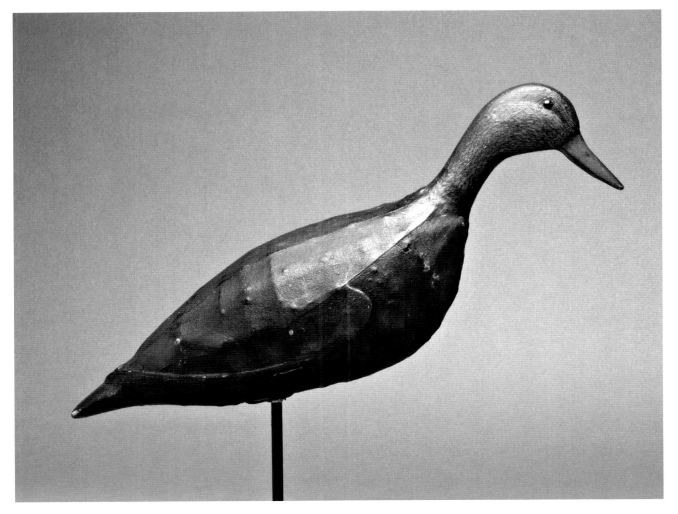

Several New England carvers, including George Boyd and Lothrop Holmes, stretched canvas over wooden frames to form the bodies for some birds, thereby making them much lighter and easier to carry than wooden-bodied decoys. This remarkable black duck, one of six found in an old Marshfield home in 1952, is covered with two layers of canvas. Dr. George Ross Starr, an early Massachusetts collector who owned one of the rig mates, offered further details: "The construction consists of a full 3/4-inch-thick profile to which the head, tail, and side frames are fastened. The small lumps on the surface indicate tacks for an inside canvas covering. The outer covering is composed of eight sections—much like the sections from which a globe is made. When this was put on, the slack was taken up along the mid base line, which shows double-tacking along its whole length. The outer skin was also tacked around the base of the neck and the tail. There is a hole in the bottom 5/8-inch square for the 'leg' stick. The bill is a separate piece and the eyes are black glass. Two thin strips of wood applied to the sides indicates the primaries." The complex construction and use of canvas and tacks suggest the maker may have been a cobbler.

The black duck is the same size but slightly heavier than the mallard, with much darker plumage adorning both sexes throughout the year and with iridescent, bluish-purple speculums. It has been a favored game species since early times and was heavily gunned along the Atlantic coast during the nineteenth and early twentieth centuries. Writing in 1912, E. H. Forbush reported that although its numbers had decreased greatly since early times, it was the only freshwater duck that remained common in New England, "owing to its ability to take care of itself . . . it has avoided the gunner by feeding mainly at night, and going out on the salt water or to some large lake during the day, where it is practically unapproachable." Its numbers steadily declined in the twentieth century because of continued overhunting and habitat loss, and, although those trends have been mitigated by far more restrictive game laws and concerted conservation efforts, fewer than a million currently exist, about half its estimated nineteenth-century population. The Audubon Society considers it a "species of concern."

NORTHERN PINTAIL

A medium-size dabbler, averaging twenty-one inches in length and weighing a little less than two pounds, the northern pintail (*Anas acuta*) is named for the male's long central tail feathers, which extend several inches beyond his body. Called *rectrices*, these long, stiff feathers are the bird's flight feathers, used to generate both thrust and lift and thereby enable flight. Pintails and other birds also have flight feathers on their wings, called *remiges*, but the drake pintail and long-tailed duck are the only ducks to have such elongated flight feathers in their tails.

Pintails are slim, elegant birds, with long, narrow necks and pointed tails. In breeding plumage, the drake's chocolate-brown head, white neck and underparts, iridescent green-purple speculum, and extremely long rectrices distinguish him from all other ducks. The hen is drably colored, but her elongated profile is also unique. Pintails are a global species with the widest range of any waterfowl. In the Americas, they breed primarily in Alaska, the north-central United States plains, and across western Canada's prairies as well as along the south of James and Hudson Bays. They winter along both the Pacific and Atlantic coasts from southeastern Alaska and Massachusetts south, with the greatest concentration in California, as well as in wetlands throughout the south-central United States, Central America, Bermuda, and Cuba. They are among the earliest

Pintail Duck [Northern Pintail]. Hand-colored lithograph by John T. Bowen after John James Audubon for *The Birds of America*, First Octavo edition. 1840–44. Philadelphia.

ducks to migrate in either direction, arriving on their nesting grounds in March and April and heading south as early as August.

Pintails are swift and acrobatic fliers, capable of quick turns and dives, and drakes put on elaborate courtship flight displays to woo females. They are also wary birds and tend to live longer in the wild than other ducks; the oldest documented wild pintail lived to be twenty-one. Their primary foods are aquatic vegetation, seeds, and insects, and, like mallards, they often feed on land, coming ashore to graze on seeds, grain, and corn. While pintails remain common, their numbers have been seriously affected by loss of breeding habitat. According to the conservation group Ducks Unlimited, more than three quarters of the pintail's traditional breeding grounds in the Great Plains grasslands have been converted to farmland in the past century, and many pintail nests are destroyed by farm equipment before the eggs can hatch.

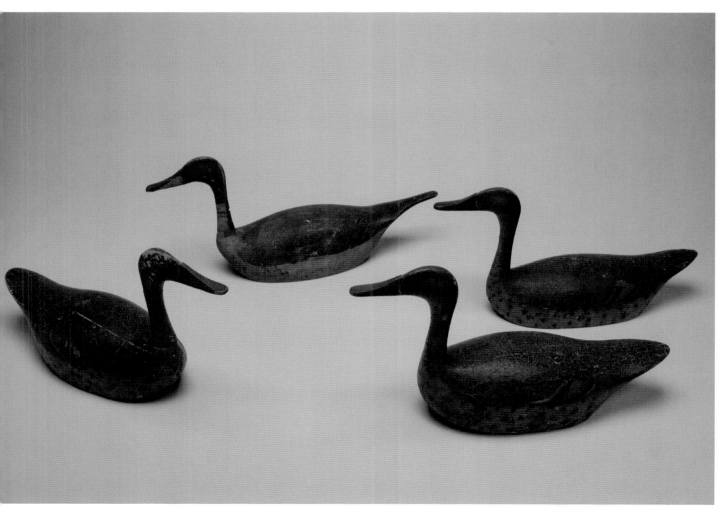

Pintails. **Maker unknown. c. 1900. Northwest Indiana. Collection of Ron Gard.** These highest of high heads by a masterful but unidentified hand capture the essence of the pintail by exaggerating the species' thin, elongated form. The decoys were used on the Grand Kankakee Marsh in Indiana, which originally covered more than 500,000 acres in northwestern Indiana and northeastern Illinois and ranked among the great freshwater wetland ecosystems and hunting grounds of the world before much of it was drained for agricultural use. Seven of these high-headed pintails were found in a house near a major railroad crossroads in Indiana, along with fourteen far less distinctive mallards and bluebills. Herman Trinosky, who was born in 1874 and worked for the railroad, owned the house, but we may never know his relation to the decoys.

AMERICAN WIGEON

The American wigeon (*Anas americana*), nicknamed "baldpate" for the male's white crown and forehead, is one of America's most northerly ducks. It breeds in Alaska and across Canada, from the edge of the tundra into the southern prairie provinces, utilizing all four major flyways to winter along both coasts of the United States and from the northern plains into Mexico and northern parts of Central America. It often winters in large flocks on Chesapeake Bay, where it was heavily gunned during the nineteenth and early twentieth centuries. It has always been prized as a table bird; its flesh is compared with the canvasback, with which it shares a taste for wild celery. Wigeon are aggressive feeders; nineteenth-century accounts claim that wigeon often mingled with canvasbacks on their feeding grounds, stealing some of the food the "cans" rooted up from the depths. Inland, wigeon are often found foraging in farm fields, where their

American Widgeon [American Wigeon]. Hand-colored aquatint, etching, and line engraving by Robert Havell Jr. after John James Audubon for *The Birds of America*. 1827–38. London.

American Widgeon
1 Male 2 Female

specially adapted bills make grazing easier than for other ducks.

Wigeon are extremely wary birds and act as sentinels within the mixed flocks they often join with to feed. In his 1898 book, *Wild Fowl of North America*, D. G. Elliott noted that the wigeon is "suspicious of everything and not only is unwilling to approach any spot or object of which it is afraid, but by keeping up a continuous whistling, alarms all the other birds in the vicinity and consequently renders itself very disagreeable and at times a considerable nuisance to the sportsman."

The species averages twenty inches long with a thirty-two-inch wingspan and weighs just over a pound and a half. The breeding male has an unusual reddish to pink-brown breast and sides and a distinctive iridescent green eye patch under his bright-white crown. The rest of the drake's neck, face, and upper back are off-white with black speckles. His wings bear large, white patches that are most noticeable in flight. Hens are mottled brown with grayish heads and have smaller, duller shoulder patches than the drakes. Both sexes have small, light-blue bills with black nails.

Pair of Wigeon. **The Sibley Co. c. 1900. Whitehall, Minnesota. Private collection. Photograph courtesy Sotheby's. Inc.** Although made in Minnesota, these decoys were designed for use on the Illinois River. The bottoms of both are stamped "PATENT APPLIED FOR 1899."

GREEN-WINGED AND BLUE-WINGED TEAL

The green-winged teal (*Anas crecca*) is the smallest of the dabbling ducks, averaging fourteen inches long with a twenty-three-inch wingspan and weighing about twelve ounces. The blue-winged teal (*Anas discors*) is slightly larger and longer-bodied but has the same wingspan as its smaller cousin. Both species are named for their large, distinctively colored wing patches, which are lined with white. The breeding green-winged drake also has a dark chestnut head and an iridescent green ear patch, while the breeding blue-winged drake is distinguished by a white crescent at the front of his blue-gray head.

Teal are long-distance migrators, breeding far north of their winter range in Alaska and Canada and southward to the northern Great Plains and Great Lakes. Green-winged teal winter in the southern

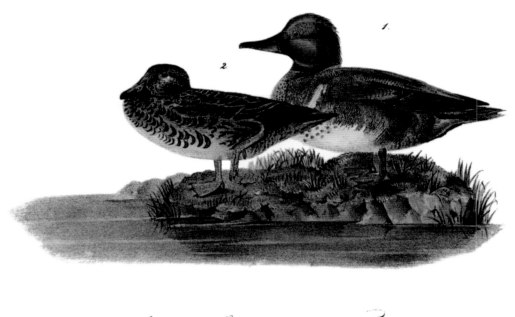

American Green-winged Teal
1 Male 2 Female

Green-winged Teal. Hand-colored aquatint, etching, and line engraving by Robert Havell Jr. after John James Audubon for *The Birds of America.* 1827–38. London.

OPPOSITE; *Pair of Green-winged Teal.* Amiel Garibaldi. c. 1935. Sacramento, California. Collection of Mike Cole. Photograph courtesy Westcoast Decoys. Amiel Garibaldi (1908–89) was a pharmacist who carved decoys for his own use and hunted at his own private club, the Anchor Duck Club, south of Colusa. Even though he carved decoys for more than fifty years, Garibaldi did not work from patterns, and no two of his birds are exactly alike. These early teal were collected directly from the Garibaldi family.

two-thirds of the United States and as far as southern Mexico, while blue-winged teal travel farther south than any other duck in North America, with significant numbers migrating as far as northern South America.

Teal fly in tight formations, often turning in unison like shorebirds. "The evolutions of a large flock of these birds are truly astonishing," wrote John Hooper Bowles in his 1909 study, *The Birds of Washington*:

> They fly in such close order that one would think their wings must interfere, even on a straight course, yet of a sudden the whole flock will turn at a right angle, or wheel and twist as if it were one bird. The looker-on can only wonder what the signal may be which is given and obeyed to such perfection, for the least hesitation or mistake on the part of a single bird would result in death or a broken wing to a score.

Teal are also extremely swift flyers, but their close-knit habits made them vulnerable to the techniques of nineteenth- and early twentieth-century gunners, who could often kill a number of birds with a single load of shot. Audubon wrote that he "was assured by a gunner residing at New Orleans, that as many as one hundred and twenty had been killed by himself at a single discharge; and I myself saw a friend of mine kill eighty-four by pulling together the triggers of his double-barreled gun!" Similar

hunting pressures persisted throughout the nineteenth and early twentieth centuries, but despite huge losses, both teal species recovered after the passage of federal game laws. Today, the blue-winged teal is the second most common duck in North America, outnumbered only by the mallard, and the green-winged teal ranks second only to mallards in hunter's bags, The migratory patterns of the blue-winged teal keep the majority of them out of harm's way during current hunting seasons. Habitat destruction is now the greatest threat to both species.

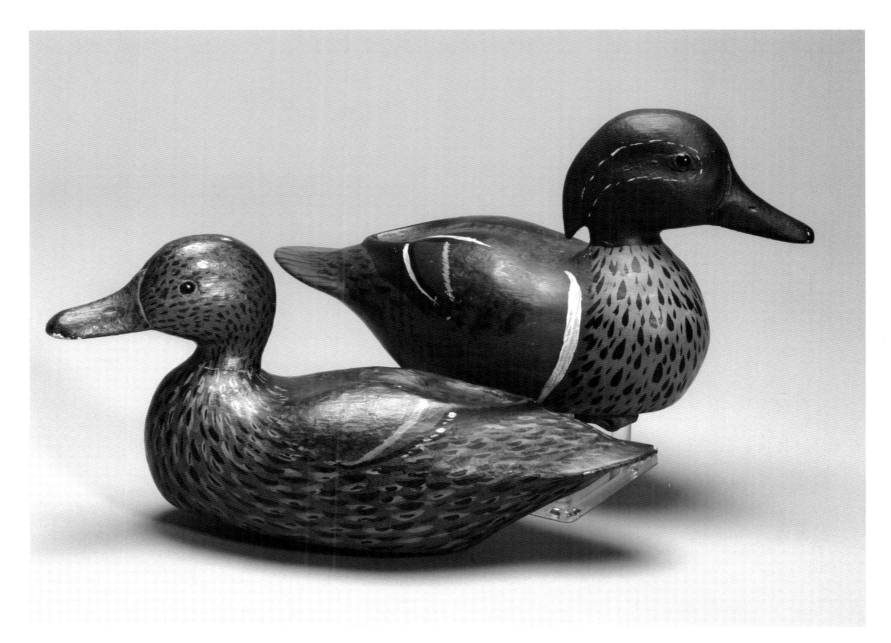

Wood Duck. Hand-colored aquatint, etching, and line engraving by Robert Havell Jr. after John James Audubon for *The Birds of America*. 1827–38. London.

WOOD DUCK

"[The Wood Duck] is the loveliest of all wild-fowl," E. H. Forbush declared unequivocally in his 1912 book on the game birds of Massachusetts:

> Even the Mandarin Duck of China is not more strikingly beautiful. The female is a fitting bride for her lord. Her plumage is not so bright, but the colors and patterns are neat and modest, and her form and carriage are remarkably attractive. Nature presents no more delightful sight than a flock of these beautiful birds at play on the surface of a pellucid woodland stream, their elegant forms floating as lightly as a drifting leaf and mirrored in the element that they love. The display of their wonderful plumage among the flashing lights and deep shadows of such a secluded nook forms such a picture, framed by the umbrageous foliage of the forest, that once seen by the lover of nature, is indelibly imprinted on his memory as one of the episodes of a lifetime.

The wood duck (*Aix sponsa*) is one of the few ducks that nest in trees. It is a denizen of forested wetlands, found wherever trees shelter freshwater. It nests in hollow tree cavities, up to fifty feet above the ground or waterline, as well as in the thousands of nesting boxes that have been built for the species since the 1930s. Wood ducks breed from southern Canada and the eastern United States southward to Cuba, and from British Columbia southward along the Pacific coast to southern California. They winter in the southern three-quarters of their breeding range, as well as in the Southwest.

Woodies are medium-size ducks that average nineteen inches long, with a wingspan of twenty-eight inches, and weigh about one and one third pounds. Both sexes have crested heads, short bills, short legs, and long tails. The spectacular breeding drake sports an iridescent purple and green head, red eyes and bill, a distinctively shaped white chin patch, a red-brown breast flecked with white, and bronze sides. Adult woodies prefer to eat seeds, berries, and acorns and other nuts, while both adults and ducklings forage for a variety of aquatic and terrestrial invertebrates.

Wood ducks were extremely popular table birds in the nineteenth and early twentieth centuries and were also extensively hunted for their colorful feathers. They were scarce in many parts of their traditional range by 1900 and thought to be near extinction. The bird's great beauty probably helped to save it. By 1910, a number of northeastern states, including New York, Connecticut, Massachusetts, and Maine, had abolished hunting of the species, and federal legislation followed a few years later. Wood ducks recovered slowly but steadily through the 1920s and '30s, and today are among the most common ducks in North America. They are avidly sought by hunters once again, and in the Atlantic and Mississippi flyways they are second only to the mallard in the number taken each year.

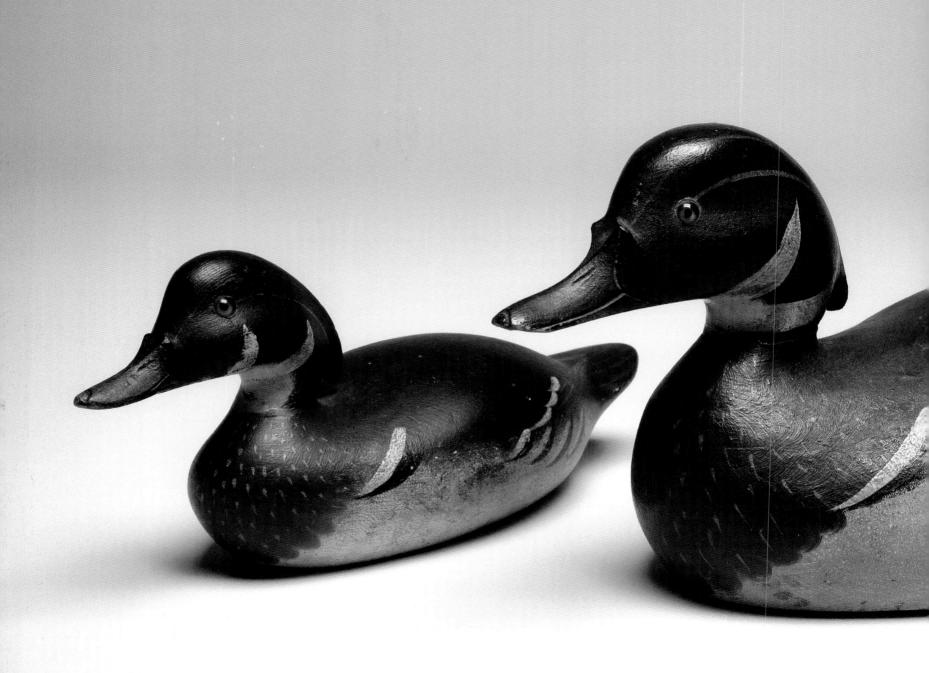

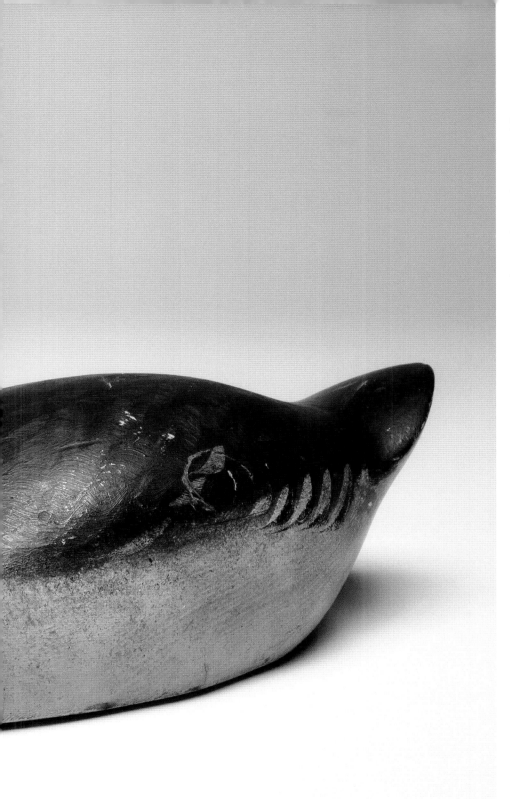

Wood Duck Drakes. **Mason Decoy Factory. c. 1910. Detroit, Michigan. Private collection.**
The larger bird is the only known Mason hollow Premier model wood duck, while the much smaller solid-bodied example is believed to have been made as a salesman's sample to show off the best the company had to offer. The pioneering collector William J. Mackey Jr. originally owned the hollow Premier woodie, and few would argue with his assessment that it is the single finest item Mason ever produced.

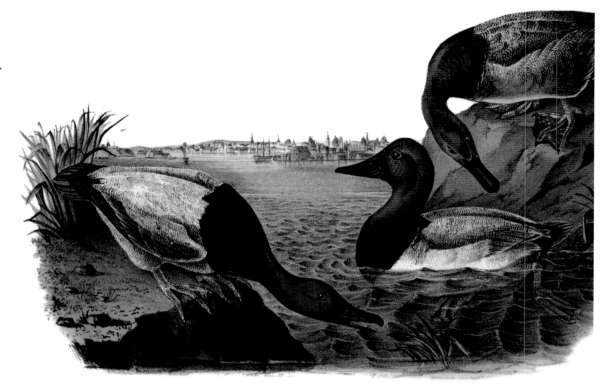

CHAPTER 5

Diving Ducks

Like dabblers, diving ducks are named for their feeding habits, which take them deep into the large lakes, river mouths, and coastal bays and inlets they frequent in search of aquatic plants, fish, shellfish, and mollusks. They also dive for protection and can swim considerable distances underwater, bobbing just their heads above water for air before diving again. They are generally more heavyset than dabblers and have large, paddle-shaped feet that propel them in water and act as rudders in the air. Most members of the group also run on top of water to gain momentum before takeoff and spread their feet when landing to ease impact. Unlike dabblers, their speculums are usually dully colored, and, because their wings tend to be smaller than dabblers, their wingbeats are more rapid when flying.

CANVASBACK

The canvasback (*Aythya valisineria*), a species unique to North America, has long been considered the "king of ducks," admired by artists, naturalists, and sportsmen alike. Canvasbacks are big, stocky, aristocratic birds, averaging twenty-one inches long with a twenty-nine-inch wingspan and weighing more than two and a half pounds. "Cans" have large heads; red eyes; long, flat, sloping foreheads; and long black bills. Its sloped-head profile distinguishes it from all other ducks, and the breeding male's brick-red head, white back, and black chest are also distinctive. Drakes were often called bulls during the nineteenth century because of their thick necks and large heads.

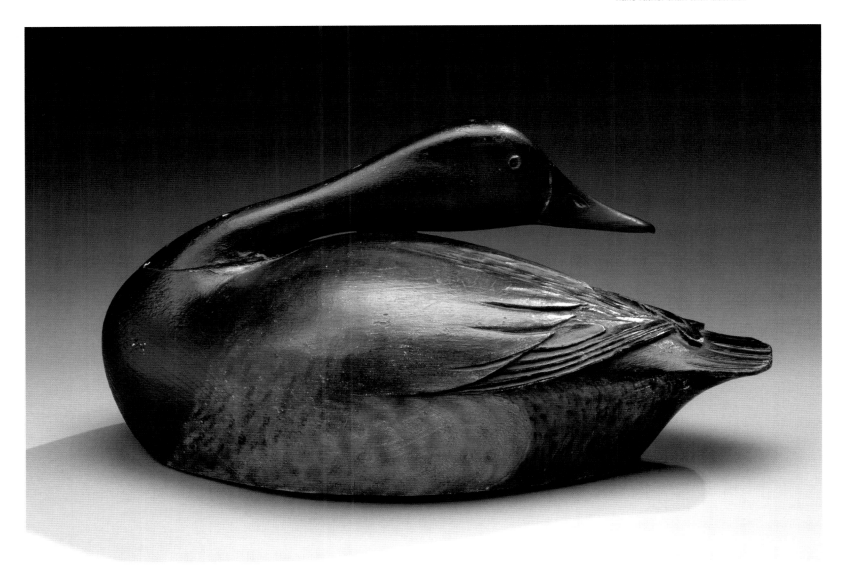

A nineteenth-century account by George Bird Grinnell, first published in *Forest and Stream* magazine, typifies the admiration that hunters of the time had for the canvasback:

> I have recently had the opportunity of being brought into what I may call close association with the greatest of all the wildfowl, the superb canvas-back duck. The locality was Currituck Sound . . . Before long the open water was so crowded with the fowl that it seemed as if it could hold no more, and as if the birds that came next must necessarily alight on the backs of their comrades.
>
> Soon after the birds alighted, they began to dive for food, and, probably one-half of them being under water at any one moment, room was made for other incoming birds to occupy. The splashing of the diving ducks made the water bubble and boil, and the play of the birds as they sometimes chased each other made the scene one of the greatest possible animation. Presently something occurred to attract their attention, and all stretched their necks up into the air and looked. I think I have never seen anything in the way of feathered animal life more impressive than this forest of thick necks, crowned by long, shapely heads of rich brown.

Canvasbacks breed from Alaska south through central northwestern Canada and winter from the Great Lakes south to the Gulf Coast and Mexico. Particularly large flocks of wintering birds are often found in Puget Sound and San Francisco Bay, southern Louisiana and Mississippi River delta lakes, Lake St. Clair, the Detroit River, western Lake Erie, Chesapeake Bay, and Currituck and Pamlico Sounds in North Carolina.

The canvasback's Latin name comes from *Vallisneria americana*, the so-called "wild celery" that has always been the bird's preferred food during migration and on its wintering grounds. Wild celery is primarily a freshwater plant found from the mid-Atlantic coast west to Minnesota and Wisconsin. It bears no resemblance to cultivated celery but is instead an underwater grass with straight, ribbonlike leaves. Wild celery is tolerant of brackish water, and hundreds of thousands of acres of it once grew in Chesapeake Bay, although it and other aquatic grasses have diminished steadily along with water quality. Canvasbacks and other diving ducks root up the plant's winter buds and rhizomes; cans can dive more than thirty-five feet to reach the plants.

Because of its size and wild celery diet, the canvasback was the dominant American game duck of the nineteenth century. As many as a half million cans once gathered in huge winter rafts on the Susquehanna Flats, an eight-mile-long stretch of shallow water off Havre de Grace, Maryland, where the Susquehanna River meets Chesapeake Bay. Sportsmen from all over the country came to the Flats to hunt cans, and local market hunters pursued the species relentlessly. Hundreds of thousands of cans were killed; a single market gunner reported taking seven thousand in a month. The species rebounded after market gunning was outlawed, but continued hunting pressure and the bird's sensitivity to habitat destruction have kept its numbers low compared to other duck species.

REDHEAD

As its Latin name suggests, the redhead (*Aythya americana*) is, like its larger relative the canvasback, found only in North America. The species breeds in marshes and leas in central Alaska, the Great Plains of Canada and the United States, and locally throughout the West and the Great Lakes region, and it winters in open water over much of the United States and Mexico. Also like canvasbacks, redheads are most often found in saltwater during the winter, with the greatest concentrations found along the Gulf Coast, especially the Laguna Madre of Texas and the Laguna Madre of Tamaulipas, Mexico, where hundreds of thousands of the birds congregate.

Redheads average nineteen inches long with a twenty-nine-inch wingspan and weigh about two and one third pounds. Breeding drakes have the bright reddish-chestnut head for which the species is named, along with a gray back, black breast and rump, yellow eyes, and a pale blue bill with a black tip. Nonbreeding males retain a red head, but their color is more subdued. Hens are tannish-brown all over.

Red-headed Duck [Redhead]. Hand-colored lithograph by John T. Bowen after John James Audubon for *The Birds of America*, First Octavo edition. 1840–44. Philadelphia.

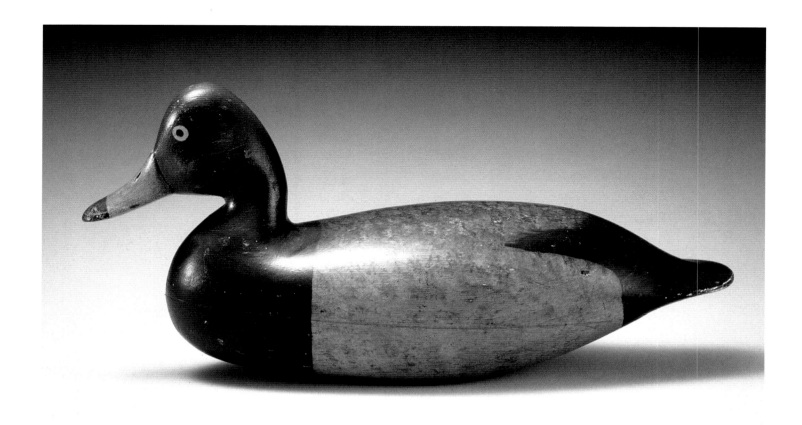

The birds feed primarily on aquatic plants and depend heavily during the winter on rhizomes of shoal grass (*Halodule wrightii*), a particularly hardy grasslike seagrass that forms extensive meadows in some areas of shallow water along the Gulf Coast.

Redheads are gregarious birds and often raft with other species. They have long been popular game birds, because of both their vegetative diet and their unsuspicious nature, and they were heavily hunted throughout the nineteenth and early twentieth centuries. According to George Bird Grinnell, redheads were shot in great numbers on the Great South Bay of Long Island during the fall and winter and also spent the winter in great numbers on the eastern shore of Virginia, Chesapeake Bay, and the sounds of the coasts of North and South Carolina. Daily bag limits for the species remained high through the 1920s, and while populations are believed to be stable, the redhead is nowhere near as common as it once was in these areas.

GREATER AND LESSER SCAUP

Descriptively called bluebills, broadbills, and black heads by early hunters, scaup are medium- to large-size divers whose wide, gray-blue bills give them their most common nicknames. The greater scaup (*Aythya marila*), which prefers saltwater, is widely distributed around the northern hemisphere, while the lesser scaup (*Aythya affinis*) is a primarily freshwater species native only to North America. It can be hard to distinguish between the two species, although the greater scaup is noticeably larger, about eighteen inches long to the lesser scaup's sixteen, and heavier to an experienced eye. Breeding males also can be distinguished by the tint of their dark, iridescent heads: greater scaup are glossy greenish-black, while lesser scaup are blue- or purple-black. The breeding male of both species is primarily black and white with a barred gray back, white sides, a black rump and breast, and yellow eyes, while drakes in nonbreeding plumage have a black head and breast, a brown body, and a black rump. The female, who is brownish overall, also has yellow eyes, but has a white semicircle at the base of her beak. The heads of lesser scaup heads are more angular than those of greater scaup, rising to a distinct peak.

The greater scaup is the hardier of the two species, breeding in tundra from Alaska across far northern Canada, and wintering in bays, lagoons, and estuaries along both the northern Atlantic and Pacific coasts, as well as in some large lakes. Despite this diversity, however, the great majority of North American greater scaup nest in western Alaska and fly southeast to winter on Long Island Sound. Lesser scaup breed in boreal forest and parklands from Alaska east to Manitoba and south into the north

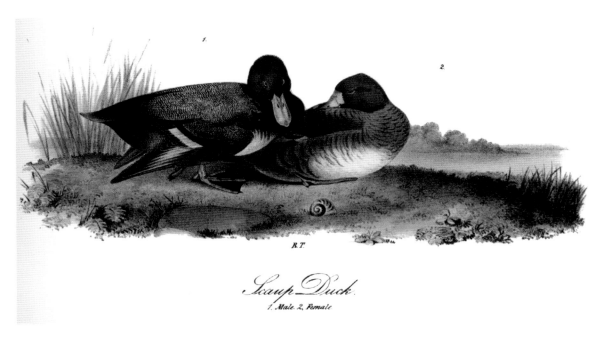

Scaup Duck [Greater Scaup]. Hand-colored lithograph by John T. Bowen after John James Audubon for *The Birds of America*, First Octavo edition. 1840–44. Philadelphia.

central United States, and winter on lakes, ponds, and rivers throughout the continental United States, Mexico, and Central America. By far the largest winter concentrations are found on the Gulf Coasts in Louisiana and Florida, Lake Okeechobee in south-central Florida, and the Pacific and Gulf coasts of Mexico. Wintering lesser scaup are also common along the Pacific coast from southern Alaska to California, in the Great Lakes, and along the Atlantic coast from New Jersey south.

Although the quality of their flesh varies enormously depending on whether they feed primarily on plants or shellfish, both scaup species were heavily hunted in the nineteenth and early twentieth centuries. Greater scaup were particularly hard hit in their winter grounds on Long Island Sound and the Great South Bay, where they were pursued by professional hunters for the New York markets. Neither species is considered of special concern today, however, and lesser scaup are among the most abundant and widely distributed of North American ducks.

Scaup Drake. **James Adam Nichol. c. 1920. Smiths Falls, Ontario. Collection of Bernie Gates.**
Nichol, a master woodworker, worked as a pattern maker, and his attention to detail was remarkable. This intricately carved decoy is hollow with a tightly fitting oval butternut board inserted into its bottom.

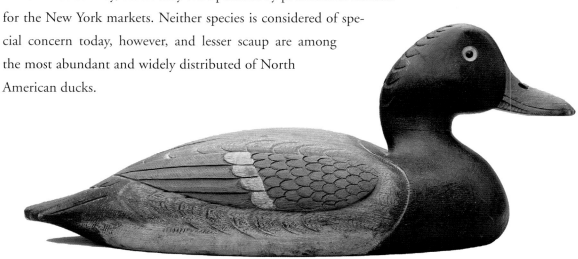

RUDDY DUCK

In his 1926 book, *A Natural History of Ducks,* the Wenham, Massachusetts, sportsman and conservationist John C. Phillips, a major patron of Cape Cod master decoy maker Elmer Crowell, summed up the ruddy duck this way: "Its intimate habits, its stupidity, its curious nesting customs and ludicrous courtship performance place [the ruddy duck] in a niche by itself. Even its eggs are unique in appearance and are deposited in a slip-shod, irregular manner that is most extraordinary. Everything about this bird is interesting to the naturalist, but almost nothing about it is interesting to the sportsman."

Ruddies are small, compact ducks with large heads and proportionally long, stiff tails that they can hold straight up in the air. They average fifteen inches long with an eighteen-and-a-half-inch wingspan and weigh a little more than a pound. Breeding males have a chestnut body, black crown, white cheeks,

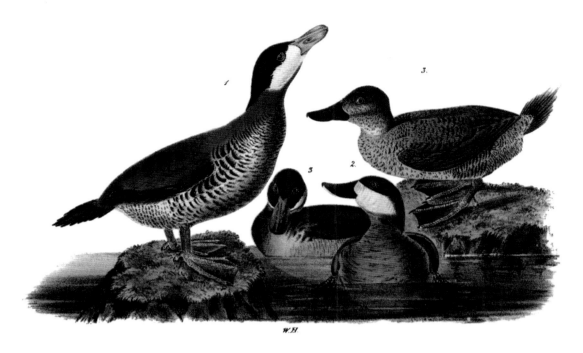

Ruddy Duck. Hand-colored lithograph by John T. Bowen after John James Audubon for *The Birds of America*, First Octavo edition. 1840–44. Philadelphia.

and a bright blue bill, while hens have white cheeks crossed by a dark line but are otherwise dusky brown all over. Winter drakes are also brown and have black bills but retain their black cap and white cheeks.

They are indeed "odd ducks," with a variety of habits unlike any other species. Their eggs are enormous in proportion to their small bodies, averaging two inches long, larger than those laid by canvasbacks, which are half again the size of ruddy ducks and weigh more than twice as much. They often lay their eggs in nests abandoned by other birds, especially coots and redheads. During courtship, drakes fan their stiff tails and hold them erect while slapping their bills against their chests, a practice called "bubbling" because the splashing creates bubbles in the water. Ruddys are strong divers that can also sink slowly into the water to avoid danger, and they are swift flyers with extremely fast wingbeats.

They breed in central Canada and the northern United States and winter along the East Coast as far north as Massachusetts, with heavy concentrations from Chesapeake Bay south into the Carolinas. Some ruddies also live year-round in central Mexico and the southwestern United States and in areas along the Pacific coast, especially San Francisco Bay and the Salton Sea. Like canvasbacks, ruddy ducks eat a primarily vegetarian diet, which they supplement with insects while breeding and small mollusks during the winter.

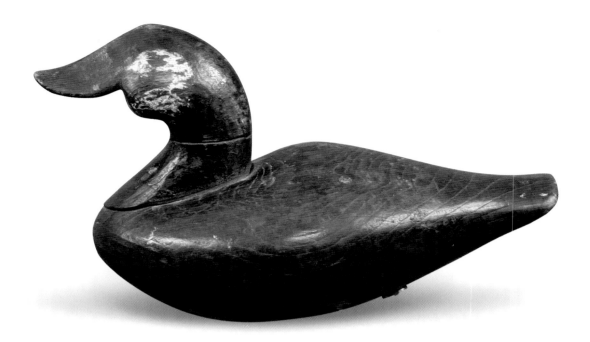

Ruddies, which were dubbed "dollar ducks" for their prevailing market price in the late 1800s, were most widely hunted among the barrier islands of southern Virginia and North Carolina.

The species came into favor with market gunners after canvasbacks grew scarce. Despite their small size, their mild, largely vegetarian diet made them quite desirable. Phillips noted that ruddy ducks were the canvasback's only rival in the turn-of-the-nineteenth-century marketplace. "When canvasbacks were selling in the New York and Boston markets at $6.00 to $8.00 a pair, these little birds which weighed only a pound, brought $2.50 a pair and sometimes more." Late nineteenth-century gunners dubbed them "dollar ducks" for the price they brought at market and hunted them heavily as canvasbacks began to disappear. They are not now considered a desirable game species, and, with hunting no longer a significant factor, populations of ruddys are stable or increasing across their entire range.

COMMON GOLDENEYE

The common goldeneye (*Bucephala clangula*) is a stocky, medium-size diver with a large head, averaging eighteen and a half inches long with a twenty-six-inch wingspan and weighing a little less than two pounds. Nicknamed "whistler" for the sound its wings make in flight, the goldeneye does indeed have golden yellow eyes. The boldly black and white breeding drake has a very dark green head that is iridescent in sunlight but otherwise appears black; he sports a round white patch in front of each eye at the base of his black bill. The hen is gray with a brown head, and both sexes have distinguishing white wing patches that are prominent in flight.

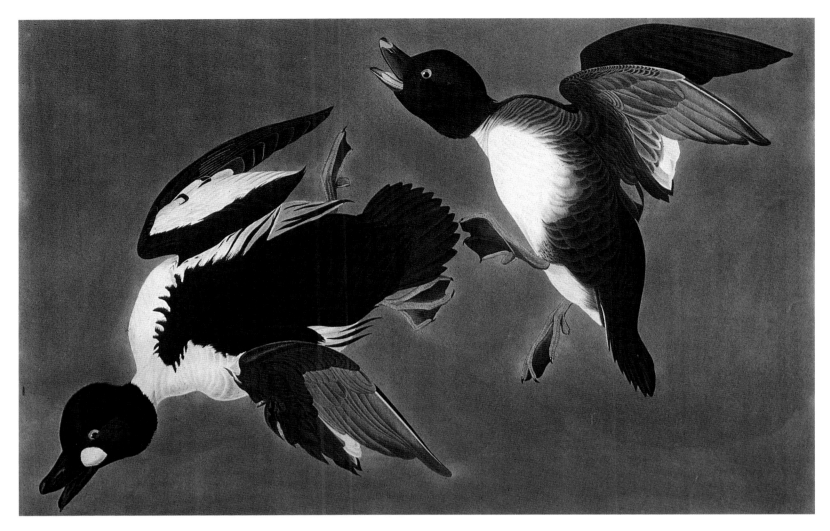

Goldeneyes are cold-hardy birds that nest in boreal forests across Alaska, Canada, and the northern United States and migrate south later than any other species, often not arriving at their winter grounds until late October or early November. They winter inland as far north as waters remain open, rafting in huge flocks in coastal bays and on large lakes across southern Canada and the United States. They prefer to winter in saltwater, where they feed on fish, mollusks, and crustaceans. They nest in tree cavities, often building their nests in holes created by pileated woodpeckers from five to sixty feet off the ground, and they also happily make use of nest boxes.

Goldeneyes were heavily gunned in the nineteenth century and were especially popular with hunters because they were on the flyways earlier in the spring and later in the fall than most other ducks. The species is stable today, although acid rain and tree harvests have affected its breeding habitat in the northern forests.

Golden-eye Duck [Common Goldeneye]. Hand-colored aquatint, etching, and line engraving by Robert Havell Jr. after John James Audubon for *The Birds of America*. 1827–38. London.

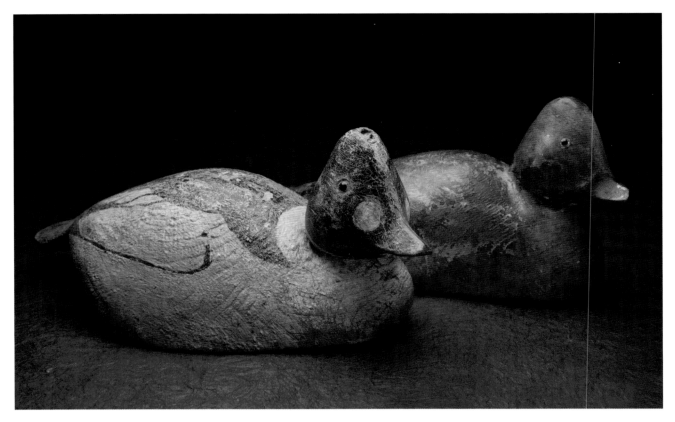

BUFFLEHEAD

The bufflehead (*Bucephala albeola*) is the smallest of all North American ducks, averaging a mere thirteen and a half inches long with a twenty-nine-inch wingspan and weighing only about thirteen ounces. They are compact little birds with rather large, bulbous heads and short, blue-gray bills. The name bufflehead is a corruption of "buffalo head." Drake buffleheads have a black head and a dark, iridescent, greenish-purple back with a large white cap behind the eye and a mainly white body; hens have a brown head and body with a small white patch behind the eye.

In his 1898 book, *Wild Fowl of North America*, D. G. Elliott describes what he calls "the butter-ball" as among the most expert divers,

> disappearing so quickly, and apparently with so little exertion, that it is almost impossible to shoot it when sitting on the water. When alarmed, with a sudden flip up of its tail and a scattering of a few drops of water, it vanishes beneath the surface, appearing almost immediately at no great distance from where it went under, and either dives again at once, or takes wing, which it does easily and without any fuss. Sometimes half a dozen of these birds will gather together in a sheltered place of water, and

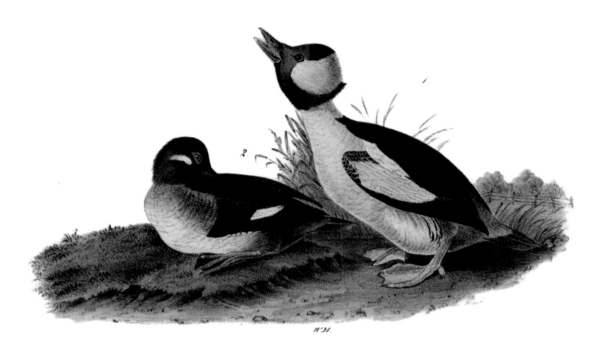

Buffel-headed Duck
[Bufflehead]. Hand-colored
lithograph by John T. Bowen
after John James Audubon for
The Birds of America, First
Octavo edition. 1840–44.
Philadelphia.

be very busy feeding. A few will dive with a sudden jerk, as if drawn beneath the surface by an invisible string, and the others will quietly swim about as if on the watch. The first that went under water having returned to the surface, the others dive, and so it goes on for a long time. Occasionally, all will disappear, and then the first one to rise seems much disconcerted at not finding any one on watch and acts as if her were saying to himself that if he 'had only known their unprotected state, he would never have gone under.

It is no wonder that nineteenth century hunters also called the species "spirit duck," "conjuring duck," "dipper," and "marionette."

Unlike most other ducks, buffleheads are monogamous and often stay with the same mate for several years. They breed in ponds and small lakes in Canada, where they nest primarily in tree cavities made by northern flickers, which are too small for other birds. They winter across the United States but concentrate along the Atlantic and Pacific coasts from New Jersey to North Carolina and Vancouver south to Washington, and also in California. Their main foods are insects, crustaceans, and mollusks.

Despite their small size, buffleheads were heavily gunned in the nineteenth and early twentieth centuries, and populations were threatened before passage of federal legislation. Overhunting continued

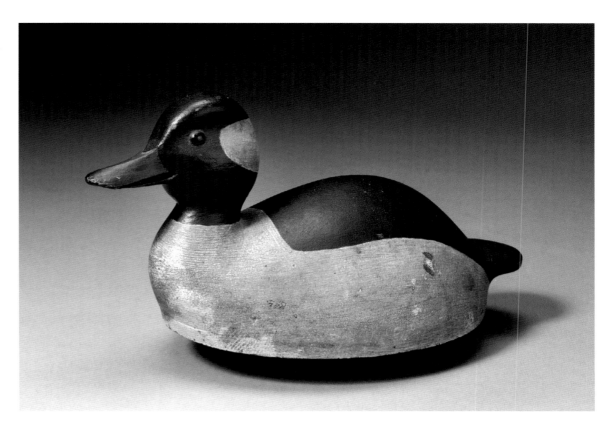

Bufflehead Drake. **Maker unknown. c. 1900. Markham, Ontario. Collection of Roger Young.**
This bufflehead is part of a remarkable rig of decoys found in Markham, Ontario, located about twenty-five miles north of Toronto. All have rounded, turtlelike backs. Unfortunately, the antiques dealer who originally bought the rig liked to strip and refinish her wares. A few redheads and bluebills avoided her dip tank, but this is the only known bufflehead in its original paint.

to be a problem into the 1950s, but tighter regulations have helped the species enormously, and it is one of the few ducks whose numbers have substantially increased over the past fifty years.

HOODED MERGANSER

On the wing [the hooded merganser] is one of the swiftest ducks that fly, and it hurls itself through the air with almost the velocity of a bullet. Generally it proceeds in a direct line, but if it is alarmed at any object suddenly appearing before it, the course is changed with the swiftness of thought, and a detour made before again taking the first line of progression. Sometimes, without apparent reason, the course will be altered, and away it shoots at right angles to the first route; and again, it vacillates as though uncertain which way to take, or as if it was looking for a good feeding place . . . It rises from the water without any preliminary motions, and is on the wing at once, and in full flight, the pinions moving with a rapidity that almost created a blur on either side of the body, the outline of the wing disappearing.

—Daniel Giraud Elliot, *The Wildfowl of North America*, 1898

The hooded merganser (*Lophodytes cucullatus*) is the smallest of the three merganser species found in North America and the only one unique to the continent. "Hoodies" average eighteen inches

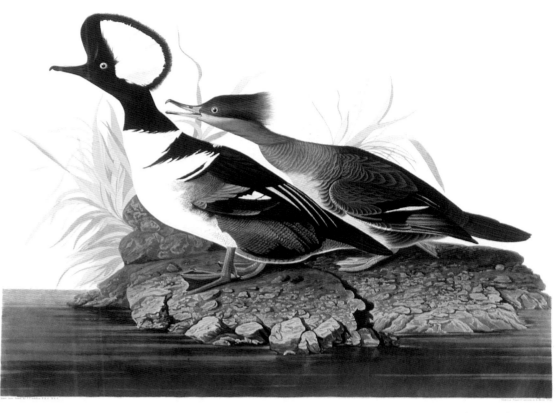

Hooded Merganser. Hand-colored aquatint, etching, and line engraving by Robert Havell Jr. after John James Audubon for *The Birds of America*. 1827–38. London.

Hooded Merganser Drake. Maker unknown. c. 1880. **Georgian Bay, Lake Huron, Ontario. Private collection. Photograph courtesy Guyette & Schmidt, Inc.** Georgian Bay, which extends from the northeast side of Lake Huron, is nearly as large as Lake Ontario.

long with a twenty-four-inch wingspan and weigh a little less than a pound and a half. They have long, narrow bills and a distinctive, fan-shaped crest, the "hood" that gives the species its name. The birds can either lay their crest feathers back or stand them up to form a bushy hood unlike any other duck. Their bills are serrated, with a nail at the tip, a design that enables them to hang on to the slippery fish and frogs they eat along with crayfish, crabs, clams, aquatic insects, and insect larvae, and they have muscular gizzards that can grind shells and exoskeletons.

Breeding drake hoodies have a black face, neck, and back and a crest with a large white patch at its center, which is bordered with black. The drake's breast and underparts are bright white, his sides are reddish brown, and his eye is yellow. By contrast, hens and nonbreeding males are dusky brown all over with reddish-brown crests. Like wood ducks, a bird of similar size with which they often share habitats, hooded mergansers prefer quiet waters that are surrounded by deciduous trees, where they build their nests in cavities. They also like clear water because they pursue prey by sight, swimming with their heads underwater as they scan for food. Hoodies are divided into distinct eastern and western populations; western birds breed from

southern Alaska south to Montana and Oregon and winter along the Pacific coast from southern Alaska to California. Eastern hoodies breed from southeastern Canada through the Great Plains and Mississippi Valley and east to the Atlantic coast. The greatest concentration of breeding hoodies is in the Great Lakes region, while wintering eastern birds concentrate along the southeastern coast of the United States.

Their diet is more varied than other mergansers, so hoodies were more palatable to hunters and were gunned heavily in the nineteenth century. Because of their widely dispersed populations and secretive nature, hoodies have not been well studied, and, while populations appear stable today, many concerns about the species remain unexplored.

LONG-TAILED DUCK (OLDSQUAW)

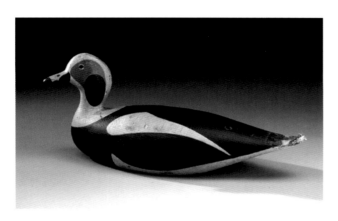

Long-tailed Duck Drake.
Orlando Sylvester Bibber.
c. 1910. South Harpswell,
Maine. Private collection.
Photograph courtesy Stephen
O'Brien Jr. Fine Arts, LLC.
Long flight feathers plucked from a dead long-tailed duck were inserted in a groove at the tail of this decoy, and remnants remain.

Winter is close at hand. There is a sting in the wind, a nip in the air, and the fingers are numb and blue as they hold the gun barrels. But out on the water, careless of wind or wave, rides a flock of "squaws," making always a merry chatter. Ever and anon some of their number rise against the breeze to dart off at lightning speed, apparently in the mere enjoyment of flight, for, circling a half a mile about, they plump down again among their comrades, all the time noisily calling to each other. We might almost say they are the only song birds among the ducks, for really their notes are very pleasant to hear and quite musical in comparison with the usual vocal production of their family.
—Walter Herbert Rich, *Feathered Game of the Northeast*, 1907

Known in North America until recently as the oldsquaw, an attempt to mimic its cry, the long-tailed duck (*Clangula hyemalis*) is an Arctic sea duck that breeds across northern Alaska and Canada and winters along northern coasts and on the Great Lakes. It is among the most vocal of ducks: Males make a loud, nasal call that they repeat again and again, especially in courtship, while hens offer a variety of soft quacks and grunts. The species' long-standing popular name was changed because conservationists were concerned that Native Americans would find "oldsquaw" pejorative and refuse to participate in efforts to assist the species. Now named for the male's pair of long, black central tail feathers, the long-tailed duck is unique in molting through three plumage phases each year instead of the usual two.

Long-tailed ducks average sixteen and a half inches long (the male's tail feathers can bring him to twenty-one inches) with a twenty-eight-inch wingspan and weigh a bit over a pound and a half. They can dive deeper than any other duck, plunging as far as two hundred feet in search of mollusks and crustaceans that other species cannot reach. Grinnell noted,

the old squaws do not reach the New England coast until the weather has grown quite cold, long after the different varieties of scoters have come and established themselves in their winter home. Here they congregate throughout the winter in vast numbers, associating with the scoters and eiders and yet often keeping very much by themselves. The old-squaw is one of the most expert of divers and it used to be stated—and may be believed—that in old times it could not be shot on the water with a flint-lock gun. Even now it frequently dives so rapidly as to apparently escape the shot, and instances are given of where a bird, shot at when flying low over the water, had dived from the wing and escaped uninjured.

Long-tailed ducks are also extremely fast on the wing and fly in irregular darting patterns that make them hard to shoot. Despite these difficulties and the fact that their fishy-tasting flesh reflects their shellfish diet too strongly for many palates, they were widely hunted by nineteenth- and early twentieth-century sportsmen. Concerns that they are being overhunted continue today, especially in Alaska, where one conservation group has listed them as imperiled.

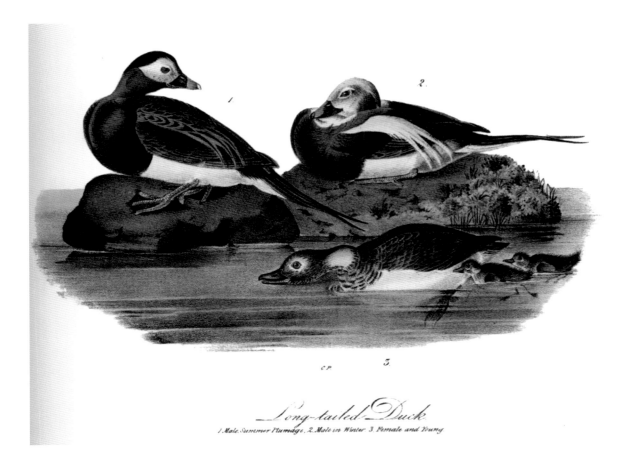

Long-tailed Duck. Hand-colored lithograph by John T. Bowen after John James Audubon for *The Birds of America*, First Octavo edition. 1840–44. Philadelphia.

COMMON EIDER

The common eider (*Somateria mollissima*) is a large sea duck that dives to feed on beds of mussels, their favorite food, as well as other mollusks and crustaceans such as clams, scallops, sea urchins, starfish, and crabs. All of these foods are swallowed whole, shells and all, and digested after being crushed and ground in the eider's large, muscular gizzard, a kind of secondary stomach that takes on the function of the teeth that eiders and other birds lack. The largest of all North American ducks, the common eider averages twenty-four inches long with a thirty-six-inch wingspan and weighs between four and a half and five pounds. Both sexes have a distinctive wedge-shaped head; the breeding male is boldly patterned in black and white with a black head cap and green bill, while the female is drab brown all over with darker bars.

Eiders spend their lives in or near saltwater. Large flocks gather to feed in relatively shallow shoal waters off headlands, islands, and rocky offshore islets and ledges, called skerries. They can dive more than sixty feet to feed on the sea bottom. They breed primarily on islands from Alaska around the pole to the Canadian Maritimes and northern New England and winter in the ocean as far north as ice does not form and as far south as eastern Long Island. They are also sometimes found on the Great Lakes during the winter.

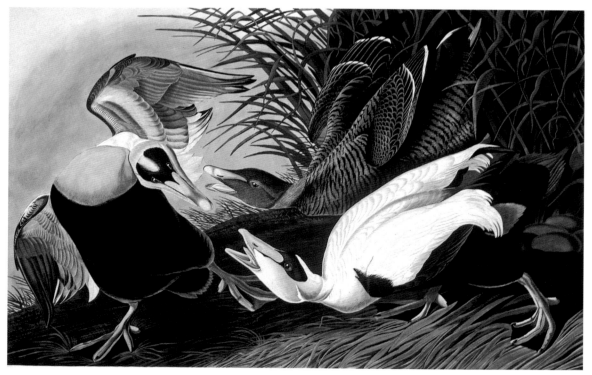

Eider Duck [Common Eider]. Hand-colored aquatint, etching, and line engraving by Robert Havell Jr. after John James Audubon for *The Birds of America*. 1827–38. London.

Eiders were heavily hunted in the nineteenth century by market and sport gunners, and their island breeding colonies were disturbed and often clumsily disrupted by people seeking the warm, fluffy down with which the birds line their nests. By 1907 the population in Maine had been reduced to a single breeding colony of a dozen pairs, and extinction seemed to be nearing. In his 1914 "Plea for the Conservation of the Eider," Charles Wendell Townsend argued, "There is no reason the eider, which furnishes the valuable eider down of commerce,

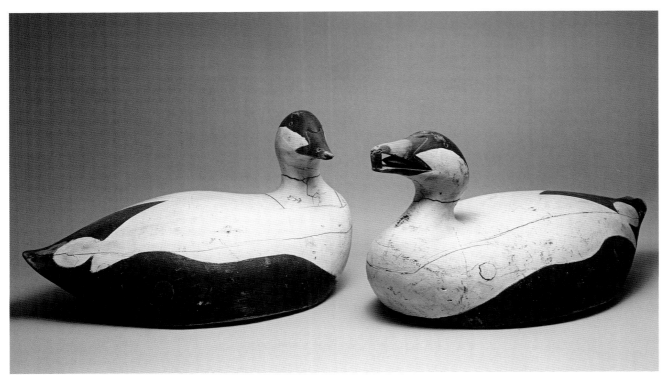

could not be made a source of considerable income without any reduction of its natural abundance. The principle of conservation can as well be applied to the eider as to a forest." Because of advocates like Townsend and the Audubon Society, the species recovered, but it is still considered "of concern," especially because current hunting laws in many areas allow the taking of what many experts feel are unsustainable numbers of the birds.

COMMON MERGANSER

This large and handsome duck has always been associated in my mind with the first signs of the breaking up of winter. Being a hardy species, it lingers on the southern border of ice and snow and is the very first of our waterfowl to start on its spring migration. We may confidently look for it in New England during the first warm days in February or as soon as the ice has begun to break up in our rivers and lakes. We are glad to greet these welcome harbingers of spring, for the sight of the handsome drakes flying along our watercourses or circling high in the air over our frozen lakes, with their brilliant colors flashing in the winter sunshine, reminds us of the migratory hosts that are soon to follow. They are looking for open water in the rivers, for rifts in the ice or open borders around the shores of the lakes, where the first warm sunshine has tempted the earliest fish to seek the genial shallows.
—Arthur Cleveland Bent, *The Life Histories of North American Wildfowl*, 1923

The common merganser, or goosander, as it known in Europe (*Mergus merganser*), is a large, fish-eating duck that prefers cold freshwater and winters as far north as lakes and rivers remain open. It is one of the northernmost wintering waterfowl in North America, wintering across Canada and the northern United States, primarily in freshwater but also along both coasts. The species breeds in boreal forests across Alaska, Canada, and the northern United States, where it nests in tree cavities.

The common merganser is the largest of the three mergansers found in North America, averaging twenty-five inches long with a thirty-four-inch wingspan and weighing just under three and a half pounds. The breeding drake has a white belly, breast, and flanks; a gray rump; a black back; a crestless, dark, iridescent green head; and bright red eyes and bill. The hen has a gray body with a reddish-brown head. The nonbreeding drake is similar to the female but has some white on his back.

Common mergansers are predators that sit at the top of the aquatic food chain, eating a wide variety of small fish as well as aquatic insects, mollusks, crustaceans, worms, eels, frogs, and small mammals and birds. The species was hunted for food in the nineteenth century; one account reported that while common mergansers fed almost exclusively on fish, their flesh was not noticeably bad in the autumn, although it was "exceedingly rank and oily" in the spring. Another, however, describes it as "about as palatable as a stewed kerosene lamp wick." Common merganser populations appear stable today, but the species has often been blamed for eating young game fish, especially stocked trout and salmon, in some areas and thus subjected to eradication efforts to reduce its numbers.

Goosander [Common Merganser]. Hand-colored aquatint, etching, and line engraving by Robert Havell Jr. after John James Audubon for *The Birds of America*. 1827–38. London.

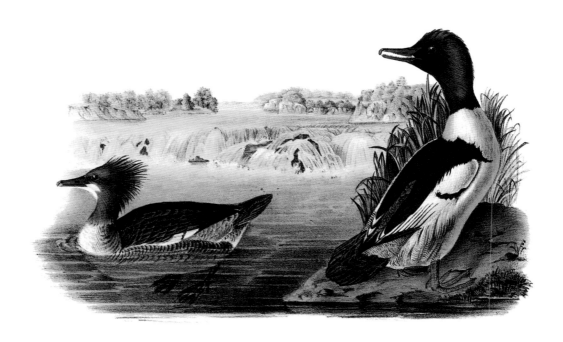

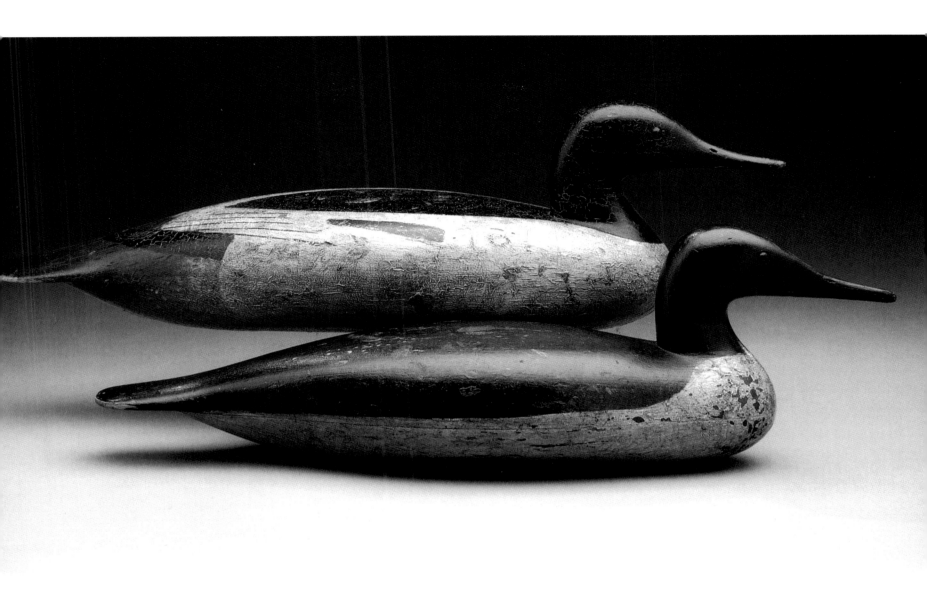

Pair of Common Mergansers.
Charles Schoenheider Sr.
c. 1910. Peoria, Illinois.
Collection of Thomas K.
Figge. Photograph courtesy
Stephen O'Brien Jr. Fine
Arts, LLC.
Since Illinois hunters did
not consider the fish-eating
common merganser a proper
game species, Schoenheider
is believed to have used this
pair as confidence decoys,
added to a rig of other
species so as to enhance
the sense of realism. Only
one other Schoenheider
merganser is known.

RED-BREASTED MERGANSER

The red-breasted merganser (*Mergus serrator*) is the medium-size North American "sawbill," averaging twenty-three inches long with a thirty-inch wingspan and weighing about two and one third pounds. The breeding drake has a black back, gray and white sides, a dark reddish chest flecked with black spots, a white neck, and an iridescent green head, while hens and nonbreeding drakes are dull gray with reddish heads. Both sexes have a distinctive shaggy double crest at the back of their heads, which distinguishes them from other mergansers.

The red-breasted merganser breeds farther north and winters farther south than either common or hooded mergansers, and it is the only one of the three that prefers saltwater to freshwater. The species breeds from the Aleutian Islands and Alaska across to the Canadian Maritimes and occasionally as far south as northern Minnesota, Wisconsin, Michigan, and Maine. It winters along the Pacific coast from Alaska to Baja California and on the Atlantic coast from Nova Scotia south and around Florida to southern Texas and northern Mexico. It is also found in the Great Lakes during the winter months.

Red-breasted mergansers eat a less varied diet than either hooded or common mergansers; they feed almost exclusively on small fish and crustaceans but also take worms, amphibians, and insects

Red-breasted Merganser. Hand-colored aquatint, etching, and line engraving by Robert Havell Jr. after John James Audubon for *The Birds of America*. 1827–38. London.

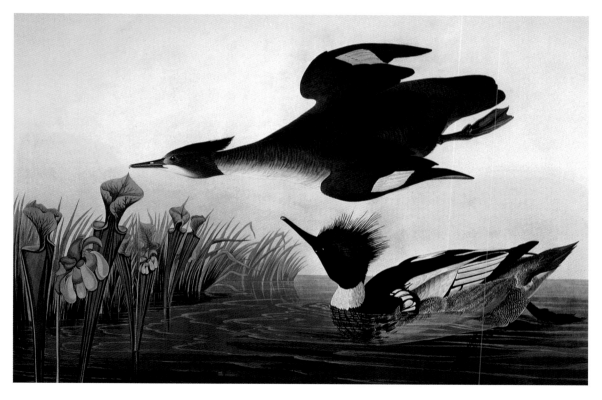

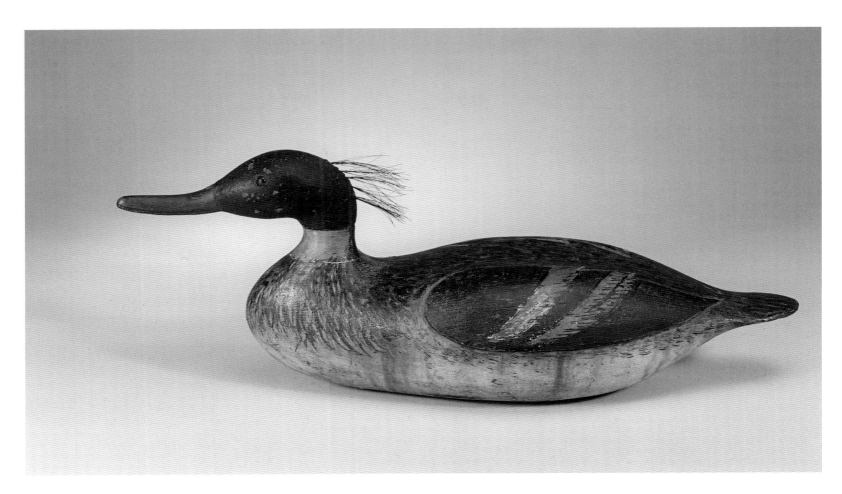

on occasion. Although George Bird Grinnell wrote of the red-breasted merganser, "There is no use shooting it, as it is useless for food," and the Cornell Lab of Ornithology's *Birds of North America* points out that most hunters "prefer to consume their fish firsthand rather than have it processed by a duck," the species was gunned all along the East Coast from the Canadian Maritimes to Virginia in the nineteenth and early twentieth centuries. Apparently, there is no accounting for taste. Like the common merganser, the red-breasted merganser is hunted today mainly where it is thought to affect trout and salmon hatcheries and stockings, although scientific evidence indicates that the birds have little overall effect on hatchlings.

Red-breasted Merganser Drake. **Captain Preston Wright. c. 1920. Osterville, Massachusetts. Private collection. Photograph courtesy the Houston Museum of Natural Science, Houston, Texas.** Captain Wright inserted horsehair at the back of his merganser's head to imitate the species' feathery crest. He probably purchased its glass eyes from the factories in nearby Sandwich, on Cape Cod.

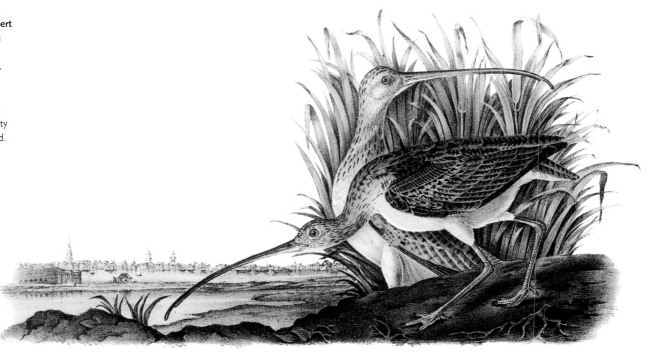

CHAPTER 6

Shorebirds

Shorebirds are a diverse group of small to medium-size birds with thin bills and relatively long, thin legs that allow them to wade in shallow water. Their feet, which are usually not webbed but can be semipalmated (partially webbed), have separated toes, which make walking and running easy and also evenly distribute the birds' weight and help keep them from sinking into wet sand or mud. Most do not swim unless they have to. They forage along ocean shorelines, tidal flats, and salt marshes, as well as on inland wetlands and grasslands, where they hunt for insects, worms, and other invertebrates as well as small vertebrates. Shorebirds range widely in size, from tiny "peep" sandpipers that measure a mere six inches long and weigh less than an ounce, to the long-billed curlew, which is more than twenty inches long and weighs more than a pound. They have an equally wide range of specially adapted bill shapes, from short, straight bills made for picking and pecking

at food at or near the surface of water or land to long, decurved bills with which they probe deeply into sand or mud.

Most shorebirds are strongly migratory, and some are among the bird world's true long-distance travelers, flying from the tip of South America to tundra above the Arctic Circle each year to nest and breed, and making nonstop transoceanic flights of several thousand miles.

LONG-BILLED CURLEW

The long-billed curlew (*Numenius americanus*) is by far America's largest shorebird, typically measuring twenty-three inches in length with a thirty-five-inch wingspan and weighing one and a third pounds. Its bill is indeed very long; it can measure nearly nine inches and is typically one third of the bird's overall length and twice the length of its smaller relative, the whimbrel. In addition to the normal shorebird diet of insects, worms, crustaceans, and mollusks, the long-billed curlew also likes to eat small frogs. Its favorite food, however, is the fiddler crab, whose holes it probes with its long decurved bill. The long-billed curlew's most common cry is a ringing rendition of its name, *cur-lew*.

"Crawfish, small crabs, periwinkles, toads, worms, larvae, grasshoppers, crickets, beetles, caterpillars when found on the ground, spiders, flies, butterflies, and berries, especially dewberries, all play minor or major parts in their diet," wrote C. W. Wickersham in a 1902 edition of *The Auk*, the journal of the American Ornithologists' Union. "The worms, larvae, etc. are pulled out of the ground by the

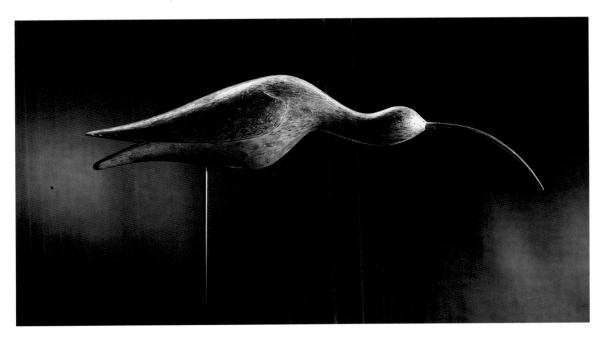

Long-billed Curlew. Maker unknown. c. 1900. Massachusetts. Collection of David Teiger.
This unique and extraordinary curlew, which was part of a rig owned by conservationist and author Dr. John C. Phillips, has sealing-wax eyes and a hardwood bill. The unknown artist was clearly familiar with Audubon's depiction of the species; his carving almost exactly follows the contours of one of the curlews painted by Audubon. A dowitcher by the same carver is pictured in Chapter 14.

long bill, the end of which may act as a finger, having separate muscles to control it, and often it is sunk into the ground as far as it will go to reach some unwilling victim. The crustaceans are taken on the beach, or discovered beneath the surface by the probing bill, are pulled out and eaten. The berries are neatly picked off the bushes, while butterflies and other insects are taken on the wing."

The long-billed curlew was once widely distributed, but habitat loss and overhunting took huge tolls on the species over the course of the nineteenth century, and today conservation groups consider the bird vulnerable throughout its current range. It was once common along the Atlantic coast during migration, but it was rarely seen there by the mid- to late 1800s and was completely gone from the region by 1900. "Had the species flesh been equal to its size," wrote Massachusetts state ornithologist E. H. Forbush in 1912, "it would have been extinct by now." Continuing, he wrote:

> On the western plains, where it feeds largely on insects and berries, its flesh is quite palatable. When it reaches the Atlantic coast, and begins to feed on marine food, it soon becomes fishy and more or less unpalatable. Therefore, it was not sought by epicures, and did not bring so high a price pound for pound as did the Eskimo Curlew. Nevertheless, its great size rendered it a good target. It readily was attracted by decoys. It sailed steadily, in toward them, presenting an imposing mark, easy to hit, and it was so solicitous of the safety of its companions that when one or two were shot down, the rest, though greatly alarmed, returned and flopped about above their stricken comrades, diving toward them and urging them to flight until so decimated by the gunner that only a remnant of the flock remained alive.

Population declines continued even after hunting the birds was banned, largely because of extensive habitat destruction. Today, the long-billed curlew breeds in the Great Plains, Great Basin, and the valleys of the western United States and southwestern Canada, and winters primarily in California, Texas, and Louisiana. Only about twenty thousand long-bills remain, and the species has been designated "highly imperiled" by both the U.S. Fish and Wildlife Service and the U.S. Shorebird Conservation Plan.

WHIMBREL (HUDSONIAN CURLEW)

The whimbrel (*Numenius phaeopus*) is America's most common and widely distributed curlew, often found on marshes and beaches from New England to the Gulf Coast as well as along the Pacific shore from British Columbia to Baja. Although it is several inches shorter overall than the significantly larger long-billed curlew (typically seventeen and a half inches long), it has a longer body and a shorter bill, which it can use to pick at its prey as well as to probe into sand, mud, and crab holes like the long-billed curlew does. Small crabs are its favorite food, and it also gorges on berries on its fall staging grounds in Maine and the Canadian Maritimes.

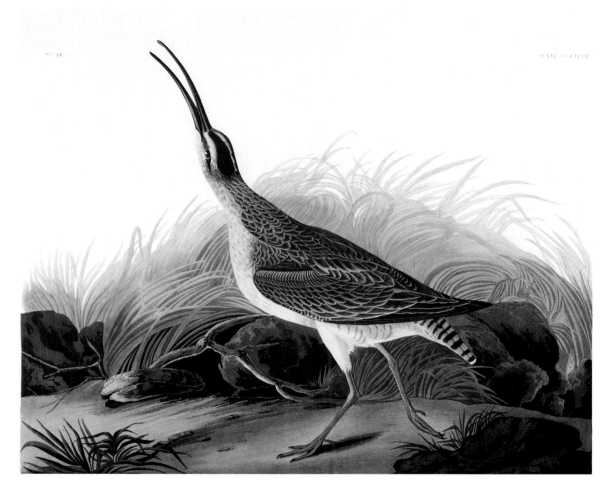

Great Eskimaux Curlew
[Whimbrel]. Hand-colored
aquatint, etching, and line
engraving by Robert Havell Jr.
after John James Audubon
for *The Birds of America.*
1827–38. London.

The North American population of the whimbrel breeds in Alaska and northern Canada and winters in a wide variety of locations, from San Francisco Bay south into Mexico and Central America in the west, and from the Gulf Coast into the Caribbean and South America in the east. It also is common in Jamaica and Bermuda during the winter, and some birds travel as far south as Tierra del Fuego. Migrating birds in the east fly directly south from staging areas in coastal Canada and New England, traveling over the Atlantic to wintering grounds in the Caribbean and South America.

Whimbrels, which were called Hudsonian curlew by early naturalists, were not common early in the nineteenth century; Arthur Bent noted that Alexander Wilson did not mention the species at all, and Audubon knew little about it. By the end of the century, however, the whimbrel had become the most common curlew species seen on the East Coast and had taken over the former domains of Eskimo and long-billed curlews. In his 1910 study, *Birds of South Carolina*, Arthur Trezevant Wayne observed, "This species supplanted the long-billed curlew between the years 1883 and 1885, for

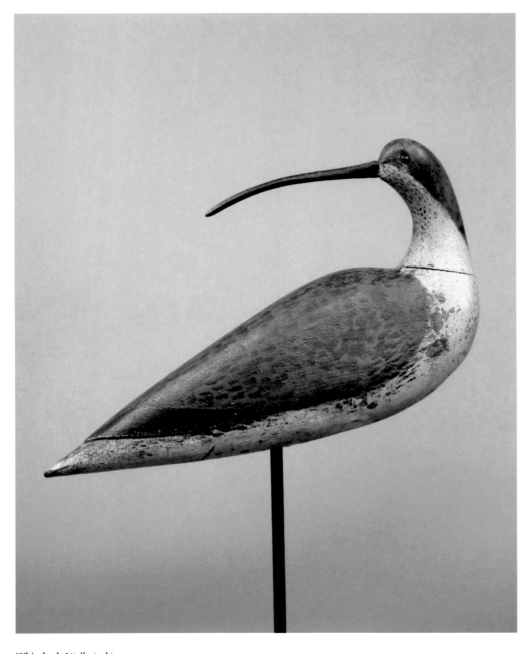

Whimbrel. Attributed to
Thomas H. Gelston. c. 1900.
Bay Ridge, New York. Private
collection. Photograph
courtesy Guyette and
Schmidt, Inc.
This alert, turned-head bird
was originally collected by
William Mackey.

previous to these dates the former species was rare, but it gradually became more abundant each year until it established itself firmly in great numbers. The result was that the long-billed curlew was driven from its accustomed range by a smaller species in the struggle for existence. The long-billed curlews fed almost entirely upon fiddlers, and the Hudsonian also subsisted upon them, and as the food supply was inadequate, one species was forced to seek other paths of migration."

The whimbrel, which typically weighs about fourteen ounces, was prized as a table bird and was heavily gunned by market hunters along the Atlantic coast in the late nineteenth and early twentieth centuries. It is a wary bird, however, and does not gather in the large flocks that many other shorebirds do, so hunting losses were not as devastating as for many other species. Whimbrels rebounded after hunting was banned but its numbers have plummeted again in the past thirty years, and current populations, estimated at between 25,000 and 100,000, are far short of the species' historic peak. Habitat destruction appears to be the major cause of recent declines, which are serious enough that the U.S. Shorebird Conservation Plan lists the whimbrel as a "species of high concern."

ESKIMO CURLEW

The Eskimo curlew (*Numenius borealis*) is (or was) the smallest of American curlews, averaging between twelve and fourteen inches long, with a much shorter bill than the its larger relatives, the whimbrel and long-billed curlew. The Eskimo's bill was also only slightly decurved, as opposed to the pronounced

Eskimaux Curlew [Eskimo Curlew]. Hand-colored aquatint, etching, and line engraving by Robert Havell Jr. after John James Audubon for *The Birds of America*. 1827–38. London.
Eskimo curlew were very sympathetic to wounded members of their flocks. Audubon depicts a male checking on his mate, who has apparently been felled by a hunter.

decurves of the other two species. The Eskimo curlew was a long-distance migrator, traveling about eighteen thousand miles a year between nesting sites north of the Arctic Circle in Canada's Northwest Territories and its wintering grounds in Patagonia. In late summer, migratory flocks gathered in southern Canada and northern New England for the long flight south, points from which they might fly thousands of miles without stopping.

Eskimo curlews were good eating, and after the passenger pigeon became scarce, many market hunters turned to the Eskimo as a substitute. They were dubbed "dough birds" by hunters because they were sometimes so fat from premigratory feasting that their breasts broke open when they hit the ground after being shot. They also were highly social birds, which made them easy targets. They flew together in large, dense flocks, and, after a hunter shot at them, they would circle back again and again to check on wounded companions, thereby putting themselves at further risk.

Although unconfirmed sightings are still occasionally made, the last Eskimo curlew specimen to be collected was shot in Barbados in 1963, and no undisputed sightings have been made since. Many experts now believe the bird to be extinct, a victim of hunting pressure and habitat destruction too intense for it to recover. In his *Life Histories of North American Shorebirds*, Arthur Bent laid the blame for the bird's demise squarely on the gunners, remarking, "There was only one cause, slaughter by human beings, slaughter in Labrador and New England in summer and fall, slaughter in South America in

winter, and slaughter, worst of all, from Texas to Canada in the spring. . . . The gentle birds had to run the gantlet all along the line and no one lifted a finger to protect them until it was too late. They were so gentle, so confiding, so full of sympathy for their fallen companions, that in closely packed ranks they fell, easy victims of the carnage."

However, while Eskimo curlew populations were reduced by overhunting, especially during their spring migration through the Great Plains, the widespread conversion of the tallgrass prairie ecosystem they had always depended on to tilled agricultural land probably affected the species more. That conversion, coupled with the suppression of the periodic wildfires that encouraged new growth of the remaining grasslands, greatly diminished populations of the insects that the curlew ate and led to the extinction of the Rocky Mountain grasshopper, which had been one of the curlew's main food sources on the journey north. Before its precipitous decline in the last quarter of the nineteenth century, there may have been hundreds of thousands of Eskimo curlews. Today, estimates from experts range from "probably extinct" to fewer than one hundred survivors.

AMERICAN GOLDEN PLOVER

Despite its small size, the American golden plover (*Pluvialis dominica*), which averages ten and a half inches in length with a twenty-six-inch wingspan and typically weighs about five ounces, is one of the marathon migrators, traveling from southern South America to the Arctic tundra twice each year, and

Golden Plover [American Golden Plover]. Hand-colored lithograph by John T. Bowen after John James Audubon for *The Birds of America*, First Octavo edition. 1840–44. Philadelphia.

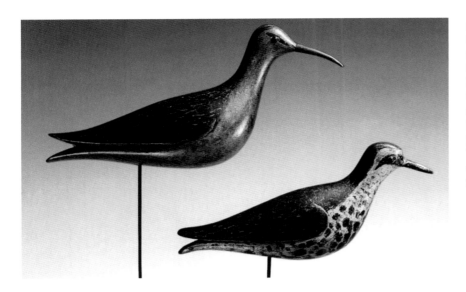

Eskimo Curlew and American Golden Plover. A member of the Folger family. c. 1870. Nantucket, Massachusetts. Ex-collection James M. McCleery, M.D. Photograph courtesy Sotheby's, Inc. Eskimo curlews and golden plovers often flew together. This early Nantucket curlew decoy is hollow bodied, while the plover is solid.

sometimes flying as much as three thousand miles over open ocean. It is also one of the swiftest shorebirds, reaching speeds of sixty miles an hour. Both sexes are distinctive in breeding plumage, which consists of a black belly, rump, throat, and eye patch and a mottled black and white back and head cap. The head cap is bordered by a white neck stripe that ends at the breast. Nonbreeding birds are dark gray above with lighter gray bellies and a dark head cap.

The species breeds across northern Canada and winters in South America from the Amazon south to Patagonia. Its migratory route is elliptical; it travels north through the center of the Americas but heads south off the Atlantic coast, flying nonstop over the ocean from staging grounds in the Canadian Maritimes to central South America. During its lengthy transoceanic southern migration, which takes place primarily in August, flocks of plover are sometimes blown onshore by coastal storms. In the nineteenth century, they often flew with Eskimo curlews, and there are many stories of huge flocks of the two species either making stopovers or being blown off course onto the outer reaches of Cape Cod and especially Nantucket island.

The American golden plover was one of the species most commonly shot by market gunners, who waited for it along both its spring and fall migration routes. Audubon estimated that 48,000 were killed in a single day near New Orleans in the spring of 1821, and as many as 9,000 were received by Boston game dealers in the spring of 1890, seventy years later. Despite the devastation wreaked by hunters in the nineteenth and early twentieth centuries, the species was able to recover after shorebird gunning was outlawed, but it is now suffering from the effects of habitat destruction. While there may once have been millions of golden plovers, the current population is estimated at only about 150,000, and the bird is listed as a "species of high concern" by the U.S. Shorebird Conservation Plan.

BLACK-BELLIED PLOVER

The black-bellied plover is an aristocrat among shore birds, the largest and strongest of the plovers, a leader of its tribe. It is a distinguished looking bird in its handsome spring livery of black and white; and its attitude, as it stands like a sentinel at the crest of a sand dune or on some distant mud flat, is always dignified and imposing. Its wild, plaintive, and musical whistle arouses the enthusiasm of the sportsman and serves both as a warning and as an invitation to the lesser fowl that look to it for leadership.
—Arthur Cleveland Bent, *Life Histories of North American Shorebirds*

The black-bellied plover (*Pluvialis squatarola*) is one of the most widely distributed of North American shorebirds. Unlike its cousin, the golden plover, the black-bellied plover is not a long-distance migrator; it breeds from western Alaska across the Canadian Arctic and winters as far north as British Columbia and Massachusetts, with other winter populations south along the Atlantic, Pacific, and Gulf coasts. During the spring and fall migration seasons, it can be found on all three of North America's coasts as well as on the Great Plains.

The black-bellied plover is slightly larger than the golden plover, averaging eleven and a half inches long with a twenty-nine-inch wingspan and a typical weight of about eight ounces. It has a relatively large head and was called "bull head" or "beetle-head" by nineteenth-century gunners. (A beetle was a hammerlike tool with a large wooden head primarily used to drive wedges.) Like the golden plover, the species sports a dark black underside during breeding season, but its rump and head are white.

Black-bellied Plover.
Hand-colored lithograph by John T. Bowen after John James Audubon for *The Birds of America*, First Octavo edition. 1840–44. Philadelphia.

While black-bellied plovers were avidly sought by nineteenth- and early twentieth-century hunters, their wariness and tendency not to travel in large flocks made them far less appealing to market gunners and more resistant to hunting pressure than most other species. They did become less common in many East Coast gunning areas in the late nineteenth century, but it is thought that they simply learned to avoid hunters and that their populations remained robust. As the naturalist and avid shorebird hunter George Henry Mackay wrote in 1892, "After many unsuccessful attempts to capture them one becomes imbued with the fact that the old birds are well calculated, under ordinary circumstances, to avoid danger; they succumb only to those sportsmen who have served a long apprenticeship and who have acquired a knowledge of their habits." Black-bellied plovers are among the most common shorebird species today, and their populations have held steady for decades.

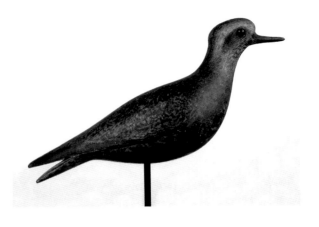

ABOVE: **Black-bellied Plover.** **Attributed to John Thomas Wilson. c. 1890. Ipswich, Massachusetts. Private collection. Photograph courtesy Decoys Unlimited, Inc.**
Tom Wilson (1843–1940) was an English-born machinist who immigrated to America in the 1880s and worked as a market hunter and guide in the late nineteenth and early twentieth centuries. This bird is hollow.

WILLET, GREATER YELLOWLEGS, AND LESSER YELLOWLEGS

These three related species tend to be more solitary and wary than other shorebirds. The dark-above, light-below breeding plumage of all three birds is quite similar, and decoys of the species are usually differentiated by size. Both species of yellowlegs do have bright yellow legs, while willets' legs are gray. The willet (recently

LEFT: **Tell-tale Godwit or Snipe** [Greater Yellowlegs]. Hand-colored lithograph by John T. Bowen after John James Audubon for **The Birds of America**, First Octavo edition. 1840–44. Philadelphia.

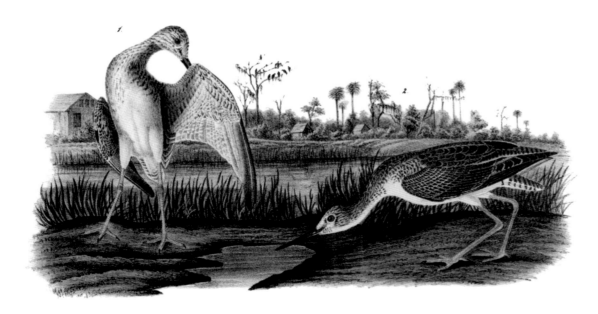

Tell-tale Godwit or Snipe
1. Male 2. Female
VIEW OF EAST FLORIDA.

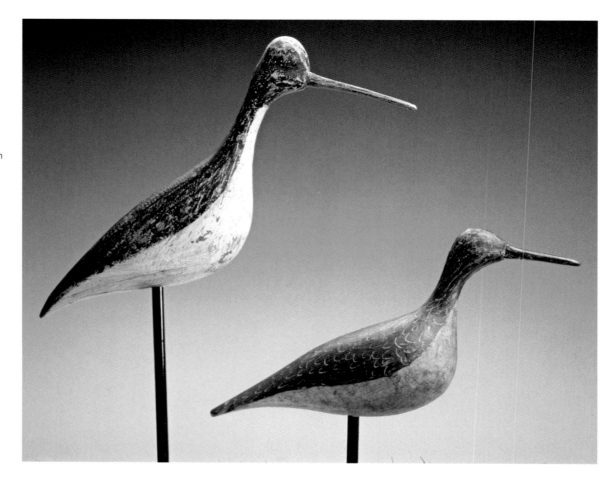

Pair of Yellowlegs.
Ira Hudson. c. 1910.
Chincoteague, Virginia.
Ex-collection James M.
McCleery, M.D. Photograph
courtesy Sotheby's, Inc.
Hudson carved shorebirds
and ducks in a variety of
styles. Both of these solid-
bodied birds are painted with
feathery loops scratched in
wet paint.

reclassified as *Tringa semipalmata*), averaging fifteen inches long and weighing eight ounces, is slightly larger and heavier than the greater yellowlegs (*Tringa melanoleuca*) at fourteen inches and six ounces. At ten and one half inches and just under three ounces, the lesser yellowlegs (*Tringa flavipes*) is aptly named. It is also the most abundant and widely distributed of the three, and one of the most common of all North American shorebirds, breeding from Alaska across central Canada into Quebec and wintering on the Pacific coast from San Francisco Bay south and on the Atlantic from southern New Jersey as well as across the southern United States, Central America, and South America.

All three species are quite vocal, especially when they are upset. The willet is named for its cry of *pill-will-willet*, and all three are sentinel birds that give repeated loud cries when alarmed, alerting any other birds nearby of imminent danger. This habit did not endear them to hunters, who called yellowlegs "tattlers" and "tell-tales" and dubbed the willet "Humility." Arthur Bent noted in his 1927 *Life Histories of North American Shorebirds (Vol. I)*, "Many a yellowlegs has been shot by an angry gunner for his exasperating loquacity."

Willets, the least northerly of the three species, once bred all along the Atlantic coast, but by 1900, hunting for both the birds and their large and apparently delicious eggs had driven the species to the brink of extinction from Virginia north to the Canadian Maritimes. Yellowlegs were also heavily gunned, but their eggs were not sought after, so they fared better. All three species rebounded after hunting for them was banned, and their populations are stable today.

LONG-BILLED AND SHORT-BILLED DOWITCHER

Long-billed dowitchers (*Limnodromus scolopaceus*) and short-billed dowitchers (*Limnodromus griseus*) are often and easily confused; the short-billed actually has quite a long bill, and the two species look so much alike and so often overlap geographically that even master birders rely on differences in their flight calls for positive identification. Both species average about eleven inches long with a nineteen-inch wingspan and weigh about four ounces. The long-billed favors freshwater and the short-billed saltwater, but the two are often seen together on either.

The long-billed dowitcher breeds in northwestern Alaska and across the Bering Strait in far western Siberia, while the more widely distributed short-billed breeds farther south and east along the southern Alaska coast south to the Queen Charlotte Islands of British Columbia, in northern Manitoba, and from the Ontario coasts of James and south Hudson bays to central Quebec and Labrador. The long-billed dowitcher winters primarily along the Pacific coast from Washington south to Mexico,

Red-breasted Snipe [Short-billed Dowitcher]. Hand-colored lithograph by John T. Bowen after John James Audubon for *The Birds of America*, First Octavo edition. 1840–44. Philadelphia.

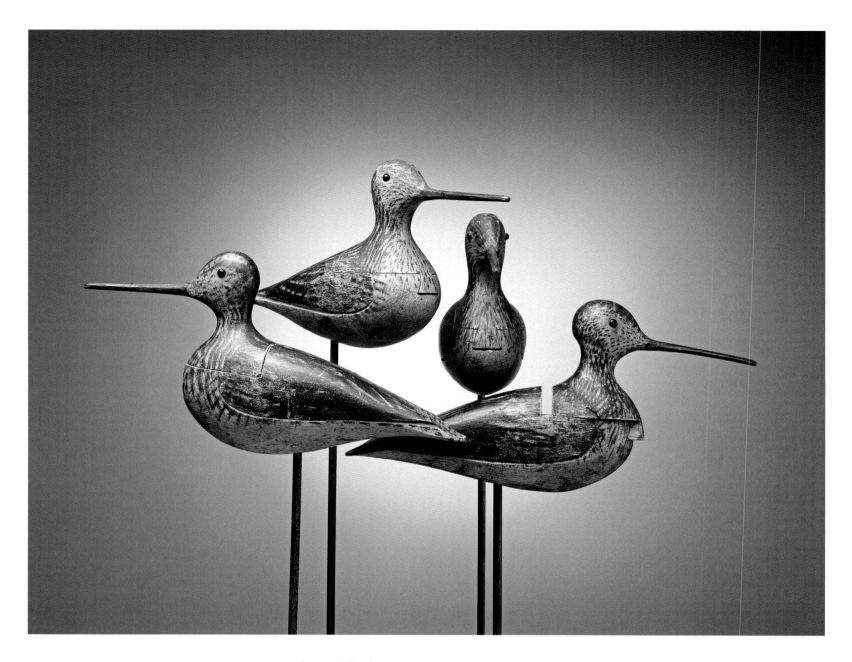

Guatemala, and El Salvador, as well as throughout Florida and west along the Gulf Coast to Mississippi. The short-billed can be found on both Atlantic and Pacific coasts in winter, from northern California south to Baja, and from Virginia south to Florida, the Caribbean, and Brazil, as well as along the Gulf Coast in the United States, Mexico, and Panama.

Both species are swift, agile flyers. "I have frequently amused myself with the various actions of these birds," Alexander Wilson wrote in his 1831 *American Ornithology*, the first comprehensive study

of American birds. "They fly rapidly, sometimes wheeling, coursing and doubling along the surface of the marshes; then shooting high in the air, there separating and forming in various bodies, uttering a kind of quivering whistle."

Short-billed dowitchers were among the most plentiful shorebirds in the late nineteenth and early twentieth centuries and were heavily gunned by market hunters. An 1868 record tells of a flight off the Maine coast that lasted more than three hours and was estimated to be twelve to fifteen miles wide "and at least 100 long." Hunting was so intense that the bird was rare by the turn of the century and thought to be near extinction by the time federal restrictions were enacted in 1918. It recovered quickly but currently appears to be on the decline again, although the reasons for this trend are unknown. About 150,000 are believed to exist. Long-billed dowitchers were also heavily hunted and sold in West Coast markets, but populations today are considered stable.

OPPOSITE: *Dowitchers.* **Maker unknown. c. 1890. North Shore of Massachusetts. Joel Barber Collection, The Shelburne Museum.** These shorebirds were unquestionably made by the same man who crafted similarly constructed and painted geese with removable dovetailed heads (one of the geese is illustrated in the introduction and Chapter 14). In addition to dowitchers, the as-yet-unidentified carver also made a few yellowlegs, willets, and black-bellied plovers with similar removeable heads.

RED KNOT

The red knot (*Calidras canutus rufa*) is a relatively large, short-billed sandpiper that averages ten and a half inches in length with a twenty-three-inch wingspan and weighs nearly five ounces. The bird is named for the distinctive color of its breeding plumage, which turns the sides of its head, neck, and underparts a rich salmon hue from May to August.

The red knot winters in Tierra del Fuego and Patagonia at the tip of Argentina and migrates north to the Canadian Arctic to breed, annually traveling nearly nine thousand miles in each direction. It

Red-breasted Sandpiper [Red Knot]. **Hand-colored aquatint, etching, and line engraving by Robert Havell Jr. after John James Audubon for *The Birds of America*. 1827–38. London.**

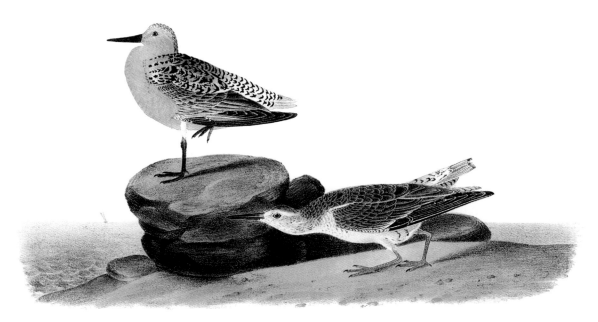

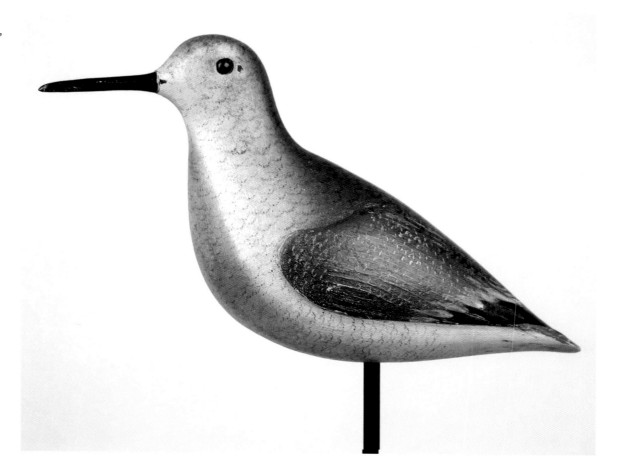

Red Knot. John Dilley.
c. 1880. Quogue, Long Island,
New York. Collection of Ted
and Judy Harmon.
This highly refined shorebird
decoy was painted in eclipse
plumage by an artist who
knew his birds.

stops in southern Brazil on its way north, where it doubles its normal weight of 4.7 ounces, adding huge amounts of body fat to fuel its upcoming marathon, and then somehow manages to fly from its feeding grounds to the mid-Atlantic coast in a matter of days. Although its route is still not clear, many of the birds apparently fly for four or five days nonstop, day and night, to reach the American coast, in an astonishing feat of navigation and endurance. By the time they arrive, they have used up all the fat they took on and are back to their normal body weight.

The red knot's arrival on the shores of southern New Jersey and Maryland is timed to coincide with the spawning of the horseshoe crab, whose abundant eggs provide the birds with the fuel needed to complete their epic journey north. The horseshoe crab (*Limulus polyphemus*) is a living fossil, one of the most ancient and primitive species surviving today; the crabs date to the Paleozoic era, 150 million years before the age of the dinosaurs. The largest concentration of mating crabs in the world is found in Delaware Bay each year from late May into June, and an equally intense concentration of shorebirds, including the red knot, ruddy turnstone, sanderling, black-bellied plover, semipalmated

plover, and various sandpipers, depend on the eggs for food. Although crab populations have been threatened by their use as bait for eels, many former bait hunters are now capturing and releasing the crabs because their blood is far more valuable. Taken by medical labs and worth $15,000 a quart, the crabs' bright blue, copper-based blood produces an extract used in required FDA testing of drugs and vaccines for possible bacterial contamination.

Red knots, which were called "robin snipe" by early gunners, were heavily hunted in the nineteenth and early twentieth centuries, and their numbers were drastically reduced. Although its current North American population is estimated at about 400,000, its numbers have declined in recent years because of habitat destruction, and it is listed as a "bird of conservation concern" by the U.S. Fish and Wildlife Service. The concern is great enough that it also has been listed as a candidate for the endangered species list in recent years.

RUDDY TURNSTONE

The ruddy turnstone (*Arenaria interpres*) is a small, stocky bird with short orange legs and a distinctive variegated plumage. It averages nine and a half inches in length with a wingspan of twenty-one inches and typically weighs just under four ounces. In addition to the year-round rufous calico of both sexes, the

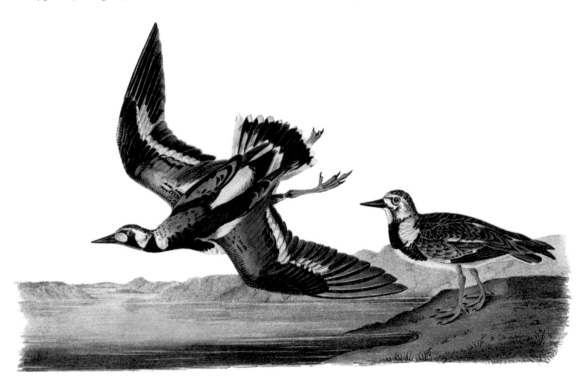

Turnstone [Ruddy Turnstone]. Hand-colored lithograph by John T. Bowen after John James Audubon for *The Birds of America*, First Octavo edition. 1840–44. Philadelphia.

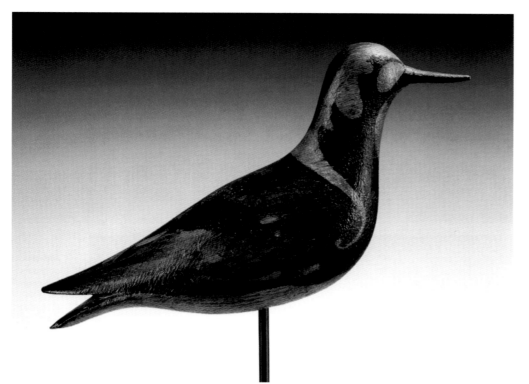

Ruddy Turnstone. Lothrop Turner Holmes. c. 1870. Kingston, Massachusetts. Collection of Paul Tudor Jones II. Photograph courtesy Sotheby's, Inc.
Holmes was not only a sophisticated carver, he was arguably the greatest master of line among all decoy painters. This is by far the best preserved of his few known turnstones.

male's breeding plumage is marked by a dramatically patterned black and white head.

The turnstone is named for its habit of using its short, upturned bill to flip over stones, pebbles, bits of seaweed, and other small obstacles in its search for food. It prefers rocky shores but also frequents sand and pebble beaches and mud flats, especially if they are covered with seaweed. While it concentrates on flies during breeding season, it is an eclectic and voracious eater the rest of the year, consuming a wide range of insects, worms, shellfish, small fish, carrion, and eggs of other birds. Frank T. Noble described his observations of the bird's method this way in a 1904 issue of *Journal of the Maine Ornithological Society*:

He would select a likely spot on the loosely packed moss and go at this work with a vim and rapidity entirely different from the other species. Underneath the bits of wood, moss, and fragments of shell his sharp upturned bill would swiftly go and a perfect shower of these would soon be falling in front [of] and beside him. Finding a morsel to his taste he would devour it in much less time than it takes to relate it, and the rooting and tossing of the bits into the air would continue. At times, quite sizable fragments of shell and pieces of moss more than an inch in length would be thrown fully 7 or 8 inches above the bird's head, and this he kept up, with scarcely an instant's pause, for quarter of an hour and until he had excavated a pit large enough to almost conceal his plump, mottled body. Occasionally he would turn about in his tracks, but as a rule he worked in one direction.

The largest proportion of the North American population winters in northern Brazil and migrates north and south along the Atlantic coast to and from its breeding grounds in Alaska and the Canadian tundra. A few birds winter along the United States coast as far north as Long Island. It appears in Delaware Bay in mid- to late May to take advantage of the spawning of horseshoe crabs; as with the red knot, this important staging area provides a windfall of protein for the turnstone as it migrates north.

Turnstones were actively gunned during the nineteenth and early twentieth centuries, and their populations were greatly diminished. About 250,000 currently exist, and many conservationists express concern about the effects of habitat destruction on the species, both in its sensitive and easily disturbed far northern breeding grounds and along its Atlantic coast migratory staging grounds.

SANDERLING SANDPIPER (SANDERLING) AND LEAST SANDPIPER

It is half tide on Cape Cod. Great waves heave high their tossing heads, which, curling, break and thunder down in sheets of snowy foam that overwhelm the beach, charging forward and upward across the sloping sands, almost to the very foot of the dunes. The sea bellows and roars. It pounds the shifting sands until the very earth trembles with the impact, and the salt spray, blown from the wave crests, drifts in clouds across the beach. The flotsam and jetsam of the sea are tossed and washed upon the beach amid the froth and spume; bits of rockweed, seaweed, sponge, cork, bamboo and driftwood, floating wreckage which was once a part of the hull of cargo of some ship overwhelmed at sea or wrecked on the treacherous sands,—all are cast high on the sands or washed here by the returning wave. Many small forms of marine life are torn from the ocean bed and thrown upon the beach.

 Here the little Sanderlings are in their element. With nimble, ready step they follow the back-wash down and retreat before the rush of the incoming wave. Sometimes in their eager pursuit of some unusually tempting morsel they run so far down the beach that they are met by the returning wave coming too fast for their little flying feet to escape its overwhelming rush. Then with ready wings they mount and flutter beyond its reach. If disturbed they rise and gather into a rather compact flock, then, wheeling out over the surf, they fly up or down the beach, now fluttering low in a great sea hollow, now skimming the crest of a foaming breaker, soon to alight again on the sands.

 —Edward Howe Forbush, *A History of the Game Birds, Wild-Fowl and Shore Birds of Massachusetts and Adjacent States*, 1912

The sanderling (*Calidras alba*) is the ubiquitous small American "beach bird," described by master birder and illustrator David Allen Sibley as "the familiar 'clockwork toy' bird seen chasing waves on sandy beaches." Perhaps the most widely distributed of all shorebirds, this inconspicuous little bird averages eight

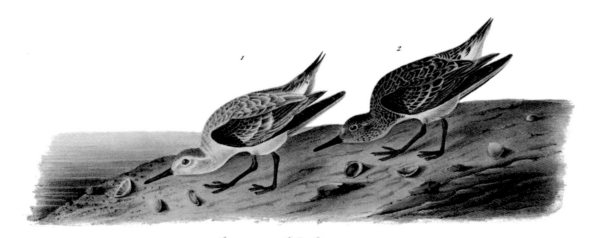

***Ruddy Plover* [Sanderling].
Hand-colored lithograph
by John T. Bowen after
John James Audubon for
The Birds of America, First
Octavo edition. 1840–44.
Philadelphia.**

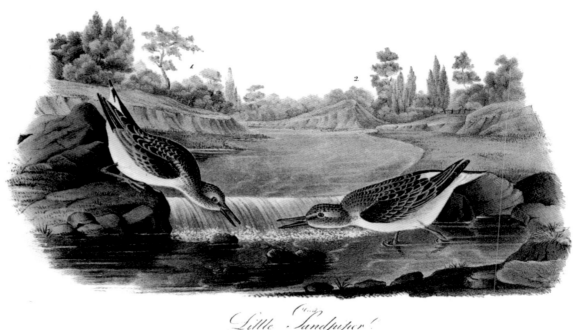

Little Sandpiper [Least Sandpiper]. Hand-colored lithograph by John T. Bowen after John James Audubon for *The Birds of America*, First Octavo edition. 1840–44. Philadelphia.

Little Sandpiper!
1. Male. Summer plumage. 2. Female.

OPPOSITE: *Group of Peeps* [Sanderlings and Least Sandpipers]. Attributed to Thomas Hewlett. c. 1900. South Shore, Long Island, New York. Ex-collection James M. McCleery, M.D. Photograph courtesy the Houston Museum of Natural Science, Houston, Texas. These tiny, fragile, cork-bodied birds, several of which would fit in the palm of one's hand, have inset glass eyes and hardwood bills. The smaller birds were intended to imitate least sandpipers, while the two larger birds, which represent sanderlings, have attached cork wings.

inches in length with a seventeen-inch wingspan and typically weighs just over two ounces. Unlike most other shorebirds, sanderlings do not have a fourth toe at the rear of their feet. It has a short, straight black bill and is dark above and light below during the summer breeding season, which it spends in the Canadian Arctic, as far north as any other shorebird. It winters primarily in Central and South America and stops in large numbers in Delaware Bay during its spring migration and in New England and Delaware Bay again on its way back south in the late summer and fall.

Called the "bull-peep" by early hunters, the sanderling became popular as a game species late in the nineteenth century, when populations of larger and more desirable species were dwindling. Perhaps because it was not hunted throughout the second half of the nineteenth century, as many other shorebirds were, it was not as seriously affected by gunners. Many other sandpipers, including the dunlin and curlew sandpiper, were actively pursued by late nineteenth-century beach gunners, as were the smallest members of the family—the Baird's, least, semipalmated, western, and white-rumped sandpipers—which hunters collectively dubbed "peeps" after their chirping flight calls.

Incredible as it seems today, peep pie was a favorite on many East Coast tables. Despite its diminutive size, the descriptively named least sandpiper (*Calidras minuttilla*), the smallest of all beach birds, was often targeted. The birds flew in heavily concentrated flocks that made them easy marks; one account relates ninety-seven killed by a single blast of shot.

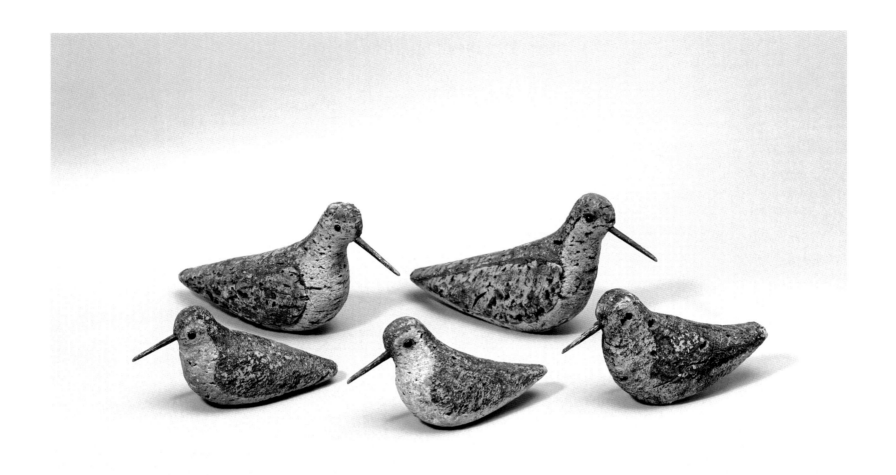

The tiny birds average only around six inches in length and weigh less than an ounce but are capable of flying as much as twenty-five hundred miles nonstop on their journey south from staging areas in the Canadian Maritimes and New England to South America. They breed farther south than other sandpipers, from Alaska across northern Canada and sometimes south to the Maritimes and Cape Cod, where they have been known to nest in sand dunes.

Sandpipers are seriously threatened by habitat destruction today. The sanderling, for example, has lost 80 percent of its population along the Atlantic coast since the 1970s. Populations remain relatively large, but groups such as the Nature Conservancy are concerned about the long-term trends for these and other shorebirds.

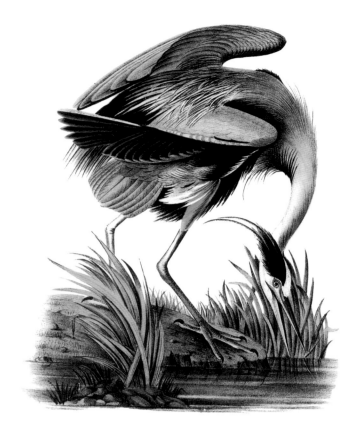

Great Blue Heron. Hand-colored aquatint, etching, and line engraving by Robert Havell Jr. after John James Audubon for *The Birds of America*. 1827–38. London.

CHAPTER 7

Birds of a Feather:
Herons, Gulls, and Terns

Herons, gulls, and terns were all hunted for their feathers, which were used to decorate hundreds of thousands of women's hats in the late nineteenth and early twentieth centuries. All three birds are fish eaters, but while herons are wary, solitary, and nocturnal denizens of fresh and brackish water and gather only to nest, gulls and terns are gregarious diurnal sea birds that are rarely seen out of each other's company. Herons are large, long-necked wading birds with plumage that is gray or white overall, while short-necked gulls and terns, which are both members of the family Larida, typically have gray or black backs and white bellies. Mature male and female gulls and terns are similar in both size and plumage color, while young birds usually sport spotted or streaked plumage that

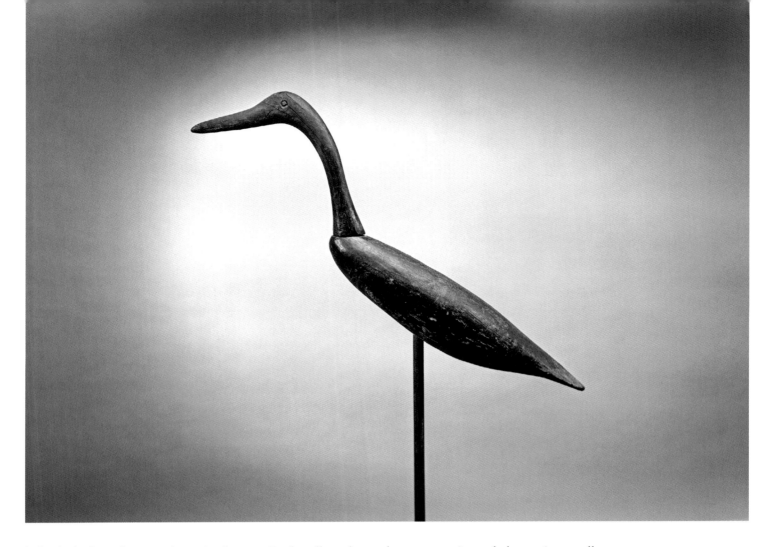

helps hide them from predators in the nest. Both gulls and terns have proportionately long wings; gulls are heavy-bodied, while terns, which are considerably smaller than gulls, have longer, narrower bodies and slender, pointed wings.

Great Blue Heron. A member of the Verity family. c. 1880. Seaford, Long Island, New York. Private collection. Photograph courtesy the Houston Museum of Natural Science, Houston, Texas. The head of this simple but highly effective decoy is carved from a tree root, chosen for both its suggestive form and structural strength.

GREAT BLUE HERON

In the tops of the cottonwoods live a number of baronial families in castles huge, gray and ugly, overlooking the sweep of the stream. They are the Great Blue Herons, whose Latin title, *Ardea herodias*, gives one some idea of their ancient lineage. They claim to be older than the storks of Egypt, and indeed, they look older as they stand humpbacked and sleepy on one leg by the side of their nests, the long fringe of light-speckled neck feathers underneath looking like a long gray beard sweeping over their recurved neck and breast. There is a wise look about them, too, for the black markings of the head sweep back over the eye and prolong into the appearance of a quill extending behind their ears.
—Charles Elmer Jenny, *Birds and Nature* magazine, 1900

The great blue heron (*Ardea herodias*) is North America's largest and most widely distributed heron, found in close proximity to humans throughout most of the United States. They are tall birds with long serpentine necks and long legs. They average forty-six inches long with a six-foot wingspan and weigh more than five pounds. They are gray overall with a dark crown and dark plumes on the back of their heads and have orange bills. An all-white color morph of the great blue heron, once thought to be a separate species, can be found in the Florida Everglades and Keys.

Great blue herons are primarily fish eaters but also stalk a variety of other aquatic life, including frogs, turtles, voles, and other small mammals, and even other birds. They sometimes literally take on more than they can chew; they have been known to choke to death trying to swallow a fish that is too big to get down their long throats.

Although great blue herons were hunted for their feathers throughout the nineteenth century, they were less popular prey than other herons and egrets. The white variety of the great blue was gunned heavily, however, along with the more common and widely distributed snowy and great white egrets. Hunters invaded rookeries, and many adult birds were killed on the nest. The species rebounded quickly after protective laws were passed, and its population today is large and secure, with the main threats coming from exposure to chemicals.

HERRING GULL

The herring gull (*Larus argentatus*) is by far the most common large gull in North America today, breeding from the southern coast of Alaska across Canada to Hudson Bay and south from there to the coast of North Carolina. Herring gulls are also year-round residents of the Great Lakes and along the East Coast from Newfoundland to North Carolina; they winter on all three American coasts as well as in the Mississippi Basin and along both coasts of Mexico and Central America.

Herring gulls vary enormously in appearance when they are young, but by their third year they take on their familiar white-headed, gray-backed plumage. Adults of both sexes have a white head, neck, and body; light gray wings; black wing tips with large white spots called mirrors; and pink legs. Their bills are yellow to light orange with a large red spot near the tip of the lower mandible, and their eyes have gold irises ringed with yellow or orange. They average twenty-five inches long with a fifty-eight-inch wingspan and weigh about two and a half pounds. They are omnivores, taking advantage of any available food source, but, as their common name suggests, they prefer small fish and other marine animals.

Both the feathers and eggs of herring gulls were in great demand in the nineteenth century, and, hard as it is to believe today, the species was nearly eliminated in the Northeast during the course of the

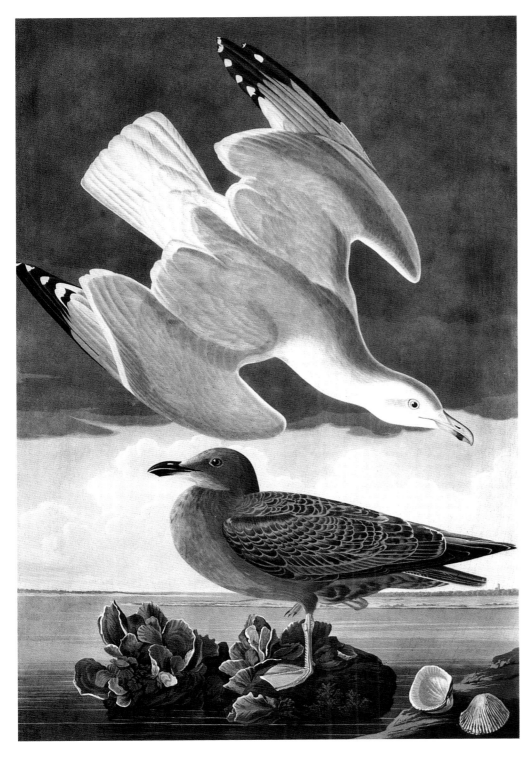

Herring Gull. Hand-colored aquatint, etching, and line engraving by Robert Havell Jr. after John James Audubon for *The Birds of America.* 1827–38. London.

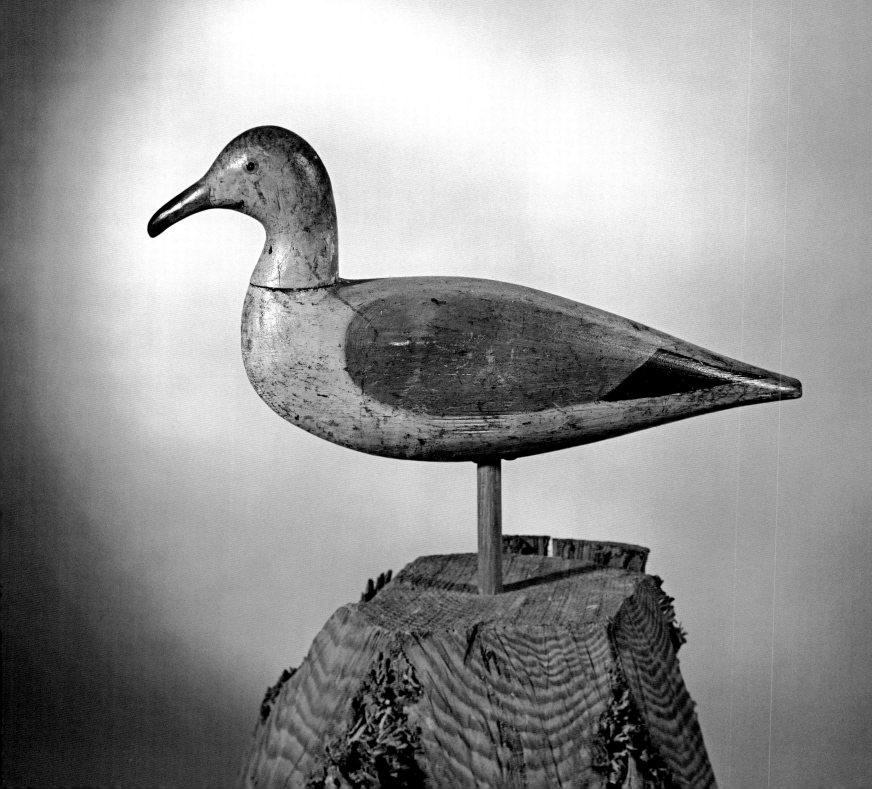

century. Audubon considered it rare in the 1830s, and only eight thousand breeding pairs were left in the United States by 1900, all of them in Maine. The population recovered quickly after hunting and egging were banned, however, and it has prospered by its proximity to humans. The herring gull has regained all of its historic range and even expanded southward, opportunistically following the spread of human civilization and often feeding on garbage.

COMMON TERN

The common tern (*Sterna hirundo*) is the most widely distributed and familiar North American tern. Averaging eleven inches long with a thirty-inch wingspan and weighing a little more than four ounces, it is a slender, elegant little bird that sports a black cap, orange-red legs, and an orange-red bill with a black tip during breeding season, along with a light gray back, pale gray underparts, and considerable

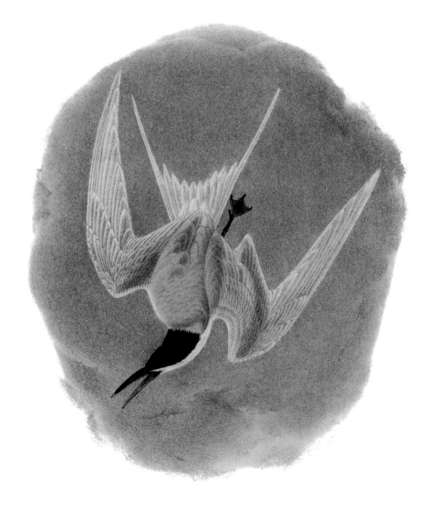

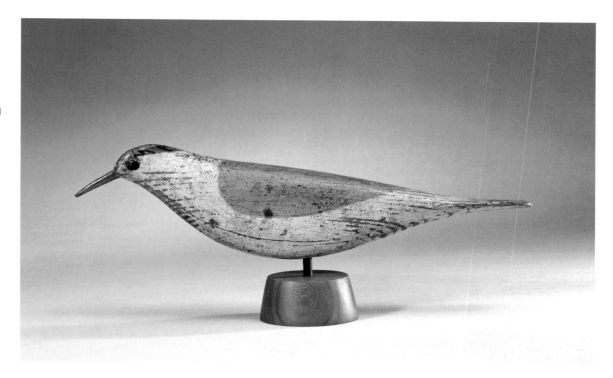

Common Tern. Daniel Demott. c. 1880. East Rockaway, Long Island, New York. Collection of Jonathan and Virginia Chua. Photograph courtesy the Houston Museum of Natural Science, Houston, Texas. This deceptively simple carving exemplifies the art of the decoy by capturing the essence of the species perfectly.

black on its outer primaries. It breeds across Canada and the northern United States from the Rockies east to inland Maine and Nova Scotia and along the Atlantic coast from southern Labrador to northern North Carolina. The bird winters primarily along the coasts of Central and South America, from northern Colombia and southern Trinidad east to Brazil and south to Argentina, and from western Mexico south to northern Chile.

Common terns were quite populous in the nineteenth century. In his 1879 study, *The Terns of the New England Coast*, William Brewster reported that hundreds of thousands were nesting on Muskeget Island, off Nantucket, alone. By 1900, however, feather hunters had almost entirely eliminated the species from its traditional haunts along the Atlantic coast. The graceful little bird became the symbol of the emerging Conservation Movement in the late 1800s and made a strong comeback after game laws protecting it and its nesting grounds were enacted early in the twentieth century. About 150,000 pairs are believed to nest in North America today. Despite these numbers, concerns remain strong. The bird is listed as endangered, threatened, or of special concern in many states around the Great Lakes and along the Atlantic coast, and many coastal nesting sites also receive special conservation attention.

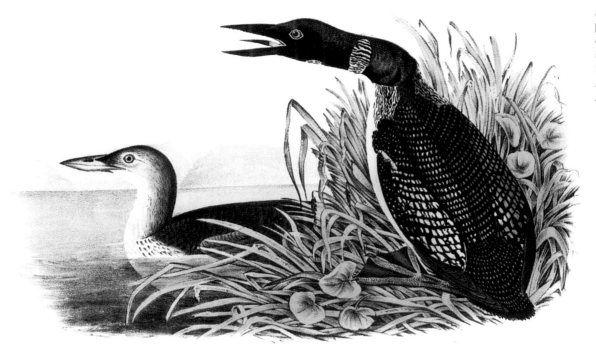

CHAPTER 8

Loons, Owls, Crows, and Pigeons

Loons, owls, crows, and pigeons—species that decoy collector and author William J. Mackey Jr. dubbed "the odd birds"—were rarely the subject of carvers' attention, and surviving decoys of these birds are few and far between. That rarity is the single common thread among these otherwise disparate species. Only the passenger pigeon was widely hunted and eaten, and it was so numerous in early years that decoys were unnecessary. Owls were never hunted for food, and loons and crows were considered palatable by only a small (and fairly undiscriminating) minority of the population. But all these species were hunted, and both the birds and the rare decoys depicting them are a rich and important part of the story of early American wildfowl and hunting practices.

COMMON LOON

The common loon (*Gavia immer*), a denizen of secluded lakes and bays in Canada and the far northern United States, is a bird of myth, romance, and legend, immortalized in everything from Native American creation stories to Hollywood movies to telephone ring tones. It is a large bird, about thirty-two inches long with a fifty-four-inch wingspan and weighing about nine pounds. It has a dark green head, distinctive, black-and-white checkerboard body markings, and red eyes.

The loon is best known for its eerie, haunting cry, which naturalist John Muir described as "one of the wildest and most striking of all the wilderness sounds, a strange, sad, mournful, unearthly cry, half laughing, half wailing." The bird has become a symbol of the northern wilderness and the struggle to preserve the species and its habitat. As Massachusetts state ornithologist E. H. Forbush put it in 1912, "Of all the wild creatures which still persist in the land, despite settlement and civilization, the Loon seems best to typify the untamed savagery of the wilderness. Its wolflike cry is the wildest sound now heard in Massachusetts, where nature has long been subdued by the rifle, axe, and plow."

While most birds have hollow bones, an adaptation that reduces overall weight and facilitates flight, the loon's bones are solid and dense to help them in diving. They are fish eaters that can dive to two hundred feet or more in pursuit of prey and swim underwater for considerable distances and periods of time. They are built for life on the water, coming on land only to nest as near shore as

Common Loon. **Maker unknown. c. 1900. Maine. The Gene & Linda Kangas Collection of American & International Folk Art.**
This rare loon decoy has the large inlet neckseat typical of Maine decoys.

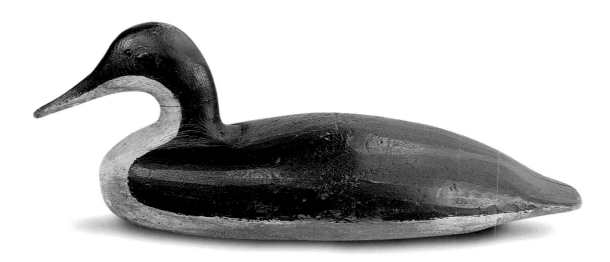

possible. They are awkward and vulnerable out of water because their large paddle feet are set well back on their bodies, ideal for propelling them forward in water but less so for walking. While they are strong and swift flyers that have been timed at up to ninety miles an hour, they have a smaller wingspan-to-body-size ratio than any other bird and require a lot of running room to take off. They can become stranded on small ponds or if they land too far from water by mistake.

Although an 1898 *New York Times* article suggested that "If a man wants real hard chewing with a taste of raw fish, let him tackle an adult loon," and an old New England recipe for loon jokes, "Place the loon on a board, bake for one hour, remove from oven, throw away the loon, eat the board," a few hardy souls did apparently eat the birds. Loon decoys were made from the Canadian Maritimes south to Long Island, and loons are still legally hunted and eaten by a few Canadian Indians, although the primary threats to the species are environmental.

BELOW: *Great Horned Owl.* Hand-colored aquatint, etching, and line engraving by Robert Havell Jr. after John James Audubon for *The Birds of America.* 1827–38. London.

GREAT HORNED OWL

The great horned owl (*Bubo virginianus*) is a year-round resident of the Americas, found from the northern tree line in Alaska and Canada throughout the United States and into Central and South America. A large, nocturnal raptor, great horned owls have tufted ears and black bills, average twenty-two inches long with a forty-nine-inch wingspan, and weigh a little more than three pounds. They are stealthy, carnivorous hunters who eat a wide range of animals, fish, and other birds. They also prey on domestic cats, dogs, and fowl, as well as reptiles, amphibians, insects, scorpions, centipedes, crayfish, worms, and spiders. They often attack and kill birds and animals considerably larger than themselves, and are the only animal that kills and eats skunks on a regular basis. The great horned owl has no natural predators other than man and larger owls, although a group of peregrine falcons will occasionally attack an owl, and crows often gather to harass them.

The great horned owl's extremely large, yellow eyes are fixed in its head. It can, however, turn its head more than 180 degrees in search of prey. It also has acute directional hearing that allows it to pinpoint the location of prey in the dark; it then swoops down on swift, silent,

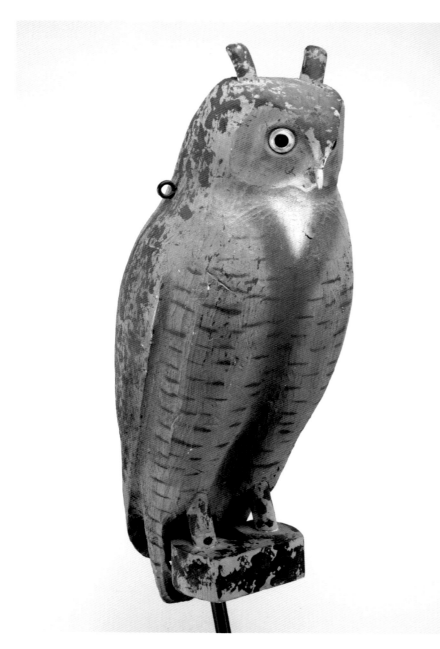

soft-feathered wings to make a kill. The birds hunt primarily by perching in trees and pouncing on prey, but sometimes glide or walk over fields or wade into water after fish, frogs, and crustaceans. They are also notorious raiders of hen and turkey houses, which they sometimes simply walk into before raising havoc. They are also known to attack domestic pigeon roosts.

Because of its taste for domestic and wild fowl of all kinds, the great horned owl was despised by farmers, gamekeepers, sportsmen, and conservationists alike well into the twentieth century, and it received no protection from hunters and trappers when laws protecting game species and other raptors were in place. Indeed, a majority of states and provinces offered bounties on the owls, and many hoped they would be wiped out or at least severely curtailed. Although the species was rare in some regions by the early decades of the twentieth century, its ecological value was finally realized and laws restricting or outlawing hunting were enacted, although not until the 1960s in some areas. Today, it is quite common and under no threat throughout its wide range. Owls do not decoy, but crows are attracted by owl decoys, which hunters often place among their counterfeit crows.

AMERICAN CROW

The American crow (*Corvus brachyrhynchos*) may be America's best-known bird. It is also one of our most common and widely distributed species. It and its cousin, the raven, are the most intelligent birds as well. Averaging seventeen and a half inches long with a thirty-nine-inch wingspan and weighing about a pound, American crows are found throughout central and southern Canada and all over the United States. About half of the crow population is resident, staying in place year-round, while the rest migrates, especially to and from the most northern parts of the

Great Horned Owl. **Herter's. c. 1940. Waseca, Minnesota. Collection of Russ and Karen Goldberger, RJG Antiques.** Herter's was a major mail-order sporting goods company that manufactured a complete line of decoys. Its owls and crows are among the best ever made for those species and were very popular with Midwest hunters. This example has a balsa wood body, glass eyes, and a bear claw inserted as a beak.

species range in Canada. They roost in groups at night, which can range from a few individuals to thousands of birds.

Crows are omnivorous and eclectic feeders, happily eating a wide variety of invertebrates, amphibians, reptiles, small birds, and mammals, as well as the eggs and young of other birds. They also eat wild and cultivated grains, seeds, and fruits. Noted scavengers, they search for roadkill and other carrion and pick through garbage. As they prefer open land to forest, they were not terribly common in pre-Colonial days. However, crow populations ballooned during the nineteenth century as humans created thousands of acres of suitable habitat by cutting forests and planting new agricultural lands. Although corn, grains, fruit, and other crops are part of their diet and farmers blame them for inflicting serious damage, they also eat harmful bugs and larvae. For these reasons, and because they are said to be good eating if one gets past cultural prejudices about eating scavengers, they have been hunted extensively since the 1800s. It was common practice to dynamite roosts well into the twentieth century; according to one report, 26,000 birds were killed in a single Oklahoma roost in 1937 and 328,000 in Illinois roosts during 1940. While they are still hunted, especially in the Midwest, a more balanced view of their place in the natural world prevails today, and they currently are in no danger at all, seeming to thrive in close proximity to people and civilization.

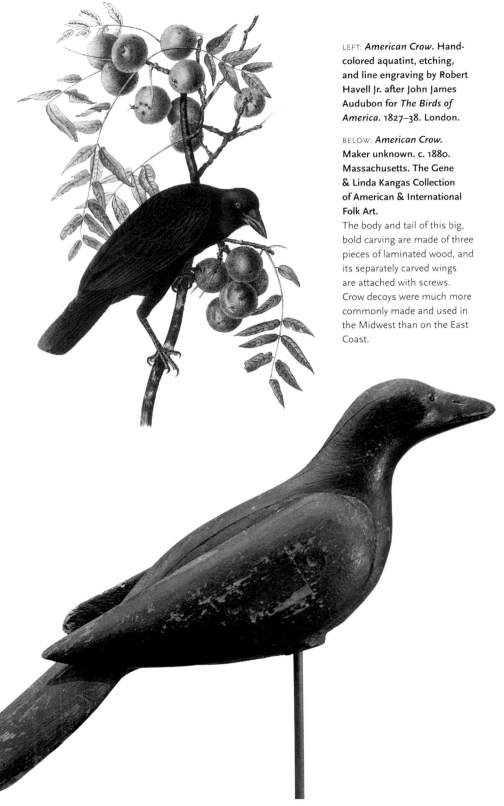

LEFT: *American Crow*. Hand-colored aquatint, etching, and line engraving by Robert Havell Jr. after John James Audubon for *The Birds of America*. 1827–38. London.

BELOW: *American Crow*. Maker unknown. c. 1880. Massachusetts. The Gene & Linda Kangas Collection of American & International Folk Art.
The body and tail of this big, bold carving are made of three pieces of laminated wood, and its separately carved wings are attached with screws. Crow decoys were much more commonly made and used in the Midwest than on the East Coast.

Crows and great horned owls are mortal enemies, and crows often gather by the dozens or even hundreds to harass an owl. Hunters often used owl decoys to lure crows, and some were even made with a carved crow clutched in their talons, presumably infuriating the highly sensitive and perceptive birds even more.

PASSENGER PIGEON

The Passenger Pigeon was no mere bird, he was a biological storm. He was the lightning that played between two biotic poles of intolerable intensity: the fat of the land and his own zest for living. Yearly the feathered tempest roared up, down, and across the continent, sucking up the laden fruits of forest and prairie, burning them in a travelling blast of life. Like any other chain reaction, the pigeon could survive no diminution of his own furious intensity. Once the pigeoners had subtracted from his numbers, and once the settlers had chopped gaps in the continuity of his fuel, his flame guttered out with hardly a sputter or even a wisp of smoke. There will always be pigeons in books and museums, but these are effigies and images, dead to all hardships and to all delights. Book-pigeons can not dive out of a cloud to make the deer run for cover, or clap their wings in thunderous applause of mast-laden woods. Book-pigeons cannot breakfast on new-mown wheat in Minnesota, and dine on blueberries in Canada. They know no urge of seasons, no lash of wind and weather. They live forever by not living at all.
—Aldo Leopold, 1947

The passenger pigeon (*Ectopistes migratorius*), once by far the most populous bird ever to fly American skies, was hunted to extinction over the course of the nineteenth century. We know exactly when the species passed: the last passenger pigeon, a twenty-nine-year-old female named Martha, died at 1 p.m. on September 1, 1914, in the Cincinnati Zoological Garden. Her mounted body was given to the Smithsonian Institution, where she was exhibited for many years.

The passenger pigeon was a large dove; males averaged sixteen inches long and weighed about twelve ounces, significantly larger than the mourning dove. They had long tails, and breeding males sported a slate-blue back and orange to pink breast. In his 1913 memoir, *The Story of My Boyhood and Youth*, the great naturalist John Muir painted a particularly vivid picture of the bird's beauty and his own ambivalence toward hunting it:

It was a great memorable day when the first flock of passenger pigeons came to our farm, calling to mind the story we had read about them when we were at school in Scotland. Of all God's feathered people that sailed the Wisconsin sky, no other bird seemed to us so wonderful. The beautiful wanderers flew like the winds in flocks of millions from climate to climate in accord with the weather, finding their food—acorns, beechnuts, pine-nuts, cranberries, strawberries, huckleberries, juniper

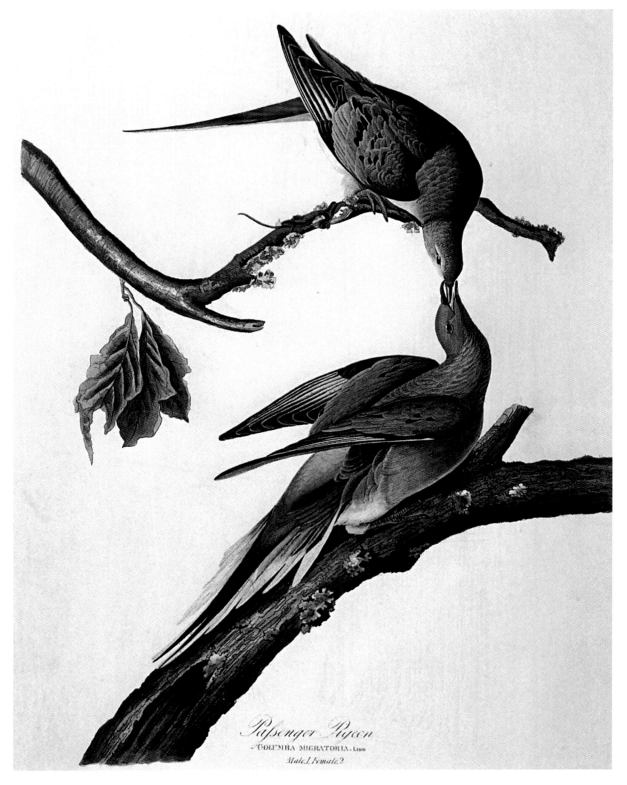

Passenger Pigeon. Hand-colored aquatint, etching, and line engraving by Robert Havell Jr. after John James Audubon for *The Birds of America.* 1827–38. London.

berries, hackberries, buckwheat, rice, wheat, oats, corn—in fields and forests thousands of miles apart. I have seen flocks streaming south in the fall so large that they were flowing over from horizon to horizon in an almost continuous stream all day long, at the rate of forty or fifty miles an hour, like a mighty river in the sky, widening, contracting, descending like falls and cataracts, and rising suddenly here and there in huge ragged masses like high-plashing spray. How wonderful the distances they flew in a day—in a year—in a lifetime! They arrived in Wisconsin in the spring just after the sun had cleared away the snow, and alighted in the woods to feed on the fallen acorns that they had missed the previous autumn. A comparatively small flock swept thousands of acres perfectly clean of acorns in a few minutes, by moving straight ahead with a broad front. All got their share, for the rear constantly became the van by flying over the flock and alighting in front, the entire flock constantly changing from rear to front, revolving something like a wheel with a low buzzing wing roar that could be heard a long way off. In summer they feasted on wheat and oats and were easily approached as they rested on the trees along the sides of the field after a good full meal, displaying beautiful iridescent colors as they moved their necks backward and forward when we went very near them.

The breast of the male is a fine, rosy red, the lower part of the neck behind and along the sides changing from the red of the breast to gold, emerald green, and rich crimson. The general color of the upper parts is grayish blue, the under parts white. The extreme length of the bird is about seventeen inches; the finely modeled, slender tail about eight inches, and extent of wings twenty-four inches. The females are scarcely less beautiful. "Oh, what bonnie, bonnie birds!" we exclaimed over the first that fell into our hands. "Oh, what colors! Look at their breasts, bonnie as roses, and at their necks aglow wi' every color just like the wonderfu' wood ducks. Oh, the bonnie, bonnie creatures, they beat a'! Where did they a' come fra, and where are they a'gan? It's awfu' like a sin to kill them!" To this some smug, practical old sinner would remark: "Aye, it's a pity, as ye say, to kill the bonnie things, but they were made to be killed, and sent for us to eat as the quails were sent to God's chosen people, the Israelites, when they were starving in the desert ayont the Red Sea. And I must confess that meat was never put up in neater, handsomer-painted packages."

At its peak, the passenger pigeon made up more than a quarter of America's total bird population, an estimated three to five billion individuals at the time Europeans first came to this continent. Explorers and early settlers reported encountering huge flocks of the birds, which extended for hundreds of miles. The Puritan minister Cotton Mather wrote of a flight a mile wide; another mile-wide flock, which took fourteen hours to pass, was witnessed in southern Ontario in 1866. Since passenger pigeons were sleek, aerodynamically built birds that could fly sixty miles an hour, the immensity of such migrations seems unimaginable today and was scarcely less staggering even to such experienced eyewitnesses as Audubon.

Passenger pigeons were birds of North America's primeval forests, dependent on the billions of acres of trees that covered most of the eastern part of the continent for both food and nesting habitat.

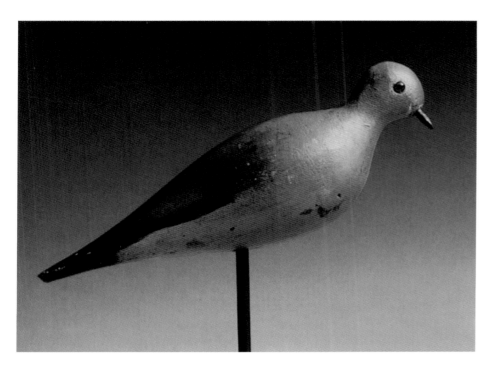

Passenger Pigeon. **Mason Decoy Factory. c. 1900. Detroit. Private collection. Photograph courtesy Sotheby's, Inc.** The Mason Factory produced only a few passenger pigeon decoys shortly before the bird disappeared from the wild, when decoys became necessary in order to lure the once-prolific species. This decoy's large size and pink breast distinguish it from the dove decoys the company also made.

They fed primarily on tree nuts—acorns, chestnuts, beechnuts, and hickory nuts—and suffered as settlers cleared forests for agriculture. They were also hunted mercilessly. They were an extremely popular table bird, and their habits of migrating and roosting in such huge concentrations made them helplessly vulnerable to market gunners, who often killed thousands of birds a day. While their numbers once seemed inexhaustible, they were scarce by the late 1800s, and the last wild passenger pigeon was killed in 1900. Although bounties were placed on the discovery of other wild pigeons, none was ever found. Breeding among captive populations proved fruitless, and the species slipped into history, bird by bird, until Martha's passing put an end to its story.

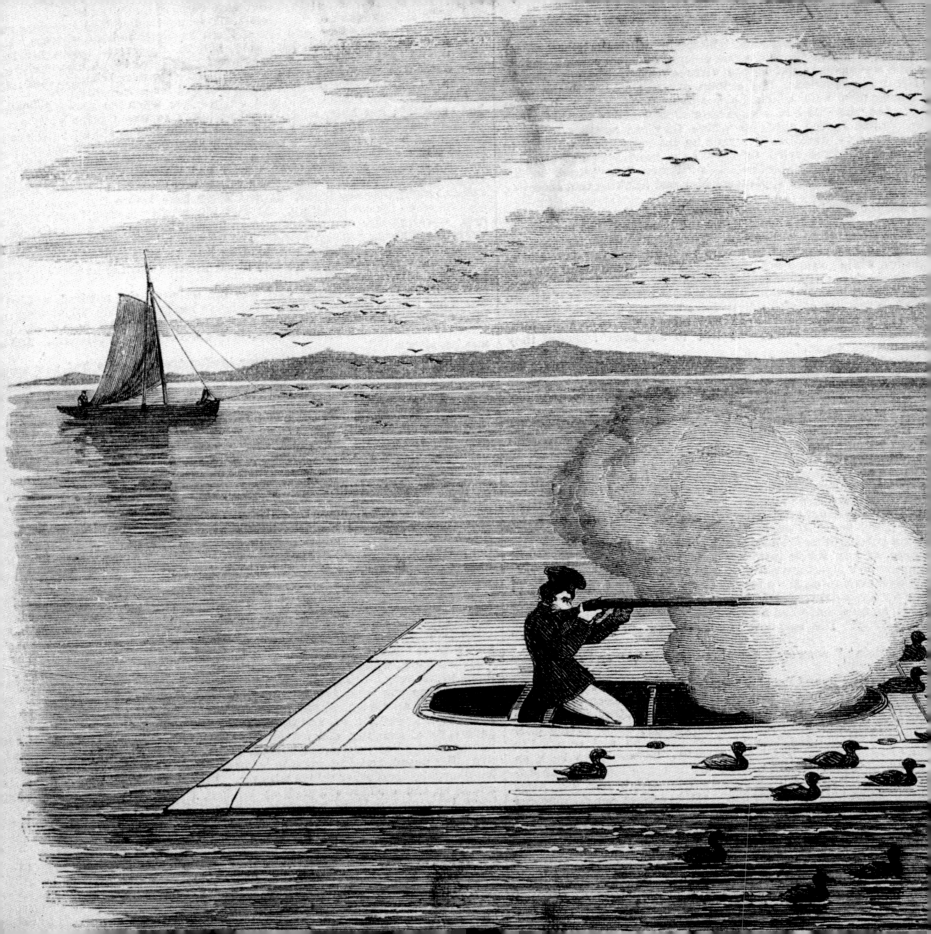

The Hunters

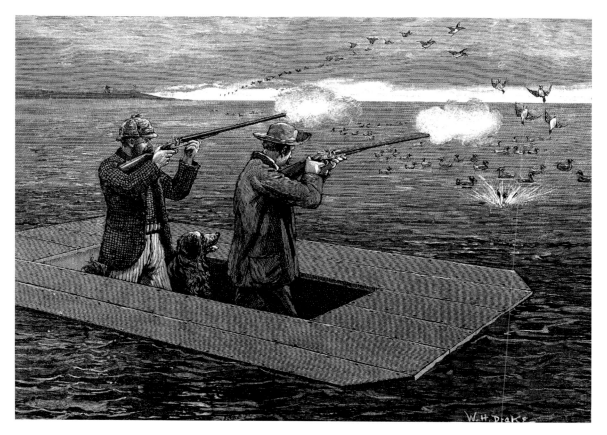

PREVIOUS PAGES: *Duck Hunting on the Potomac.* Engraving. 1850.

Canvas-back Duck Shooting on Chesapeake Bay. Line engraving from a photograph by S. Fisher Corlies and sketch by W. H. Drake. 1888. A pair of market gunners shooting canvasbacks from a sinkbox. Sinkboxes like this, which allowed the hunter to lie in hiding below the waterline, were in use in the Chesapeake Bay region by the 1840s.

CHAPTER 9

The Market Gunners:
Food for America's Tables

Commercial hunting of wildfowl became big business after the Civil War and continued unabated until laws banning the sale of migratory birds were enacted at the end of World War I. The practice burgeoned along with the country, expanding in direct correlation to the building of the railroads and the growth of the nation's cities. It reached its peak in the late nineteenth and early twentieth centuries with the introduction of automatic weaponry, which gave professional gunners the deadliest and most efficient tools for their trade.

The earliest commercial market hunters probably started work around the turn of the nineteenth century near New York, Philadelphia, and other major cities that had well-developed wholesale and retail game markets. In his *Birds of America*, John James Audubon wrote that in 1805 he saw

schooners "loaded in bulk with [passenger] Pigeons caught up the Hudson River, coming in to the wharf at New York, when the birds sold for a cent a piece, [and] in March 1830, they were so abundant in the markets of New York that piles of them met the eye in every direction." Passenger pigeons were so numerous, so easily taken in large numbers, and such good eating that they dominated the early commercial trade in wildfowl.

Audubon painted an extraordinary picture of what a pigeon hunt was like in the early decades of the nineteenth century. Despite all of his experience, he could barely believe what he witnessed. The scene was a passenger pigeon roost on the Green River in Kentucky, where a veritable legion of hunters had gathered in preparation for the return of the birds at sundown. Their number included professional gunners who would sell their catch at market as well as those who were gathering the pigeons for their own use.

It was, as is always the case, in a portion of the forest where the trees were of great magnitude, and where there was little under-wood. I rode through it upwards of forty miles, and, crossing it in different parts, found its average breadth to be rather more than three miles.

My first view of it was about a fortnight subsequent to the period when [the birds] had made choice of it, and I arrived there nearly two hours before sunset. Few Pigeons were then to be seen, but

Shooting Wild Passenger Pigeons in Iowa. Leslie's Illustrated Newspaper. September 21, 1867.
At the time this scene was published, passenger pigeons were still the most populous bird species in North America. They would decline precipitously over the coming decades and become extinct by 1914.

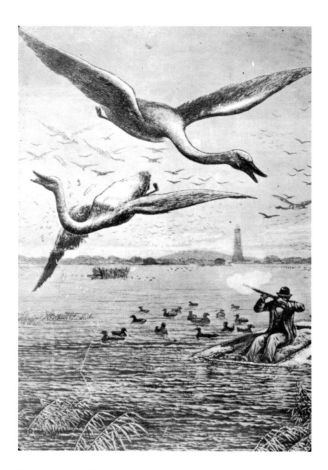

Swan Shooting. **Engraving.**
c. 1850.
Swans were legal game until
1905, and young birds, known
as cygnets, were considered
good eating.

a great number of persons, with horses and wagons, guns and ammunition, had already established encampments on the borders. Two farmers from the vicinity of Russelsville, distant more than a hundred miles, had driven upwards of three hundred hogs to be fattened on the pigeons which were to be slaughtered. Here and there, the people employed in plucking and salting what had already been procured, were seen sitting in the midst of large piles of these birds. The dung lay several inches deep, covering the whole extent of the roosting-place. Many trees two feet in diameter, I observed, were broken off at no great distance from the ground; and the branches of many of the largest and tallest had given way, as if the forest had been swept by a tornado. Every thing proved to me that the number of birds resorting to this part of the forest must be immense beyond conception. As the period of their arrival approached, their foes anxiously prepared to receive them. Some were furnished with iron-pots containing sulphur, others with torches of pine-knots, many with poles, and the rest with guns. The sun was lost to our view, yet not a Pigeon had arrived. Every thing was ready, and all eyes were gazing on the clear sky, which appeared in glimpses amidst the tall trees. Suddenly there burst forth a general cry of "Here they come!" The noise which they made, though yet distant, reminded me of a hard gale at sea, passing through the rigging of a close-reefed vessel. As the birds arrived and passed over me, I felt a current of air that surprised me. Thousands were soon knocked down by the pole-men. The birds continued to pour in. The fires were lighted, and a magnificent, as well as wonderful and almost terrifying, sight presented itself. The Pigeons, arriving by thousands, alighted everywhere, one above another, until solid masses were formed on the branches all round. Here and there the perches gave way under the weight with a crash, and, falling to the ground, destroyed hundreds of the birds beneath, forcing down the dense groups with which every stick was loaded. It was a scene of uproar and confusion. I found it quite useless to speak, or even to shout to those persons who were nearest to me. Even the reports of the guns were seldom heard, and I was made aware of the firing only by seeing the shooters reloading.

No one dared venture within the line of devastation. The hogs had been penned up in due time, the picking up of the dead and wounded being left for the next morning's employment.

The Pigeons were constantly coming, and it was past midnight before I perceived a decrease in the number of those that arrived. The uproar continued the whole night; and as I was anxious to know to what distance the sound reached, I sent off a man, accustomed to perambulate the forest, who, returning two hours afterwards, informed me he had heard it distinctly when three miles distant from the spot. Towards the approach of day, the noise in some measure subsided: long before objects were distinguishable, the Pigeons began to move off in a direction quite different from that in which they had arrived the evening before, and at sunrise all that were able to fly had disappeared. The howlings of the wolves now reached our ears, and the foxes, lynxes, cougars, bears, raccoons, opossums and pole-cats were seen sneaking off, whilst eagles and hawks of different species accompanied by a crowd of vultures, came to supplant them, and enjoy their share of the spoil.

It was then that the authors of all this devastation began their entry amongst the dead, the dying, and the mangled. The Pigeons were picked up and piled in heaps, until each had as many as he could possibly dispose of, when the hogs were let loose to feed on the remainder.

Despite Audubon's stated belief that the supply of passenger pigeons was so great that they would not be affected by such slaughter, the species did reach a tipping point soon after the Civil War and was scarce by the end of the nineteenth century. Long before that eventuality however, commercial hunters had broadened their horizons to include a wide array of ducks, geese, swans, and shorebird species, which they gathered with equally deadly and ruthless proficiency. There were few restrictions on their methodology, so, as professionals seeking to maximize returns, they used every means at their disposal. Their goal was to kill as many birds as possible with the least expenditure of time, effort, and capital. They were extraordinary shots; the best of them rarely missed, even at considerable distances and under the most difficult physical circumstances, and they could often kill a number of birds with a single shotgun blast.

Market hunting was by definition a seasonal profession, and many, if not most, of the men who gunned for their livelihood plied other trades over the course of the year. Many were baymen, who, depending on where they lived, also fished; hunted for deer and other game; guided sportsmen; trapped lobsters or crabs; dredged for oysters; dug for clams; built and repaired boats; painted houses; picked wild berries, fruits, herbs, vegetables, and mushrooms; cut trees for wood and seasonal greens; or practiced handcrafts such as blacksmithing, basketmaking, or pottery. Some made decoys for themselves and their peers during the months when other work was not possible or available. Until public opinion turned against their trade in the late nineteenth century, many market gunners were respected members of their communities, and even after the Conservation Movement began to gain political ground, their detractors were far less often their neighbors than peers of the city dwellers who ultimately consumed their kill.

Double Battery at Dawn, Chesapeake Bay. **Photograph. c. 1900.**
A full spread of decoys with two gunners and hundreds of lures ready for action.

From Long Island Sound south to North Carolina, one of the deadliest tools used by nineteenth-century market gunners was the sinkbox or battery. The method was so effective that laws fining sinkbox gunners were passed in New York as early as 1838, although the laws were unenforceable and gunners continued to use them for decades. A sinkbox consisted of a coffin-shaped wooden box just large and deep enough to hold a man lying on his back. This was ringed by a narrow wooden deck and hinged platforms of lightweight slat covered with canvas and painted gray. With a gunner in the box and weight added to the deck and wings, which were all that kept the box afloat, the whole rig was perilously close to water level even in calm seas, and a bailing can was an essential part of the hunter's equipment.

J. C. JACKSON
WHOLESALERS
POULTRY AND WILDFOWL
BALT. MD. EST. 1786

SHIPPING PRICES

NAME	PRICE/PAIR
Buffell Head	$.30 – .50
Brant	1.25
Black Duck	1.25
Whistler	.30 – .50
Butterballs	1.00
Broad Bills	.30 – .50
Goose	2.00
Red Heads	2.50
Canvas Back Prime	5.00 – 7.00
" " Regular	2.50 – 5.00
Old Squaw	.70 – .90
Ruddy	.90 – 1.00
Coot (Scoter)	.50
Sprigtail	.50
Widgeon	.50
Yellowlegs	1.00
Curlew	3.00
King Rail (Per Dozen)	.70 – 1.00
Blackbirds	.25 – .75
Reedbirds	1.00

J. C. Jackson Wholesale Price List. c. 1885. Baltimore. As this list suggests, canvasbacks were the king of American table birds.

In the Susquehanna Flats, off Havre de Grace, Maryland, where battery gunning was practiced with perhaps the deadliest proficiency, one or two of these batteries would be towed out to the chosen hunting spot behind a big, flat-bottomed sailboat and anchored. The sailboat served as home base for the gunners and their support team, which typically included a cook in addition to the sailboat's captain and a couple of crew member. In preparation for the hunt, the deck of the sinkbox was often weighted with cast-iron decoys, made by creating molds of wooden birds, and the wings were brought to water level by half-bodied wooden "sinkbox" decoys that had been fitted with a sheet of lead on their bottoms. Finally, the entire sinkbox was surrounded by a large rig of as many as five hundred wooden decoys. All this was done the afternoon before shooting was planned. The following day, the gunners and their weapons were loaded into the sinkbox before dawn to await flocks of redheads and canvasbacks, their primary targets because of the quality and saleability of their meat. After taking down a sufficient number and watching until the bodies had drifted a safe distance away from their position, the gunners would call in assisting rowboats, which moved in to pick up the kills and cripples.

The ducks were sold either directly to local hotels and restaurants or, more commonly, to middlemen who supplied the markets in Baltimore, the nearest large city. Writing in *Duck Shooting Along the Atlantic Tidewater*, J. Kemp Bartlett recalled:

It was a familiar sight to see ducks hanging in the Baltimore markets and over the sidewalks on Camden Street in front of the stores of the commission merchants. The geese and swan were always picked except for the wings and neck. The ducks hung over the market stalls in Lexington and Richmond markets, and under them the terrapin would be displayed on their backs, slowly flapping their legs . . .

Quail were $3.00 a dozen. Canvasbacks were $3.00 to $4.00 a pair, redheads $2.00 and blackheads $1.00. The old unshaven man with his gunning sack of terrapin and his string of canvasbacks, standing on the corner of Calvert and Redwood streets, was a familiar sight to Baltimoreans. A list of his customers would include the most prominent bankers and businessmen in Baltimore. At the Rennert Hotel:

Canvasback duck	$3.00*
Redhead duck	2.50
Blackhead duck	1.50
Mallards	1.50

always appeared on the menu when they were in season. An order consisted of half a duck carved off the carcass, with the wing and leg attached, together with a large helping of hominy. If you asked for it, the carcass would be put in a press and the juices and gravy poured over the hominy. Of course, oysters from Lynnhaven and Mobjack Bay would precede the meal, and a good heady claret or port wine would accompany it. [* $3 in the 1880s was the equivalent of about $60 today, so these were not cheap meals by any measure.]

Deadly as the practice was, gunning from a battery retained at least an aspect of sport. Other methods used by some market hunters did not, crossing over the line from sport to out-and-out murder. Night gunning with a light was probably the most effective of all the techniques employed by Atlantic coast market gunners. In this variation of the fire-lighting technique first used by Native Americans and described by Audubon in connection with pigeons, a kerosene lamp was mounted on the front of a skiff and lit while the gunner paddled quietly toward rafts of birds feeding or sleeping on the water. The forward-facing light confused the birds and completely hid the gunner from his prey, allowing him to approach closely without driving the birds from the water before beginning to shoot.

The so-called big guns used for night shooting by some hunters on the Susquehanna Flats and Chesapeake Bay in the late nineteenth and early twentieth centuries were also deadly, but much more problematic than the use of a light. Also called punt guns, these were in effect small cannons, with bores as big as two inches across and capable of firing two pounds of shot into a raft of geese or ducks. They were never popular because they were dangerous and unpredictable, capable of capsizing a boat and throwing its occupant into icy water in the dark, and because the gunner also had to return to shore to reload after each shot. Many times, only one shot was taken in the course of a night and the gunner came back empty, but a single good shot was capable of killing thirty to as many as a hundred ducks at once.

In addition to ducks and geese, market gunners also targeted shorebirds of all kinds, especially the flavorful Eskimo curlew and American golden plover, which often flew together. Both were plentiful

until the 1870s, by which time overhunting, especially during spring migration through the Mississippi Valley and Great Plains, had severely reduced their numbers. Audubon reported on an 1821 golden plover shoot that shows the kind of pressure put on golden plover early in the century. He writes that he was invited by some French gunners in New Orleans

to witness the passage of thousands of these birds, which were coming from the Northeast and continuing their course. At the first appearance of the birds early in the morning, the gunners had assembled by parties of from 20 to 50 at different places, where they knew from experience that the plover would pass. There stationed, at nearly equal distances from each other, they were sitting on the ground. When a flock approached, every individual whistled in imitation of the plover's call note, on which the birds descended, wheeled, and passing within 40 or 50 yards, ran the gauntlet, as it were. . . . This sport was continued all day, and at sunset, when I left one of these lines of gunners, they seemed as intent on killing more as they were when I arrived. A man near the place where I was seated had killed 63 dozens. I calculated the number in the field at 200, and supposing each to have shot 20 dozen, 48,000 golden plovers would have fallen that day.

In his book *Game Birds, Wild-Fowl and Shore Birds of Massachusetts*, E. H. Forbush records "that about the last of August 1852, a tremendous flight of Gold Plover landed on the coast. They came over the hills in such numbers and so fast and low that any one who went there seemed in danger of being struck by birds in full flight. A three days' rainstorm was blowing. On the first day, the wind was northeast, the second day east and the third day southeast. The next day was Sunday, and on Monday the Boston market was so overstocked with birds that the marketmen would give only five cents apiece for them, and a Mr. Newell of Ispswich, a market hunter, gave up gunning for a time, because there was no sale for birds."

The numbers of birds killed by market hunters over the course of the nineteenth century is beyond reckoning. The tallies of birds and attendant monetary rewards go on and on, each one as incredible and appalling to modern sensibilities as the next. Daily takes of a hundred or more ducks, geese, or shorebirds were not uncommon, and markets all over the country seemed insatiable. Whatever the gunners could supply, they absorbed. Joel Barber recorded the story of Long Island market gunners Charles Hawkins and Wilburn R. Corwin, who took 640 ducks, most of them broadbills, on a single day in 1878. Hawkins did the gunning from a single battery, while Corwin tended him and picked up the dead and crippled. They shipped the birds to New York at twenty-five cents a pair, "F.O.B. Bellport," thus taking home a total of $80 for the day's work, the equivalent of about $1,600 today.

Barber also related the story of William Dobson of Havre de Grace, Maryland, reputed to have been "the fastest and most accurate shooting man the Chesapeake ever produced." The story

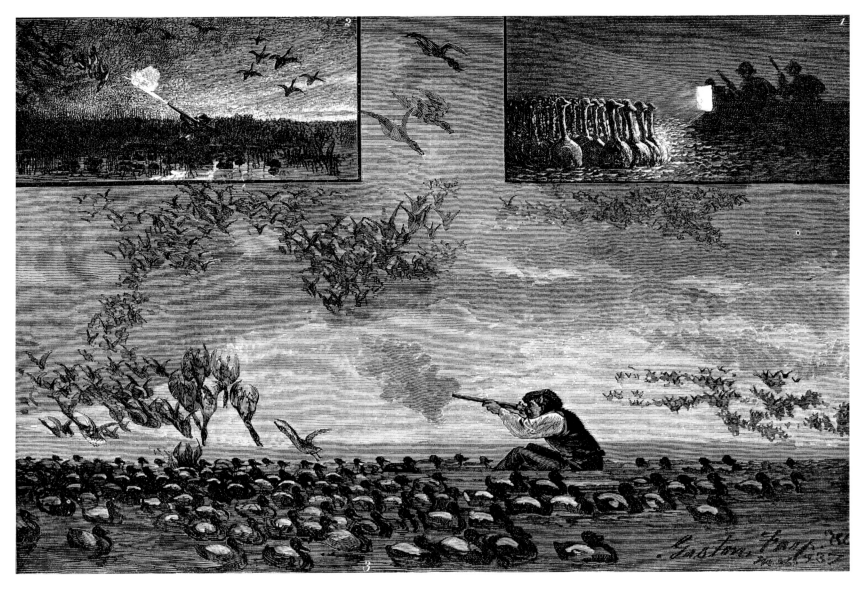

Wildfowl Massacres. **Line engraving after drawing by Gaston Fay. 1880.**
The deadly practice of night gunning with a light is illustrated at the upper right.

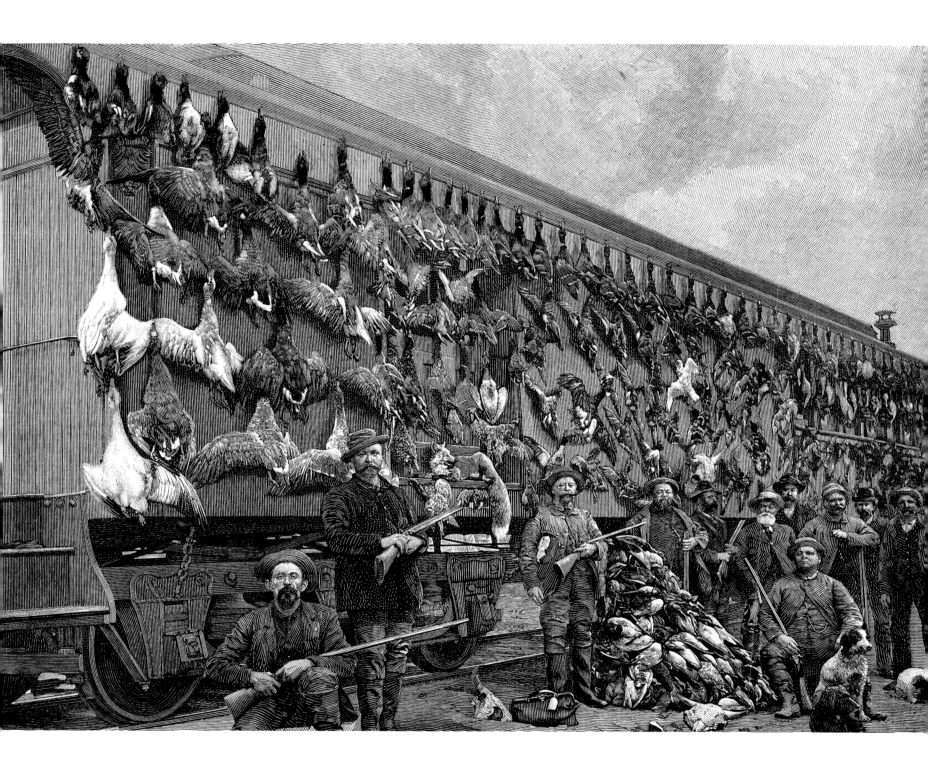

was told to him by another Havre de Grace gunner, Captain W. E. Moore, who had lost his lower right arm in a gunning accident in the 1870s but continued to work as a market hunter for decades afterward. "It happened right here, on the flats off Havre de Grace," Moore told Barber, "on the opening day of the season in 1879. Dobson killed over five hundred ducks—there is no question about it. He started out as usual shooting two guns, double breech loaders of ten gauge. During the early hours of the morning, one gun burst and was thrown overboard. Birds were coming in so steadily, there was no time to replace it. He continued shooting all day with the remaining gun, keeping it cool by frequent immersion in the bay. When results were tallied that evening, it was found that Mr. Dobson had shot five hundred and nine birds. About sixty Canvas-backs, the remainder Redheads."

OPPOSITE: *The Product of a Day's Sport near Webster, Dakota.* **Line engraving from a photograph by H. R. Farr. 1888.**
Eleven hunters, three dogs, and their appallingly enormous (to today's sensibilities) day's bag of birds and game hung on the side of a railroad caboose. Webster is in northeastern South Dakota.

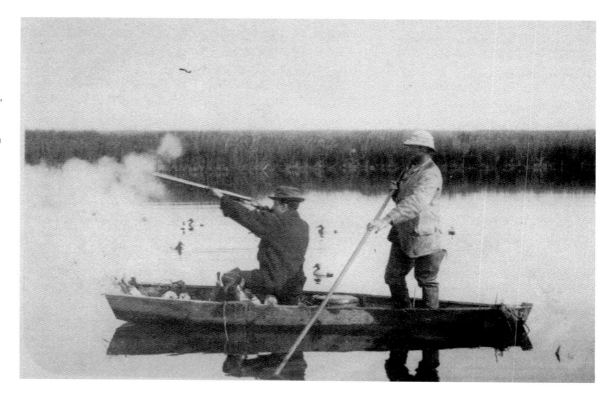

Duck Shooting, Cordelia Slough. The Bancroft Library. University of California, Berkeley. c. 1883.
A gentleman hunter and his guide on the Cordelia Slough, a waterway connected to Grizzly and Suisun Bays, about twenty-five miles south of Napa, California.

CHAPTER 10

The Sports:
Gunning for Pleasure

In the decades following the Civil War, America experienced an economic boom the likes of which the world had never seen before. The opening of the country brought immense wealth to a new class called "businessmen," a word invented in America in the 1830s to describe the entrepreneurs who were seizing the new country's wide-open opportunities. The American businessman was "a peculiarly American type of community maker and community leader," according to former librarian of Congress Daniel J. Boorstein. Writing in his book *The Americans: The National Experience*, Boorstein continues, "His startling belief was in the interfusing of public and private prosperity. Born of a social vagueness unknown in the Old World, he was a distinctive product of the New." Businessmen could literally build cities and shape entire communities, and everything that benefited the growth

of the brand-new cities that they fostered also benefited them. The robber barons of this so-called Gilded Age amassed wealth never before held by private individuals and enjoyed every luxury available to the de facto royalty that they were, including private railroad cars and lines, sprawling city mansions and summer "cottages" the size of modern-day hotels, servants of every stripe, and the best furniture, clothing, household goods, horses, carriages, and sporting equipment money could buy.

The railroads that they helped build made traveling to formerly remote areas possible, and they began to travel to prime fishing and hunting spots all over the United States and Canada. In the space of a day, affluent New Yorkers could board a train and find themselves on the Eastern Shore of Virginia or the Outer Banks of North Carolina, among the Thousand Islands on the Canadian border, at Shinnecock Bay or Montauk Point at the eastern tip of Long Island, or dozens of other choice destinations. When they found spots they particularly liked, they bought sizeable tracts of prime hunting land, either privately or communally, formed clubs, and built substantial lodges where they could stay and be ministered to while they pursued local game and fish. Between 1870 and 1920, northern businessmen established more than a hundred clubs and lodges on Virginia's Back Bay and Eastern Shore and North Carolina's Currituck Sound alone. Long Island's most exclusive club, the Southside Sportsmen's Club, owned more than 2,300 acres of land and leased another 1,100; its members included William K. Vanderbilt, Pierre Lorillard, Charles L. Tiffany, and Hugh D. Auchincloss. North Carolina was home to the Currituck Shooting Club, the Narrows Island Club, and the Carteret Rod and Gun Club. The Cobb family held forth on its eponymous island off the Eastern Shore of Virginia, while Maryland boasted the Carroll Island Gun Club, home of the legendary Chesapeake Bay retriever. In Ontario, there were the Long Point and St. Clair Flats shooting clubs, and in Illinois, the Senachwine Club and the Princeton Fish and Game Club, to name just a few.

SNACHWINE LAKE.

This famous duck and geese and shooting resort can be reached via PUTNAM STATION, on the PEORIA DIVISION of the

CHICAGO, ROCK ISLAND & PACIFIC R. R.,

122 miles from CHICAGO. There is no place so easy of access, and within a reasonable distance of Chicago that affords such excellent duck and geese shooting as SNACHWINE LAKE. There is a good hotel on the grounds, with ample accommodations for sportsmen. A full supply of Decoys and boats are always available, and to be had on reasonable terms.

Two trains leave Chicago daily for SNACHWINE LAKE by

THE GREAT ROCK ISLAND ROUTE!

WITH ITS OWN TRACK BETWEEN

Chicago, Minneapolis and St. Paul, Kansas City, Leavenworth, Atchison, Council Bluffs & Omaha,

Chicago, Rock Island & Pacific Railroad advertisement. c. 1880. In the late nineteenth and early twentieth centuries, railroads provided special service to hunting resorts all over the United States and Canada. Senachwine Lake (the correct spelling) in Illinois was a major destination for Midwestern sportsmen.

An 1881 advertisement for one of these haunts, the Atlantic Hotel on Chincoteague Island, suggests the many pleasures that awaited visiting sportsmen:

The undersigned beg leave to inform their friends and the general public that they have leased and refurbished the above elegant and commodious house, and are now prepared to accommodate permanent and transient guests in first-class style.

Large, airy rooms. Home comforts. Fine Sea and Bay fishing, gunning, and bathing, etc. The table is provided with wild fowl, terrapin, fish, oysters, crabs, and all the luxuries of the season.

Pleasure boats of all kinds, guides, fishing lines, decoys, ponies, etc., always ready for the use of guests.

First-class Bar attached. Choice wines, liquors, ales, beers, and cigars.

Passengers for Chincoteague connect with Steamer for the Island at Franklin City, the terminus of the Worcester Railroad, morning and evening. Connections may also be made daily at Nashville. All who visit the Atlantic may rest assured that they will receive courteous treatment and excellent fare.

Your patronage is respectfully solicited.

W.J MATTHEWS & Co.

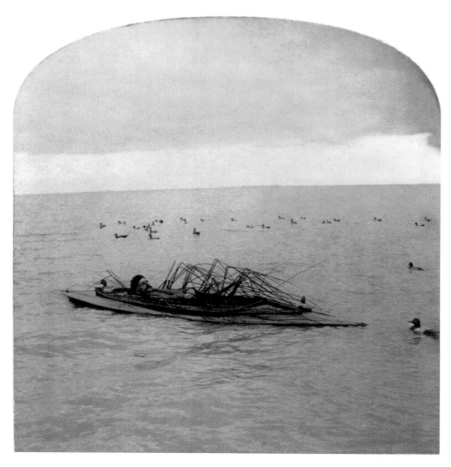

Decoying Wild Ducks—Lying Low—A Flock Coming. Stereograph. c. 1890.

The locals who built the lodges and worked for the big-city hunters as caretakers, drivers, cooks, and guides called them "sports," because they fished and shot only for sport, for the pleasure of the hunt, not for sustenance. This was a new concept, a romanticized amalgam of the privilege of English aristocracy and the fierce individualism of American frontiersmen perhaps best exemplified by Theodore Roosevelt (1858–1919), whose life and accomplishments spanned the great age of American sport hunting. Like Roosevelt, many gentlemen sport hunters considered themselves naturalists who also liked to shoot and ultimately became involved in the Conservation Movement. They fostered ethical hunting rules, promoted laws that protected game from abuse and overhunting, and worked to protect wilderness from development. They were motivated by both self-interest and noblesse oblige; the charters of the exclusive gunning clubs they founded make it clear that they were created to protect and preserve wild game birds at the same time they provided recreation for their members. But many of the actions and efforts of the clubs and their members were to prove critical to the survival of American wildfowl in the late nineteenth and early twentieth centuries.

The sports had little use for commercial market gunners, whose practices they deemed uncouth and harmful to their own interests as well as those of the birds they pursued. "The legitimate sportsmen

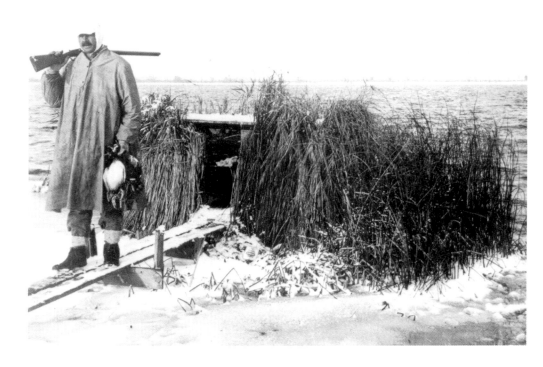

Returning to Camp to Thaw Out—A Winter Day's Duck Hunt. **Stereograph. c. 1906. North Bennington, Vermont. Courtesy H.C. White Co.** Even for a well-equipped sportsman, duck hunting was not without its hardships.

upon the Potomac are much annoyed by pot hunters," wrote Charles Hallock in his 1877 *Sportsman's Gazeteer and General Guide*, "who, with swivel cannons and from batteries, slaughter great numbers of ducks when the first arrive and render the survivors so wild that it is quite impossible to get near enough to shoot at them with a shoulder gun. Since the laws in reference to these engines of destruction have been so rigidly enforced on the Chesapeake, many of the market hunters from there have come to the Potomac, where they make great havoc among the birds." As the nineteenth century wore on, many prominent sportsmen, appalled by what they saw as unsportsmanlike slaughter that was seriously affecting bird populations, became advocates of conservation and helped turn public opinion and legislative efforts against the market hunters.

No matter one's wealth or social status, wildfowl hunting posed numerous challenges. In *American Duck Shooting*, George Bird Grinnell proposed,

> If it be true, as has often been said, that the enjoyment taken in any sport is proportioned to its difficulties and hardships, then we may readily comprehend why wildfowl shooting is popular. . . . As the finest weather for duck shooting is what is usually denominated foul weather—that is windy, cloudy, or rainy, often with snow squalls and a temperature so low that ice forms—the gunner must always go prepared to suffer some discomfort. If his shooting is done from a boat and in a place where

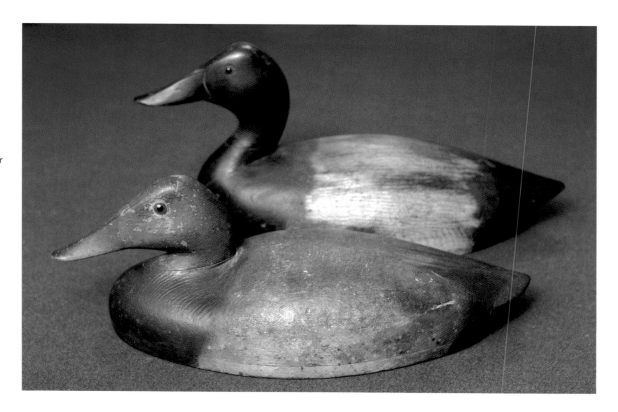

TOP: *Canvasback Drake.* **Thomas Chambers. c. 1910. Wallaceburg, Ontario.** BOTTOM: *Canvasback Hen.* **George and James Warin. c. 1880. Toronto, Ontario. The Malcomb Family Collection.** The Chambers decoy was originally used at the St. Clair Flats Shooting Company (Canada Club) and is branded "Geo. Hendrie," for George Hendrie, who was a club member from 1889 to 1943. The Warin was originally used at the Long Point Company and bears three brands: "E.H." for Edward Harris, who was a club member from 1877 to 1896; "A. Cochrane," for Cochrane, who was a club member from 1902 to 1915; and "G. & J. Warin, Builders, Toronto."

the wind has any sweep, he is sure to get wet and may even be swamped; or if it happens that he guns in a locality where there are wide flats which may be overlaid by a skim of ice, too thick to be pushed through with a boat, yet hardly strong enough to bear one's weight, there is danger of a wetting if not of something worse; for the mud is deep and sticky, and he who is once mired in it will escape only with difficulty and discomfort.

No wonder an old joke likens the sport to taking a cold shower with one's clothes on at 4 a.m., all the while tearing up $20 bills.

In addition to ducks, the sports gunned for geese, brunt, rail, snipe, pheasant, doves, pigeons, quail, woodcock, and shorebirds, and they used a variety of techniques to bag their chosen prey. Except in the case of driven birds like pheasant and quail, decoys were part of their equipment, and they bought from and commissioned work by the best local carvers and mail-order houses. It was the sports who sustained the Mason Decoy Factory's top Premier and Challenge grades and for whom Harvey and George Stevens made their high-quality decoys in the last decades of the nineteenth century. Sportsmen also were the main clients of such highly skilled professional carvers as the Warin brothers in Toronto, Thomas Chambers on Ontario's Lake St. Clair, Robert and Catherine Elliston in Illinois, Elmer Crowell and Joe Lincoln in Massachusetts, Obediah Verity on Long

Island, Harry Shourds in New Jersey, the Ward brothers and the Holly family in Maryland, and Charles Birch and Nathan Cobb Jr. in Virginia. The sports took decoys wherever they gunned; Mason decoys in particular have been found all over the United States and Canada. James Holly made decoys for several prominent members of the Currituck Club in North Carolina; the Ellistons apparently sold decoys to hunters in Wisconsin, Minnesota, and even Massachusetts; and rigs of Wards and Crowells were gunned over at clubs in California.

Many sportsmen developed long-lasting relationships with particular carvers and were instrumental in supporting their work after market hunting was legislated out of existence. Tom Chambers, for example, managed the St. Clair Flats Shooting Company for forty years, and three generations of the Reeves family carved decoys for members of the Long Point Shooting Club on Lake Erie. Huck Caines worked for financier and diplomat Bernard Baruch at his massive Hobcaw Barony estate in South Carolina. Elmer Crowell carved his earliest and most highly regarded decoys for patrons like Drs. John C. Phillips and John H. Cunningham. Phillips, an independently wealthy sportsman and conservationist who was later to write the four-volume study *A Natural History of the Ducks*, employed Crowell as the caretaker of his property on Wenham Lake in Beverly, Massachusetts, from 1900 to 1910 and continued to buy carvings from him into the 1930s. Another of Crowell's early patrons and employers, Charles Ashley Hardy, helped provide the capital that allowed Crowell to open his own full-time carving shop not long after he left Phillips's employment.

While most of the clubs focused on geese, brant, and ducks, shorebirds were also popular targets of late nineteenth-century sportsmen. They were most common in the late summer and early fall, when geese and ducks were still breeding in the north, and shooting them was a piece of cake, requiring little of the stealth and physical hardship of duck hunting. Gunning at the beach on a late summer or early fall morning was a far cry from crouching in a blind or boat along a frigid marsh, and all the hunter needed was a shotgun, ammunition, and a few decoys, which were small, light, and easy to carry. If he was not proficient at imitating the cries of shorebirds, he might also carry a tin shorebird whistle or two, which did the job better than most gunners could.

Charles Hallock described the methods and pleasures of bay shooting for shorebirds, a sport that, as he reported, "is much enjoyed by many, and with us of the Eastern coasts it has the additional

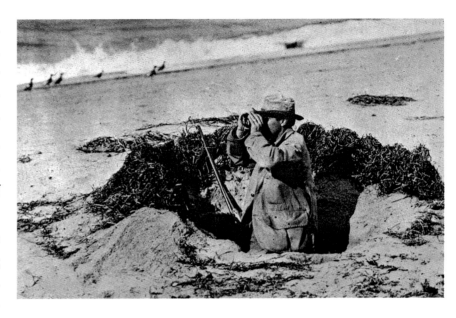

Dr. John C. Phillips Hunting Shorebirds. Probably Cape Cod. c. 1900. Photograph courtesy Guyette & Schmidt, Inc.
Phillips, Elmer Crowell's major patron, gunned over some of the most extraordinary decoys ever made. Several are included in this book.

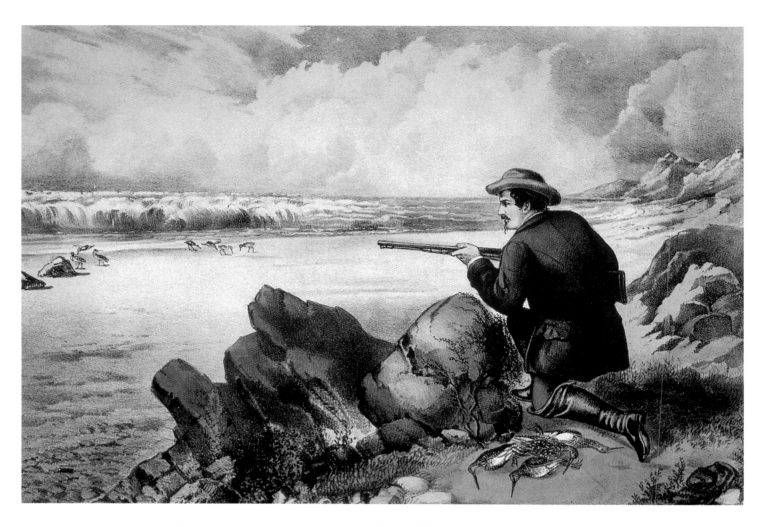

Shooting on the Beach. Hand-colored lithograph. Published by Currier & Ives. c. 1870. New York.

"By many sportsmen, shore bird shooting has been termed a lazy man's pastime, but an experienced shore bird shooter knows that . . . the man who would secure a good bag of them must be not only constantly upon the alert, but unusually quick of eye, and a more than ordinarily good wing shot." From "Shore Bird Shooting" by Walter Drew, published in *The Sportsman's Magazine*, October 1896.

advantage of being so convenient and accessible from the city, that any business men can easily and at short notice reach the shooting ground, where circumstances prohibit a long sojourn from the city." He then proceeds to offer the following advice to the would-be "snipe" hunter:

There are but a few methods employed in the pursuit of these birds, as the habits of most of the species are identical . . . The best feeding grounds are Pelican Bar, South Bay; Egg Harbor, Montauk Point, Forked River near Barnegat, several promontories near Stonington, Conn., Currituck Inlet, N. C., and Cobb's Island on the eastern shore of Virginia. At the two latter named places, shooting commences early in September, and at the former early in August. To one contemplating a visit to any of these resorts, with the view of enjoying Bay bird shooting, we would give the following advice: If possible, go out very early in the morning on a high flood tide, taking care to select a long narrow sand-bar that is not covered at high-water, and one that juts out from the mainland; gather some dry drift-wood and build a small blind, scooping out the sand. You can then put out a few stools about twenty-five yards from the blinds on the edge of high-water, and commence to imitate the whistle of any bay bird with

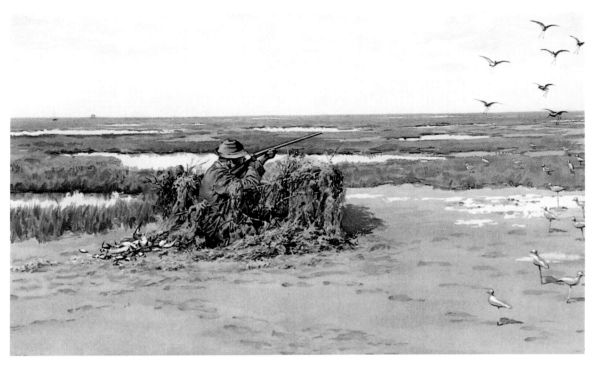

Bay Snipe Shooting.
Arthur Burdette Frost.
Chromolithograph by
Armstrong & Co., Boston.
Published in *Shooting*
***Pictures*. New York: Charles**
Scribner & Sons, 1895.
"Shore birds, with the
exception of the smaller
varieties, almost invariably
follow the water line; it is
good usage, therefore, to
take one's position in the box
perhaps an hour before the
flood tide commences, and
the water rising, forces the
birds shoreward as they feed
on the edge of the incoming
tide. When the water has
reached the box it is then
advisable for the gunner to
take in his decoys and retreat
to his blind, which may
be from 100 to 200 yards
further shoreward and at the
edge of the sand dunes up
to which the water reaches
at the highest point of the
tide. Here he enjoys excellent
shooting, while the high tide
lasts, and even for an hour
afterward, as it recedes."
From "Shore Bird Shooting"
by Walter Drew, published in
The Sportsman's Magazine,
October 1896.

whose note you have become familiar; if the wind should be blowing on shore and the tide likely to be very high, the sand-bars will be all covered and the birds, having no place to alight, fly backwards and forwards across this point waiting for the tide to recede. Never pick up the wing-tipped birds, as they act as decoys; they flutter their wings, uttering shrill whistles, and bring down hundreds of others to see "what is the matter." As the flocks wheel around over the stools and at the instant when during one of their circlings, they show their white bellies, is the time to touch the trigger. You may then secure a dozen birds at a single discharge. Whistling down certain kinds of beach birds to decoys is practiced successfully by old gunners who are adepts in this art. Novices had better trust to their decoys. Another plan is to sail leisurely down on the birds as they are feeding on the bars; but if there are any Curlew there, it is necessary to remain perfectly still and hide yourself. The slightest oversight on the part of the sportsman to observe these laws will cause the Curlew instantly to give the alarm and your sport is nil. With everything in your favor, tides, wind, slightly foggy weather, the shooting of Curlew is generally at long range. Now and then you may get a shot at them as they fly over at forty yards or so. Your clothes should be of a marsh-grass, or sedge color. Always have the barrels of your gun well "browned"; use a ten-bore, four and a half drachms of powder, and one and a quarter ounces of No. 7 shot, a pair of long rubber boots and a light rubber blanket. For the smaller bay snipe you can use No. 10 shot and upwards, according to their size. For Plover, if you have a fine retrieving spaniel, he will be of service.

By these methods are shot Willets, Large and Small Yellow-legs, Dowitchers, Killdeer, Robin-snipe, Turnstones and very many of the smaller Sand-pipers and Plover.

CHAPTER 11

The Feather Hunters:
Birds for the Millinery Trade

I n 1886, Dr. Frank Chapman, an ornithologist at the American Museum of Natural History and a conservationist, went birding in New York City. He spotted more than three dozen species, including herons, terns, shorebirds, a wide variety of songbirds, a prairie chicken, and an owl. What he was looking for and found were not live birds, however, but dead ones, like the mounts and skins he worked with at the museum. And they were all to be found on the women's hats he saw as he strolled the streets of Manhattan, the heart of fashionable society.

Chapman sent his findings to George Bird Grinnell, the editor of *Forest and Stream* magazine, noting:

In view of the fact that the destruction of birds for millinery purposes is at present attracting general attention, the appended list of native birds seen on hats worn by ladies in the streets of New York, may be of interest. It is chiefly the result of two late afternoon walks through the uptown shopping districts, and, while very incomplete, still gives an idea of the species destroyed and the relative numbers of each.

Robin, four.

Brown thrush, one.

Bluebird, three.

Blackburnion warbler, one.

Blackpoll warbler, three.

Wilson's black-capped flycatcher, three.

Scarlet tanager, three.

White-bellied swallow, one.

Bohemian waxwing, one.

Waxwing, twenty-three.

Great northern shrike, one.

Pine grosbeak, one.

Snow bunting, fifteen.

Tree sparrow, two.

White-throated sparrow, one.

Bobolink, one.

Meadow lark, two.

Baltimore oriole, nine.

Purple grackle, five.

Bluejay, five.

Swallow-tailed flycatcher, one.

Kingbird, one.

Kingfisher, one.

Pileated woodpecker, one.

Red-headed woodpecker, two.

Golden-winged woodpecker, twenty-one.

Acadian owl, one.

Carolina dove, one.

Pinnated grouse, one.

Ruffed grouse, two.

Quail, sixteen.

Helmet quail, two.

Sanderling, five.

Big yellowlegs, one.

Green heron, one.

Virginia rail, one.

Laughing gull, one.

Common tern, twenty-one.

Black tern, one.

Grebe, seven.

It is evident that, in proportion to the number of hats seen, the list of birds given is very small; but in most cases mutilation rendered identification impossible. Thus, while one afternoon 700 hats were counted and on them but 20 birds recognized, 543 were decorated (?) with feathers of some kind. Of the 158 remaining, 72 were worn by young or middle aged ladies and 86 by ladies in mourning or elderly ladies, or—

Percentage of hats with feathers..........................77

Without feathers...10

Without feathers, worn by ladies in
mourning or elderly ladies...................................12

As Chapman's survey suggests, feathers were everywhere in late Victorian America, and many of them were not attached to their original owners. Lavishly ornamented hats were the height of fashion, and the bigger and more extravagant, the better. Beginning soon after the end of Civil War, milliners on both sides of the Atlantic tried to outdo one another each year, creating hats piled high with velvet, silk, taffeta, fur, the tails and heads of mink and other small mammals, and dried fruits

The Millinery Trade Review — New York

Jane Hading

Baronne de Carlsberg

Suzanne

ABOVE: **Young woman modeling feathered hat. Photograph by Fritz W. Guerin. c. 1900.**

Fashion Plate from the *Millinery Trade Review*. 1897. New York.
Colorful feathers, flowers, and fruit adorn these stylish hats designed in Madame Carlier's Paris establishment and worn by actresses at the Théâtre du Gymnase. The *Millinery Trade Review* instructed American milliners in how to create these Parisian concoctions in their own shops.

RIGHT: **Advertisement for women's feathered hats. *Harper's Bazaar*. 1880.**

and flowers. Feathers were the most coveted of all ornaments, and by the end of the century milliners were using feathers, wings, tails, heads, and even whole bodies of more than sixty species, exotic and mundane, wild and cultivated, in their work.

Although there were ranches in the United States that raised ostriches, peacocks, and other species capable of domestication, the vast majority of the feathers came from the killing of wild birds. To counter this attack, the millinery trade put out propaganda claiming that the feathers used were merely shed cast-offs and that no birds were harmed in their gathering. The reality, however, was quite different. The same year that Chapman tallied his findings, the nascent Audubon Society estimated that five million wild birds were being killed each year for their feathers. Tens of thousands more were being mounted by taxidermists for use in grouped displays exhibited under glass domes, or, in the case of larger birds, as single specimens, all offered to the public as part of the hugely popular movement to bring nature into the home.

It was a great age of interest, exploration, and exploitation of the natural world, and seemingly everyone wanted a piece of the discoveries for themselves. Natural history museums and zoos, which packaged and presented nature to city dwellers, were founded and prospered: the American Museum of Natural History was founded in New York in 1869, and the Bronx Zoo opened its doors in 1899. Natural history supply houses offered feathers, skins, mounts, and eggs to ornithologists and collectors. (One such dealer, Charles K. Reed in Worchester, Massachusetts, advertised that he sold "Instruments and Supplies for Ornithologists, Oologists, Entomologists, Botanists, Mineralogists, and Taxidermists. Also Bird's Skins, Bird's Eggs, Minerals, Shells and Curiosities.") Millinery suppliers dispensed a wide array of feathers in their catalogs, and a woman could buy a pair of gull's wings for her hat at Macy's department store in Manhattan, for which the store had paid a gunner eleven cents.

Feathers and mounted birds were big business, and, like every business, the trade employed its own set of suppliers. The men who did the killing were highly specialized hunters whose output peaked in the last quarter of the nineteenth century and continued until federal legislation put an end to it in 1918. Theirs was a ruthless business that often involved plundering the nesting colonies of herons, egrets, terns, and other desirable species, killing adult birds on the nest, and leaving the nestlings to fend for themselves. While a few survived, many, of course, simply starved.

The plumes most esteemed by the millinery trade and the fashionable women it serviced were part of the breeding plumage of snowy egrets and the white morph of the great blue heron. The Everglades, where the largest nesting colonies of herons and egrets were to be found, was besieged by hunters, including native Seminole Indians who knew the area and birds best and were lured into the trade by the prospect of ready cash. Feather hunting provided windfalls to professional gunners. Just after the turn of the century, millinery suppliers were paying $32 an ounce for fancy egret plumes, nearly twice

Head and shoulders of model wearing "Chanticleer" hat of bird feathers. c. 1912.

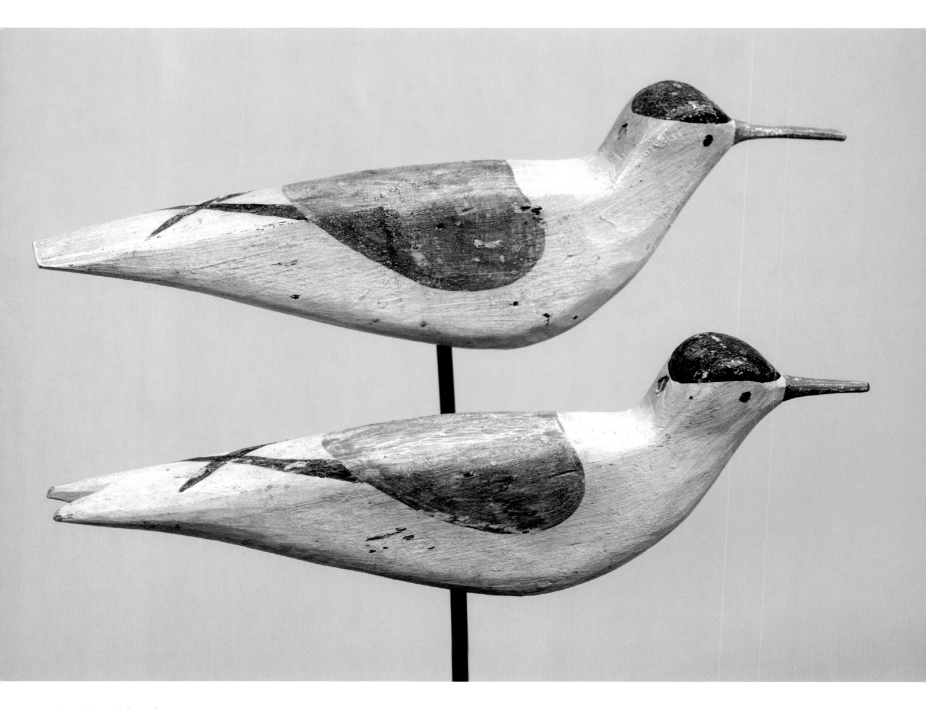

Least Terns. **Maker unknown.**
c. 1880. Long Island. Courtesy
Collectable Old Decoys.
These simple decoys were
used by feather hunters on
Long Island.

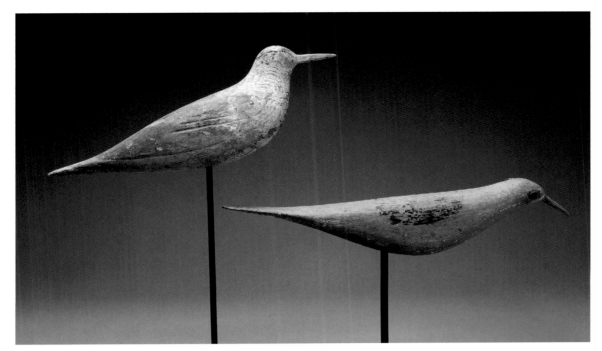

the price of gold at the time, and prices climbed as high as $80 an ounce as the birds became scarce from overhunting. Hundreds of thousands were killed annually; according to one report, more than a million egret skins from the Everglades were sold at auction in London between 1897 and 1911.

Terns and gulls of all kinds were hunted on Long Island. Bayman and former market gunner Nelson Verity recalled that two gunners killed six hundred terns in a single day, and a 1900 issue of *The Auk*, the journal of the American Ornithologists' Union, reported that Long Island baymen had made more money the previous winter selling birds to Wilson's millinery supply in Wantagh, the nation's largest supplier to the millinery trade, than they had by their normal pursuits of fishing and oystering. It was hardly a surprise then that the little birds had become scarce on Long Island's south shore by the end of the nineteenth century.

Wilson's employed fifty workers who prepared birds for sale. When the factory burned down late in 1899, it was reported that the inventory included

> 10,000 stuffed sea gulls, 20,000 wings of various other birds, 10,000 heads of birds representing many varieties, from the beautiful plumaged birds of the South to the plain Long Island Crow.
> The resources of the establishment had been severely taxed during the past year to provide long wings and single feathers, and a number of special gunners were sent out to provide a supply of those birds that would meet the demand. [In addition to the aforementioned Long Island baymen], the establishment had men stationed on Cape Cod, the islands off the coast of Maine, the shores of Virginia and on the Florida coasts. These men were kept busy filling special orders for certain varieties of birds in those localities.

AMERICAN ORNITHOLOGISTS
OTTAWA CANADA. OCT 13ᵗʰ 19

CHAPTER 12

The Conservation Movement

It was the highly visible excesses of the feather trade that launched the Conservation Movement in the 1870s and '80s. Massachusetts had led the way by creating the first state game department in 1865. Under pressure from sportsmen, Arkansas passed the first law banning commercial hunting of waterfowl in 1875. Similar laws were passed in Florida and other states in the 1870s, but they were ahead of their time and proved impossible to enforce because public and political will was not yet behind them. The American Ornithologists' Union, the first American organization devoted to the scientific study of birds, was formed in 1883, and its publication, *The Auk*, became a powerful voice of the Conservation Movement.

The key mover and shaker in the early Conservation Movement was George Bird Grinnell, the owner and influential editor of *Forest and Stream* magazine, the most widely read of more than thirty

outdoor journals of the age. As a young man, Grinnell had traveled and hunted widely in the West and had witnessed the decimation of the buffalo and passenger pigeon. He published numerous editorials in the early 1880s championing the urgent need for conservation. Grinnell was instrumental in the fight to save Yellowstone, which had become the first national park in 1872. He also helped protect the remnants of the once-immense northern buffalo herd and advocated for the preservation of the Adirondacks and better management of the nation's forests. His audience grew to the point that in 1886 he launched a sister publication for birders. Grinnell, who had attended Lucy Audubon's day school and was a great admirer of her late husband's art and writings, called it *Audubon Magazine*. The magazine proved so successful that Grinnell had to shut it down in 1888 because he simply could not keep up with the demands of both publications, but the idea he had fostered would in the next decade blossom into a national movement.

In 1887, Theodore Roosevelt, who had brought his first book to Grinnell a few years earlier, founded the highly exclusive Boone and Crockett Club, named for two of America's greatest frontier heroes. Limited to one hundred members, the founders included Grinnell, General William Tecumseh Sherman, and Gifford Pinchot, who later would become the first chief of the United States Forest Service. The club's intention was to create a coalition of powerful, dedicated conservationists and sportsmen who would provide leadership to the budding Conservation Movement, and its Fair Chase statement was the first document outlining a code of conduct and ethics for sportsmen.

Somewhat ironically, women, the primary consumers of the wares of the feather hunters, were among the leaders in bringing attention to the plight of the millions of wild birds that were being killed annually for use by the millinery trade. Women crusaded for many just causes in the late 1800s and early 1900s, including temperance and suffrage, so conservation was a natural for many of them. Writing in the journal *Birds and Nature* in November 1900, Lynda Jones put the case this way:

> There is but one way to stop this work of extermination, and that is to take away the demand. This remedy lies wholly in the hands of women. Unless they are willing to take a firm stand against the use of feathers for purposes of ornament, the birds are doomed. This may seem like a strong statement, but a little reflection will prove it true. When the birds which are now hunted for

ABOVE: **Theodore Roosevelt and John Muir on Glacier Point, Yosemite Valley. 1906.** Roosevelt and Muir were the two most powerful voices of the Conservation Movement in the early 1900s. Muir convinced Roosevelt of the urgent need to protect Yosemite and other natural wonders by bringing them into the fledgling national park system.

George Bird Grinnell. Photograph by William Notman. c. 1880–1900. Grinnell was both an avid hunter and a passionate conservationist and among the first men who, rightly so, saw no contradiction between the two.

plumes and feathers are gone, there will be a modification of the demand to include birds of different plumage, just as the aigrette is giving place to the quill. After the quill and the long-pointed wing will come the shorter wing, and after that the plumage of the small birds, and the cycle of destruction will be complete. . . . It should not be an impossible task to stop this whole cruel business. But laws will not do it without a wholesome public sentiment behind it. Women are notably foremost in all good works, and many of them are doing nobly in this work, but it is painfully evident that many are not. Let us make "a long pull and a strong pull and a pull all together," and then we shall drag this growing evil back and down forever.

Women came to the forefront of the Conservation Movement in 1896, when Boston socialite Harriet Hemenway read about the destructive practices of the feather trade and immediately determined to do whatever she could to stop the slaughter. Realizing that her social peers would be the best allies she could find, she initiated a series of educational teas for upper-class Boston women, at which she asked them to renounce the wearing of feathered hats and join a new society for the protection of native birds.

Birds and Bonnets—The Slaughter of the Innocents. Line engraving. 1886. Beginning in the 1880s, many American women grew sensitive to the destruction that their choices in fashion were wreaking and became important voices in the budding conservation movement.

She called the group the Massachusetts Audubon Society, and it became a model quickly followed by a number of other states, including New York, where Grinnell and Roosevelt were among the original members.

Progress continued apace as support for conservation and protection of wild birds grew. In 1900, Congress passed the Lacey Act, named for its sponsor, Iowa congressman John F. Lacey, which prohibited interstate transport of animals killed or captured in violation of individual state game laws. That same year, ornithologist Frank Chapman, who had counted birds on women's hats in 1886 and launched the publication *Bird Lore* in 1899, proposed that traditional Christmas hunts be replaced with

an annual Christmas bird count, an activity that has continued to the present day. In 1903, President Theodore Roosevelt created the first National Wildlife Refuge on Florida's Pelican Island, one of more than fifty bird refuges he would designate with the support of financing from state Audubon societies. The National Association of Audubon Societies for the Protection of Wild Birds and Animals was incorporated in New York State in 1905.

That same year, however, one of the first Audubon wardens was murdered by poachers who were hunting egrets in Florida, and another warden was killed in 1908. Although the perpetrators were never caught, the deaths received widespread press coverage and further enraged an already aware and vigilant public. In 1911 the New York state legislature enacted the Audubon Plumage Law, prohibiting the sale or possession of feathers from native bird species and effectively putting the millinery trade's feather hunters out of business in the state.

While the Lacey Act provided the first federal help in the battle against the ongoing slaughter of America's wild birds, it was not well funded and proved inadequate to stop the entrenched

Snowy Egret. Hand-colored engraving by Robert Havell Jr. after John James Audubon for *The Birds of America*. 1827–38. London.

Egret plumes were among the most highly sought of all bird feathers, and protection of egret nesting colonies was a priority of early conservationists.

interests of commercial hunting. Congressmen John Weeks of Massachusetts and Dan Anthony of Kansas worked with Senator George McLean of Connecticut to push through a stronger bill, and in 1913, they succeeded. Basing its authority on the government's right to control interstate commerce, the Weeks-McLean Act pronounced, "All wild geese, wild swans, brunt, wild ducks, snipe, plover, woodcock, rail, wild pigeons, and all other migratory game and insectivorous birds which in their northern and southern migrations pass through or do not remain permanently the entire year within the borders of any State or Territory, shall hereafter be deemed to be within the custody and protection of the Government of the United States, and shall not be destroyed or taken contrary to regulations hereinafter provided therefor." Migratory birds were now under the aegis of the federal government and protected throughout the United States.

In 1916, Congress approved the creation of the National Park Service, and the United States entered into a convention for the protection of migratory birds with Great Britain, acting on behalf of Canada, which extended the Weeks-McLean Act's reach and power across the international border. The Federal Migratory Bird Act of 1918 implemented the treaty and established a federal prohibition, unless permitted by regulations, to "pursue, hunt, take, capture, kill, attempt to take, capture or kill, possess, offer for sale, sell, offer to purchase, purchase, deliver for shipment, ship, cause to be shipped, deliver for transportation, transport, cause to be transported, carry, or cause to be carried by any means whatever, receive for shipment, transportation or carriage, or export, at any time, or in any manner, any migratory bird, included in the terms of this Convention . . . for the protection of migratory birds . . . or any part, nest, or egg of any such bird."

The Federal Migratory Bird Act put the final nail in the coffin of the remaining commercial market and feather hunters. It came too late for the great auk, the Carolina parakeet, the Labrador duck, and the passenger pigeon, but it saved a number of other threatened species from similar fates. Led by an unlikely coalition of concerned sportsmen and socially conscious women, the Conservation Movement changed North American attitudes toward wild game and land stewardship forever and fostered management practices that still resonate. The passion they felt for American birds transformed their attitudes toward the wild, and their respect for the sanctity of nature and wildfowl ultimately put an end to an era of profligate waste, destruction, and slaughter.

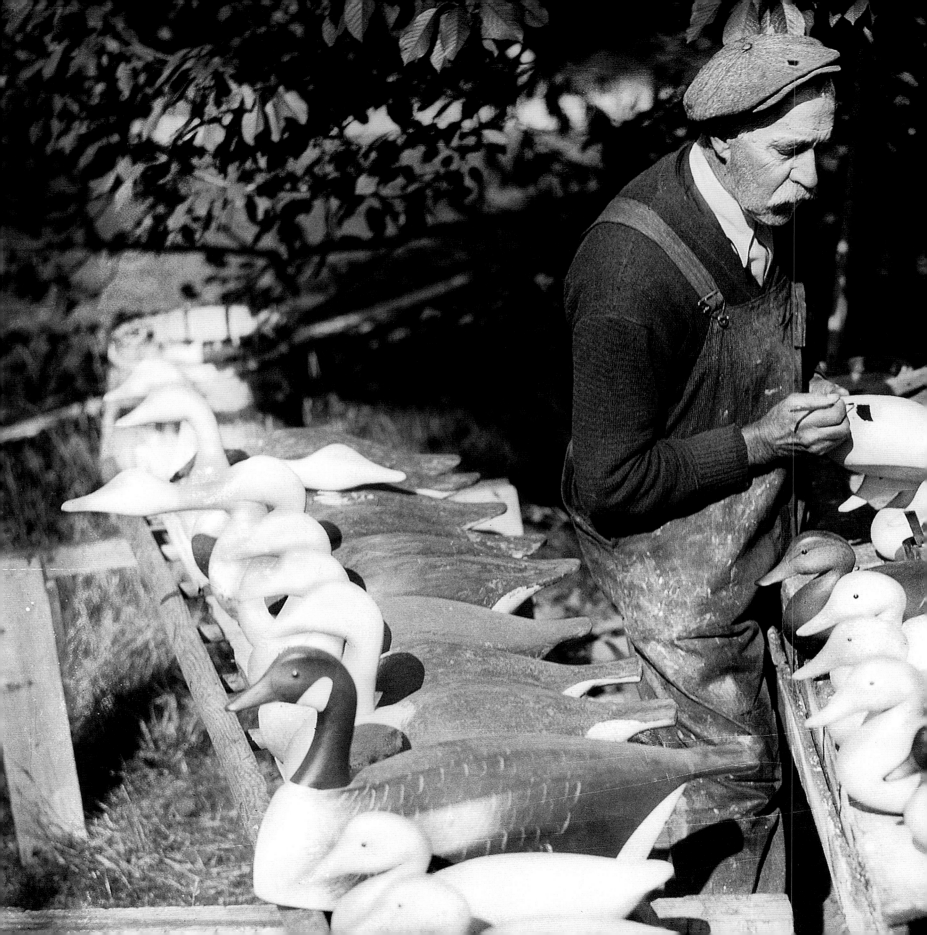

The Hunting Regions and Carvers

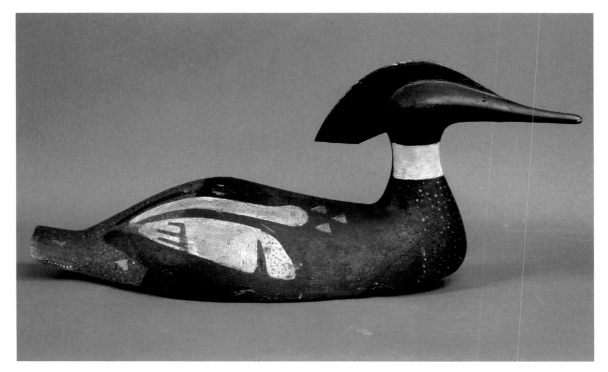

CHAPTER 13

Down East:
Maine and the Canadian Maritimes

The rugged and mostly rockbound coasts of Nova Scotia and northern Maine elicited a wide range of decoy forms, primarily representing the common cold-water sea ducks of the region, including eiders, scoters, red-breasted mergansers, and long-tailed ducks, which were until recently called oldsquaws. The entire region is referred to as Down East because it juts farther east into the Atlantic than any other part of North America. The designation "Down East" in Maine arose because ships sailing from Boston northeast to ports in Maine had the wind at their backs; they were sailing downwind, hence Down East.

The region also is home to the widest fluctuations in tide on the planet. The difference between high and low tide in the Bay of Fundy on Nova Scotia's north coast can be more than fifty feet, with the sea returning at a foot a minute, and the scouring seas have created a host of deep-water harbors

from midcoastal Maine north across Nova Scotia. Nova Scotia has more than 4,750 miles of coastline, while Maine's mainland coast extends 3,500 miles with another 5,000 miles of coast around its myriad islands, many of which have been inhabited year-round for hundreds of years.

Almost all hunting in Nova Scotia was done on the south side of the peninsula, especially in bays southwest of Halifax, the capital city, an area called the South Shore. Unlike Maine and Prince Edward Island, Nova Scotia's soil is poor for farming, and residents depended almost exclusively on the sea for both work and sustenance. Most were poor, and they readily ate loons, mergansers, oldsquaws, and other fishy-tasting sea birds with evident relish. Since the part of the south shore where most hunting was done was settled by German immigrants, it has been suggested that their cuisine may have given them the wherewithal to mask rank-tasting meat with spices. But their poverty and lack of culinary choices undoubtedly tipped the balance in favor of the birds most readily at hand.

In marked contrast to Maine and Nova Scotia, Prince Edward Island, a 120-mile-long, crescent-shaped island north of Nova Scotia and New Brunswick, is rolling pastoral land bordered by sand beaches, salt marshes, and sandstone cliffs. The north shore of the island is warmed by the Gulf Stream, and a number of bays there, most notably Malpeque Bay, are sheltered from the Atlantic by barriers of sand hills. Huge numbers of geese and brant frequented the north shore of Prince Edward Island

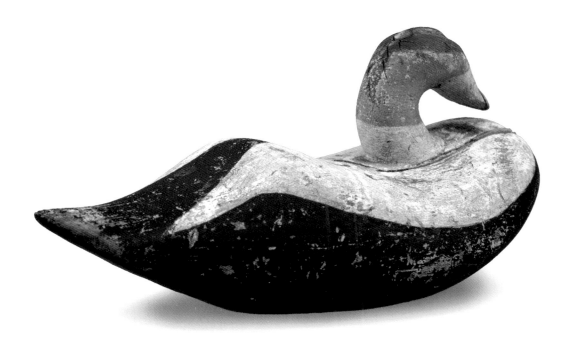

Eider Drake. **Maker unknown. c. 1890. Deer Isle, Maine. The Gene & Linda Kangas Collection of American & International Folk Art.**
Deer Isle is a large island in Penobscot Bay, east of Camden and south of Mount Desert. Early year-round residents depended on fishing and hunting to sustain themselves. This distinctively shaped decoy was part of a rig that originally included about a dozen birds, most of which have survived. The few that remain in early paint are numbered on the bottom; this one is number ten.

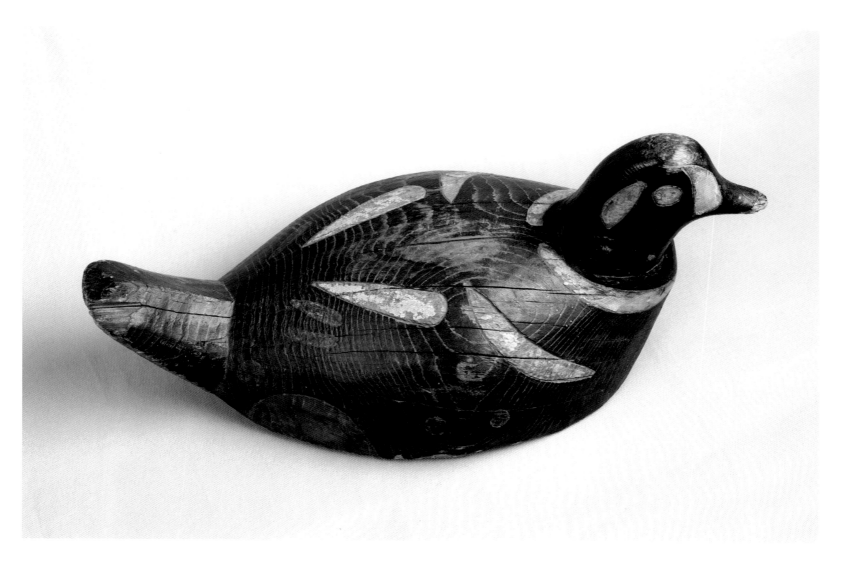

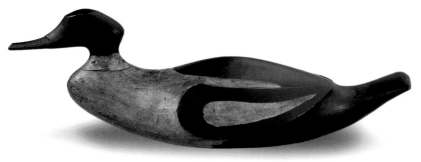

LEFT: **Common Merganser Drake. Orran Hiltz.** c. 1930–40. Indian Point, Nova Scotia. The Gene & Linda Kangas Collection of American & International Folk Art.

Orran Hiltz (1901–78) carved very few common mergansers. All of his early mergansers have oddly shaped, relief-carved wings.

ABOVE: **Harlequin Drake.** George May. c. 1880. Musquodiboit Harbor, Nova Scotia. Courtesy Collectable Old Decoys.

Harlequins are cold-water sea ducks most often found in the Canadian Maritime provinces. Only three of these turtle-backed harlequins by May are known.

Herring Gull. John Ramsey. c. 1900. Summerside, Prince Edward Island. The Gene & Linda Kangas Collection of American & International Folk Art.
Only three of these oversized standing gulls by Ramsey are known. They were probably used as confidence decoys, set at the side of a rig of geese or brant to add realism to the scene.

in the nineteenth and early twentieth centuries and were the primary species hunted there, along with shorebirds. Prince Edward Island has a tradition of standing goose and brant decoys that dates to the nineteenth century, and its carvers also created many decoys that featured unusual head positions. The standers, which were mounted on one or two wooden or metal poles that imitated legs, were originally used for spring shooting on ice.

The island's major carver was John Ramsey (1858–1934) of Summerside, who is believed to have sold more than one thousand goose and brant decoys to hunters in the Malpeque and Bedeque bay regions. Ramsey's smooth-bodied decoys were carved in a variety of postures, including standing birds with front-preening or outstretched belligerent necks and floating sleepers with their heads turned back on their bodies. He also carved a handful of standing gull decoys and some shorebirds. Gulls often associate with brant, so Ramsey's gulls were probably set out with brant decoys as "confidence decoys," intended to add verisimilitude to the scene and reassure live birds that things were safe below.

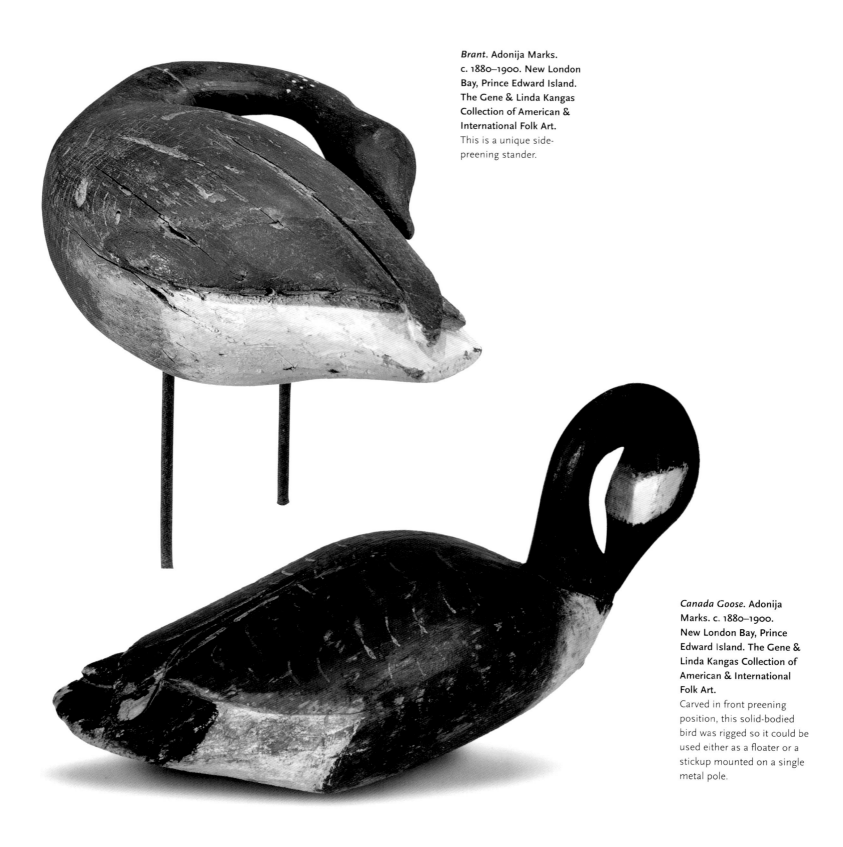

Brant. Adonija Marks.
c. 1880–1900. New London
Bay, Prince Edward Island.
The Gene & Linda Kangas
Collection of American &
International Folk Art.
This is a unique side-
preening stander.

Canada Goose. Adonija
Marks. c. 1880–1900.
New London Bay, Prince
Edward Island. The Gene &
Linda Kangas Collection of
American & International
Folk Art.
Carved in front preening
position, this solid-bodied
bird was rigged so it could be
used either as a floater or a
stickup mounted on a single
metal pole.

Adonija "Nigel" Marks (1858–1945) of New London Bay, a contemporary of Ramsey's, was less prolific but no less imaginative. A cabinetmaker and sleighmaker by trade, Marks, like Ramsey, apparently carved for his own use as well as for sale to other hunters, and his decoys were carved with a variety of head and neck positions. Many of the geese and brant attributed to his hand have crossed wing tips carved in relief and necks turned and twisted in unusual positions. His standing side-preening brant are utterly distinctive, with the extended necks set at odd angles to the bodies.

Because they were often used in heavy seas, Maine and Nova Scotia sea duck decoys typically had wide, flat-bottomed bodies designed to ride the rough North Atlantic swells. The birds were almost always solid-bodied, with heads carved from a second solid block of wood and inlet into a neck seat on the bodies. Saltwater was not kind to paint, which meant that the decoys had to be repainted often, so Down East paint patterns were simple, usually no more than stylized outlines of the birds' plumage colors.

While some carvers made mostly eiders and scoters, others, such as Nova Scotia's Orran Hiltz (1901–78) and Captain Edward Backman (1872–1914) and Maine's George Huey (1866–1947) and Orlando Sylvester "Os" Bibber (1882–1971), concentrated on mergansers and oldsquaws, crafting highly stylized decoys that captured the long, low profiles of these coastal divers. While Hiltz, Backman, and Huey carved the crests of their mergansers in distinctive ways, Bibber stuck bits of leather or horsehair into the top of his heads to imitate their feathered crests and sometimes inserted a long plucked tail feather into the rear of his oldsquaws.

Huey was a genuine piece of work, a wiry, rail-thin bachelor eccentric whose antics are still remembered in his hometown of Friendship, an oceanside community on Muscongus Bay, about thirty-seven miles southeast of Augusta, Maine. Huey, who made what money he needed by clamming, picking up lobster pots, and carving, lived with his mother, Saltanny, (who, according to Maine decoy historian Dr. John Dinan, made well-crafted models of Friendship homes from shoeboxes) for many years before literally shacking up with Martha Cronch, a ten-inch-tall woman he carved and introduced to town children who came to visit him. He had neither running water nor electricity in his shack, proudly wore a railroad conductor's uniform someone had given him, and regularly appeared—unannounced, often unwanted, and always smelling bad because of his lack of access to hot water—on neighbors' doorsteps at dinnertime, hoping to be invited in for a meal. He often carved his initials on the bottoms of his solid-bodied decoys, almost all of which are mergansers, a bird with which he seemed to have enjoyed a special affinity.

Bibber, who lived in South Harpswell, at the tip of a peninsula south of Brunswick that extends far into Casco Bay, was, by contrast, a sophisticated man who worked as a chief engineer on steamships

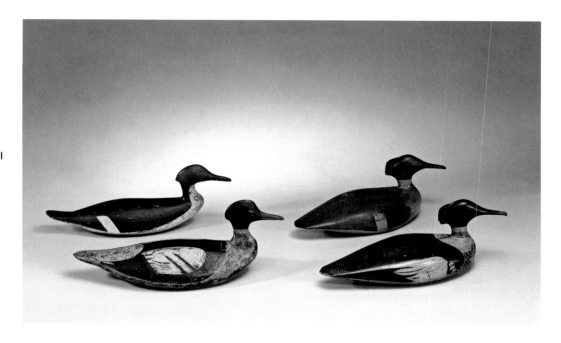

Pairs of Red-breasted Mergansers. LEFT: **George Raymond Huey. c. 1910. Friendship, Maine.** RIGHT: **Orlando Sylvester Bibber. c. 1920. South Harpswell, Maine. Ex-collection James M. McCleery, M.D. Photograph courtesy the Houston Museum of Natural Science, Houston, Texas.** This is an instantly recognizable pair of mergansers by two of Maine's master carvers.

that ran from Portland to New Brunswick and often as far south as Cuba. Known as Os or Ollie, he made decoys that are atypical of the Maine coast. To begin with, they are usually hollow, with bodies hollowed to a thin shell and set on a thin bottom board, more in the manner of Ontario decoys than the work of any Down East makers. He was apparently a fastidious man who, unlike Huey, made decoys only for his own use and devoted considerable time to their making. Again going against the regional norm, Bibber did not inlet his heads, instead seating them directly on the bodies. Many of his decoys have slightly turned heads, and, judging by the birds that survive him, his own working rig must have been quite realistic and animated.

Maine sea-duck hunters often employed an approach called "ducking in line," in which groups of hunters in fifteen or twenty flat-bottomed skiffs anchored themselves hundreds of yards apart in a line extending from a point about a mile out into the ocean. Sea ducks sleep far out at sea and come in to land to feed at sunrise, so hunters arranged in this way could shoot the birds as they flew in across the gantlet of boats. George Bird Grinnell vividly described the difficulties of the practice in *American Duck Shooting*:

> Usually lots are drawn for position, those nearest the shore not being so desirable as those farther out. An effort is made to be on the ground before daylight, as the shooting begins with the earliest dawn. Often, therefore, the gunners are obliged to rise at two or three o'clock in the morning to make their way to the shore, get into their boats and perhaps pull a distance of three or four miles before reaching the ground. At other times all of them will congregate in some barn near the starting point and sleep there, and the start will be made by all together.

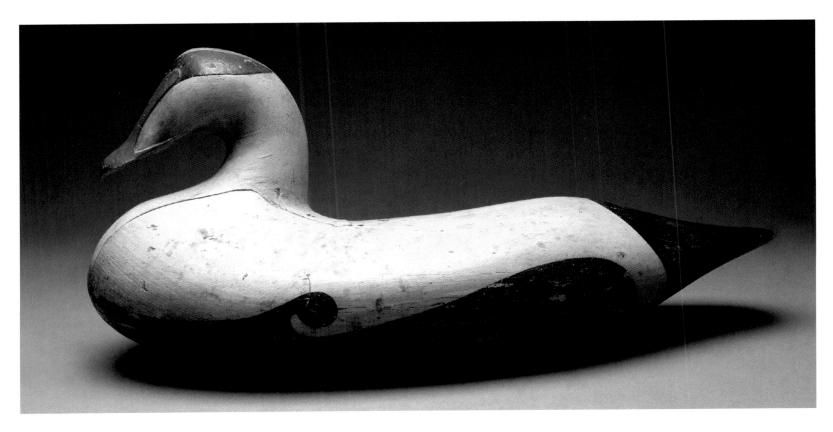

. . . It is often no joke to pull one of these little flat-bottomed skiffs three or four miles through the darkness against a headwind and through a rough sea, and even after the gunner is anchored, if the wind blows hard, the work is wet and uncomfortable, and the reports of the guns are punctuated by the angry slapping of the skiffs upon the water, as they rise and fall with the sea. Even if the water is calm it may be bitterly cold, and ice may be making along the edges of the bay, so that after the gunner has reached his stand, and thrown over his anchor, and the labor of rowing is at an end, he soon chills, slaps his arms vigorously and dances jigs on the ice in the bottom of his boat.

Maine's greatest and most prolific carver was Augustus Aaron "Gus" Wilson (1864–1950), who was born in Tremont, on Mount Desert Island, in the northeastern part of the state. He made his living for many years in that region as a fisherman and boatbuilder and then worked in the lighthouse service in southern Maine from 1915 to 1934. His last post was at the Spring Point Light off Portland, the city where he lived after he retired. Wilson is believed to have made his first decoys in the 1880s, probably for his own use, and sold his carvings from at least the turn of the century through the 1940s. He was a prolific carver who, in addition to working decoys of eiders, scoters, mergansers, black ducks, mallards, and goldeneyes, also created three life-size herons, a variety of standing songbirds and seagulls with wire legs, and flying ducks with attached wings and feet. After seeing a huge circus tiger in the early

Eider Drake. **Maker unknown. c. 1900. Probably Monhegan Island, Maine. Private collection.**
This is arguably the most sophisticated of all eider decoys, with flowing lines and stylized abstract paint worthy of a Zen calligrapher. Monhegan is one of Maine's most remote inhabited islands, located twelve miles out to sea.

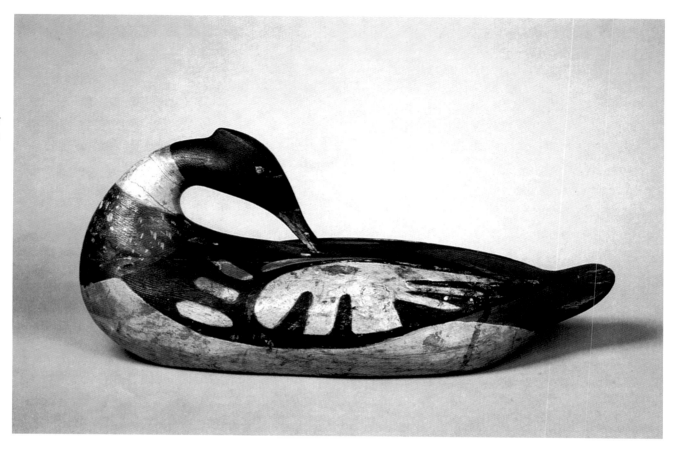

1930s, Wilson carved a handful of small images of the animal, as well as three extraordinary life-size beasts, two of which are in the collection of the Brooklyn Museum. The third and largest, which is in a private collection, measures eighty-two inches from nose to tail. According to Fred Anderson, who assisted Wilson in his later years, a distraught and lonely Wilson contemplated carving a life-size image of his beloved second wife after her death. Anderson talked him out of it, perhaps robbing posterity of another masterpiece of vernacular sculpture, but keeping peace with the neighbors, who thought the old man odd enough already.

Wilson had few equals among decoy makers as a sculptor; only his contemporary Ira Hudson in Virginia carved so wide a variety of forms. Wilson carved both heads and bodies freehand, holding the piece of wood in his hands, and this approach allowed him the tactile immediacy that characterizes his work. His best birds are at once powerful and imaginative. Some of his decoys feature open bills, while others have attached wings or rocking heads attached with a dowel across the open neck seat so that they bobbed up and down with the motion of the swells on which they rode. A few of his mergansers have strips of leather inserted in the bills to mimic a freshly caught fish, and he also made a number of eiders

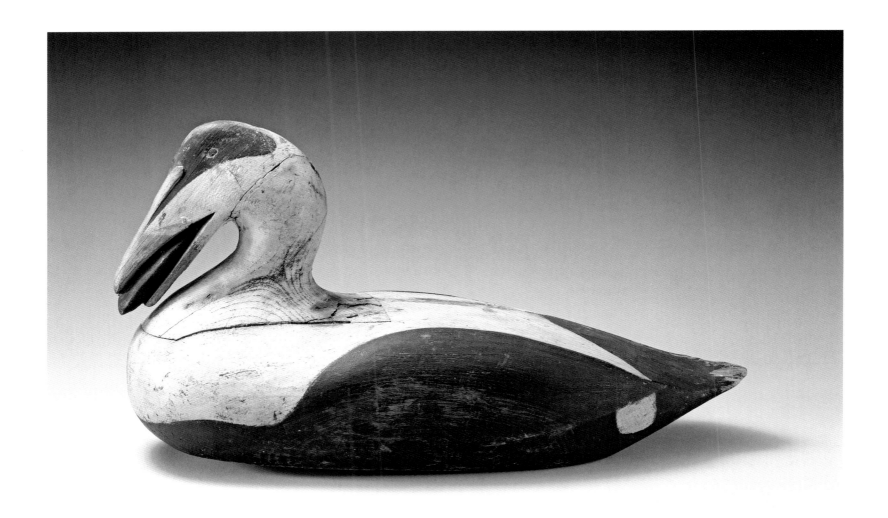

and scoters that hold carved mussels in their bills. In addition, he created front and back preeners with gracefully arched necks, birds with heads that could be turned 360 degrees, ducks with their heads fixed at odd angles or tucked under an attached wing, and feeding ducks with their heads extended down and forward. Following Maine tradition, Wilson inlet the heads of his birds into the bodies, and the bottoms of most of his decoys are flat. Like other Down East carvers, his paint patterns are simple but effective, and the bottoms of his decoys usually were left unpainted. Painting the bottoms would have been a waste of paint in his eyes, since neither the birds nor the men who bought his decoys could see that part of the decoy in the water. He did not prime his birds and also apparently sold both painted and unpainted decoys, a practice that reflects both his Yankee practicality and his strong artistic preference for carving over painting. He was a frugal Yankee craftsman who worked with whatever materials were available, and it is not uncommon to find bodies he carved from blocks that had knots or other flaws in the wood.

Eider Drake with Carved Mussel in Bill. Augustus Aaron Wilson. c. 1910. South Portland, Maine. Collection of Richard W. Carlson. Photograph courtesy Sotheby's, Inc.
Mussels are the eider's favorite food. Wilson carved eiders and scoters holding wooden mussels in their bills as well as red-breasted mergansers with a strip of leather clenched in their jaws to imitate a small fish about to be swallowed.

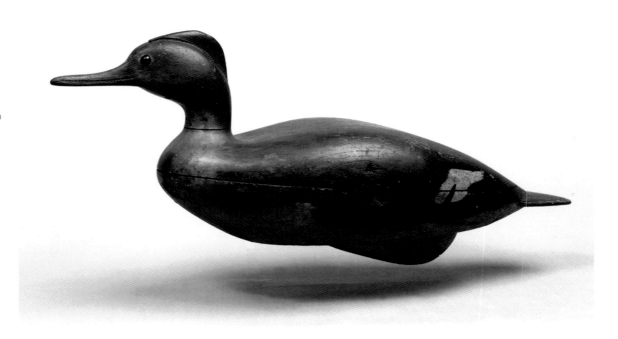

Red-breasted Merganser Hen. **Attributed to Samuel Augustus Fabens. c. 1850–70. Marblehead, Massachusetts. Courtesy Collectable Old Decoys.** Marblehead is a historic shipping and fishing port on the North Shore, about eighteen miles north of Boston. Fabens (1813–99) was a Salem-born sea captain who commanded ships bound for London, Antwerp, Havana, St. Petersburg, Honolulu, Calcutta, Rio de Janeiro, Hong Kong, and other exotic ports of call. The decidedly boatlike, hollow-bodied decoys he gunned over, some of which are branded "S.A. Fabens," have deep wooden keels. It is not clear whether Fabens made the birds himself or a ship's carpenter perhaps constructed them for him.

CHAPTER 14

The Massachusetts Coast and Islands

The Massachusetts region, which includes coastal New Hampshire, Cape Cod, the islands of Nantucket and Martha's Vineyard, and the state of Rhode Island, arguably produced more first-quality decoys than any other area of the country and was home to a number of the decoy's greatest artists, including such masters as Elmer Crowell, Joe Lincoln, Lothrop Holmes, and George Boyd.

Massachusetts also produced several of the greatest as yet unidentified carvers. Many of the region's most accomplished and inventive nineteenth-century shorebird carvers have never been identified, while a uniquely constructed group of geese and red-breasted mergansers is attributed by oral tradition to a Salem sea captain named Charles C. Osgood, although whether he actually made them or not may never be known. One unidentified master carved a rig of astonishing

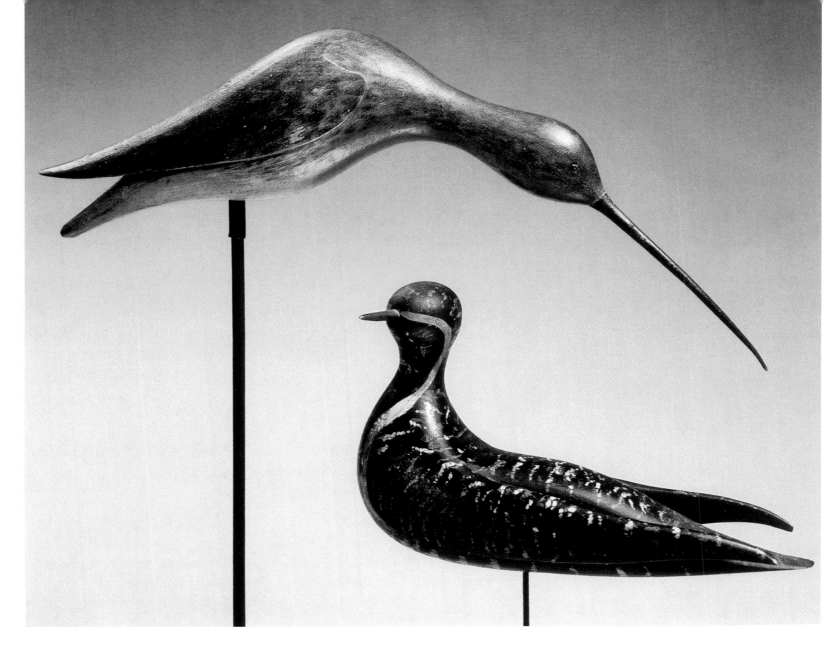

animated shorebirds for Dr. John C. Phillips, a wealthy sportsman and amateur ornithologist who was also one of Elmer Crowell's most important patrons, while another made equally remarkable geese and shorebirds with tightly fitting, removable dovetailed heads.

Although it is relatively small, the Massachusetts region is geographically diverse, with a wide variety of lakes, ponds, rivers, islands, beaches, coastal bays, and marshes. It is home to an equally wide array of wildfowl, including geese and brant; saltwater ducks such as mergansers, scoters, canvasbacks, redheads, and bluebills; and freshwater ducks

ABOVE LEFT TO RIGHT: *Long-billed Dowitcher, Spring Plumage.* **The John C. Phillips Rig Carver. c. 1900. Probably Cape Cod, Massachusetts.** *Golden Plover.* **Attributed to a "Mr. Webster." c. 1870. Nantucket, Massachusetts. Ex-collection James M. McCleery, M.D. Photograph courtesy the Houston Museum of Natural Science, Houston, Texas.**

It is remarkable that the dowitcher's extremely long and fragile bill has survived. The bird was carved by the same man who crafted an equally bold long-billed curlew used by Phillips, which is illustrated in Chapter 6. A handful of other golden plover by Webster are known.

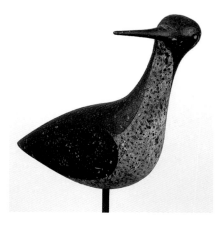

Yellowlegs. **A member of the Chipman family. c. 1860–80. Sandwich, Massachusetts. Private collection. Photograph courtesy Decoys Unlimited, Inc.**
With its head cocked 90 degrees, this early decoy was found in Eastham, Massachusetts, along with peeps and black-bellied plovers carved by the same hand. The decoy was hollowed from the bottom to a thin shell and has deep green Sandwich glass eyes.

such as mallards, pintails, black ducks, wigeon, ruddy ducks, and wood ducks. The region's thousand-plus miles of winding and mostly sandy coast attracted many species of shorebirds, from curlews to tiny sandpipers. Yellowlegs, black-bellied plovers, and dowitchers were widely hunted, and huge flocks of golden plovers and Eskimo curlews were sometimes forced down over Cape Cod and Nantucket by the powerful storms known in New England as "nor'easters" because of their prevailing wind direction.

Small gunning rigs of well-crafted decoys were the rule in the region, and area craftsmen paid greater attention to detail in both their carving and their painting than did their counterparts in most other areas of the country. They also created a rich array of forms and experimented with many materials and structural variations. Boyd, Lincoln, Holmes, and others made decoys with bodies of canvas tightly stretched and tacked over a wooden slat frame. Both Boyd and Lincoln are known to have worked as shoemakers, a trade common in the area, which may explain how the idea was generated. Lincoln made "self-bailing" ducks with canvas-over-frame bodies that were open at the back, allowing water to slosh in and out and giving the decoys a more natural ride in the water. Lincoln also specialized in geese with wooden slat bodies, some of them massively oversized "loomers" that were intended to draw the attention of high-flying birds and draw them in close enough to be further deceived by normal-size decoys. Shorebird carvers, known and unknown alike, made feeders, runners, sleepers, birds with their heads twisted in unusual alert or quizzical attitudes, thin-shelled hollow birds with open bottoms that balanced on their sticks and rocked in the sea breezes, and decoys with attached wings and detachable heads. Some made shorebirds of papier-mâché and cork, while Strater and Sohier, a manufacturer in Boston, specialized in "tinnies," which had jointed molded tin forms that could be unfolded and stacked flat in the tin boxes they were sold in. Crowell and other carvers often made geese and ducks with tucked or turned heads, and Lincoln and Boyd also both occasionally made "belligerent" hissing geese whose necks were fully outstretched in front of their bodies.

The region's greatest nineteenth-century carver was Lothrop Turner Holmes (1824–99) of Kingston, Massachusetts, on the state's south shore between Marshfield to the north and Plymouth to the south. Holmes worked as an iron molder, pouring molten iron in area mills, most likely including the Triphammer foundry in Kingston, founded by his grandfather and owned by his uncle. "Bog" iron ore found in local ponds sustained several serious forges in Kingston that manufactured ship's anchors, shovel blades, stoves, and a variety of other useful objects during the nineteenth century. According to an obituary notice published in the October 14, 1899, issue of the *Old Colony Memorial*: "Mr. Holmes . . . spent most of his life in Kingston, except when following his trade, a molder, at Providence, R.I. He also worked at factories here. Mr. Holmes was for many years superintendent of Evergreen Cemetery, resigning a few years ago. He lived a quiet life, and was respected by the community at large. He was passionately

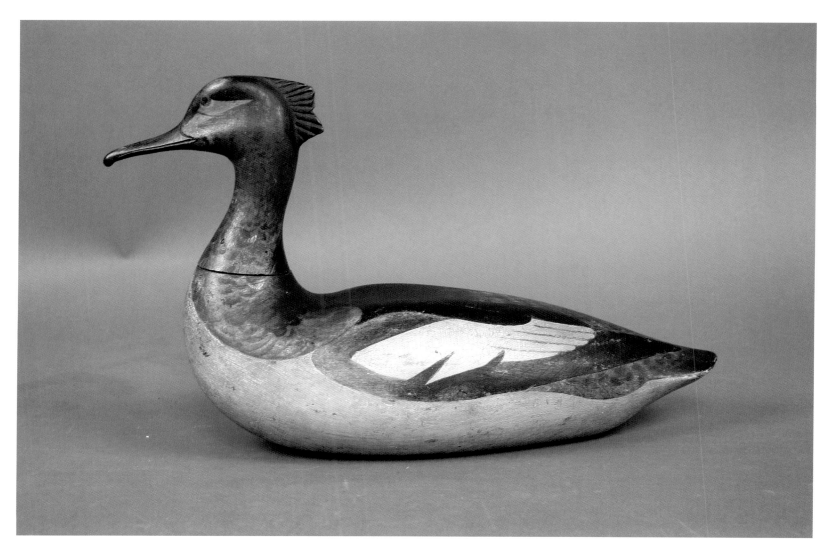

fond of instrumental music, the banjo being his favorite. Mr. Holmes was a widower, his wife having died several years ago. He was a Mason." Holmes lived next door to the cemetery and is buried there.

Holmes was an avid hunter and fisherman who gunned Kingston ponds and also owned a half-acre of land on the Cut River in Marshfield, where he probably hunted sea ducks such as scoters, mergansers, and oldsquaws. He is remembered today for his merganser and oldsquaw duck decoys and for his shorebirds, all of which are incomparable. Adele Earnest, author of *The Art of the Decoy*, called him the most sophisticated carver of the nineteenth century and declared his red-breasted mergansers to be "a legacy any man would be proud to leave." Earnest noted, "The sensitive modeling and brushwork of these birds resemble the exquisite renderings of waterfowl on Chinese scrolls and china." The mergansers are solid-bodied, with extensive crest carving on their heads, but Holmes came up with an

Red-breasted Merganser Hen. **Lothrop Turner Holmes. c. 1870. Kingston, Massachusetts. Private collection. Photograph courtesy Guyette & Schmidt, Inc.** Holmes's mergansers are among the most artistically sophisticated decoys ever made.

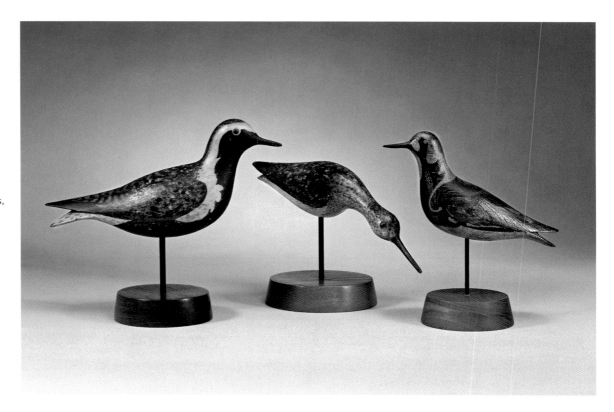

LEFT TO RIGHT: *Black-bellied Plover, Yellowlegs (feeding position), Ruddy Turnstone.* **Lothrop Turner Holmes. c. 1870. Kingston, Massachusetts. Ex-collection James M. McCleery, M.D. Photograph courtesy the Houston Museum of Natural Science, Houston, Texas.** Like a number of other Massachusetts decoy makers, Holmes was both a great sculptor and a remarkable painter.

ingenious solution to lighten the carrying weight of his unique oldsquaw decoys. Instead of making a wooden body, he built an almost architectural ash frame and then stretched canvas tightly over it, tucking it under the body and attaching it with tacks. The canvas-covered frame was set on a bottom board and a carved pine head attached.

Holmes owned a full set of woodworking tools and made his own gunning box, which is the work of a master cabinetmaker. He apparently carved only for his own use, and surviving examples of his work are consequently rare. In addition to the ducks, he is known to have crafted representations of feeding, reaching, and straight-headed yellowlegs, as well as black-bellied and golden plovers, ruddy turnstones, and at least one curlew sandpiper. As Earnest suggests, Holmes was equally skilled with a paintbrush as with a knife, and the stylized lines of his paint patterns perfectly complement the flowing forms of his carvings. He is the greatest master of line among decoy makers; where other carvers drew broad outlines of plumage, Holmes accurately delineated the intricate, interweaving lines of each species' plumage with a sure, unwavering hand.

Joseph Whiting Lincoln (1859–1938), a generation younger than Holmes, lived all his life in Accord, a small town near Weymouth, south of Boston, where he made a living as a decoy carver,

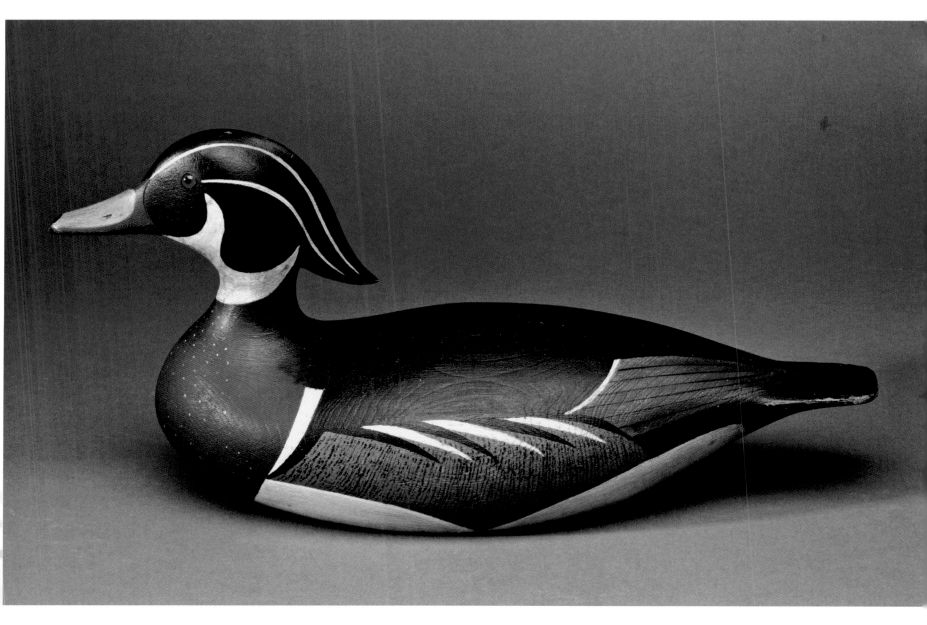

Wood Duck Drake. Joseph
Whiting Lincoln. c. 1920.
Accord, Massachusetts.
Collection of Paul Tudor
Jones II. Photograph
courtesy Guyette & Schmidt,
Inc.
Only a handful of Lincoln's
brilliantly stylized wood ducks,
all of them drakes, are known.

upholsterer, and clock repairman, and grew prize-winning dahlias in his garden. He carved working brant, goose, duck, and shorebird decoys, including such species rarely carved in Massachusetts as American mergansers, buffleheads, wood ducks, and wigeon, and he also made miniature and quarter-size decoys that he called "toys." Lincoln was a laconic man, a consummate Yankee craftsman whose solid-bodied decoys are reflections of their maker's personality—direct and spare, with not a gesture wasted. Their clean, crisp lines and reductively abstract paint patterns capture the essentials of each species' form and plumage with remarkable integrity and economy of means.

George Boyd (1873–1941) of Seabrook, New Hampshire, situated just north of the Massachusetts line and part of the small bit of New Hampshire that adjoins the Atlantic, was a professional carver who made geese, a variety of ducks, and black-bellied plover and yellowlegs shorebird decoys as well as miniature standing birds of many different species. All of Boyd's birds have immediately recognizable square heads, which are flattened at the crown, while his duck and goose decoys have flat bottoms, rounded backs, and relatively long tails. The tails are usually squared off, although some paddle-tail examples are known. Boyd made his own paintbrushes and combined crisply outlined plumage patterns with soft feather patterns. His shorebirds have painted tack eyes, while his ducks and geese are fitted with glass eyes.

Charles Augustus Safford (1877–1957), a good friend of Boyd's, was a cabinetmaker, silversmith, boatbuilder, coffin maker, and market gunner who lived year-round at his camp at Hale's Cove on Plum Island, a barrier island east of Newburyport, just south of the New Hampshire state line. Although he was a multitalented handcraftsman, Safford much preferred life in camp to work of any kind, and he practiced his various trades only long enough to support his passion for wildfowling. After the island was given to the National Audubon Society to be preserved as a wildlife refuge, Safford was hired as its game warden and patrolled the area, primarily on horseback, until it was sold to the federal government in 1942. Safford's superbly crafted goose decoys, which for many years were mistakenly attributed to Lothrop Holmes, were designed to be mounted on large, flat, iron triangles and left out all year in the Plum Island marshes where he hunted. All of his work was carved from blocks made from vertically laminated blocks of wood; even the miniatures he carved for his nephews were constructed in this exacting and time-consuming manner, rather than from solid blocks. The heads and necks of his straight-headed geese were constructed of two vertically laminated pieces of wood to add strength at this most vulnerable part of a decoy.

Anthony Elmer Crowell, who is widely recognized as the greatest of all decoy makers, was born in East Harwich, Massachusetts, a few miles inland from Cape Cod's elbow, in 1862. From his earliest days, Crowell, who went by Elmer, was fascinated by the abundant birdlife on the Cape.

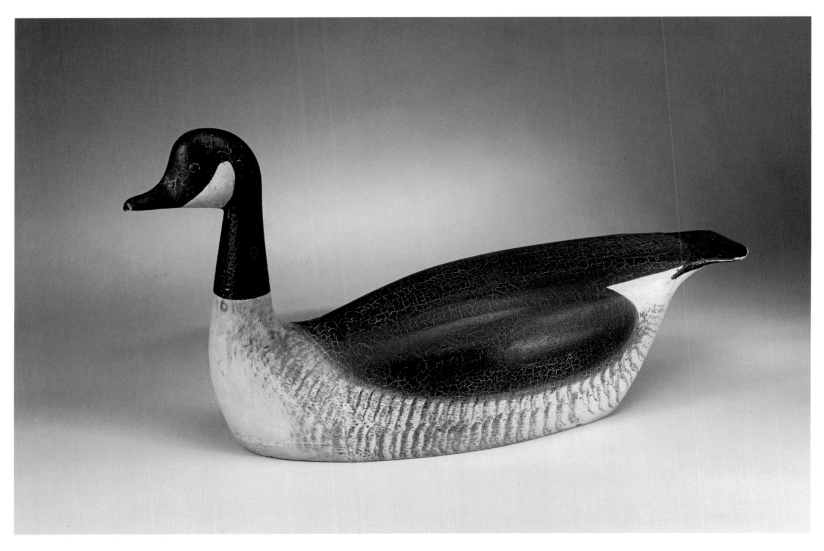

Jutting far enough out into the Atlantic that all but the most pelagic of migratory birds passed over, nineteenth-century Cape Cod was a gunner's paradise and a wonderful place to observe a wide variety of ducks, geese, upland game birds, songbirds, and shorebirds. The Conservation Movement was yet unborn, and, like Audubon and many other nineteenth-century "birders," young Crowell observed birds by killing them. Before he was ten, he was given two bow-and-arrow guns by an old woodsman, and, using a needle stuck into the arrow's tip, Crowell shot many small birds such as robins, doves and blackbirds. On his twelfth birthday, his father gave him a 12-gauge shotgun, which is now in the Shelburne Museum collection. Then, as Crowell put it in a memoir written in the 1940s, "I was some boy! . . . The next fall I killed my first duck. That was the beginning of my real shooting."

Canada Goose. George Boyd. 1902. Seabrook, New Hampshire. Private collection. Photograph courtesy the Houston Museum of Natural Science, Houston, Texas.
This pristine canvas-over-frame goose decoy was presented to the founder of Camp Kewonke ("Call of the Goose"), a girls' camp on New Hampshire's Lake Winnipesauke, and was never used.

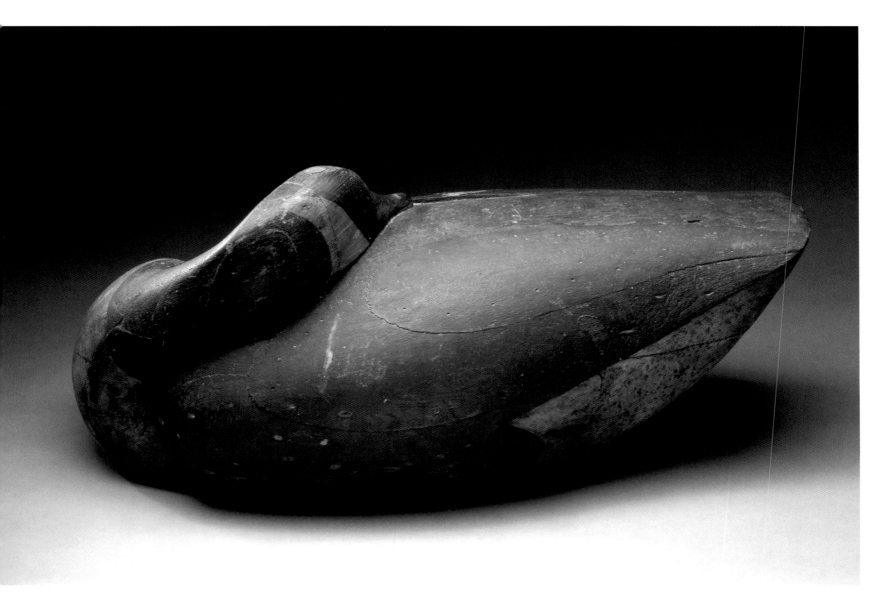

Canada Goose. **Charles Augustus Safford. c. 1910. Plum Island, Newburyport, Massachusetts. Collection of Cap and Paige Vinal.** The body of this remarkable goose was carved from fifteen vertically laminated pieces of wood. The sleeping head position is also unique.

Like many of his contemporaries, Crowell, who soon developed into a crack shot, found seasonal employment gunning birds for market as a young man. Although he apparently started fashioning decoys and miniatures in the early 1880s, he did not sell any of his carvings until around 1900, when he was thirty-eight years old. His only artistic training was as a painter. In his middle teens, he persuaded his parents to let him take painting lessons from a professional artist, Miss Emily King, of Middleboro, Massachusetts, who summered in Harwichport. He took twenty-four lessons from King in 1876 (at $1 a lesson); perhaps she can be credited with teaching Crowell at least some of his remarkable range of painting techniques.

Crowell's first patron was Dr. John C. Phillips, who had hired him to manage his hunting camp at Wenham Lake outside Beverly on the North Shore. Crowell began working for Phillips in 1900, developing the camp, guiding guests and family members, gunning, and tending live decoys, and, most important as it turned out, carving in his spare time. Phillips recalled, "Elmer used to decorate Wenham Camp with all sorts of mythical-looking birds, whittled out and suspended from the ceiling so that they revolved solemnly around if your blew a puff of smoke their way . . ." Crowell also carved some extraordinary decoys for Phillips. He later told the *Boston Globe* that Phillips had so admired some hastily made decoys that he made a few better ones for the doctor's personal use. The *Globe* story goes on to say that Crowell "also whittled out a small miniature bird which attracted Dr. Phillips' favorable notice to the extent that he had a dozen made for his den." Crowell continued to work for Phillips until around 1910, managing the camp at Wenham Lake and another at Oldham Pond in Pembroke and carving decoys and miniatures for Phillips and his wealthy friends. His reputation grew by word of mouth among the hunting community, and orders poured in.

In 1912, at age fifty, he gave up his work as a seasonal gunner, caretaker, guide, and cranberry farmer to carve birds full-time, probably with financial support from his friend and patron Charles Ashley Hardy, for whom he had managed a hunting camp in East Harwich before he began working for Phillips. Crowell's son, Cleon (1891–1961), worked on an equal footing with his father from the time the shop opened, and, while his contribution has been largely ignored by collectors, he clearly had a part in making many birds that have been credited solely to his father. Cleon, an only child, lived at home until he married in 1920 and moved next door, where he lived until 1946. The bird carving business was a full partnership, and unlike other teams, such as Robert and Catherine Elliston, Charles and Edna Perdew, and the Ward brothers, who divided carving and painting tasks down the middle, both men carved and painted. In many cases, it is impossible to know where one started and the other left off. Massachusetts birder, decoy historian, and conservator Gigi Hopkins, who has studied the Crowells' work for decades, says:

> Cleon was there from very early on, and I'd guess made more Crowells than his dad did, which no one wants to hear. I've always felt that Elmer's reference material was his deep knowledge of the birds, and Cleon's reference material was his father's work. To me, Cleon was a step away

Cleon and Elmer Crowell in the doorway of their shop. c. 1927–30. East Harwich, Massachusetts.
Cleon, at left, is holding an oversized mallard decoy that he presumably made, while his father is holding an ornamental white heron.

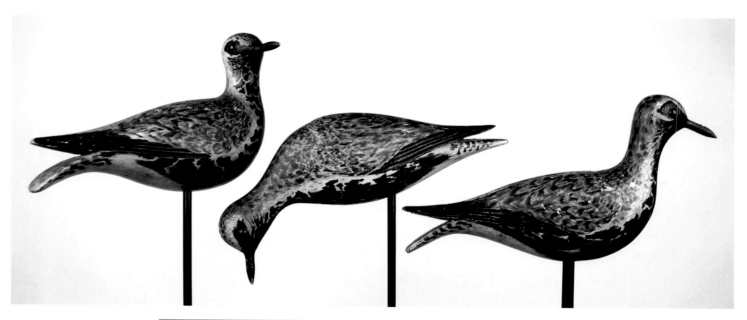

Black-bellied Plovers. A. Elmer Crowell. c. 1900–10. East Harwich, Massachusetts. Collection of Ted and Judy Harmon.

This early and complementary trio represents Elmer Crowell at the height of his powers.

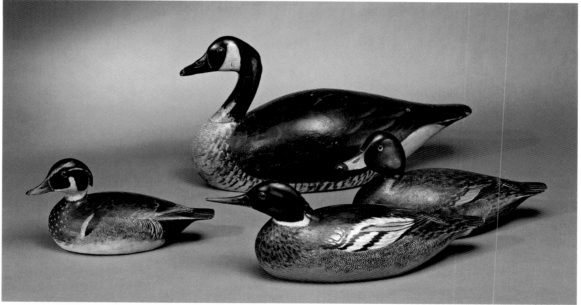

LEFT TO RIGHT: *Wood Duck Drake.* c. 1920. Private collection. *Canada Goose.* c. 1915. Private collection. *Red-breasted Merganser Drake.* c. 1920. Private collection. *Redhead Drake.* c. 1915. A. Elmer and Cleon Crowell.

Collection of Jonathan and Virginia Chua. East Harwich, Massachusetts. Photograph courtesy the Houston Museum of Natural Science, Houston, Texas.

These are examples of Elmer Crowell's best-quality hunting decoys, made early in his professional career. All four birds bear Crowell's oval brand, indicating that they were made after he opened his shop in 1912. Cleon was working with his father by the time these birds were made, although the extent of his participation in their crafting will probably never be known. The three ducks were all owned by Crowell's great patron, Dr. John C. Phillips, and appear to have been unused.

from the source. (This may have been because he was simply too busy for niceties; they had back-orders to fill!) Elmer's carvings, especially early on, are "birdier" and less commercial-looking than his son's—the skulls are wonderful, everything is right anatomically, and the birds are dressed in perfectly-seen plumage. But—there are carvings you can't identify as being by one man or the other. I wonder how many of the early pieces would turn out to be Cleon's if there were a way to tell? How good was he when still enthused about what they were doing? We'll never know.

The Crowells' gunning decoys were made in several grades to suit the wide variety of pocketbooks and sensibilities found among their clientele over the years. Elmer Crowell's finest early ducks and shorebirds, made for wealthy sportsmen like Phillips and Hardy, have elaborately detailed paint and extensive tail and wing carving. On the ducks, the wing tips are carved in relief on the bird's back, one crossed over the other, with several overlapping primary feathers clearly defined as well. Grooves to represent feathers appear at the tail, the bird's nostrils are incised in double outline, and the bill tip or nail is deeply carved. On his finest early shorebirds, Crowell carved a V-shaped split tail typical of Massachusetts carvers but elaborated by carving as many as six primary feathers on each side.

Almost without exception, the bodies of Crowell decoys were carved from solid blocks of pine. In this, he seems to have followed the practice of most of the earlier Massachusetts carvers. Besides, hollow decoys required more time to craft, time that could be lavished on fine details of paint and carving or simply on making more. The Crowells started their work from patterns drawn from the species, marking the block of wood with the basic form of the bird. The marked blocks were then roughed out with a hand axe or a foot-powered band saw, carved into shape with a drawknife and pocketknife, and sanded smooth, except, of course, where there was relief carving. The flat bottoms of many of the carvings also received a brand. While Elmer's earliest decoys are unbranded, many birds made after he began working professionally in 1912 bear an oval brand with the legend *A. Elmer Crowell DECOYS, East Harwich, Mass.* As a professional craftsman trying to make a living, Crowell used the brand as an advertising device. In the late 1920s, after the oval brand had worn out from repeated use, Crowell switched to a smaller rectangular brand.

Although some imitated him, Cleon best of all, few other decoy makers ever approached Elmer Crowell's mastery with a brush. His control was incomparable; he seems to have been able to make the brush do whatever he wanted it to—pounce, dab, spot, blend. While some of his early decoys were painted with house paint, Elmer and Cleon worked with professional artists' oil paints in their shop from at least 1920 and probably earlier. Early on, Elmer developed a special blending

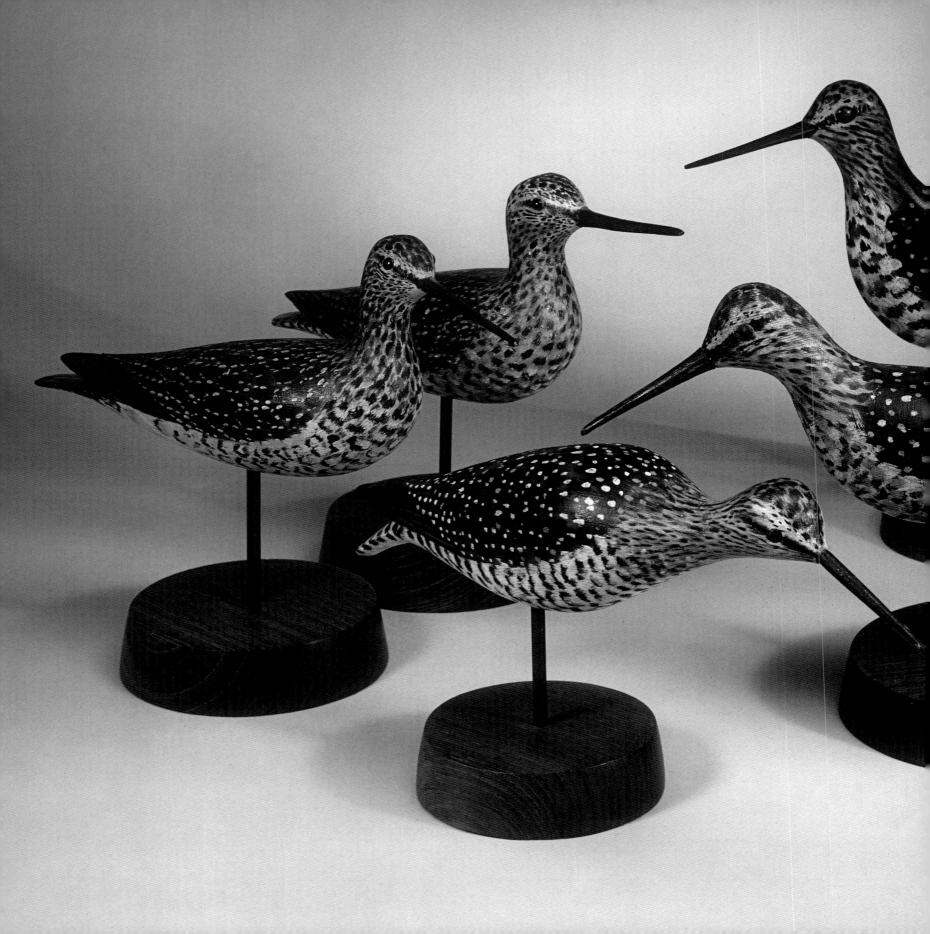

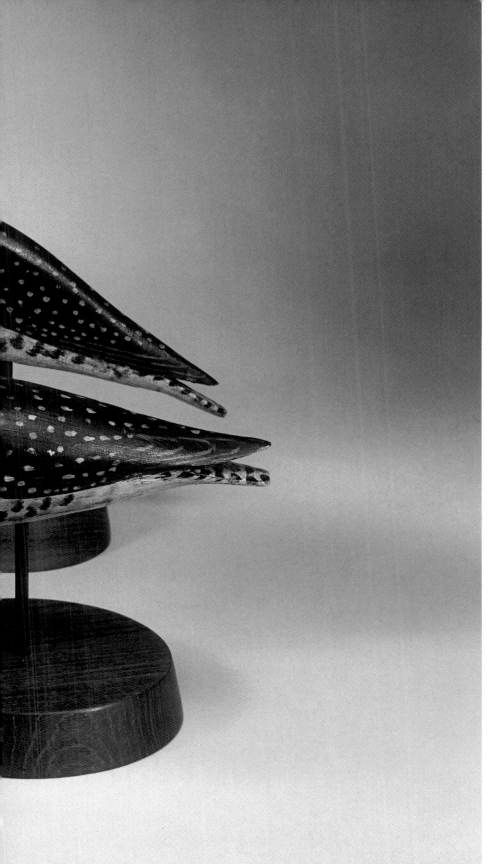

Group of Yellowlegs.
A. Elmer Crowell. c. 1910.
East Harwich, Massachusetts.
Ex-collection James M.
McCleery, M.D. Photograph
courtesy the Houston
Museum of Natural Science,
Houston, Texas.
This dynamic group of
Crowell yellowlegs includes a
flat-sided bird at upper right.

technique, which gave a soft, feathery feel to the surface of his lures. After priming, he applied a thick layer of carefully chosen plumage colors. The birds were then set aside to dry for a while, and then the paint was blended with a dry brush while it was still tacky to produce a surface full of delicate brushstrokes and subtle color mixtures that closely approximated the look and feel of real feathers.

The Crowell method was actually quite complex; Cleon described it in precise detail in a shop order book. To paint a summer yellowlegs ornamental, he wrote, "After priming coat, put in dots on head & neck and blend in, paint wings dark color and put in bars under breast, also paint wing quills black, that's all for this time, next time put in feather markings and put in the dark color and blend them in, now put in wing feather lines. When you put this bird on the legs you put in the white specks on the body feathers. The dark color is black, raw umber & burnt umber mixed together."

As Elmer Crowell's reputation spread, other carvers began to seek him out, particularly to learn his painting technique. He was always modest and generous with his time and skills. More than a few birds have been discovered that were carved by other hands but bear the unmistakable touch of Crowell's brush. Some of these were apparently done by Crowell as study pieces for fellow carvers to show how they might approach their own work. Others were repaints of well-used birds ordered by hunters familiar with Crowell's artistic skills. One contemporary, Keyes Chadwick of Martha's Vineyard, admired his friend's brushwork so much that around 1930 he bought a particularly nice pair of Crowell's decoys to use as models. Chadwick was a man of considerable artistic ability; he was an accomplished professional decoy maker and wrote such a perfect Spencerian script that Harvard hired him to inscribe diplomas for them. However, try as he might, Chadwick could not come close to duplicating Crowell's paint, and the pair of birds was retired to the mantelpiece in his dining room. Their final resting place gives some indication of Chadwick's respect for his colleague's skills; his own decoys were relegated to the basement.

The Crowells' workshop was in an old chicken coop attached to the barn behind Elmer's house in East Harwich. A number of photographs exist that show him and Cleon posed inside or outside the shop, surrounded by decoys, miniatures, and ornamentals of all descriptions. Within the shop, coffee cans filled with brushes, tins of paint, paper carving patterns, sandpaper, and penknives cover the workbenches, and wood shavings litter the floor. Everything was made to order, and the orders were penciled into a child's copybook that the Crowells kept on hand at all times. The rule was always first come, first served; they worked on special orders as they were received and played no favorites.

By the mid-1920s, demand for miniatures and ornamental carvings outstripped orders for decoys. Elmer Crowell told *Cape Cod Magazine* in 1926 that he no longer had much time to work on decoys. "The ladies keep me too busy making the small birds for them; there is better money in them too. I make them for schools a lot, and gardens, and houses, and for private collectors."

Elmer Crowell remained a proudly independent craftsman throughout his life. He was approached at least three times in his career by people who offered to provide backing if he would consider expanding his operation to a wholesale scale. Although the financial temptation must have been strong, he flatly refused the offers because he could not bear the thought of having his patterns mass-produced. He felt strongly that it was his own personal touch that made each piece what it was and that without his direct involvement, the work would have no real value. He stopped carving in the late 1930s and was forced to stop painting in 1943. Rheumatism in his hands had advanced, so he could no longer grip his knife and brushes tightly or long enough to work. Cleon continued to fill orders, using his father's patterns, and Elmer stayed on in the shop, where he oversaw the work and reminisced with friends and customers, including the legendary birder Roger Tory Peterson, about days gone by. Dorothea Setzer recalled him in his old age: "A round, ruddy faced man with twinkling blue eyes who loved to sit with his hands folded across his plump stomach, telling tales of the time when he was young, skinny and a crackshot." Crowell's 1944 memoir, in which he recalls his last years of gunning with Cleon just after World War I, gives a taste of the homespun storytelling of the elder statesman. When Cleon came back from the war, Elmer bought a little piece of land on a local pond and built a blind. He had not gunned for birds in some years, but now "the old fever came over me again. We gunned it there for a few years. We baited it with corn and had good shooting most of the time. One year we had a heavy flight of pintail ducks. The pond was full of them each morning when we got there. In about four years the law cut out baiting, so we gave up the blind; and I sold it . . . I am eighty-four years old and my mind wanders back to the good old days when there was no law on birds. They were the days for me!" Elmer Crowell died in 1952 at the age of ninety, leaving an estate valued at $200. The bird carvings that he and his son created are his legacy.

Dr. Clarence Tripp Gardner (1844–1907), a prominent surgeon and president of the Rhode Island Medical Society, and Newton Dexter (1841–1901), a naturalist associated with the Smithsonian, were hunting and fishing companions who worked together on the creation of a number of remarkable shorebird decoys, including hollow and solid-bodied curlews, yellowlegs, black-bellied and golden plovers, and dowitchers. Both men were skilled in taxidermy and mounted many of the birds they shot; their collection of specimens was later donated to the Roger Williams Park Museum of Natural History in Providence.

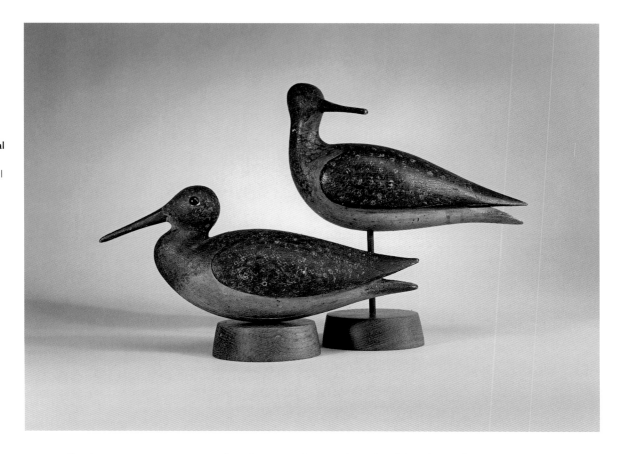

Pair of Dowitchers.
**Dr. Clarence T. Gardner
and Newton Dexter.
c. 1890. Sakonnet Point,
Little Compton, Rhode
Island. Ex-collection
James M. McCleery, M.D.
Photograph courtesy the
Houston Museum of Natural
Science, Houston, Texas.**
Gardner and Dexter's careful
study of live and mounted
birds is evident in this
singular pair of dowitchers.

Gardner was precocious and ambitious—he taught school briefly at fourteen, entered Brown University at sixteen, enlisted in the Union Army when the Civil War broke out even though he was two years under age, fought in the first and last engagements of the war, and graduated from Harvard Medical School in 1866. In 1883, he built a summer home in Little Compton, Rhode Island, on a spot on Sakonnet Point that is still called Gardner's Bluff, where he hunted and fished with Dexter and his son, Clarence H. Gardner, who was also a skilled taxidermist. In a memorial appreciation, Gardner's colleague, Dr. Walter Lee Munroe, noted:

> He was a daring and original surgeon . . . He was a born mechanic and dextrous in the use of all manner of tools. Many of his happiest leisure hours were spent in his work-shop where he was equally at home whether engaged in fashioning and painting decoys or installing an electric lighting plant. To this mechanical dexterity can be attributed many of his successes as a surgeon . . . He was an ardent sportsman, especially with the shotgun, and lost no opportunity when the birds were flying and he was away from business. He had a profound knowledge of natural history and especially ornithology. His collection of shore-birds and sea-fowl at Seaconnet, all shot and mounted by himself, his son, and the late Newton Dexter, would be hard to duplicate. His retentive memory made him a mine of information as to the habits and habitat of the different species.

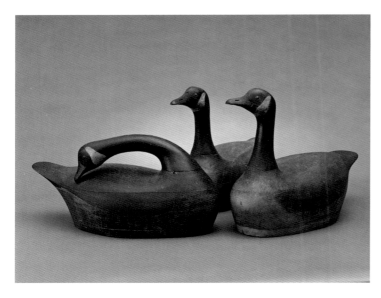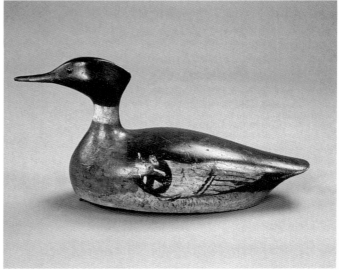

Newton Dexter was a largely self-taught naturalist whose early talents were sufficient enough that he was invited to assist the renowned Harvard scientist Louis Agassiz on an 1865 expedition up the Amazon. The pioneering psychologist William James, who was then a medical student at Harvard, was also an assistant on the trip and became a good friend of Dexter's. Dexter showed such remarkable ability as a naturalist during the trip that Agassiz recommended him to the Smithsonian for a return expedition, after which he gave up the idea of going to college and devoted the rest of his life to scientific studies. He spent several years in the American West, where he lived for a time in a Sioux village and befriended both Sitting Bull and Buffalo Bill Cody, and traveled extensively in pursuit of specimens throughout his life. In later years, Dexter wintered at Oak Lodge in Grant, Florida, a boardinghouse frequented by naturalists and sportsmen, on the St. Johns River south of Melbourne, and spent summers with Gardner in Sakonnet. He died there in 1901 after suffering a heart attack while the two men were out fishing.

ABOVE LEFT: *Canada Geese.* **Attributed to Captain Charles C. Osgood. c. 1850–70. Salem, Massachusetts. Collection of the Shelburne Museum. Gift of Mrs. P. H. B. Frelinghusen.**
According to oral tradition, Osgood (1820–86) carved a rig of hollow geese with removable heads while in port at San Francisco and used them at his hunting camp on the Rowley River, a small stream on Massachusetts's North Shore, surrounded by tidal salt marshes. The Shelburne Museum owns five of Osgood's geese—a sleeper, three upright-headed birds, and a forward-reaching feeder—while two other straight heads are in private collections. The Peabody Essex Museum in Salem owns a gunning journal kept by Osgood, but it does not mention either geese or decoys.

ABOVE RIGHT: *Red-breasted Merganser Drake.* **Attributed to Captain Charles C. Osgood. c. 1870. Salem, Massachusetts. Collection of the Long Island Museum.**
A handful of graceful mergansers are stylistically tied to the same man who carved the "Osgood" geese.

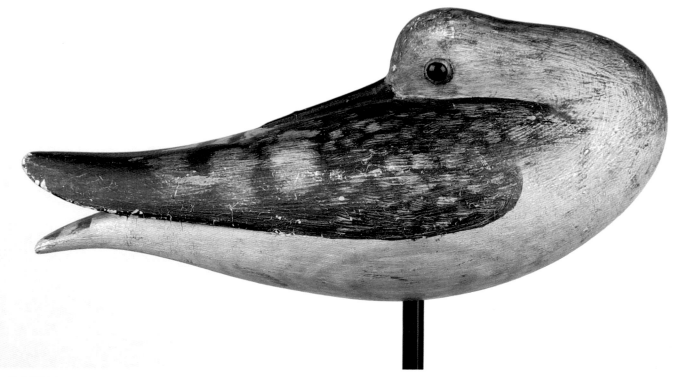

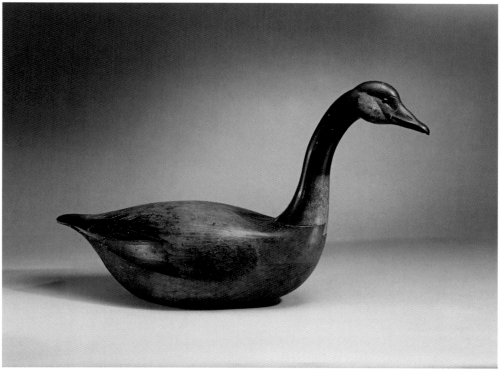

LEFT: *Canada Goose.*
Maker unknown. c. 1890.
Massachusetts. Private
collection. Photograph
courtesy the Houston
Museum of Natural Science,
Houston, Texas.

This extraordinary goose, one
of only three known to have
been carved by the same
masterful hand, has a dovetail
at the base of its neck that
slips into a mortised joint
atop of the body. This one is
numbered "3."

ABOVE: *Yellowlegs.* Melvin
Gardner Lawrence. c. 1910.
Revere, Massachusetts.
Private collection. Photograph
courtesy Decoys
Unlimited, Inc.

Lawrence (1880–1930) had
a camp in the Pinkhorn area
of Brewster, on Cape Cod.
This sleeping shorebird decoy
was carved from a single
piece of hardwood and fitted
with high-quality glass eyes
made for use by taxidermists.
Lawrence's approach to
creating an easy-to-carry
shorebird decoy with an
unbreakable head is unique,
as he gracefully integrated
form with function.

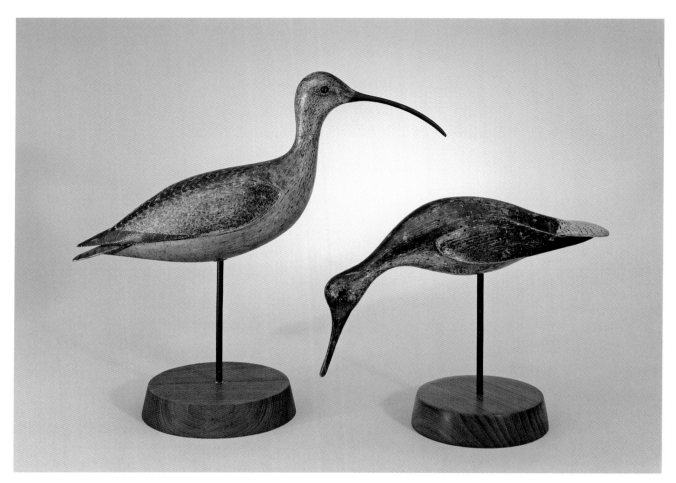

Yellowlegs and Whimbrel.
Frederick Melville Nichols.
c. 1890. Lynn, Massachusetts.
Ex-collection James M.
McCleery, M.D. Photograph
courtesy the Houston
Museum of Natural Science,
Houston, Texas.

Lynn is on the North Shore
of Massachusetts, north of
Boston between Revere and
Salem. Nichols's (1854–1924)
obituary states that he was
"especially interested in
music and birds, giving great
attention to the shore-birds."
Both in form and paint, his
handful of surviving whimbrels,
yellowlegs, and plovers ranks
with the finest ever produced.
He was a member of the Essex
County Ornithological Club,
whose first president was the
renowned painter and etcher
Frank Benson.

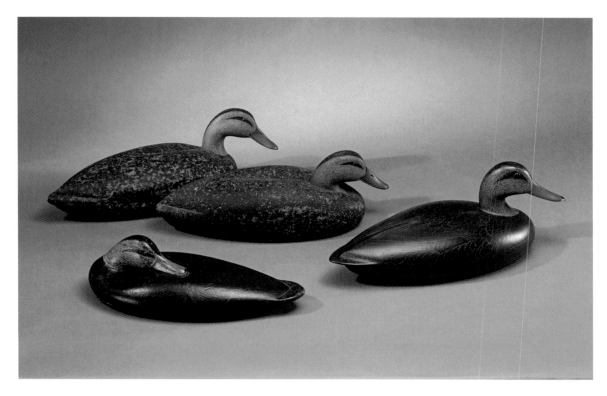

CHAPTER 15

Long Island Sound

Long Island Sound, which separates Connecticut and Long Island, is a large body of relatively shallow water (its average depth is sixty-three feet) fed by numerous freshwater streams and rivers and connected to the Atlantic at both ends. Encompassing 1,320 square miles, the sound is technically an estuary, a place where saltwater and freshwater mix, and its sheltered tidal waters and varied habitats are home to a wide range of plants and animals, including many species of wildfowl.

The two main gunning areas in the sound are on the Connecticut coast, centered around the mouths of the Connecticut River, near Essex and Saybrook, and the Housatonic River, which empties into the sound between Milford and Stratford. The Stratford/Milford area was particularly rich in wildfowl, especially black ducks, scaup, and goldeneyes, all of which frequented the marshes and islands at the Housatonic's mouth. Writing of early days in the area, the renowned Stratford carver and

outdoorsman Charles "Shang" Wheeler recalled, "In those days, it was not difficult for an experienced gunner to gather a fair bag of really good birds almost any day. There were Canada Geese, Brants, Mallards, Blackducks, Pintails, both Blue- and Green-wing Teal, both greater and lesser Scaup (Broadbill), Whistlers, Old Squaws, American and Red-breasted Mergansers (Sheldrake), Buffleheads, an occasional Baldpate and both Whitewing and Surf Scoters (Coots), all in quantities in keeping with the food supply." Decoys of all these species were carved by local hunters and craftsmen from at least the 1850s on.

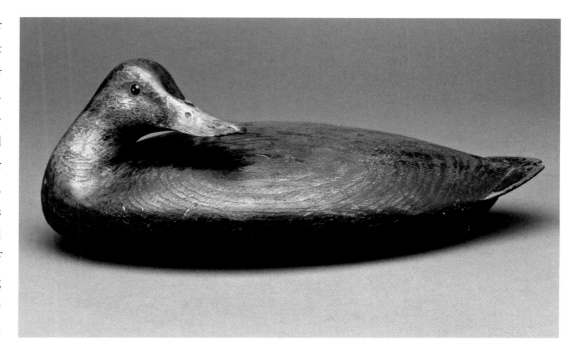

Black Duck. **Albert Davids Laing. c. 1850. New York. Collection of Paul Tudor Jones II. Photograph courtesy Guyette & Schmidt, Inc.** Laing is the first carver known to have varied the positions of his heads to add life to his rigs.

Wheeler also described the most popular and versatile gunning boat used at the mouth of the Housatonic, which was a small, shallow, flat-bottomed skiff, "partially decked over so that sedge or rockweed might be draped over the deck as a camouflage. These boats were anywhere from ten to fourteen feet long, three-and-a-half– to four-and-a-half–feet wide, and just deep enough to conceal the hunter when he stretched out on his back in the boat, with his legs forward under the deck. These boats would float in about three inches of water, slide easily over soft mud and could be used as a sneak boat in the creeks, poled through the sedge or cattails or hidden in the reefs or rocks along the shore." Gunners lay on their backs, rising only to shoot when ducks came in to the decoys they had set out. Wheeler's own skiff is in the collection of Vermont's Shelburne Museum.

Stratford was blessed with a succession of four generations of master carvers, whose influence was enormous and far reaching. The eldest member of what has come to be known as the Stratford school was Albert Davids Laing (1811–86), who codified a style of carving that became particular to Stratford, with hollow, two-piece bodies, protruding chests, and varied head positions. Laing is one of the earliest documented carvers, with extant decoys that are believed to date from the mid-1830s, when he was in his early twenties, to the 1850s. He was born in New Jersey, but his family moved to New York when he was nine, and it was in the bays around that city where he apparently did most of his early hunting. He began keeping a gunning journal when he was twenty, so we know that he was active at an early age. The journal, which still survives, records two stretches of Laing's hunting, from October

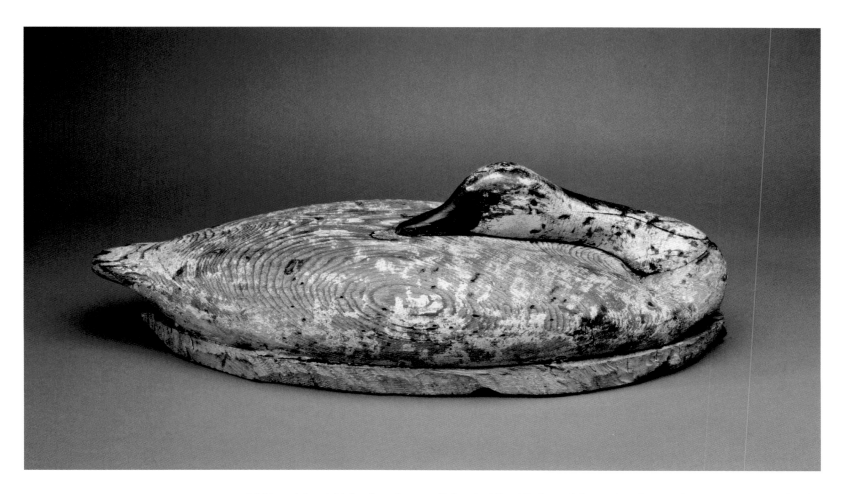

Swan. **Albert Davids Laing. c. 1850. New York. Collection of Paul Tudor Jones II. Photograph courtesy Guyette & Schmidt, Inc.**

This early masterpiece is Laing's only known swan and one of the few sleeping swans ever carved. The elegance of its lines is incomparable. The bird was found on Chincoteague Island in Virginia, where Laing, who is known to have traveled widely, presumably used it. The crude bottom board is a later addition.

1831 to May 1836, when he was living in New York, and from October 1863 to May 1871, after he had moved to Stratford. The twenty-seven-year gap in the record is unexplained, but there is little doubt that Laing was active throughout those years as well.

Laing was an innovator, and he was one of the first, if not the first ever, to make hollow floating decoys, a model that became the norm in many parts of North America in the second half of the nineteenth century. Although he made a few decoys with thin bottom boards, the majority have bodies made of equally sized hollowed-out half forms that are joined at the midseam with a countersunk cut or hand-wrought copper nails and filled with white lead. The use of nonrusting copper nails was yet another Laing innovation. The birds are elegant and deceptively simple, with smooth, rounded body forms; well-delineated bill, nostril, and nail carving; and a shallow groove extending along the center of the back to suggest wings. Flat, pointed tails extend beyond the rounded upper-body form, which ends in a V shape where it meets the tail.

Laing also appears to have been the first carver to vary the head positions of his lures in order to present a more realistic picture to his prey. He carved a number of decoys with their heads nestled into

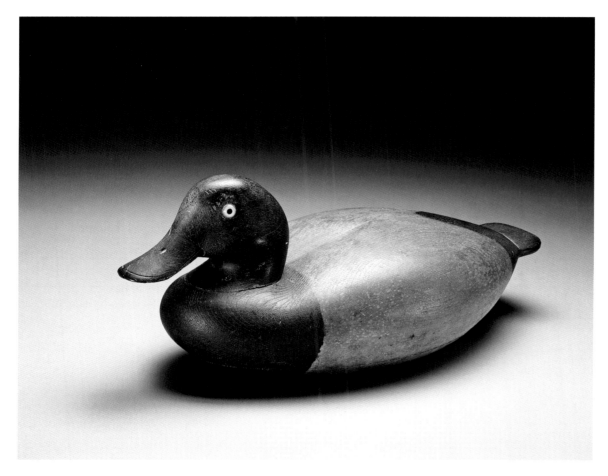

their breasts or turned back 180 degrees on the bodies to imitate sleeping birds. Dating to before 1850, these are the earliest known decoys carved in these naturalistic positions. He also carved thin-bodied birds with flat bottoms intended to be placed on exposed mud flats, and others with their upturned heads arched back over their bodies at an angle. His cousin, Richard Wintars Davids (1825–63) of Philadelphia, also carved hollow-bodied sleepers and turned heads very similar to Laing's that probably date from the late 1840s or early 1850s. It is not known what the relationship between the cousins was, but they probably hunted together, and it seems evident that Davids followed the lead of his older cousin in making decoys for his own use.

Ironically, Laing is not believed to have made decoys in Stratford. By the time the fifty-two-year-old sportsman had moved there in 1863, his carving days apparently were over. He owned 111 decoys at the time of his death, and if he brought that many to Stratford, he probably had all he needed. The decoys he brought with him, however, influenced almost all subsequent craftsmen in the region, most notably his neighbor, Benjamin Holmes, and Shang Wheeler, who owned and gunned over some of

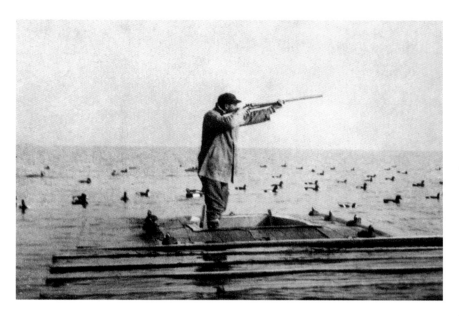

"Shang" Wheeler Shooting from a Battery in Long Island Sound. c. 1900.
Wheeler was an avid hunter and fisherman who worked as a market gunner when he was a young man.

Laing's birds in the late nineteenth and early twentieth centuries and gave some to Joel Barber. Laing shot himself with his fowling piece on October 18, 1886. His will instructed that his 111 decoys, about half of which carried his bold *LAING* brand, be sold for $45. Every collector has done the math.

Laing's neighbor, Benjamin Holmes (1843–1912), who worked as a carpenter and boatbuilder, was twenty when the elder sportsman arrived in Stratford. As a young man, Holmes borrowed and copied some of Laing's decoys, including goldeneyes with heads tucked into their breasts and black ducks with normal, straight heads. The Laing prototypes that Holmes followed had bottom boards about half an inch thick rather than joined halves, and all of his decoys were made in this fashion. Holmes did make a few changes to Laing's designs over the years: He carved the mandibles of the bills; the shoulder grooves on the backs of his decoys are deeper, wider, and shorter than Laing's; and the breasts are narrower and more pointed. Unlike Laing, Holmes made decoys for sale, and he also won a gold medal for a group of a dozen scaup he sent to the 1876 Centennial Exposition in Philadelphia.

Charles Edward "Shang" Wheeler (1872–1949) was an all-around athlete and sportsman who worked as a market hunter and commercial fisherman as a young man and also guided in the Everglades for a number of years. He was an accomplished football player, amateur boxer, and fly fisherman. He served in the Connecticut legislature and on the state fish and game commission, drew cartoons on conservation subjects for the *Bridgeport Sunday Post*, and managed the Connecticut Oyster Farms in Milford from 1912 until his death in 1946. A big, shambling man, Wheeler was nicknamed "Shang" as a boy, after a nearly eight-foot-tall Chinese giant named Chang who worked for showman P. T. Barnum in nearby Bridgeport, and he was known by that moniker throughout his life.

Strongly influenced by both Laing and Holmes, Wheeler created working decoys, including some with solid cork bodies and inset wooden tails, and dozens of show birds in decoy form that were intended solely for exhibition. He also carved life-size half models of salmon, trout, and striped bass that he and his friends caught, as well as full-size ornamental plovers, starfish, crabs, a passenger pigeon, a macaw parrot on a perch, and a sandhill crane that is now in the collection of the Abby Aldrich Rockefeller Folk Art Museum at Colonial Williamsburg. He took the grand prize at the first decoy show and carving competition ever held, which was organized by Joel Barber in 1923, and exhibited his own carvings alongside Barber's collection of historic decoys several times at Abercrombie and Fitch's

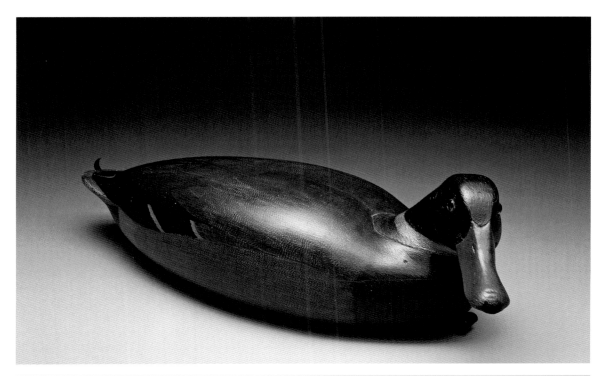

Mallard Drake. Charles E. "Shang" Wheeler. 1923. Stratford, Connecticut. Joel Barber Collection, The Shelburne Museum.
This bird and its mate won the grand prize at the first decoy-carving contest ever held. The sophistication of Wheeler's work astonished other carvers of his time.

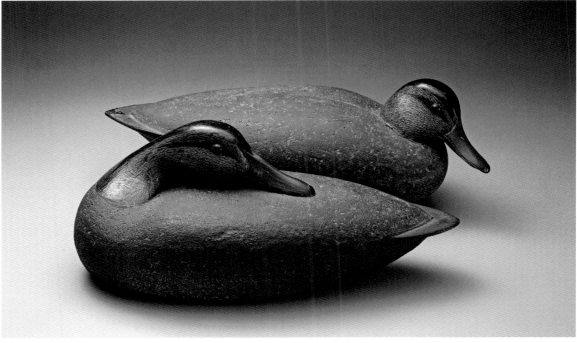

Black Ducks. Louis Rathmell. 1941. Danbury, Connecticut. Collection of the Shelburne Museum.
These two birds, with Fibracork bodies and wooden tails and heads, were part of Rathmell's own gunning rig.

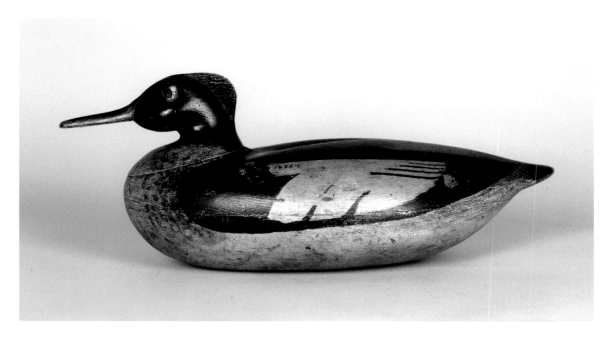

sporting goods store in New York City. He gave the pair of mallards that won the 1923 grand prize to Barber, and they are now in the collection of the Shelburne Museum. Wheeler carved only for his own use, as had Laing, and also made decoys and other carvings as gifts for his friends. He was one of the most sophisticated carvers of his day, and, along with Elmer Crowell, one of the first to create decoys that were intended for the mantelpiece rather than the marsh. The Charles E. Wheeler Wildlife Sanctuary, which encompasses a number of the islands where he hunted at the mouth of the Housatonic, was named in honor of his conservation work.

Louis Rathmell (1898–1974) was the most accomplished fourth-generation carver in the Stratford style. He lived in Danbury, northwest of Stratford on the New York state border, but hunted at the mouth of the Housatonic, especially on Knell's Island, an extensive marshland on the Milford side of the river. Rathmell shaped the bodies of his decoys from Fibracork, a dense and sturdy commercial material, adding wooden heads and inserted wooden tails. Wheeler, whom he rivaled both as a carver and painter, provided the model for Rathmell, and his work is almost indistinguishable from the older master's. Like Laing and Wheeler, Rathmell varied the head positions of birds in his working rig, and, like Wheeler, he also carved wooden exhibition decoys that he entered in competitions.

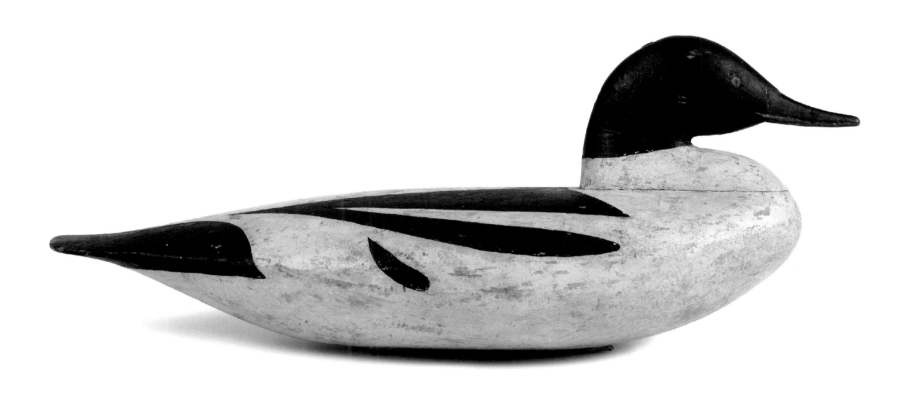

Common Merganser Drake.
**Attributed to Samuel Collins
Jr. c. 1880. Essex, Connecticut.
Private collection. Photograph
courtesy Northeast Auctions.**
Sam Collins Jr. (1854–1948)
was an oysterman, carpenter,
boat builder, and punter who
also was the most skilled
decoy maker on the lower
Connecticut River. All of his
solid-bodied decoys have
pronounced breasts. Some
have attributed birds like this
one to Collins's father, but
there is no solid evidence that
he ever carved.

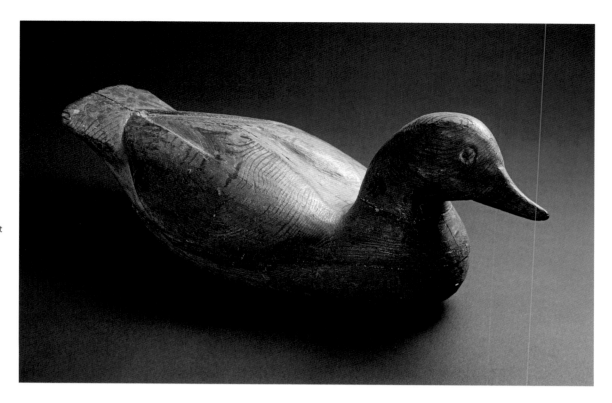

Herring Gull. Captain Ketchum Sr. c. 1860–75. Copiague, Long Island, New York. Joel Barber Collection, The Shelburne Museum, Shelburne, Vermont. This early, hollow, floating gull was given to Barber by Captain Al Ketchum, who recalled shooting brant with his father and grandfather when he was a boy. It was his job to load the guns and keep the gunning box bailed out. Ketchum told Barber that both men made gull decoys that, in Barber's words, were "anchored off one side of the main rig to give further assurance that all was well at the ambush." Barber recalled, "The gull was older than his memory. It is always reminiscent of a shivering boy, crouching at the feet of his father and grandfather, in the bottom of a hazy 'box'; alternately bailing and loading guns in a desperate effort to stem the tide of birds. Every time I see that gull I hear again the end of his story. 'Why some nights, Mr. Barber, I couldn't hear at all, from the shooting over my head all day.'"

CHAPTER 16

The Great South Bay and Other Long Island Lagoons

L ong Island was a gunner's paradise in the nineteenth and early twentieth centuries. Close to New York but still largely undeveloped, the aptly named island, which juts 118 miles east into the Atlantic, teemed with migratory and native birds of all kinds. Wealthy sportsmen traveled from the city by rail to shoot at the island's many resorts and private gunning clubs, and native island baymen, who hunted and fished to feed their families, supplied the city "sports" with decoys, boats, and guide services. Long Island was also probably the region in the country where birds were first hunted commercially; the demands of the game markets and restaurants of New York provided steady income to Long Island market hunters as early as the 1830s. The millinery trade added another dimension to Long Island hunting in the second half of the nineteenth century, and many gunners specialized in hunting gulls, terns, and herons for their feathers.

The bulk of Long Island's hunting was done on the south side of the island. The Great South Bay, the island's major early hunting ground, is the largest of a string of lagoons—shallow coastal bodies of saltwater separated from the ocean by barrier islands—stretching for ninety miles along the south shore, from Coney Island in Brooklyn east to Southampton. Other barrier island protected lagoons on the south shore include Jamaica Bay, Oyster Bay, Moriches Bay, and Shinnecock Bay. The Great South Bay is bounded by Fire Island, which shelters it from the open ocean, as well as by the eastern end of Jones Beach Island. Encompassing a third of Long Island's ninety-mile stretch of barrier lagoons and 151 square miles of water, it is the largest shallow saltwater bay in New York State and the only one of Long Island's south shore bays that is fed by major rivers (the Carmans and Connetquot).

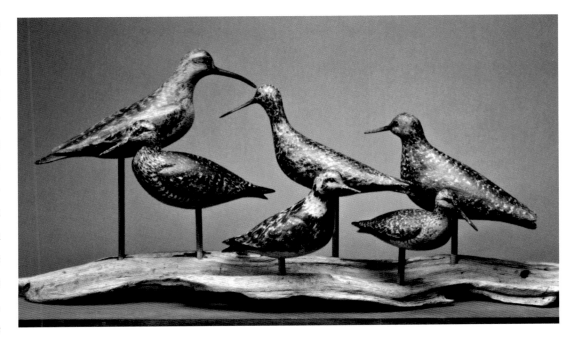

BACK ROW: *Whimbrel, Greater Yellowlegs or Willet* (High head, Yellowlegs or Willet).
FRONT ROW: *Yellowlegs, Ruddy Turnstone, Dowitcher* (fall plumage). Attributed to William Bowman. c. 1890. Lawrence, Long Island, New York. Collection of Paul Tudor Jones II. Photograph courtesy Guyette & Schmidt, Inc. Whoever he was, the carver currently identified as Bill Bowman was an incomparable craftsman who captured the essence of every bird he depicted in wood and paint. He made very few turnstones.

In addition to game and feather hunting, more shorebird gunning was done on Long Island than in any other part of the country. Whimbrels, black-bellied and golden plovers, yellowlegs, dowitchers, red knots, turnstones, sanderlings, and many other shorebird species frequented the marshes and beaches of Long Island's south shore in great numbers, and the birds were avidly hunted from the Great South Bay to Montauk Point. They were popular table fare all over the island, especially during the summer months, when ducks and geese were scarce, and they were also a staple of the game stands in New York's Fulton and Washington markets, where they were purchased by city businessmen and restaurateurs.

Several members of the accepted pantheon of shorebird decoy carvers, including Obediah Verity, William Bowman, John Dilley, and Thomas Gelston, left hundreds of their decoys on Long Island. However, while the work attached to each of these names is utterly distinctive, only Gelston has been positively identified, and it is not clear whether he actually carved decoys or merely hunted over them. The others are shadowy figures, the details of whose lives have thus far resisted historical research to one extent or another. Verity (poss. 1813–1901), of Seaford, was a bayman, remembered by his neighbors as a lifelong bachelor who spent his days following the sea. However, while this carver's name, marital status, and habits are known, it is not clear which of the six Obediah Veritys who lived in Seaford during

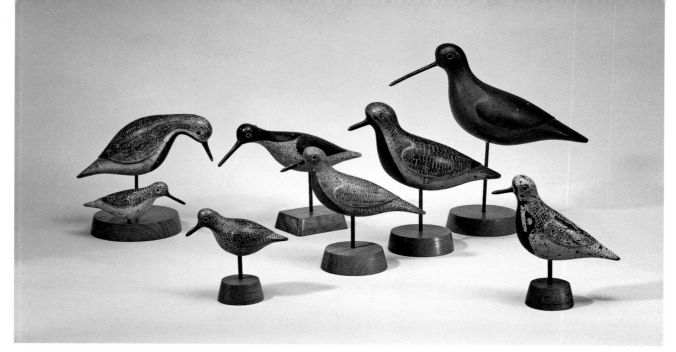

LEFT TO RIGHT: *Black-bellied Plover* (feeding position), *Red-backed Sandpiper, Sanderling.* Attributed to Obediah Verity. c. 1880. Seaford, Long Island, New York. *Yellowlegs.* Attributed to Smith Clinton Verity. c. 1880. Seaford, Long Island, New York. *Red Knot, Black-bellied Plover, Whimbrel, Ruddy Turnstone.* Attributed to Obediah Verity. c. 1880. Seaford, Long Island, New York. Ex-collection James M. McCleery, M.D. Photograph courtesy the Houston Museum of Natural Science, Houston, Texas.

Obediah Verity carved almost every shorebird species that was hunted on Long Island. The plover at left with its head bent in a feeding position is his signature form. Smith Clinton Verity (1845–1920) was probably related to Obediah, but Verity was a very common name in Seaford, and the histories of both men remain shadowy.

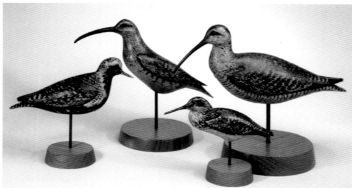

LEFT TO RIGHT: *Black-bellied Plover, Whimbrel, Lesser Yellowlegs, Whimbrel.* Attributed to William Bowman. c. 1890. Lawrence, Long Island, New York. Ex-collection James M. McCleery, M.D. Photograph courtesy the Houston Museum of Natural Science, Houston, Texas.

The yellowlegs, its head tucked into its chest as if facing into a bitter cold wind, is Bowman's rarest form. A similar yellowlegs is in the collection of the Long Island Museum, and a unique hunkered whimbrel is privately owned. The large whimbrel at right is hollow, with vertical body halves that are joined with white lead and hand-cut square nails. All the others have solid bodies.

the nineteenth century he was. Obediah the carver fashioned solid-bodied ducks, herons, terns, and shorebirds. His ducks and shorebirds typically have plump, rounded bodies, with relief-carved S-shaped wing contours, V-shaped primaries, and round, relief-carved eyes. The backs of his shorebirds carry stippled daubs of paint in imitation of mottled light and dark feather patterns, and the bills are round and tubular. Verity's most distinctive form is a feeding shorebird, with its bulbous head bent down and forward, its fixed eyes seemingly intent on some choice morsel before it. The outline of the bending form is a series of graceful unbroken curves that extend from the tip of the tail over and around all sides of the body, neck, and head.

According to the oral tradition of the Herrick family, who owned many of his duck and shorebird decoys and donated a number to the Long Island Museum, Bill Bowman (poss. 1824–1906) was a cabinetmaker from Bangor, Maine, who traveled to Lawrence on Long Island each summer to hunt shorebirds. A Bill Bowman did exist; he is mentioned twice in Harold Herrick's 1891 gunning journal, but there is no mention of him carving. Recent

research has suggested the possibility that the ducks, brant, and geese attributed to Bowman by Harold Herrick may have actually been carved by a Shinnecock Indian named Charles Sumner Bunn, although the evidence is far from conclusive and, although they were clearly made by the same hand, no solid connection has ever been documented between the floating lures and the shorebirds attributed to Bowman. Whoever he was, this carver produced decoys of the full range of shorebird species hunted on Long Island in the late 1800s, including whimbrels, black-bellied and golden plovers, dowitchers, willets, yellowlegs, and ruddy turnstones. The shorebirds are *sui generis*, carved to suggest nuances of body forms and underlying bone and muscle that no other carver even attempted. All of Bowman's decoys are extremely lifelike, and his best works, which include his whimbrels and hunkered yellowlegs, transcend the decoy genre to rank among the finest bird portraits created by any American artist.

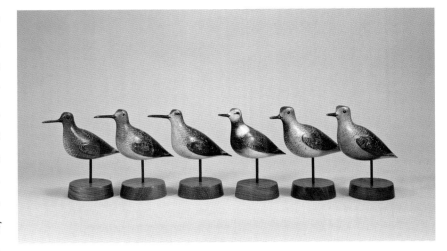

LEFT TO RIGHT: *Dowitcher* (breeding plumage), *Dowitcher* (late eclipse plumage), *Dowitcher* (fall plumage), *Ruddy Turnstone*, *Black-bellied Plover* (fall plumage), *Golden Plover* (fall plumage). John Dilley. c. 1890. Quogue, Long Island, New York. Ex-collection James M. McCleery, M.D. Photograph courtesy the Houston Museum of Natural Science, Houston, Texas. Dilley painted shorebirds in a wider and more precisely observed array of seasonal plumage variations than any other decoy maker.

John Dilley is nearly as insubstantial as Bowman, little more than a name signed in elegant script on the bottom of a number of decoys and said to have been stenciled on a single box of shorebirds made in the latter decades of the nineteenth century. Dilley also marked the names of the species—"Dowitch, Curlew, Green Back Plover, Brant Bird, Robin Snipe, Large Yellow Leg, Willet, Black Breast Plover"— on the bottom of many of his birds. Although the first group of six of these shorebirds was discovered in New Jersey, dozens of others that were clearly carved and painted by the same highly skilled hand have turned up on Long Island, so it is assumed that Dilley worked there. Unfortunately, research has not revealed one scrap of solid evidence about his identity, and the trail remains cold.

Whoever the man who called himself Dilley was, the exquisitely detailed paint on his shorebirds is unmistakable. His highly refined paint is the most sophisticated of any decoy maker, and his carved forms, though lacking the gestural variety of other Long Island craftsmen or Bill Bowman's detailed anatomical modeling, are dead-accurate representations of the various species he painted so beautifully. He knew his shorebirds intimately and painted a wider variety of seasonal plumage variations than any other craftsman. He painted dowitchers, for example, in vividly detailed breeding, eclipse, and fall plumages, each rendered with meticulous attention to every nuance of their coloring. In an essay on shorebird decoys published in the book *The McCleery Auction*, collector and scholar Lloyd Griffith called Dilley's "soft, precise fine art strokes reminiscent of cloisonné enamel." Shorebird decoy expert Gigi Hopkins, who has scrutinized Dilley's work for years, says the birds were painted in methodical steps, using many different brushes that he made specifically for this work:

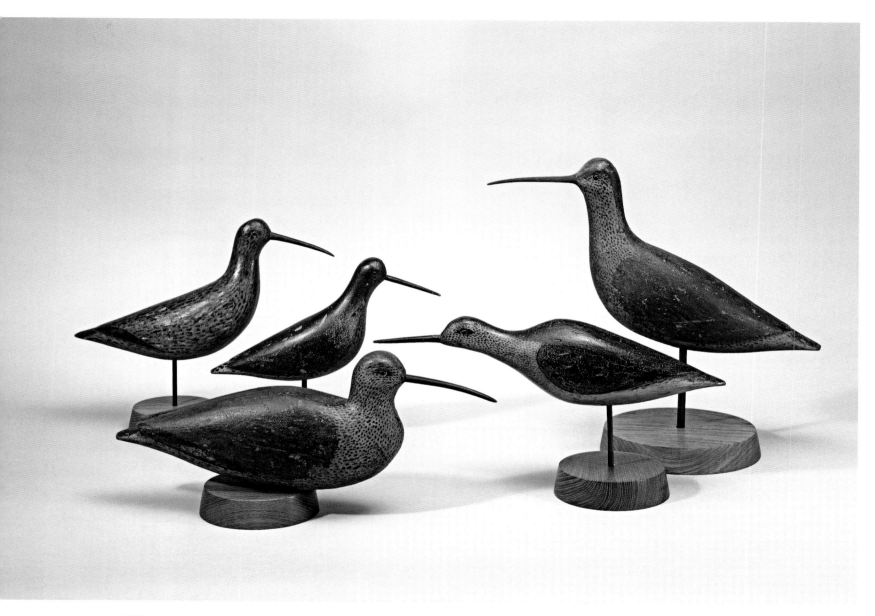

LEFT TO RIGHT: *Willet, Whimbrel* (resting position), *Dowitcher, Yellowlegs* (running position), *Whimbrel.* Attributed to Thomas H. Gelston. c. 1890. Bay Ridge, New York. Ex-collection James M. McCleery, M.D. Photograph courtesy the Houston Museum of Natural Science, Houston, Texas. Gelston carved shorebirds in a wide variety of positions. The resting whimbrel suggests a bird lying on the sand with its legs tucked under its body.

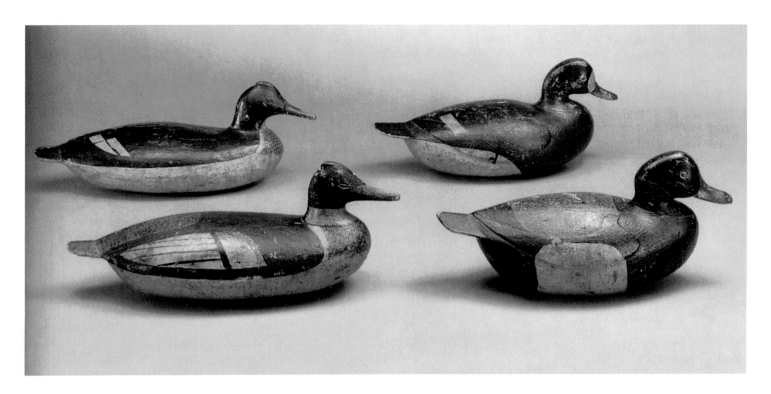

He primed the birds first with white or gray and allowed that to dry. Then he laid on ground colors with subtle pounced blending. Those tacked up or dried. Black primaries and the curved lines across the wing were added, and black was applied to the beak. These tacked or dried. Next came white secondary/primary feather details, curved wing lines and C-crescents. Finally, black C-crescents—although sometimes, the black detail went on first with white over it. There are also pounced dabs of color on the birds' back and rump—ochre on golden plovers, b & w/grey on beetleheads, browns on dowitchers, white on willets. Dilley held the birds in every possible position during the involved process he developed and penciled species names on the bellies as he worked, which explains why they run in different directions. He was using shorthand—dowitch, BBP, Golden—in between steps, to keep track of the species each bird was becoming. That also explains why some pencil is found under the primer coat, some on the paint itself. They were notes to himself. After he finished painting, he added the full species name in black script. That was for the client.

*LEFT: **Pair of Red-breasted Mergansers.** RIGHT: **Pair of Scaup.** Attributed to Obediah Verity. c. 1880. Seaford, Long Island, New York. Ex-collection James M. McCleery, M.D. Photograph courtesy the Houston Museum of Natural Science, Houston, Texas.*
Like his shorebirds, Verity's ducks are plump and solid bodied, with carved eyes and S-shaped, relief-carved wing outlines.

One of those clients was Henry C. Squires, who ran one of the most successful sporting goods businesses in New York City in the latter decades of the nineteenth century. Lawrence B. Romaine, the author of *A Guide to American Trade Catalogs, 1744–1900*, has called Squires's mail-order catalogs, which included illustrations by the likes of Frederick Remington and A. B. Frost, "among [the] most outstanding in the whole field of American advertising." The Squires firm's stamp has been found on the bottom of several Dilleys, and his 1891 catalog advertises: "Snipe decoys; hand made, shaped and painted from life; the finest decoys ever produced; can be supplied only in limited

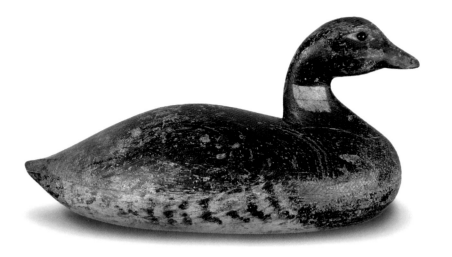

ABOVE: **Brant.** Attributed to William Bowman. c. 1890. Lawrence, Long Island, New York. Private collection. Photograph courtesy Decoys Unlimited, Inc.
Bowman's masterful floating lures bear many similarities to the shorebirds that are also attributed to his hand. Of this example, shorebird expert Gigi Hopkins, who has done conservation work on many Bowman shorebirds, commented, "It took only seconds to realize that whoever made the shorebirds also made this brant. The flash was that strong. And the thing that clinched it wasn't the paint, though that matches perfectly. It was the brant's expression. Bowman shorebirds all share this doe-eyed look of uneasiness and slight anxiousness, which is exactly what you see when banding live shorebirds in-hand. Amazingly, this brant has the very same expression."

BELOW: **Great Blue Heron.** Attributed to Charles Sumner Bunn. c. 1900. Southampton, Long Island, New York. The Gene & Linda Kangas Collection of American & International Folk Art.

Bunn (1865–1952), a member of the Shinnecock tribe, was a well-known decoy maker and professional guide who worked for wealthy sports who traveled to the tip of Long Island. One of his printed business cards advertised, "SNIPE-DUCK-GOOSE-SHOOTING" and "PLAIN OR FANCY DECOYS."

quantities. $12 per doz." There can be little doubt that those $1-a-piece shorebirds were carved and painted by Dilley.

Thomas H. Gelston (1851–1924) was a genuine flesh-and-blood historical figure, a scion of a prominent Bay Ridge, Brooklyn, family for whom the neighborhood's Gelston Avenue was named. His father was a prosperous developer and businessman who owned considerable property in Fort Hamilton, near the site of the current Verrazano-Narrows Bridge, and young Thomas is believed to have hunted ducks and shorebirds in the salt marshes of Sheepshead Bay, off the southeast side of Brooklyn near Coney Island. He apparently inherited a considerable amount of money when his father died and led the life of a gentleman sport. He is associated with a variety of shorebird decoys for his own use as well, a few brant, black ducks, and at least two pairs of red-breasted mergansers. All of his decoys are solid-bodied, in the Long Island manner, many with bodies made of cork. His paint is simple but sure, with multiple dots of color used to represent feathering, and his forms are animated and powerful.

Frank Kellum of Babylon (1858–c. 1930) was a colorful bayman who worked as a housepainter. According to Joel Barber, he was sufficiently skilled with a brush that a group of New York sportsmen sponsored him to study art in the city, but he did not find formal schooling to his liking. He made distinctive mergansers and curlews and at least three stickup gull decoys, two of which were collected by Joel Barber, who lived in Babylon for many years. Like many other Long Island gulls, Kellum's decoys were made to be used as adjuncts to brant rigs, placed near the brant decoys to enhance the illusion of safety below. Barber said he considered the use of such confidence decoys "a gesture of superstition, a gunner's lucky charm rather than a lure."

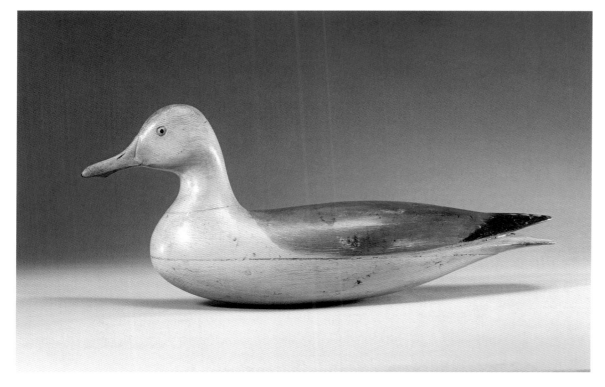

CHAPTER 17

Barnegat Bay and the Jersey Shore

B arnegat Bay, from early times the center of New Jersey's coastal hunting grounds, is a thirty-mile-long estuary of brackish water protected from the Atlantic by a barrier island. Similarly protected bays, salt marshes, and river mouths extend south to Cape May, a Victorian resort community at the tip of the state that has long been one of America's prime birding spots because of the remarkable number of migratory species that pass through during the course of the year. The brackish water of Barnegat and other New Jersey bays and river mouths supported extensive beds of wild celery and eelgrass in the nineteenth century and attracted large numbers of brant, geese, and ducks, while the state's extensive sandy beaches and mud flats provided ideal habitats for a diverse range of shorebirds. Red knots and ruddy turnstones, rarely seen to the north, were common, as were whimbrels, black-bellied plovers, dowitchers, yellowlegs and various small sandpipers. Herons, egrets, and gulls, which were hunted for their feathers, were also plentiful.

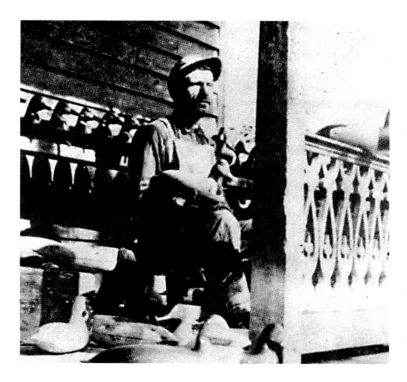

Harry V. Shourds carving on his porch. c. 1910.

The bountiful natural resources of the Jersey coast supported many of the region's inhabitants, who hunted, fished, and guided sportsmen from nearby New York and Philadelphia. The same rail system that brought the sports and thousands of big-city tourists to the Jersey shore from the 1850s on also supported a substantial number of market gunners, who were shipping their takes to city markets as early as the 1840s.

The state's predominant floating decoy form, which was fully developed before the Civil War, was the so-called dugout, with a body made of equal halves of hollowed cedar. Dugout decoys were designed for use in the ubiquitous "sneakbox" boats long employed by Jersey gunners. Sneakboxes were shallow, round-bottomed boats, typically twelve to fourteen feet long and about four feet wide. Fitted with a sail, they were equally at home in the open ocean and on winter ice, for which use they were painted white and equipped with a pair of runners. Because the sneakboxes were small and decoys had to be stored on the aft deck, dugout decoys were made smaller than those in other regions. The bodies of dugouts were smooth, with round bottoms and separately attached pine heads that almost always faced straight forward for use as handles by the gunners. Because they were used in saltwater or brackish water and were therefore often in need of repainting or touch-ups, dugout decoy plumage patterns were usually just outlined in blocks of solid colors. A flat pad or inlet weight was added to the bottom for ballast and balance in the sea.

New Jersey's most influential decoy maker was Harry Vinucksen Shourds (1861–1920) of Tuckerton, a seaport on Great Bay, at the mouth of the Mullica River north of Atlantic City, which was a commercial fishing hub in the nineteenth century. Shourds was one of North America's most prolific and efficient decoy makers. A guide and housepainter as a young man, he became a full-time decoy maker in the 1880s and shipped his birds all over the country in barrels loaded onto railcars in Tuckerton. Supposedly able to complete the head of a decoy while sitting in the barber's chair, he made thousands of birds over the course of his career, probably more than any other individual carver.

Despite his prodigious output, Shourds's lures are uniformly well made, with a graceful economy of means matched by few other carvers. That economy extended to his weights, which he made by pouring lead into a rectangular hole he chiseled in the bottom of his floating lures. In addition to hollow ducks, geese, and brant, Shourds also crafted solid-bodied shorebirds representing

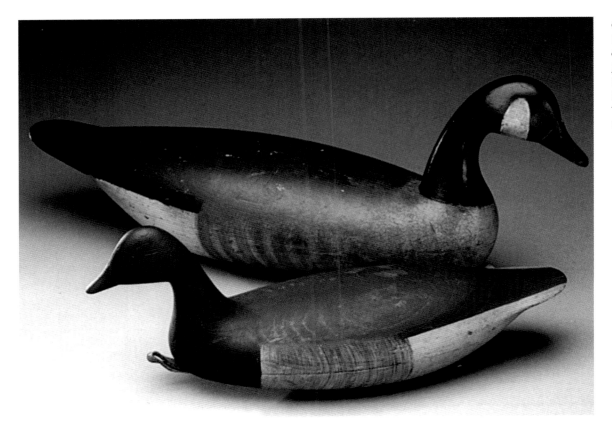

the full range of common New Jersey species in a variety of seasonal plumages. He also carved a few flying brant, which were mounted on sticks and had attached wings of canvas stretched over a wire frame, and at least two gulls, which could be used either as stickups of floaters. The gulls, which have long, sleek bodies, carved split tails, and detailed bill carving that includes the pronounced gonydeal angle (a ridge along the tip of the lower mandible at the junction of the two joined halves that is prominent in gulls), are arguably Shourds's masterpieces, representing the essence of his deceptively simple style.

Nathan Rowley Horner (1881–1942), a generation younger than Shourds, lived near the master in West Creek and made decoys in the style of his mentor. He was much less prolific than Shourds, but his duck, brant, and goose decoys are among the most refined made on the New Jersey shore, with spare, elegant lines and subtly blended paint. He weighted his decoys with bevel-edged sheets of lead that he attached with brass screws, another measure of his precision and meticulous attention to detail.

In addition to Shourds and Horner, who also carved a few shorebirds, New Jersey produced a number of other accomplished shorebird carvers, some whose identities are known and others who will

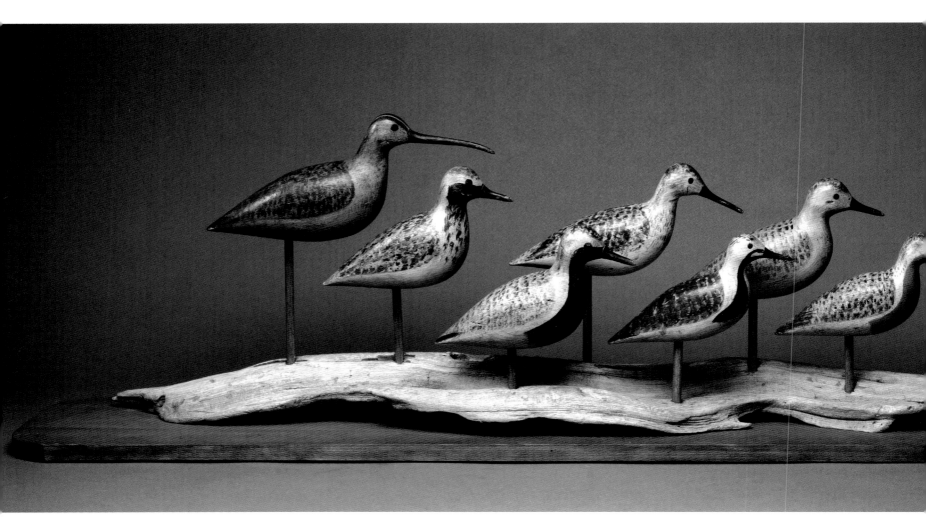

LEFT TO RIGHT: *Whimbrel,*
Black-bellied Plover (eclipse
plumage), *Black-bellied*
Plover (breeding plumage),
Yellowlegs, Ruddy Turnstone
(breeding plumage), *Black-*
bellied Plover (fall plumage),
Red Knot (breeding plumage).
Harry Vinucksen Shourds.
c. 1890. Tuckerton, New
Jersey. Collection of Paul
Tudor Jones II. Photograph
courtesy Guyette and
Schmidt, Inc.
Turnstones by Shourds are
extremely rare.

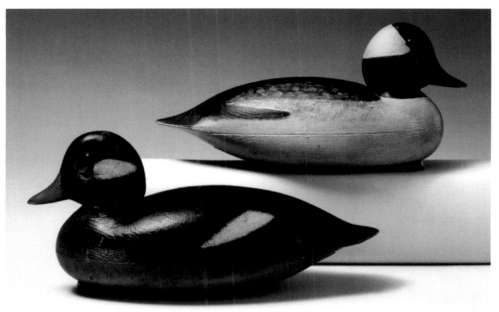

probably always remain anonymous. Taylor Johnson (1863–1929) of Point Pleasant was a bayman and professional carver who made equally fine ducks and shorebirds, both of which had more elongated forms than the Jersey norm. Again breaking with regional tradition, he did not sand the surfaces of his shorebirds smooth, instead leaving knife marks that clearly show under his simple paint patterns. His birds all have long, thin necks, small heads, and proportionally narrow bills. Lou Barkelow (1870–1952) of Forked River also made simply carved and painted shorebirds that manage to capture the essence of the species he portrayed. His yellowlegs share Johnson's elongated approach to form. Although a few ducks by his hand are known, Dan Lake Leeds (1852–1922) of Pleasantville concentrated primarily on shorebirds. All of them have raised-wing carving, split tails, and detailed paint patterns. The intricate lines that delineate his plumage are unmatched among New Jersey carvers. Another of New Jersey's most skilled shorebird carvers was an anonymous artisan who carved a small group of bold long-billed curlews and Hudsonian godwits, a rarely encountered species. The birds were found in Brigantine, on a barrier island just north of Atlantic City. Both species have bodies made of highly unusual vertically laminated halves, and their wings are carved in low relief. The curlews are particularly impressive, measuring twenty-three inches from tail to tip of the bill, with glass eyes and properly decurved wooden bills that are nearly ten inches long.

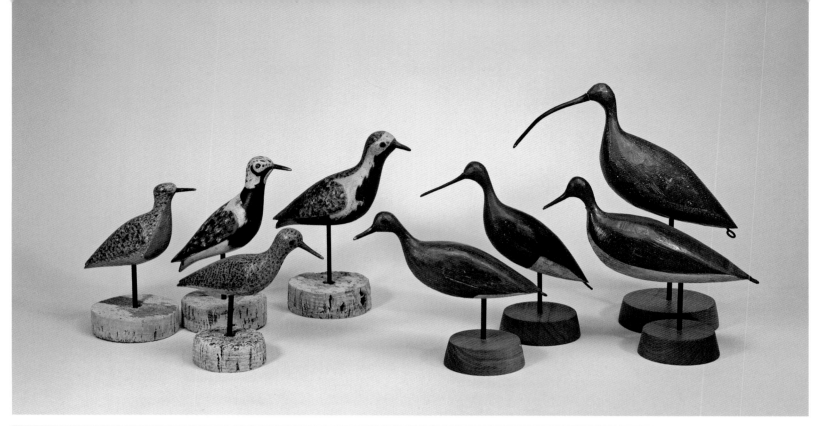

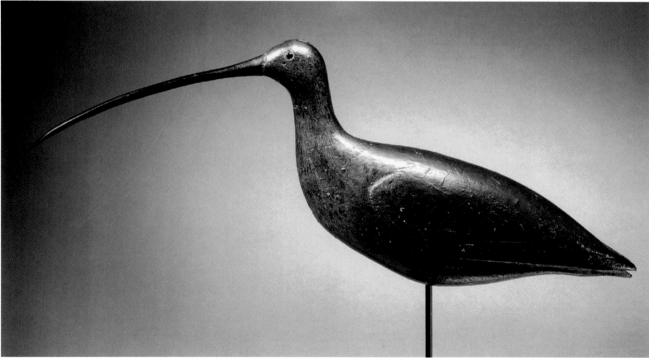

LEFT: *Long-billed Curlew.*
**Maker unknown. c. 1900.
Brigantine, New Jersey.
Private collection. Photograph
courtesy David A. Schorsch—
Eileen M. Smiles American
Antiques.**
Only three of these massive
birds are extant, and none
retains all of its appropriately
long original bills. Another
is in the collection of
the Shelburne Museum.
This bird's bill has been
professionally restored.

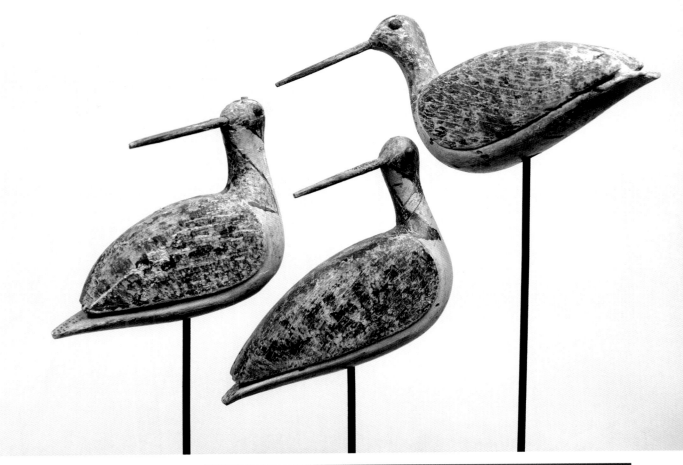

OPPOSITE TOP, LEFT TO RIGHT:
Red Knot, Ruddy Turnstone, Lesser Yellowlegs, Black-bellied Plover. Daniel Lake Leeds. c. 1890. Pleasantville, New Jersey. *Red Knot, Dowitcher, Whimbrel, Yellowlegs.* Taylor Johnson. c. 1900. Point Pleasant, New Jersey. Ex-collection James M. McCleery, M.D. Photograph courtesy the Houston Museum of Natural Science, Houston, Texas.

RIGHT TOP: *Dowitchers.* Attributed to George Applegate. c. 1880. Barnegat, New Jersey. Courtesy Collectable Old Decoys. New Jersey shorebirds with turned heads are uncommon.

RIGHT: *Canada Goose.* Maker unknown. c. 1900. Barnegat Bay area, New Jersey. Collection of The Shelburne Museum. This rare hollow-bodied stickup is slightly flat sided.

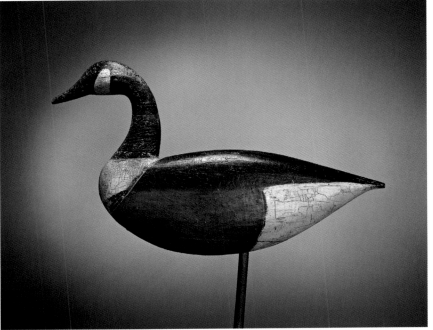

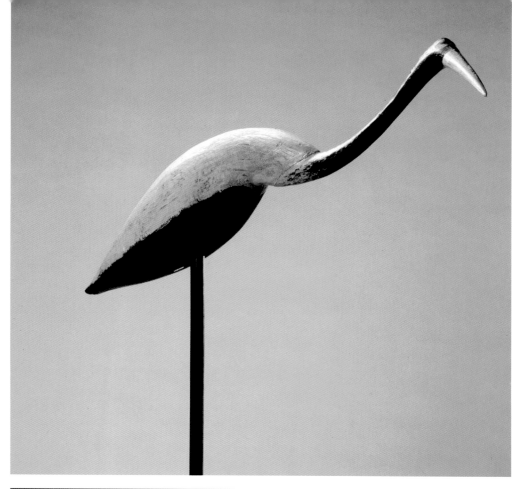

LEFT: *Great Blue Heron.*
Maker unknown. c. 1900.
New Jersey. The Michael
and Julie Hall Collection,
Milwaukee Museum of Art.
The maker of this simple but
unusually fluid heron turned
a normal body form upside
down to create a sense of
forward movement. The head
and neck were carved from a
tree root.

BELOW: *Group of Yellowlegs.*
Louis Barkelow. c. 1890–1910.
Forked River, New Jersey.
Collection of Paul Tudor
Jones II. Photograph courtesy
Guyette & Schmidt, Inc.
These birds are slightly flat
sided, which is typical of
Barkelow's work.

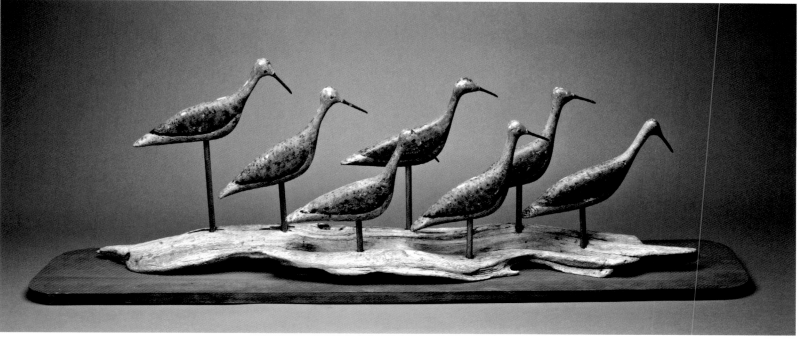

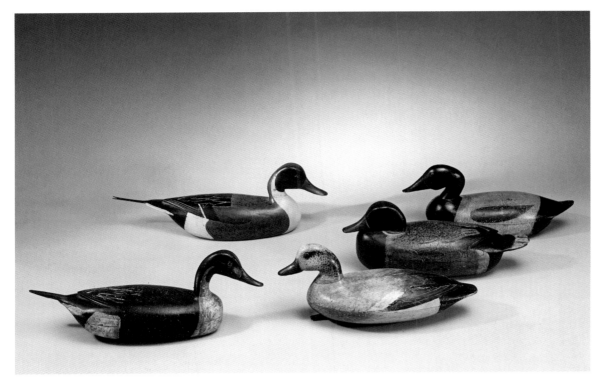

CHAPTER 18

The Delaware River

The Delaware River, which demarks a considerable portion of the border between Pennsylvania and New Jersey and most of the border between Delaware and New Jersey before flowing into Delaware Bay, provided a rich and varied habitat for dabbling ducks such as pintails, mallards, teal, wigeons, black ducks, and gadwalls. The river meets tidewater near Trenton, New Jersey, 130 miles above its mouth, and its character gradually changes as it flows south from that point, widening and slowing considerably as it approaches the sea, with extensive marshes flanking it on both sides.

The Delaware River differed from most North American wildfowling regions in that market gunning was not a major part of its tradition; almost all of its hunters were local sportsmen, many of whom carved decoys for their own use. And, because relatively few decoys were required, the quality standards of hunters and carvers tended to be high, with fine craftsmanship being the rule.

Hunter Approaching Decoyed Birds in a Boat Camouflaged with Grass. Etching. c. 1880. This method required highly realistic decoys and was practiced on the Upper Delaware River.

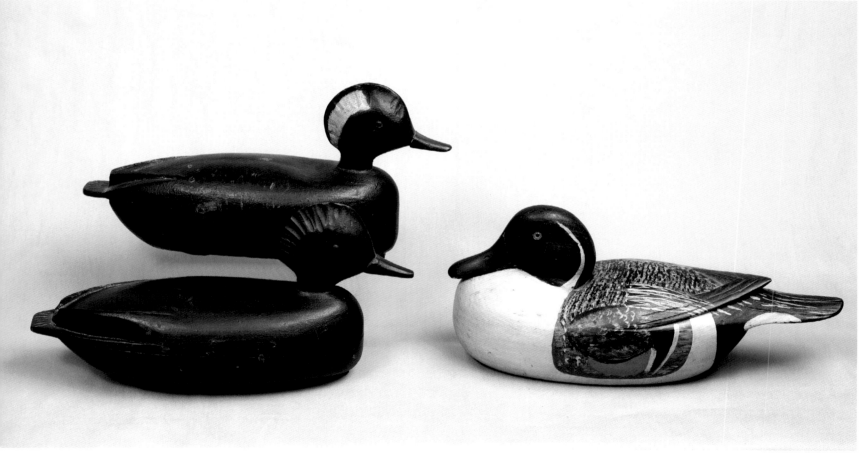

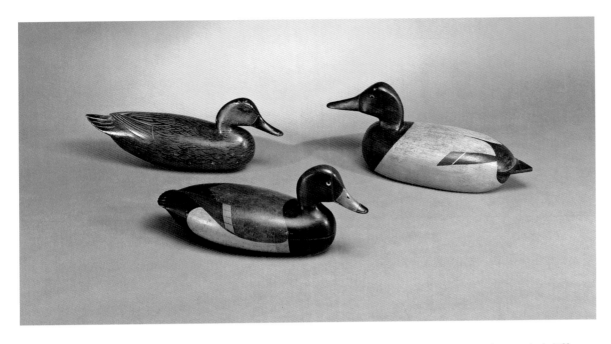

The increasingly brackish water and slower flowing currents of the lower river demanded different hunting techniques and decoy forms than did the swifter largely freshwater found upriver between the mouth of the Rancocas River, which empties into the Delaware a few miles north of Philadelphia, and Trenton, at the top of the last big bend in the river. Hunters in this portion of the river anchored rigs of thirty to forty-five decoys so that they faced upstream and then rowed upriver to wait for wild birds to come in. Their boats were sculls, so called because they not only could be rowed with a pair of side-mounted oars but also could be maneuvered quietly downstream with a single sculling oar mounted at the stern. Hunters covered their sculls with marsh grass so that they were well camouflaged when they lay on their backs to patiently await their prey. When wild birds were lured in by the anchored decoys, the hunters quietly sculled within gunning range. After shooting and retrieving their kill, they would row upstream again to repeat the process.

Because this approach required decoys that could deceive birds that were close enough to give them considerable scrutiny, a higher degree of realism was required than in most other regions of the country. The style setter on the upper Delaware was John English (1852–1915), who lived in Florence, New Jersey, at the bottom of a wide bend in the river south of Trenton. English was both a masterful carver and painter, and unlike any decoys that came before, his birds had raised, carved wing tips, carved tail feathers, and plumage patterns that were painted with greater detail than the regional norm. Most of his birds have straight heads, some of them with quite long high necks, but he also made a few with their heads tucked into a contented position.

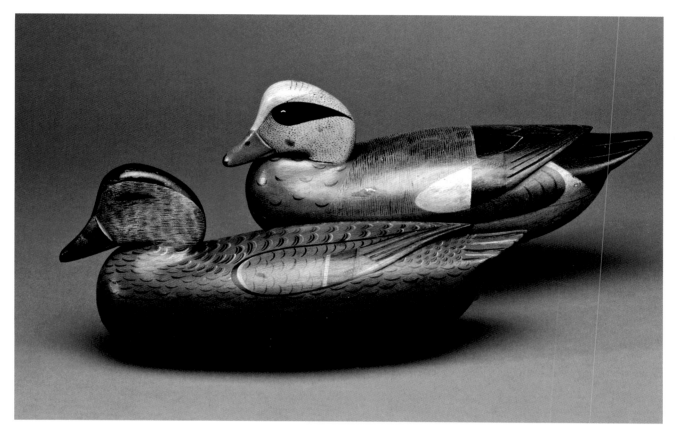

Wigeon Pair. Carved by John English. c. 1880. Florence, New Jersey. Painted by John Dawson. c. 1910. Trenton, New Jersey. Collection of Paul Tudor Jones II. Photograph courtesy Guyette and Schmidt, Inc.
Dawson added his ornate paint to some of John English's masterful carvings a generation after they were made.

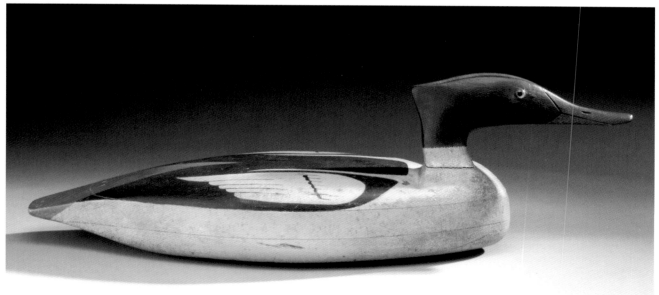

Common Merganser Drake. John Dawson. c. 1920. Trenton, New Jersey. Private collection. Photograph courtesy Stephen O'Brien Jr. Fine Arts, LLC.
Dawson's mergansers achieved a perfect balance between realism and abstraction in both form and applied paint patterns.

English's birds set an extremely high standard for all subsequent decoy makers on the Delaware River, one of whom was his son Daniel (1883–1962), a professional pattern maker and an accomplished carver and painter who learned directly from the master. Dan English and other early twentieth-century Delaware River carvers expanded on his father's strong example, varying head positions within a rig and carving more pronounced wings, primaries, and tails.

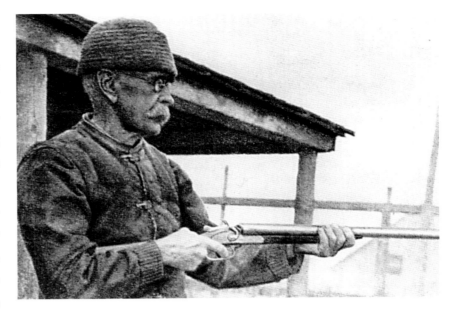

About a hundred of John English's decoys were repainted around 1920 by John Dawson (1889–1959), an artistic man who lived in Trenton and had a hunting cabin on nearby Duck Island. Dawson was a carpenter and potter who also painted accomplished landscapes of the river and applied his considerable skills as a painter to the surfaces of English's elegantly carved lures. His highly stylized, abstract paint patterns

John Blair Sr. c. 1900.

are among the most distinctive and impressive applied to any decoys. Dawson also carved some of his own decoys, of which his long, low-bodied American mergansers, made for use on ice, are the most notable, a perfect blend of stylized form and paint.

The major carver in the lower Delaware area was John Blair Sr. (1842–1928), a wheelwright and sportsman who lived in Frankford, Pennsylvania, and worked on vehicles for well-to-do Philadelphians in the decades following the Civil War. Blair was a respected member of Philadelphia society who belonged to two exclusive shooting clubs and is said to have given decoys to A. Mercer Biddle Sr., a prominent Philadelphia lawyer who gunned with then president Ulysses S. Grant in the 1870s. The Blair family owned property in Elkton, Maryland, just over the line from Delaware and near the head of Chesapeake Bay, and Blair apparently hunted on both the Elk River in Maryland, which empties into Chesapeake Bay, and in the lower reaches of the Delaware River, which was also nearby. His business was successful enough that he retired to a place on the Elk River in 1900, where he led the life of a gentleman farmer and sportsman.

According to Blair family members and to Joel Barber, who knew Blair's son, John Blair Sr. carved his first rig of seventeen mallards in 1866. These and other decoys that Blair made for his own use and as gifts for his friends have rounded, oval-shaped hollow two-piece bodies that are joined with 5/8- to 3/4-inch dowels that can be seen on the bottom and are finished with small nails. The heads sit on a raised shelf and have upholsterer's tacks for eyes, and the birds have full, swelling chests. They are completely smooth-bodied, with none of the wing and tail carving of decoys by Blair's slightly younger contemporary, John English. They are beautifully painted, with crisp, linear patterns that

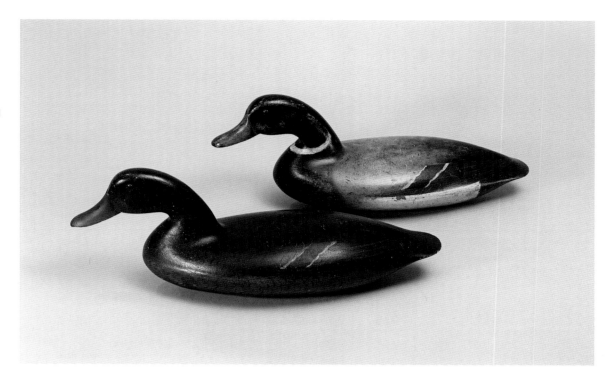

Pair of Mallards. John Blair Sr. c. 1865. Philadelphia, Pennsylvania, and Elkton, Maryland. Ex-collection James M. McCleery, M.D. Photograph courtesy the Houston Museum of Natural Science, Houston, Texas. This elegant pair is carved in swimming position, with their necks set forward of their rounded chests. The sense of motion is so palpable that one can almost sense the bird's webbed feet paddling beneath them.

many have compared with carriage decoration, and rectangular beveled lead weights that are attached to the rear of their bottoms with tiny nails. John Blair Jr. told Barber that the birds had been painted by "a Philadelphia portrait painter of considerable note," and, while no one has determined who that might have been, it is as plausible as the theory that they were decorated by a carriage painter.

A number of other decoys related to the highly refined birds known to have been carved by John Blair Sr. have appeared over the years, some with hollow but flatter body forms and others with solid bodies. Although they are clearly influenced by Blair's work, and some have suggested that they might have been made in his Philadelphia shop, the identities of their carvers remain unknown.

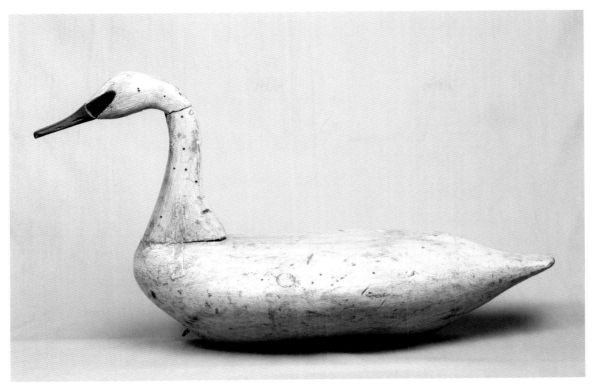

CHAPTER 19

The Susquehanna Flats and Chesapeake Bay

The vast Chesapeake Bay watershed spans 64,000 square miles, encompassing parts of New York, Pennsylvania, West Virginia, Delaware, Maryland, Virginia, and the District of Columbia and more than 150 major rivers and streams that drain into the bay. Chesapeake Bay itself is America's largest estuary, a substantial body of mixed fresh and brackish water covering about 3,200 square miles. (To put its size into perspective, Lake Ontario, the smallest of the Great Lakes, encompasses about 7,500 square miles, and Lake Superior, more than 31,000.) The bay is 195 miles long and varies from about four miles wide at its north end, near Annapolis, Maryland, to thirty miles wide near Cape Charles, Virginia, just south of the mouth of the Potomac River. The bay was named by the Algonquin, who called it Chesepiook, meaning "great shellfish bay," a reference to its immense populations of oysters, clams, and blue crabs.

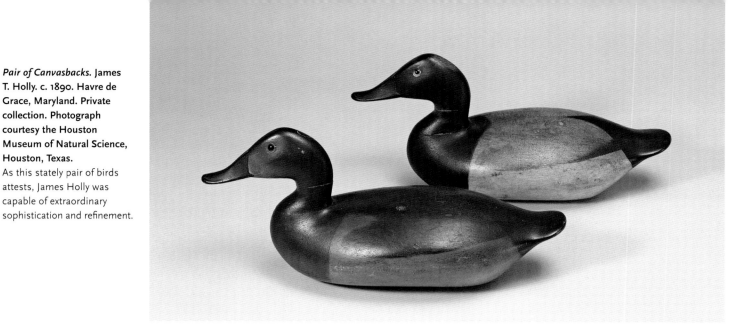

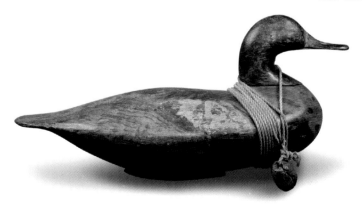

The Susquehanna River flows into Chesapeake Bay near the town of Havre de Grace, Maryland, a major fishing and hunting center in the nineteenth and early twentieth centuries. Many of its citizens were employed in oystering, crabbing, fishing, guiding, decoy making, and market gunning. The town had many posh hotels and gunning camps that catered to the big-city sportsmen who came from all over the country to enjoy the superb hunting on the Susquehanna Flats. This stretch of shallow water extends about six miles from the mouth of the Susquehanna River into the upper reaches of Chesapeake Bay.

While the average depth of Chesapeake Bay is twenty-one feet, the aptly named flats range from only two to five feet deep, with a variation of about a foot and a half between high and low tides. In early days, the flats were replete with eelgrass and wild celery, the favored foods of brant and canvasbacks, respectively, and immense concentrations of those and other species gathered there to feed on the rich resources.

Havre de Grace was home to a number of talented decoy carvers, of whom the Holly family was the most notable. Captain John "Daddy" Holly Sr. (1818–92) is credited as the creator of the decoy style; he was followed by his son James (1855–1935) and generations of other subsequent Havre de Grace and Harford County, Maryland, carvers. Like almost all decoys made for use on the flats and the bay, Daddy Holly's decoys were solid-bodied, but their upswept tails flowed directly from their bodies without carved delineation, and their heads sat directly atop their bodies, without the carved neck seats common in decoys from other areas of the bay.

In addition to his decoy making, Jim Holly worked as a boat designer and builder; his obituary credits him with designing the coffin-shaped sinkbox used by

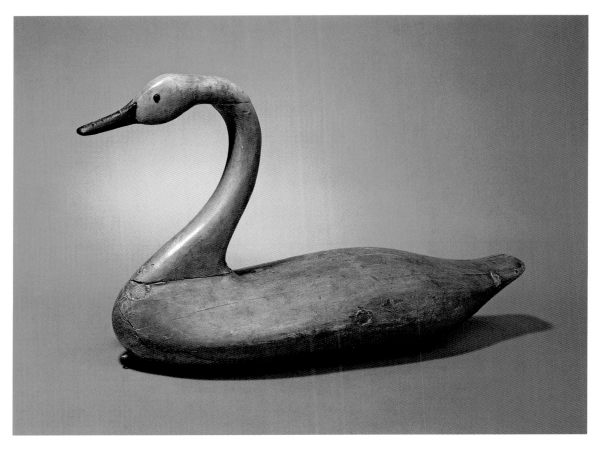

gunners on the Flats during the late nineteenth and early twentieth centuries. Jim Holly refined the style set by his father, making some of the most elegantly carved and painted decoys ever to ride American waters. His ledger book shows that boats were his main product; a 1916 entry indicates that he sold a sinkbox for $75 and one hundred decoys for $50.

Swans were common on the flats in the nineteenth century, and, while surviving examples are rare, more swan decoys were made in the region than anywhere else in America. Both Daddy and Jim Holly made a few, as did a number of other Upper Bay carvers. As Joel Barber noted in *Wild Fowl Decoys*, "Swan decoys are among the rarest on the coast, found only along the shores of the Chesapeake, Back Bay, Virginia, and Currituck Sound. Swan shooting has never been classed as a sport or business, most of those killed being the result of chance encounters by gunners in pursuit of other birds. Swan, however, are subject to attraction by decoys, particularly the tender fleshed young birds (cygnets). And here and there, the rigs of professional gunners included a few Swan decoys. When Swan shooting was prohibited in 1913, many of these men knocked off the long heads and converted their swan into geese. Those that remain are few and far between."

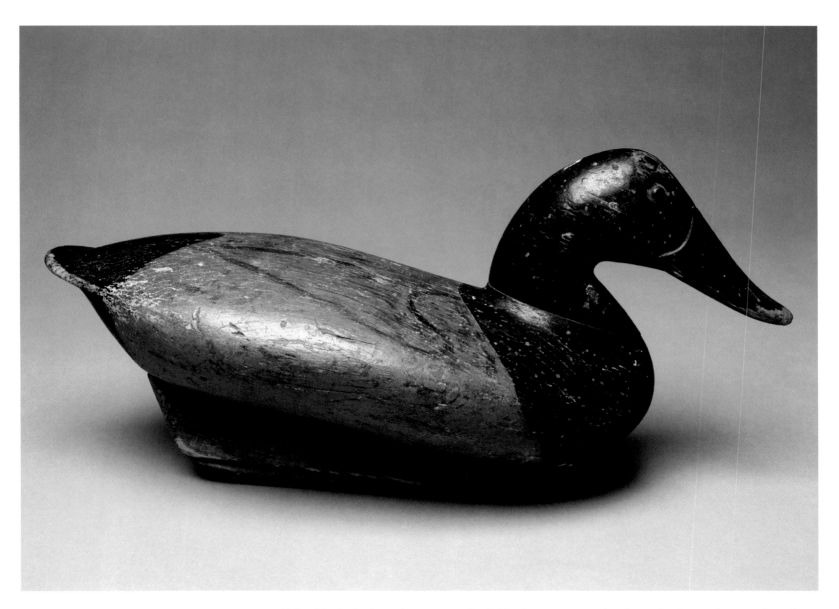

Canvasback Hen. John B. Graham. c. 1870. Charlestown, Maryland. Collection of Ron Gard.

Like decoy makers in most regions, Upper Bay carvers made far fewer hens than drakes. This rare early survivor is original in every respect.

John Black Graham (1822–1912) of Charlestown, Maryland, on the Susquehanna Flats about eight miles east of Havre de Grace, was the trendsetter in Cecil County. A cabinetmaker, undertaker, boatbuilder, and professional decoy carver who is believed to have produced thousands of decoys, Graham crafted birds with rounded body forms, short but distinct paddle tails, and heads that rest on well-defined neck shelves. His style changed a number of times over the years, and there is speculation that other members of his extended family, which was among Charlestown's oldest and most prominent, may also have carved decoys, a notion that would also help explain the large numbers of extant Graham decoys.

Another early Cecil County carver was Benjamin Dye (1821–96), who lived on the Susquehanna Flats at Stump's Point, outside Perryville, a Cecil County city directly across the mouth of the Susquehanna River from Havre de Grace. Like John Graham, Dye was a professional decoy maker, but his decoys are more finely detailed than most other Cecil County carvers and have longer tails than Graham's. He is one of the few Susquehanna Flats carvers known to have made ruddy ducks, and they and his equally diminutive and well-carved teal are considered by many to be his best work. He is also credited with a group of canvasback decoys now known as "Cleveland cans" because President Grover Cleveland, who was an avid duck hunter, gunned over on them.

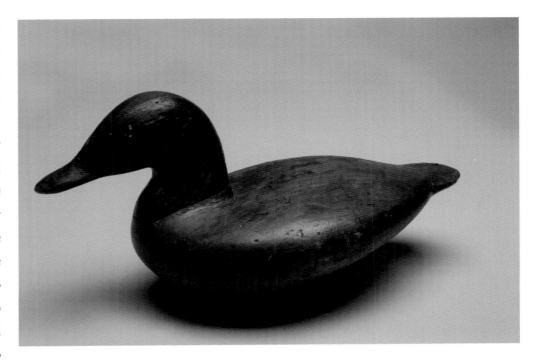

Ruddy Duck. **Benjamin Dye. c. 1880. Perryville, Maryland. Collection of Ron Gard.** Dye is one of the few Chesapeake Bay carvers known to have made ruddies.

Charles Nelson Barnard (1876–1958) was born in Havre de Grace but lived in Elkton in Cecil County for a couple of decades before moving back home in 1915. His decoys, which have pronounced neck seats and straight paddle tails, may have been influenced by exposure to Cecil County lures by Graham, Dye, and other carvers. He followed his own muse, however, and his rare, high-head cans, with necks that extend a full six inches above their bodies, are unlike any others created in the region.

Stephen W. Ward (1895–1976) and his brother Lemuel Travis Ward (1896–1984) of Crisfield, Maryland, were by far the most prominent Chesapeake Bay carvers of the twentieth century and among the greatest and most influential bird carvers of all time. The brothers worked closely together throughout their lives, combining the complementary talents of Steve's hand carving and Lem's brushwork to create works of extraordinary grace and realism.

Crisfield, located at the lower end of Chesapeake Bay on Maryland's Eastern Shore, was the oyster capital of the country in the late nineteenth and early twentieth centuries, shipping bivalves harvested from the huge beds in Tangier Sound all over the country by railroad, which came to the town soon after the Civil War. Crisfield is literally built on oysters; much of the town rests on a foundation of tons of crushed oyster shells that were used as fill after it was incorporated in 1872. It was also a major center for fishing and seafood processing and was regularly visited by steamships, scows, skipjacks, and many other bay boats. By the time the Wards were young men, however, the

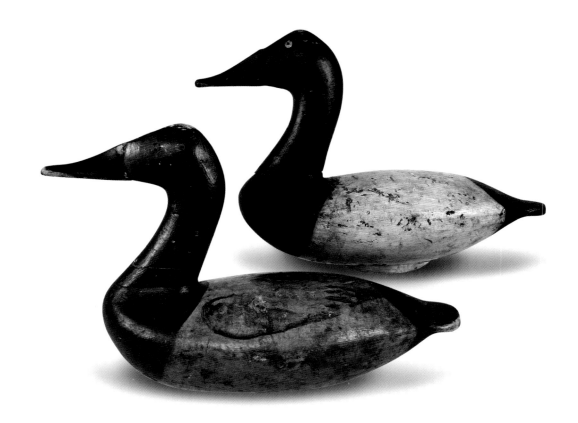

town was in decline, and life there remained a hardscrabble existence until after Word War II.

The brothers began carving in their early teens under the tutelage of their father, Travis Ward (1873–1926), an accomplished boatbuilder and decoy maker who also taught his boys how to hunt and cut hair, which was his profession. Travis taught his sons how to make decoys in a style unique to Crisfield. Like other Crisfield decoy makers, including various members of the Sterling and Tyler families, Travis carved oversized, flat-bottomed, solid-bodied lures with strong, simple paint patterns and bold forms, often with their heads cocked or turned in unusual positions.

Lem, a natural lefty who was born with a deformed left hand, taught himself to paint with his good hand, while Steve exhibited strong carving skills early on, creating dynamic forms for Lem to paint. Surviving Ward decoys from the late 1910s and early 1920s have dramatically humped backs,

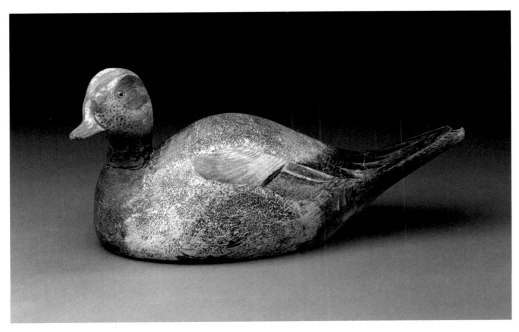

LEFT: *Wigeon Drake.* Lemuel and Stephen Ward. c. 1925. Crisfield, Maryland. Private collection. Photograph courtesy Guyette & Schmidt, Inc.
Steve Ward carved a number of sculpturally powerful decoys with exaggerated humped backs in the 1920s, which Lem completed with his detailed painting.

BELOW: *Pair of Canvasbacks.* 1936. *Canada Goose.* 1940. Lemuel and Stephen Ward. Crisfield, Maryland. Collection of Ron Gard.
The Wards' 1936 designs were aimed at sport gunners who demanded realistic-looking decoys. They proved very popular and were purchased by many clubs in the Chesapeake Bay area. This 1940 goose design is arguably their most elegant representation of that species.

extended tails, and angled head positions unlike anything that had preceded them. The brothers made decoys only for their own use until their father's untimely death, when they began to sell their work to local hunters to help support their families. Both brothers moved back to the family homestead after their father's death, supplementing income from their barbering with decoy making and hunting. Both Lem and Steve continued to cut hair for decades, making birds after hours or when the chairs were empty.

The Ward brothers established a regional reputation for their lures in the 1920s and '30s and sold hundreds of their decoys to local gunners and hunting clubs, including the Fox Island Club, the Deal Island Club, and the Bishops Head Club. They pushed themselves constantly, changing styles for the various species they created several times a year. Looking back, Steve said, "We didn't claim to know it all then. We were not satisfied then and we are still not, for we have sense enough to know there is still room for improvement."

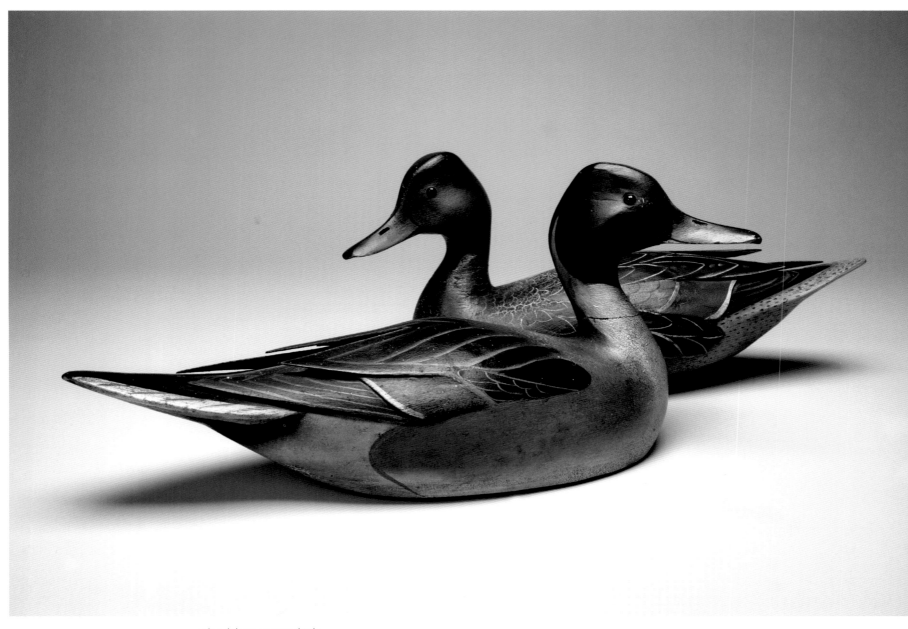

Pair of Pintails. **Lemuel and Stephen Ward. c. 1935. Crisfield, Maryland. Collection of Ron Gard.** This is one of Lem Ward's earliest experiments with inserted wing and tail feathers, which he carved from the staves of a peach basket. The customer who ordered these gunning birds returned them to the Wards because he thought they were too fragile to hunt over, and they were never used.

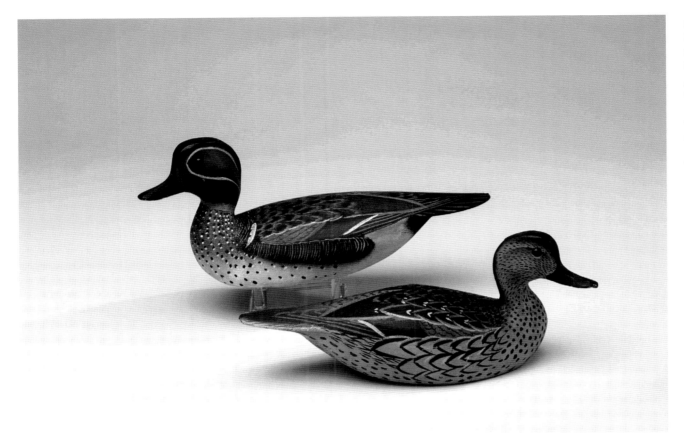

After World War II, economic changes and Lem's artistic inclinations led the brothers to focus increasingly on ornamental work for competitions and mantelpieces. Neither brother ever learned to drive or owned a car, making their way around Crisfield on their bicycles instead. But in 1948, a friend convinced Lem to take the train to New York and enter some of his work in the annual National Decoy Makers Contest and Exhibition sponsored by the Schaefer Brewing Company. He took best of show for a sleeping mallard drake and also won the prizes for best marsh duck and best diving duck, establishing a national reputation and opening up new avenues for his and Steve's work. The Wards went on to become seminal figures in the transition from working decoys to decorative bird carving that took place in the 1950s and '60s, with Lem pioneering many carving and painting techniques, including separately inserted feathers. The sign outside their shop billed them as "Wildfowl Counterfeiters in Wood," and, though they continued to cut hair, they spent more and more time making wooden birds. Lem in particular became a teacher and inspiration to a generation of young carvers, including Bruce Burk, Arnold Melbye, and Don Briddell, who, along with their mentor, helped establish the art of decorative bird carving. The

Ward Foundation, a nonprofit institution dedicated to perpetuating the work of the Wards and other American wildfowl carvers and artists, was founded in Salisbury, Maryland, in 1968, and Lem was honored as a National Heritage Fellow by the National Endowment for the Humanities Folk Art program in 1983.

Despite their enormous and largely unsought success, the Wards were uneducated and unassuming men who were never swayed by the attention they received. Lem always claimed to be nothing more than a "dumb old country boy." Both were amateur versifiers, adding a bit of poetry and a signature to the bottoms of many of their carvings. One of Steve's poems, about an old, battered working decoy, reveals his own deeply modest feelings about his place in the world:

"The Drifter"
I'm just an old has-been decoy,
No ribbons have I won.
My sides and head are full of shot
From many a blazing gun.
My home has been by the river,
Just drifting along with the tide.
No roof have I had for a shelter,
No one place where I could abide.
I've rocked to winter's wild fury
I've scorched in the heat of the sun.
I've drifted and drifted and drifted
For tides never cease to run.
I was picked up by some fool collector
Who put me up on a shelf.
But my place is out on a river
Where I can drift all by myself.
I want to go back to the shoreline
Where flying clouds hang thick and low.
And get the touch of rain drops,
And the velvety soft touch of snow.

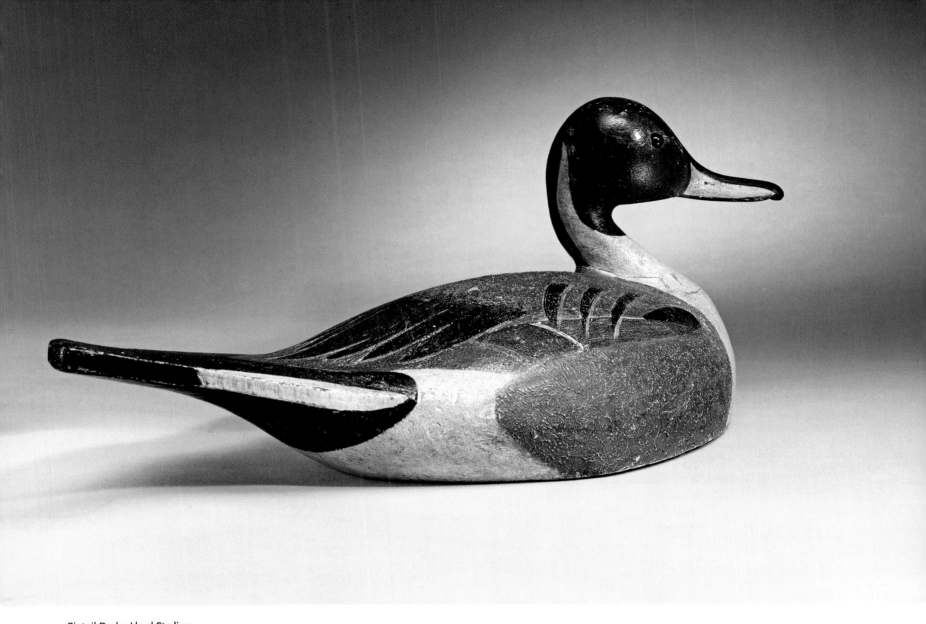

Pintail Drake. Lloyd Sterling.
c. 1930. Crisfield, Maryland.
Private collection. Photograph
courtesy the Houston
Museum of Natural Science,
Houston, Texas.
Sterling (1880–1964) was a
friend of the Ward brothers,
so it is not surprising that
Lem painted some of his
carvings. This big, flamboyant
pintail rivals the best early
work of the Wards.

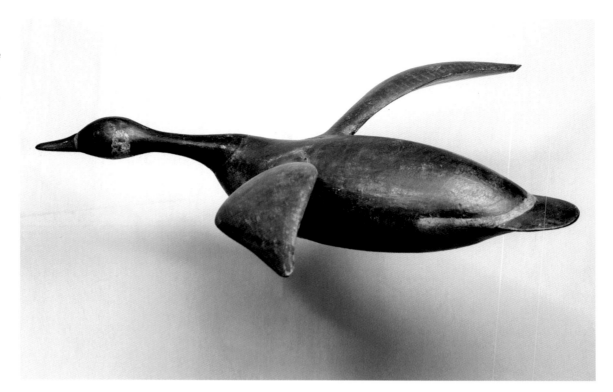

Canada Goose. Ira Hudson.
c. 1930. Chincoteague,
Virginia. Courtesy Collectable
Old Decoys.
This compelling bird, a
rare—and possibly unique—
working flyer with attached
wooden wings, epitomizes
Hudson's imagination and
carving skills.

The South Atlantic Coast:
Chincoteague, the Eastern Shore, the Outer Banks, and Beyond

The string of barrier islands that shield the coasts of Virginia and the Carolinas from the Atlantic's powerful storms provided a rich habitat for swans, geese, brant, and a variety of duck and shorebird species in the nineteenth and early twentieth centuries. Tens of thousands of geese wintered on the protected bay side of the barrier islands of the Eastern Shore and Outer Banks and provided residents with food and sport. In the second half of the nineteenth century, the region was also discovered by affluent northern sportsmen and became home to dozens of private clubs and hunting camps.

Chincoteague, an isolated barrier island just south of the Maryland line and about five miles from the mainland, is best known for its population of wild ponies, which were stranded on the island

in a sixteenth-century shipwreck, but it was also visited by hosts of migratory birds, especially geese. An 1877 article in *Scribner's Monthly* paints a vivid picture of the remote island, which it describes as:

> . . . enchanted, cut loose from modern progress and left drifting some seventy-five years backward in the ocean of time . . . So far as one sees, geese, dogs, children and pigs compose the chief population of Chincoteague. The last thing to be heard in the evening and at intervals during the night is the cackling of geese, and when one wakes in the morning the geese are cackling still. . . . Every year numbers of [wild geese] are shot in their passage south. The natives sink a barrel into the ground close to the beach in which they hide, and when the geese swimming far out at sea approach the beach to gravel they fall an easy prey to the gunners. Those that are only winged are saved and subsequently domesticated. One frequently hears the peculiar resonant hank of the wild geese, and, looking in the direction from which it came, sees the black head and neck of a bird stretching above the surrounding sedge. These birds cross freely with the ordinary domesticated geese, producing a hybrid which is called a mule goose.

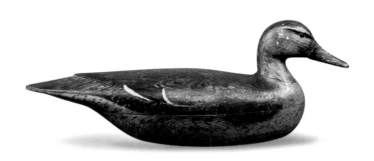

ABOVE: *Pintail Hen.*
**David Watson. c. 1910.
Chincoteague, Virginia.
Private collection. Photograph
courtesy Guyette &
Schmidt, Inc.**
Only a handful of Watson pintails are known. This hollow bird best showcases his combined talents as a carver and painter. The distinctive wing and tail carving and deep eye grooves are unique to Watson.

David Watson (1851–1938), who lived on Chincoteague, was an eccentric man who was nicknamed "Umbrella" for his habit of carrying a bumbershoot wherever he went, rain or shine. He worked as a market gunner, carving only what he needed for his own use, until federal restrictions cut into his income from market gunning and he began selling his work. His surviving decoys, which include geese, brant, black ducks, canvasbacks, redheads, and pintails, are hollow and well carved, and he also crafted a few plump little solid-bodied peeps. He was reportedly a slow-working, methodical carver who sold many of his decoys to the Gooseville Hunting Club in Hatteras, North Carolina, on the Outer Banks. Hollow decoys are the exception in the South Atlantic, and there is speculation that Watson, who was born in Delaware, may have brought that region's concept of hollow, two-piece bodies south with him.

Ira Hudson (1876–1949) was a prolific professional boatbuilder and bird carver who also lived on Chincoteague and undoubtedly knew Umbrella Watson. Hudson was the region's dominant professional carver during the first half of the twentieth century and is believed to have carved as many as 25,000 working decoys and ornamental birds over the course of his career. Unlike Watson, Hudson was not much of a hunter; he apparently preferred carving birds to shooting them. He crafted an extremely wide variety of species and forms over the years, including geese, brant, ducks, and shorebirds, as well as life-size decorative birds and fish. He was a restlessly creative man who experimented throughout his life with different approaches to form and paint. Hudson was particularly fond of lifelike, animated head and body forms, and he produced working decoys with their heads turned and twisted in a variety of ways as well as a few standing decoys,

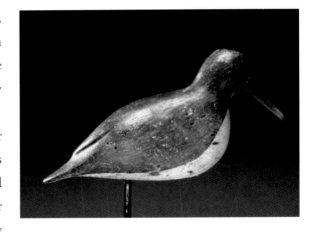

ABOVE: *Sanderling.*
**David Watson. c. 1910.
Chincoteague, Virginia.
Private collection. Photograph
courtesy Copley Fine Art
Auctions, LLC.**
A plump, well-fed peep, typical of Watson's hand.

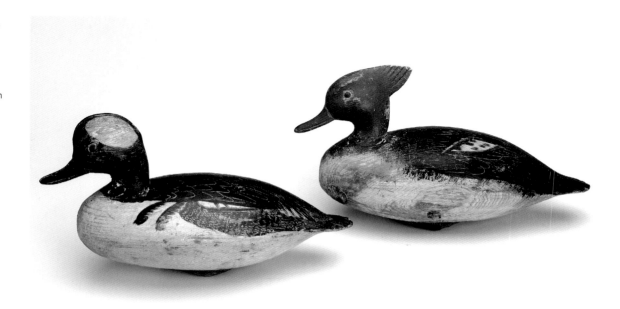

and at least one flying goose decoy, which has outspread wings that are separately carved and attached. Only a handful of other carvers were as imaginative as Hudson, and only his contemporary, Gus Wilson in Maine, produced as many unusual head and body forms.

As a commercial carver, Hudson produced gunning decoys in a number of grades and price ranges. All of his birds were well made, but his finest decoys, which were probably crafted for the wealthy sportsmen who occasionally visited his shop on Chincoteague, are distinguished by their carefully rendered forms and detailed paint patterns, which often included feathers scratched in wet paint.

Charles Birch (1868–1956) of Willis Wharf, Virginia, a small, unincorporated seaside village on Parting Creek, midway down the Eastern Shore peninsula, was a boatbuilder and fisherman who also made some of the Eastern Shore's most finely crafted decoys. Willis Wharf was a deepwater port during the eighteenth and nineteenth centuries whose major products were clams, scallops, and oysters; the town was dubbed "Clam Town" and is still renowned for its bivalves, which are now grown by aquaculture. Birch is best known for a singular group of swan decoys that were made for use on Chesapeake Bay and rank with the finest swans made by bay carvers. Like all of his best decoys, the swans are hollow-bodied and have long, gently curved necks. The separately carved bills are of oak and wedged into the head with a spline to hold them in place.

Virginia's best-known hunting and fishing retreat was located on Cobb's Island, a barrier island off the Eastern Shore that was owned by the family for which it was named. A correspondent for *Forest and Stream* magazine told readers the island's story in 1880:

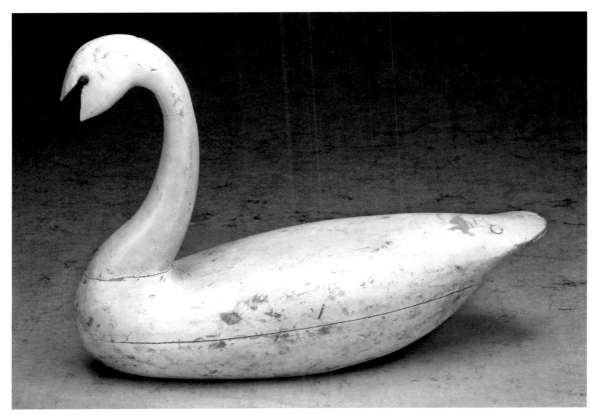

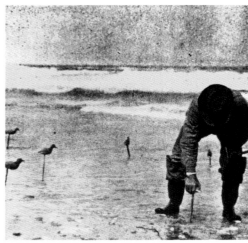

LEFT: *Swan*. Charles Birch.
c. 1900. Willis Wharf,
Virginia. Collection of
Dr. Peter J. Muller.
The elegantly flowing lines of
Birch's hollow-bodied decoys
place him among the most
sophisticated of Southern
carvers.

ABOVE: **Guide setting out
shorebirds on Cobb Island.**
c. 1880.

"All About Cobb's Island"
Warrenton, Va., Aug. 13th, 1880.

Editor Forest and Stream:—
Many years ago—when you, I and the wearied proofreader who revises this were boys—there dwelt
in a shanty on a barren sand bank that had risen, like the fabled isle Calypso, from out of the depths
of the ocean, a rough, weather-beaten fisherman named Cobb, who gained his living by casting his
nets as well as shooting ducks, wild fowl and geese, vast quantities of which, in the winter, flocked to
the great Broadwater region lying near. When he first bought his domain it was but four or five acres
in extent, and the price paid was $30 in gold and ten bags of salt. . . . Day by day, hour by hour, by
the ceaseless, restless action of the waters did his island increase . . . [and] Cobb's Island soon became
a wrecking station. On this dangerous coast many a stately vessel has been dashed to pieces and their
crews drowned in the vicinity of this island. Indeed, the old man Cobb and his stalwart sons made
many thousands of dollars' salvage from wrecked vessels, as well as rescuing many lives. In one ship
alone, that went to pieces on the island, their share of the profits of the cargo they saved amounted to
$8,000. All that is over now, for there is a United States life saving service station on the island, under
the charge of Mr. Crump, who, by the way, is a genial, fine-souled fellow.

Time passed on—as time, that maddest of wags, will always do—and from a little sand bank of
only a few acres, old man Cobb found himself possessed of a domain of several hundred. Trees had

grown up, gardens been laid out, and his boys, becoming men, became, as was natural, ambitious; and disdaining the humble life, and its sure but slow gains of their progenitors, they determined to spend the few thousands they had earned in their dangerous calling by fitting up a watering place. They built a hotel of that rambling style of architecture known as the Virginia tavern, also a few cottages. A wharf was constructed, a tugboat purchased to bring guests from Cherrystone, and then the place was thrown open to the public. A great rush ensued, and the island, from its varied attractions, soon gathered a large crowd. . . .

Last year Tom Spady joined with the grandson of old man Cobb and reopened the place in a quiet way. . . . The rates of board are cheaper than any resort on the Atlantic coast, being $30 a month, $12 per week and $2 per day. So far from the guides charging sportsmen anything they want, there are printed schedules of prices hung up all over the hotel. I copy one:—

Guest desiring guides will find the following prices:

For shooting on a tide, one person	$1.50
For shooting on a tide, two persons	2.50
For fishing, each person	.50
For sharking, each person	.75

SPADY & COBB, Proprietors.

Thus it will be seen that the charges are very reasonable. The guides furnish everything, decoys, boats, etc., and as each hunting trip last several hours, generally a half a day, they earn their money by the hardest kind of work. I know of no manual labor that is equal to their duties of crouching close behind a blind on a salt meadow, with the blazing sun beating down, straining your eyes to catch sight of the birds, so as to whistle them to the decoys, and almost blinded by the dazzling glare, and then chasing the wounded birds, often waist deep in water. All this in cold blood, they not having guns, and, of course, not being braced up with the excitement and stimulus that the shooter feels.

In the winter the board at the hotel is the same as the summer, and the charges for a day's duck and geese shooting is $3 per day; and never once during the last summer or this did the guides claim any of the game killed. On the contrary, they would cheerfully pack them in ice and send them off as directed. I forwarded all the birds I killed to friends and heard no protest. I know it is but right as regards winter shooting, that the shootist should have all the game he kills. If I see a disposition in any public place to victimize sportsmen I would be swift to brand it through the press.

The guides at Cobb's Island, for the most part, are good-natured, kind, and thoroughly honest. I have often left valuable things in the boat, and totally forgotten them, but they have always been returned.

Nathan Cobb Jr. (c. 1825–1905), one of the three sons of the "Old Cobb" referred to above, is believed to have carved the majority of the decoys used on Cobb's Island, many of which are

LEFT TO RIGHT: *Black-bellied Plover, Red Knot.* Nathan Cobb Jr. c. 1875. Cobb's Island, Virginia. *Whimbrel.* Luther Lee Nottingham. c. 1890. Chesapeake (formerly Cobb's Station), Virginia. *Whimbrel, Black-bellied Plover.* Nathan Cobb Jr. c. 1875. Cobb's Island, Virginia. Ex-collection James M. McCleery, M.D. Photograph courtesy the Houston Museum of Natural Science, Houston, Texas. Nottingham served as a game warden in Cobb's Station, where travelers to Cobb's Island embarked from the mainland. Both Nottingham's and Cobb's shorebirds have carved oak bills that are splined through the back of the head to ensure a tight, long-lasting fit.

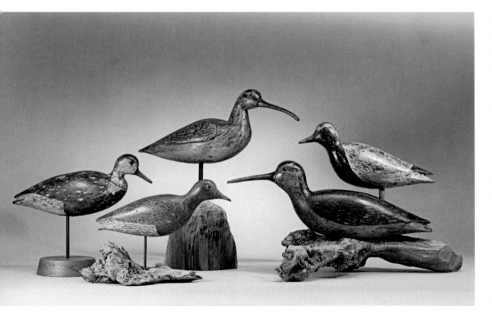

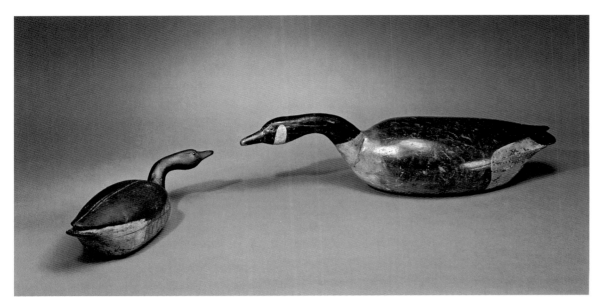

marked with a carved, serifed "N" on their bottoms. Others are marked "E" for his brother Elkanah, and "A" for Albert, who is also known to have done some carving. As is the case with most decoys, the initials were probably brands of ownership. Nathan produced many geese and brant, as well as black ducks, redheads, scaup, and buffleheads (the last probably to add variety to a rig because they were not considered good eating), and several species of shorebirds. His floating decoys, many of them crafted from salvaged ship's spars, have full, hollow, two-piece bodies with notched tails and often feature shoulder carving and other details. For his remarkably lifelike goose and brant decoys, Cobb created animated, twisting necks by skillfully shaping naturally curved roots and branches he gathered from seaside holly trees. All of his birds are fitted with good-quality glass eyes, and his shorebirds have oak bills that are tightly splined through the back of their heads. Although they follow the same general construction patterns, no two of Cobb's decoys are exactly the same, and the myriad large and small variations in form play off one another and make the decoys work together in ways that few other carvers ever approached.

Cobb's Island was hit by two tremendous nor'easters in the 1890s, the second of which destroyed almost everything the first had left behind. Nathan Cobb and the few other remaining residents had no choice but to evacuate the island for good. On October 13, 1896, the *New York Times* reported, "Cobb's Island was entirely submerged yesterday at high tide. The hotel was entirely demolished and partly washed to sea. All

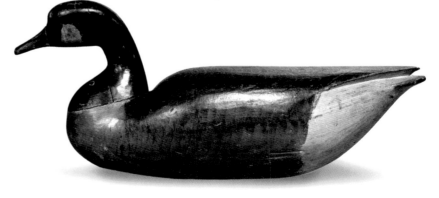

Swan. **Maker unknown. c. 1910. Manns Harbor, North Carolina. Courtesy Collectable Old Decoys.**

A number of North Carolina craftsmen fashioned swans with bodies made of sail canvas stretched over wooden frames—a solution that was both lightweight and highly effective in the field. This is the earliest, completely original canvas-covered swan known. The bird is expertly hand-stitched, with its only seam tightly sewn under the base of the tail; the head/bottom-board attachment is a single unit. The maker was clearly experienced in the boatyard and sailcloth repair trades. Mann's Harbor, on the western shore of Croatan Sound on the Outer Banks, was an isolated commercial fishing village at the turn of the twentieth century.

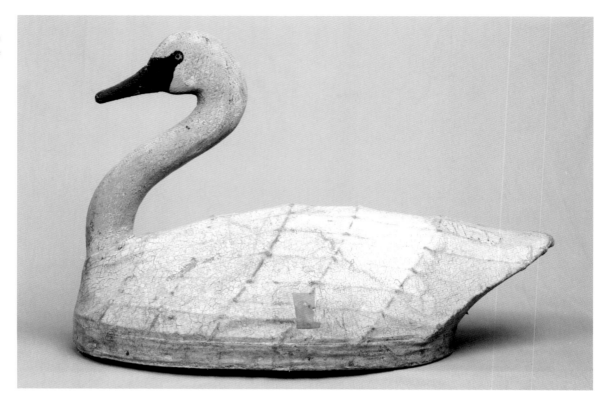

buildings save three were demolished or washed away. The only buildings remaining are the life-saving station, a cottage belonging to Mr. Ashby Jones of Richmond, Va., and a cottage belonging to Thomas Smith. The latter was built by the Rev. Thomas Dixon, Jr., of New-York about three years ago. The beach has washed [out] so that an ordinary tide now washes over the island. Nearly all of the inhabitants of the island have left. No lives were lost. Cobb's Island has been a famous Summer resort for forty years."

The Outer Banks are a chain of narrow barrier islands that extend southward in a bowl-shaped concave arc more than 175 miles along the coast of North Carolina, from Back Bay, Virginia, to Cape Lookout, North Carolina, separating Currituck, Albemarle, and Pamlico sounds from the Atlantic Ocean and shielding them from the full brunt of the region's violent storms. One of the islands, Roanoke, was the site of the first English colony in the Americas, and the birthplace of Virginia Dare, the first English child born in the New World. She was born in 1587, the year the colony was founded, but she and the rest of the colony vanished without a trace before 1590. Kill Devil Hills, near Kitty Hawk on Bodie Island, was the site of Orville Wright's first flight in 1903.

Lee and Lem Dudley were twin brothers who lived on Knott's Island, a marshy island about thirty miles south of Virginia Beach on Currituck Sound that is protected from the Atlantic by Currituck Banks, the northernmost of the Outer Banks. The island straddles the Virginia–North Carolina

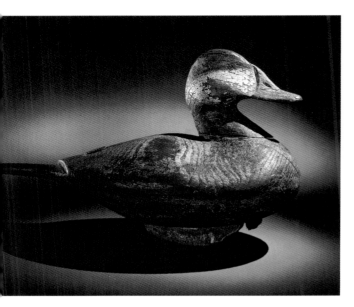

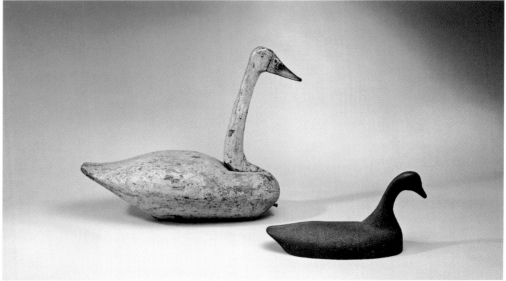

border, along lines drawn by William Byrd II when he surveyed the Virginia state line in 1728, and it is now connected to the Virginia mainland by a causeway. The Dudley brothers were born in 1861; Lem died in 1932 and Lee in 1942. They worked as trappers and market hunters on the island in the late nineteenth and early twentieth centuries, and Lee began carving decoys, primarily canvasbacks and ruddy ducks, for their own use around 1890. Joel Barber visited the island in the 1920s, where he found "a group of old-time Ruddy Duck . . . six or eight of them" in a club boathouse. "They were very old and of singular perfection. . . . Only traces of the original painting remained, but the bottom of each decoy, burned deep on the dead rise, bore the initials L.D."

Learning that "L.D." stood for Lee Dudley, who was described as "a one-time professional gunner and celebrated as a decoy carver," Barber tracked him down and showed him one of the birds. "Talk held steadily on ducks and decoys," reported Barber. "The old Ruddy started a train of reminiscence covering years of Virginia gunning. I learned first hand of days when Boobies [Ruddy] sold for only five cents apiece, barely enough to pay for 'loading your shells;' during the nineties, the price went to a dollar apiece, and the gunners called them 'dollar ducks.' . . . With the passing of market shooting, he had sold his rig . . . [and] since becoming a dirt farmer, he had made no decoys. In 1913 the entire Dudley rig had been sold to the club at the then prevailing price of fifty cents apiece."

Dudley's small output of solid-bodied decoys, made solely for use by him and his twin, is indeed of singular perfection; the birds are among the most beautifully sculpted ever made. They are deceptively simple, with graceful, flowing lines and gently curving forms that echo and complement each other in every direction.

ABOVE LEFT: *Ruddy Duck Drake.* Lee Dudley. c. 1890. Knott's Island, North Carolina. Joel Barber Collection, the Shelburne Museum.
This magnificent little sculpture, the best-known and most revered of all ruddy duck decoys, was collected by Barber on a trip to Knott's Island. Like most of the birds Dudley carved for his own use, it bears a prominent "LD" brand on its underside.

TOP RIGHT, LEFT: *Whistling Swan.* John Williams. c. 1890. Little Cedar Island, Virginia.
RIGHT: *Brant.* Maker unknown. c. 1900. Possibly Elizabeth City, North Carolina. Ex-collection James M. McCleery, M.D. Photograph courtesy the Houston Museum of Natural Science, Houston, Texas.
Solid cast-iron decoys were used to weight a battery rig down to within inches of the water level. Cast-iron decoys of this size were unwieldy and are therefore quite rare.

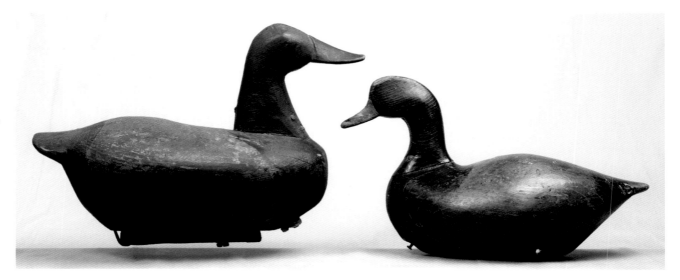

John Williams (1857–1936) lived on Little Cedar Island, just north of Knott's Island in Back Bay, Virginia, a protected brackish-water lagoon. Williams, who worked as a guide for sportsmen on either side of the border, is best known for his swans and ruddy ducks. Although they are primitive in conception and execution, his solid-bodied decoys have strong sculptural lines, with humpbacked body forms and heads that sit on low, flat neck seats forward of the exaggerated backs. Despite the huge difference in size, the forms of the swans and ruddies are remarkably similar, and the pert, boatlike little ruddies look for all the world like miniature Civil War–era submarines.

Alvirah Wright (1869–1951) lived in Duck, a small community on Bodie Island, north of Kitty Hawk, where he worked as a boatbuilder and made decoys for his own use. His ruddy ducks, redheads, and canvasbacks can be described only as mighty; even the tiny ruddies have a visceral, almost monumental physical presence achieved by few other carvers, with deep, solid, boat-shaped bodies, sharply sloping lower sides, and powerfully angular heads.

James Best (1866–1933) lived in Kitty Hawk and reportedly carved a rig that included swans, geese, and redheads from the spar of the schooner *William H. Davidson*, which was lost off Paul Camiels Hill on December 12, 1910. The cold waters of the Labrador Current meet the Gulf Stream off the Outer Banks, producing treacherous currents that are only exacerbated by the powerful nor'easters that often hit in the late fall and early winter. Wrecks were so common that the region was dubbed "the Graveyard of the Atlantic." Best's deep-bodied decoys rival Lee Dudley's in the clean, simple elegance of their lines and are among the most skillfully carved of all Southern decoys.

Between 1905 and 1907, financier, statesman, and presidential adviser Bernard Baruch, a native of South Carolina, bought eleven former rice plantations on Waccamaw Neck, outside Georgetown, in

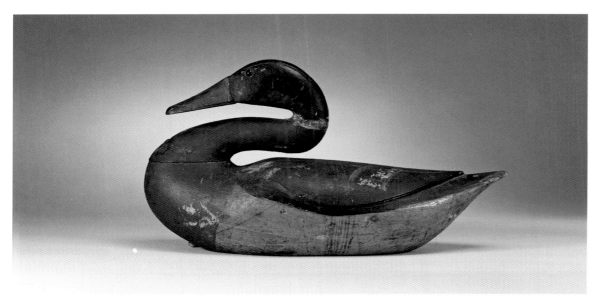

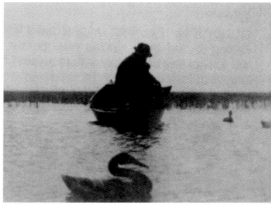

the northeast corner of the state, for use as a winter hunting retreat. Ultimately encompassing 17,500 acres, Hobcaw Barony was a mix of abandoned rice fields, swamps, pine and hardwood forests, salt marshes, and barrier islands that provided a varied range of habit for wildfowl and other game. The land was bordered by the Waccamaw River, Winyah Bay, and the Atlantic Ocean—Native Americans called it Hobcaw, meaning "between the waters." It was originally claimed in 1718 by John, Lord Carteret, one of the eight British lord proprietors of the colony, as a barony, a medieval term for a land grant given directly to an individual by the king of England. Lord Carteret sold it sight unseen in the 1730s, and it was subdivided into fourteen rice plantations, which were worked by hundreds of slaves and operated with enormous profit until the Civil War disrupted the plantation system.

Georgetown was the center of South Carolina's rice empire by 1750 and, by the 1840s, nearly half of the total United States rice crop was produced in the region. During the decade preceding the Civil War, Hobcaw Barony produced just under six million pounds of rice in one year alone. Years later, Bernard Baruch purchased Hobcaw Barony when land prices were low because of the decline of rice cultivation. In the early decades of the twentieth century, he and such distinguished guests as Winston Churchill and General John J. Pershing came to Hobcaw to gun for the area's bounty of mallards and black ducks as well as turkey, deer, quail, fox, and wild pig.

Baruch eventually sold Hobcaw Barony to his eldest child, Belle, who, on her death, created a private foundation to manage the land as an outdoor laboratory for colleges and universities in South Carolina. Today, the Belle W. Baruch Foundation operates a small interpretive museum on the property and offers a variety of tours and programs to the public.

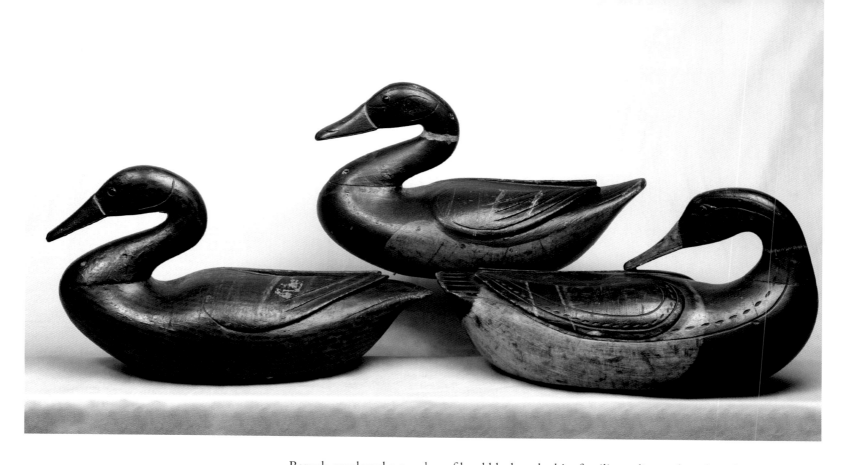

Baruch employed a number of local black and white families to live and work at the property and provided them with education and medical care. Most notable among these were the Caines brothers, who had grown up hunting the land Baruch now owned. Both because they knew his territory so well and because they were now poaching it, Baruch wisely signed four of the five brothers on as guides. The Caines brothers produced a number of remarkable decoys that were used by Baruch; some of them carry his "BMB" brand. It is not known which of the brothers did the carving, although Hucks and Ball (the renegade half brother who refused to sign on with Baruch and spent time in jail for his offenses) are most often mentioned. Whoever made them, the Caines decoys are utterly distinctive, with exaggerated, elongated necks curved into elegant S shapes or turned back on their bodies as if preening. In every case, the long, flowing curves of the bodies are perfectly complemented by the beautiful negative spaces described by the decoys' curved necks. The most detailed of the Baruch/Caines decoys have carved, raised wings and elaborate lines of grooved carving on their heads and bodies. The carving, which is unique to these birds but strikingly similar to the scarified body decorations of some rice plantation slaves, suggests the possibility of an African American influence or even that the birds may have been made by an African American. The most likely candidate is a man named Eddie Roberts, who lived with Ball Caines and, like him, was served papers by the U.S. Marshals Service for trespassing on Baruch's property.

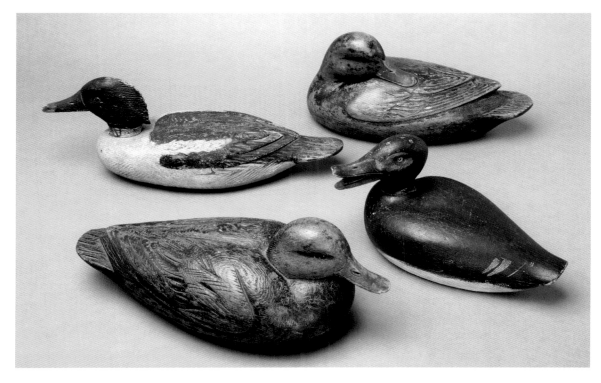

TOP RIGHT AND BOTTOM LEFT: *Pair of Black Ducks.* Robert Paquette. c. 1940. Ile Perrot, Quebec. TOP LEFT: *Common Merganser Drake.* Henri Laviolette. c. 1920. Valleyfield, Quebec. BOTTOM RIGHT: *Redhead Hen.* Denis Forest. c. 1930. St. Sulpice, Quebec. Collection of Jamie Stalker. Unlike the work of most other decoy makers working in Quebec, Robert Paquette's decoys are hollow. He ranks with Bill Cooper, by whom he was influenced, as Quebec's most technically skilled craftsman. Both his father, Joseph, and his uncle George were also carvers. Henri Laviolette (c. 1895–1922) created hundreds of long-tailed birds with layered wing tips before his untimely death in a bar shooting. Denis Forest (1895–1962), who made the open-billed redhead, was, coincidentally or not, a dentist by profession.

CHAPTER 21

The St. Lawrence River Region:
Quebec, Eastern Ontario, and Upstate New York

The St. Lawrence River connects the Great Lakes with the Atlantic Ocean and is thus part of the largest freshwater estuary in the world. The river originates at the outflow of Lake Ontario, between Kingston, Ontario, and Cape Vincent, New York, and runs northeast for 744 miles before ultimately emptying into the Gulf of St. Lawrence off Quebec's Gaspé Peninsula.

The St. Lawrence is extremely wide near its source, and its lakelike beginnings are straddled by a fifty-mile-long archipelago known as the Thousand Islands. There are actually nearly 1,800 islands in the St. Lawrence between Lake Ontario and Ogdensburg, New York; the largest, Wolfe Island, at the confluence of the lake and river, encompasses more than forty square miles, while the smallest are little more than rock outcroppings. The Thousand Islands region has long been known for its wildfowl, and many exclusive hunting camps operated there during the nineteenth and early twentieth centuries.

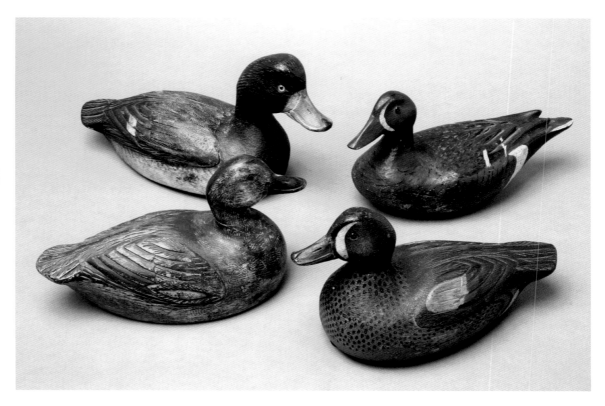

From the Thousand Islands, the St. Lawrence runs northeast to the island city of Montreal, where the treacherous Lachine Rapids stopped river traffic in both directions and made Montreal the trading center of eastern Canada. On the east side of Montreal, the river becomes calm again and can be navigated to the ocean.

Quebec was originally a French colony, and both the culture and language of the province are still predominately French. Like the furniture and other crafts of the region, Quebec decoys, with their intensely textured surface carvings, are unique. French Canadian decoys, which were typically carved from solid blocks of cedar with attached pine heads and round, flat bottoms, have the most extravagantly carved surfaces of all North American decoys. Many were further embellished with intricate paint patterns often achieved with the use of a fine-toothed graining comb.

French Canada's greatest and most prolific carver was Orel LeBoeuf (1886–1968), who lived in St. Anicet, about fifty miles southwest of Montreal, and gunned on Lac Saint-François, a wide expansion of the St. Lawrence River near the U.S. border. The lake is often whipped by strong winds, and LeBoeuf's chunky, solid-bodied, flat-bottomed decoys were made to ride the chop with aplomb.

LeBoeuf used a penknife to cut obsessively textured surfaces on the tops and sides of his birds that are deeper and more detailed than any other decoy maker's. In addition to relief-carved wings

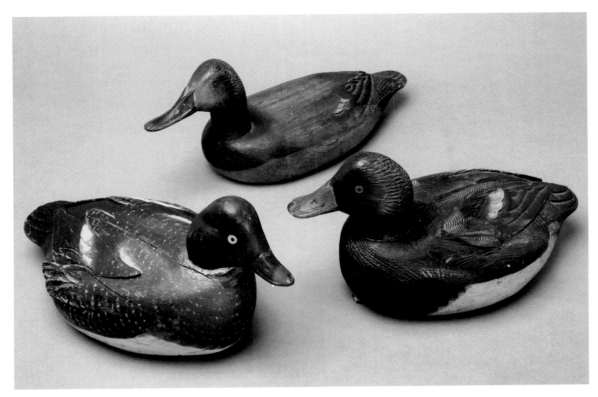

and feathers and detailed bill carving, LeBoeuf made numerous small incisions into the edges of his relief carving to imitate feathering and also added detailed grain painting. More than 250 bird species frequent Lac Saint-François, and, while LeBoeuf himself hunted primarily bluebills, he made decoys of a wide range of other duck species. He also carved a few decoys with open bills and made a handful of life-size ornamental ducks that stand on carved wooden legs and feet. LeBoeuf, who was trained as a lather, worked as a market gunner before beginning to sell some of his decoys in the 1920s, after hunting laws became restrictive. He became increasingly reclusive and peculiar after the untimely death of his wife, ultimately shunning contact with hunters who came to buy his decoys but continuing to carve. After his two daughters moved in with their married older brother, LeBoeuf, who was barely five feet tall, spent two years living in his tiny ice-fishing hut. He later moved to a comparatively expansive ten-by-fourteen-foot cabin that also served as his carving shop. For years, he let the cedar chips from his work pile up where they fell. When the cabin burned to the ground in 1965, he lost all but one of the carvings he had hoarded there, a tragedy from which he never recovered.

Many decoy makers in eastern Ontario also added textured carving to the surfaces of their lures. Samuel Hutchings (1894–1995) of Jones Falls, on the Rideau Canal, scored the surface of his goldeneye and hooded merganser decoys with checkered crosshatched incisions, while many other makers in the

Hooded Merganser Drake.
Samuel Hutchings. c. 1920.
Jones Falls, Ontario. Courtesy
Collectable Old Decoys.
Hutchings checkered the
surfaces of his early decoys to
reduce glare.

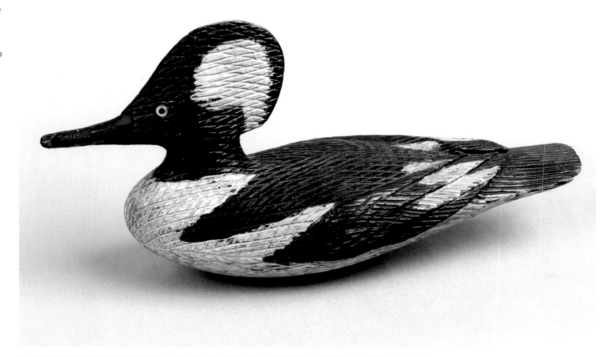

TOP: *Redhead Drake.* **Robert**
Jones. c. 1890. Demorestville,
Ontario. Private collection.
BOTTOM: *Goldeneye Drake.*
James Adam Nichol.
c. 1920. Smiths Falls,
Ontario. Collection of Max
Hoyos.
These masterpieces are by
two of eastern Ontario's
greatest carvers. Both birds
are hollow, but while Jones's
is smooth-bodied with an
attached bottom board,
Addie Nichol's has wings
carved in low relief, detailed
combed feather paint, and
an oval piece of butternut
inserted into its flat bottom.

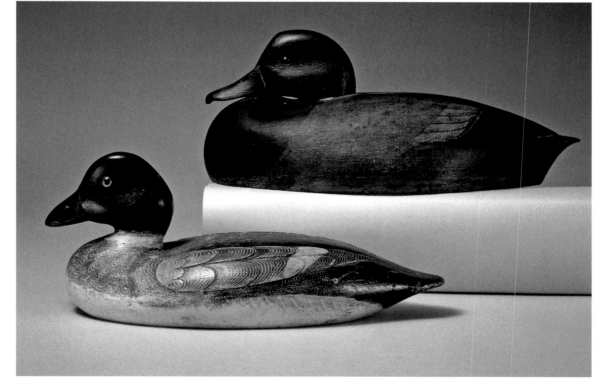

region carved wings in relief. The Rideau, a 125-mile waterway built in the 1830s to connect Ottawa and Kingston with Lake Ontario, also runs through Smiths Falls, which was home to the Nichol family, the most prominent of the eastern Ontario decoy carvers. David K. Nichol (1859–1949) was a master carpenter and a boatbuilder who lived, hunted, and carved with his equally talented younger brother Adam (1864–1929), known as Addie. Both men were lifelong bachelors who carved bluebills, goldeneyes, hooded mergansers, and a few black ducks for their own use and sold their old decoys to other hunters whenever they made a new rig. Both men were meticulous craftsmen whose carving styles were similar: relief carved wings and feather markings, and detailed combed paint. Addie's extremely lightweight hollow birds have form-fitting butternut ovals set tightly into their flat bottoms, a unique measure of his woodworking skills, while Davey's have thin bottom boards. The Nichols' nephew David W. Nichol (1890–1977) was a professional carver who also created superb solid-bodied decoys in the family style.

Prince Edward County, Ontario, is a large peninsula that juts into the northeast end of Lake Ontario and is almost completely surrounded by the waters of the lake and the Bay of Quinte. Known simply as "the County" in Canada, the water-bound headland was settled primarily by British loyalists during and after the American Revolution and became a major producer of barley and hops, which were shipped across the lake to American breweries during the nineteenth century. The region's many sheltered shallow bays and inland lakes were filled with substantial beds of wild celery and other aquatic vegetation that attracted huge flocks of migrating ducks in the fall, and these birds remained to feed for considerable periods of time before continuing their journey south. From early times, locals depended on duck hunting to supply their tables, and sizeable market- and sport-gunning businesses developed in the region during the second half of the nineteenth century.

Robert James Jones of Demorestville (1861–1937) was arguably the County's most accomplished carver and a regional style setter. Bob was a blacksmith who made a variety of decoy forms and species over the years, including standing solid-bodied field geese, black ducks with extended necks turned back over the bodies at an angle or stretched fully forward in feeding position, and at least two ducks of indeterminate species with their heads cocked sideways as though looking up at the sky. He also made a large rig of redheads for a local hunter, several of which have uniquely carved tucked heads.

The only known surviving decoys by Angus Lake (1872–1957) of West Lake are black ducks, which he carved in an extremely wide and imaginative variety of head and body configurations. One, which was mounted on a rod set at the bottom center of its body, was a "tipper"—the rod was pushed into the mud so that the bird rested at water level. When the hunter pulled a cord from his hiding place, the decoy would tip forward as if it were feeding, showing off a pair of nicely carved wooden

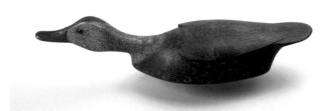

feet. Lake also made at least three ducks with tails uplifted and necks extending straight forward. This unique form was meant to represent a hen in breeding position, ready to receive the attention of a mate. Lake's method of lightening his decoys was as eccentric as his style of carving—instead of building hollow decoys like other County carvers, he drilled large holes in the bottoms of his solid-bodied lures and filled them with cork.

Belleville, on the mainland just north of the County and across the Bay of Quinte, produced a number of skilled carvers as well, most notably William Crysler (1868–1945) and William Harvey Hart (1875–1946). Crysler was a carpenter and boatbuilder in his younger days and later worked as a housepainter and interior decorator. All of these skills are manifested in his expertly carved and painted decoys, which set the standard for other local carvers. Bill Hart was also a housepainter and interior decorator by trade who, like Crysler, made decoys both for his own use and for sale and

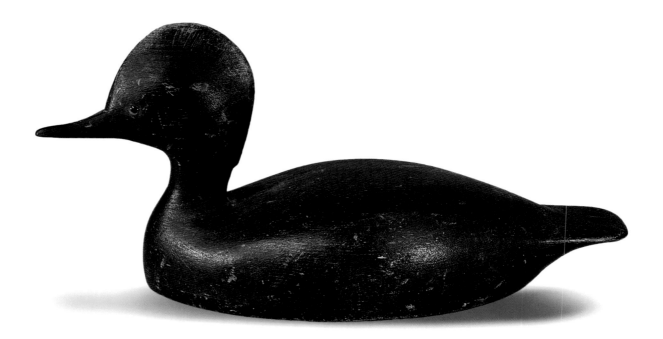

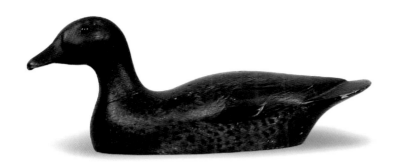

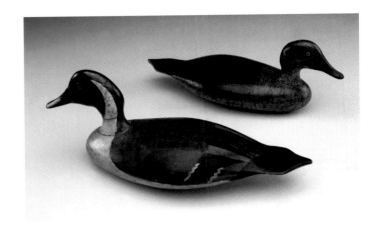

carved both solid and hollow-bodied birds. At his best, Hart was Crysler's equal as a carver, and a few of his surviving decoys are decorated with particularly subtle and well-executed paint that is the match of any Canadian decoy maker.

Across the U.S. border, a sportsman and skilled taxidermist named Harvey A. Stevens (1847–94) of Weedsport, New York, west of Syracuse on the edge of the Montezuma Marshes and the Finger Lakes, began advertising his decoys in the upscale *Forest and Stream* magazine in 1876. His first notice, nestled among ads for shotguns, read:

DECOY DUCKS
Send for a price list of the BEST DECOYS IN THE WORLD.

Although he claimed to be a "manufacturer" in later advertising, Harvey Stevens's decoys were entirely handmade by him, his brother George (1859–1905), and members of the Lamphere family, who were first cousins. Harvey aimed his advertising squarely at well-to-do New York sportsmen, pointing out, "You should have good decoys. They are invaluable and require no more room [in your boat] than poor ones. You can double your success by using the Stevens Decoys." In addition to the ads, Harvey also worked as a traveling salesman, peddling his decoys to sporting goods stores across the state. According to Dr. Peter J. and Peggy L. Muller, authors of *The Stevens Brothers: Their Lives, Their Times and Their Decoys*, "Harvey Stevens had an in-depth knowledge about the wealthy and passionate duck hunters of the nineteenth century. His presence within the gun clubs and sporting goods stores of New York State made him a familiar figure amid the sporting elite. He sold his decoys to them and surely hunted with them, understanding the emotional state of his customers. When the *Auburn* [New York] *Weekly*

ABOVE LEFT: *Green-winged Teal Drake*. William Harvey Hart. c. 1910. Belleville, Ontario. Private collection. Photograph courtesy Guyette & Schmidt, Inc.
Hart was a housepainter by trade and a clarinet player and decoy carver by avocation. This rare teal by his hand has the initials "JT" on its bottom, which is believed to stand for James Tuttle, a fellow housepainter who may have painted the Hart mallards and teal he gunned over.

ABOVE: *Pair of Pintails*. George R. Stevens. c. 1895. Weedsport, New York. Collection of Dr. Peter J. Muller.
These unique birds were special orders made for Schoverling, Daly, and Gales, a New York City sporting goods store to which the Stevens brothers sold many birds. George Stevens's memorandum book records that he shipped twenty-three pintails to the firm in October 1895, and these may have been part of that order. They are very similar in form and may have been made as a pair. Neither is marked with the normal Stevens stencil. The Stevenses made only a few pintail and wigeon decoys with extended pointed tails, and there is only one other Stevens decoy known that has scratch-feather paint.

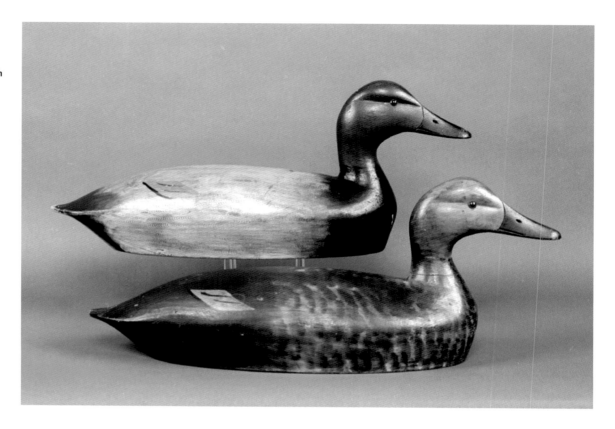

Pair of Canvasbacks.
Chauncey Wheeler. c. 1932.
Alexandria Bay, New York.
Private collection. Photograph
courtesy Guyette &
Schmidt, Inc.
All of Wheeler's birds have a
carved eye groove, a feature
that was adopted by a
number of other upstate
New York craftsmen.

News printed his obituary, it described him as 'one of the best known sporting men in this section of the state.'"

After Harvey succumbed to influenza in 1894, George continued the business with the help of younger brother Fred (1864–1939), a wallpaper hanger and house and sign painter who assisted him with the painting of the decoys. The Stevens operation continued to produce its high-quality decoys under George's leadership until 1904, when the tuberculosis that ran in the family made him too ill to go on. He died of the disease the following year.

The Stevens brothers produced a number of body and head variations over their company's nearly thirty years in operation. More than twenty-five of the cardboard and wooden templates drawn and cut by Harvey and George Stevens are in the collection of Vermont's Shelburne Museum, and the patterns have allowed Dr. Muller to thoroughly document the body forms that Harvey and George created. All the Stevens decoys had smooth, solid cedar bodies. The earlier birds, which were made by Harvey, have flat bottoms, tucked heads, and humped backs, while the brothers' later, more refined styles have narrow, rounded, oval bodies; relatively long, flat tails; and detailed paint that includes combed feathering and skilled, feathery brushwork. With few

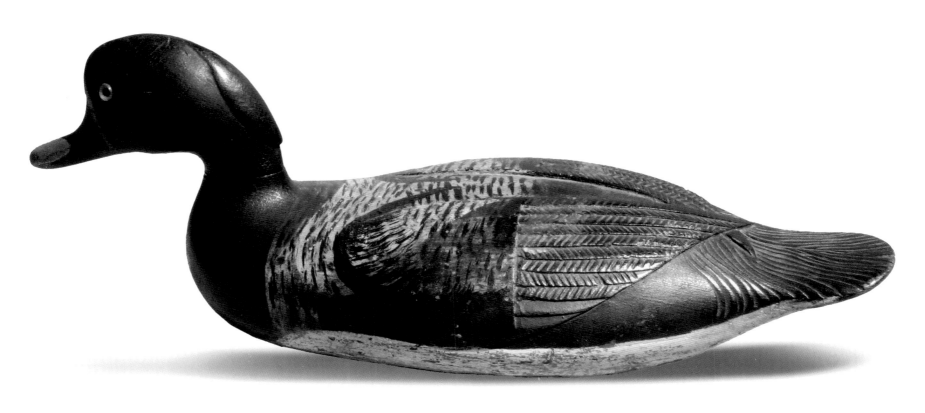

**Ring-necked Duck Drake.
Maker unknown. c. 1910.
Wolfe Island, Ontario.
Collection of Bernie Gates.**
Wolfe Island is located at the juncture of Lake Ontario and the St. Lawrence River. This elaborately carved bird was hollowed from the bottom and has stiff canvas covering the access hole. Several other decoys by the same masterful hand are known, but none is as well preserved as this example. Ring-necked ducks (*Aythya collaris*) are medium-size divers with peaked heads and a subtle ring around their necks that is almost impossible to see in the field. They have long been called ringbills by hunters, after the far more conspicuous white ring around their bills.

exceptions, the birds carry stencils on their bottoms identifying the company, and many bear pencil inscriptions as well.

Another New York carver, Chauncey Wheeler (1862–1937) of Alexandria Bay, on the St. Lawrence in the midst of the Thousand Islands, codified a regional carving style that others imitated well into the twentieth century, making solid-bodied brant and ducks with a distinctive carved, recessed, horizontal eye groove on each side of their heads. Wheeler's birds have flat, oval bottoms, and their long, low bodies have angled sides, with straight or slightly angled heads that rest on prominent, raised neck seats.

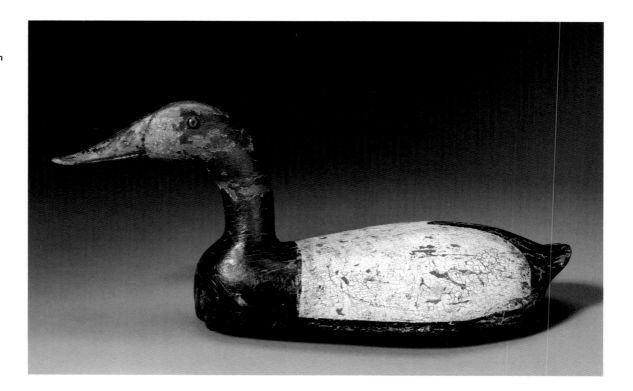

Canvasback Drake. **Maker unknown. c. 1910. Harsens Island, Michigan. Collection of Jim Grochowski.** This battle-scared, hollow-bodied highhead, made for use on Lake St. Clair, was William Mackey's favorite Flats decoy.

CHAPTER 22

Toronto, Detroit, and the Lakes:
Southwestern Ontario and Michigan

The stretch of North America between Toronto, on the northwestern shore of Lake Ontario, and Detroit, 250 miles to the west and a few miles north of Lake Erie on the Detroit River, is among the richest wildfowl habitats in the world. Although the region is dominated by Lakes Ontario, Erie, and Huron, the three smallest of the Great Lakes, it contains many other notable hunting grounds among its myriad other lakes and streams. Prominent among these is Lake St. Clair, a shallow, 430-square-mile body of water that lies halfway between Lake Huron and Lake Erie. Lake St. Clair connects the two far larger lakes via the St. Clair River, which branches to form a hundred-square-mile delta as it flows south into Lake St. Clair, and the Detroit River, which runs from its south end. The St. Clair Flats, as the delta at the northeast end of the lake is known, was a favorite gunning area for hunters from both sides of the border and the site of a number of highly exclusive shooting clubs.

Multiple migratory routes converge over the region, which teemed with wild birds throughout the nineteenth and early twentieth centuries, including geese, pintails, canvasbacks, goldeneyes, wigeon, black ducks, mallards, teal, and wood ducks. The region's numerous lakes, rivers, bays, and marshes offered an extremely wide range of water conditions, from shallow water so placid that even tiny, hollow teal decoys did not need to be weighted for balance, to water so rough that bold, heavy, oversized lures with keels were required to ride the chop. It was home to many exclusive hunting clubs frequented by wealthy sportsmen from all over Canada and the United States, and the region's carvers produced some of the finest decoys ever made.

Nineteenth-century Toronto was a booming city built on Lake Ontario's finest natural harbor. Incorporated in 1834, the city grew from about 9,250 inhabitants at the time of its incorporation to more than 200,000 by the dawn of the twentieth century, becoming one of Canada's major industrial and commercial centers. Toronto Harbour, which is a basically a circle about two and a half miles in diameter, is sheltered from Lake Ontario by a huge sandbar that was originally a peninsula but has been reshaped by storms into a series of islands. In the nineteenth century, the many bays and marshes within and around the harbor teemed with ducks, geese, and shorebirds and supported large numbers of both private and market gunners.

The city was full of talented craftsmen, especially boatbuilders, many of whom also applied their finely honed woodworking skills to decoy making. George (1830–1905) and James Warin (1831–84) were Toronto's leading makers of high-end racing sculls and the region's trendsetters in crafting duck and goose decoys of equally high quality. The brothers were born in England but immigrated to Toronto with their parents in 1832. They cut their teeth working in a highly esteemed boatbuilding business operated by Robert G. Renardson, who may also have taught them how to make decoys, and took over the operation after Renardson's death in 1873. Soon after, George became involved in promoting Ned Hanlon, the greatest oarsman of his time, to whom he had given rowing lessons when he was just starting out. Racing in Warin-built sculls, which were fitted with a then unique sliding seat of George's invention, Hanlon became Canada's champion in 1877 and went on to take the world championship in 1881 and 1882. His fame only enhanced the already substantial reputation of the Warin brothers' sculls, bringing them worldwide attention and publicity.

Despite having lost his left arm while cleaning a gun when he was young, George was an avid and accomplished hunter who founded the St. Clair Flats Shooting Company in 1874. The decoys that he and his brother made as a sideline to boatbuilding set a new standard of excellence

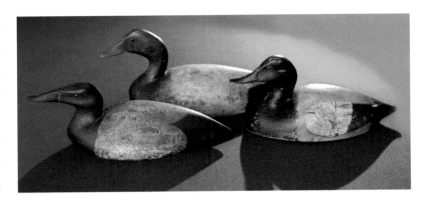

TOP LEFT TO RIGHT:
Canvasback Drake. Maker unknown. c. 1875. Harsens Island, Lake St. Clair, Michigan. *Canvasback Hen.* Maker unknown. c. 1880. Turkey Point, Ontario. *Canvasback Hen.* Attributed to Isaiah Brown. c. 1880. Port Rowan, Ontario. The Malcomb Family Collection.

These three superb canvasbacks, two of them by unidentified carvers, exemplify the extremely high quality of western Ontario decoys in the last quarter of the nineteenth century. The Harsens Island can was found at the St. Clair Flats Company (Canada Company) and is one of two drakes known by this yet-to-be-identified hand. The middle bird, which is branded "McInnes," was found in a lodge at Turkey Point on the north shore of Lake Erie near Long Point. The cabin's original owner was Dr. McInnes of Vittoria, Ontario, a physician and avid sportsman. The bird at right, which is attributed to Isaiah Brown, was originally used at the Long Point Company and is branded "S," probably for company member Henry M. Sage.

Canada Geese. **George and James Warin. c. 1877. Toronto. Malcomb and Brisco Family collections.**

These large and early Warin geese are the only two known in this form. They were probably carved to order for Edward W. Harris of Toronto, who was a Long Point Company member from 1877 to 1896. The subtle differences in the forms of the two geese suggest a gander and a slightly more relaxed goose. The bodies of both are hollowed to an eggshell thinness.

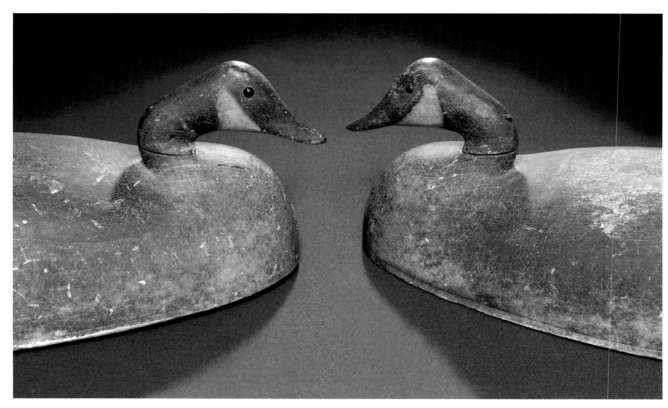

Mallard Drake. **George Warin. c. 1875. Toronto. Private collection. Photograph courtesy Copley Fine Art Auctions, LLC.**

George and James Warin popularized this low-head form later adopted by many Ontario carvers. Hollowed to an eggshell thinness, this bird also shows off Warin's sophisticated painting skills. It is branded "CM" and "T.H.S." and also has "Gray Duck" written in pencil script on its unpainted bottom. It was found at Rice Lake, an eighteen-mile-long body of water just north of Lake Ontario and about ninety-five miles east of Toronto.

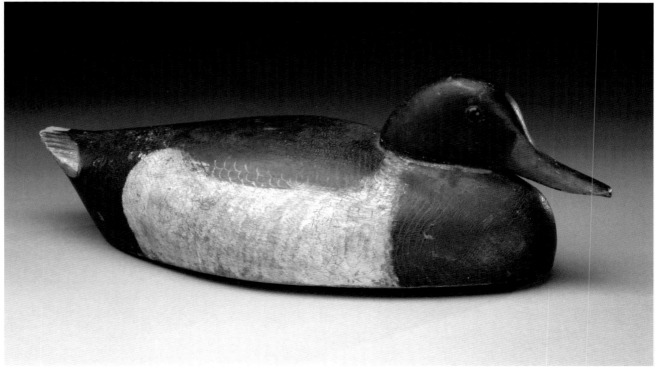

in the region and were imitated by dozens of later Toronto and southwestern Ontario craftsmen. While most early decoy makers in the region had created solid-bodied and somewhat crudely carved lures, the Warins hollowed the bodies of many of their birds to eggshell thickness and set them on thin bottom boards, in effect creating forms resembling small overturned boats. The birds were extremely lightweight and perfect for use in the calm, protected waters of Toronto Harbour, the St. Clair Flats, and other sheltered waters of southwest Ontario. The Warins made a number of different goose body and head forms and also appear to be the first Canadians to have made low-head decoys, whose heads were tucked close in to the breasts. Many of their decoys also carried detailed comb and feather paint that perfectly complemented the simple but elegant lines of their carving.

John R. Wells (1861–1953) was another prominent Toronto boatbuilder and decoy maker who worked for more than forty years at the city's Aykroyd Boat Building Company, where he made sailing skiffs. He was a close friend of both George Warin's and Tom Chambers's, and he and Warin often hunted together at clubs on Lake St. Clair. Wells was a prolific professional craftsman who made decoys in a number of styles, including hollow and solid-bodied ducks and cork-bodied black ducks with scratch-painted heads. His finest decoys, a rig of three hundred that were hollow-carved in the classic Toronto style and decorated with detailed scratch, comb, and feather paint, were commissioned by the Prince of Wales for a 1919 Canadian hunting trip.

Thomas Chambers (1864–1950) began his career working as a market gunner in Toronto. He also worked at the St. Anne's Club on Lake St. Clair and became manager of the St. Clair Flats Shooting Company in 1900, a position he held until he retired forty-three years later. Like his friend and contemporary John R. Wells, Chambers carved in the Toronto style but developed his own body forms and head profiles. He carved both long- and short-bodied birds with flatter backs than other Toronto carvers, and the heads of many of his decoys have flattened crowns, diamond-shaped nostrils, and subtly but distinctly curved lower mandibles.

Phineas Reeves (1833–92) was the patriarch of a family of carvers who worked as guides at the Long Point Shooting Club on Lake Erie. Long Point is a thirty-mile-long peninsula that juts into the lake from the north, and its elite shooting club was incorporated in 1866. Before taking the job at Long Point, Reeves had worked as a carriage and

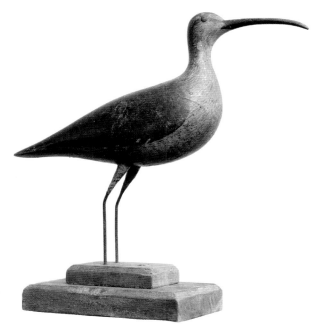

Whimbrel. **Maker unknown. c. 1870. Toronto area. The Brisco Family Collection.** A wide variety of shorebirds were hunted in Ontario during the late nineteenth and early twentieth centuries. A typical Ontario shorebird decoy was mounted on a pair of cotton-wrapped wire legs attached to a board that decoy historian Paul Brisco calls a "sand shelf." He theorizes that the shelf was buried in beach sand to stabilize the birds against the constant waves of the lakes. This beautifully carved and painted whimbrel is the finest of the more than two hundred known Ontario shorebirds. The body, head, and bill were all carved from a single piece of wood.

Wood Duck Drake. **Thomas Chambers. c. 1915. Wallaceburg, Ontario. Private collection. Photograph courtesy Guyette & Schmidt, Inc.** Only two Chambers wood ducks are known. Both were carved after he had become the manager of the St. Clair Flats Shooting Club.

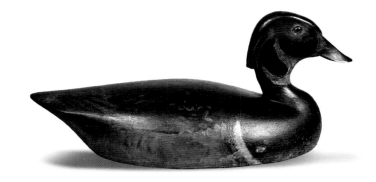

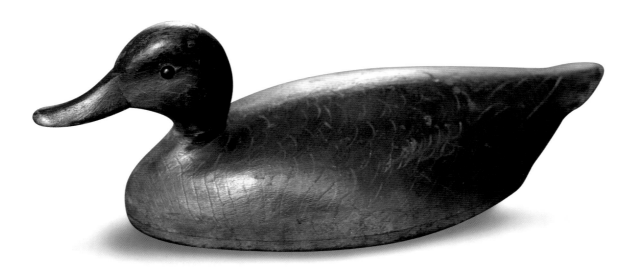

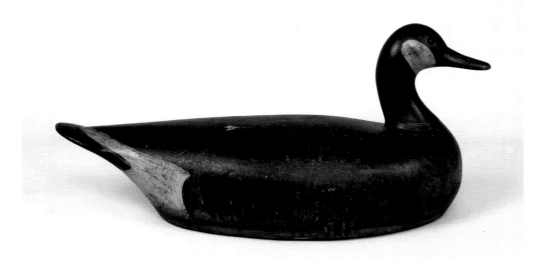

furniture painter, experience that came in handy when he set to making decoys for the sports he punted for. His surviving geese and pintails are regal birds in the hollow Toronto style, with pronounced neck seats and simple but elegant paint patterns.

Peter Marshall Pringle (1878–1953) was an academically trained artist who ran a professional art studio in Toronto. He was also an avid sportsman who often escaped the city to fish and hunt near his native Dunnville, just a few miles from Lake Erie. Pringle spent more than twenty years carving his solid-bodied decoys for his own use; he created about 120 in all, representing a wide variety of species. He was a meticulous craftsman who carved and rasped the bodies and heads of his lures to create realistically shaped,

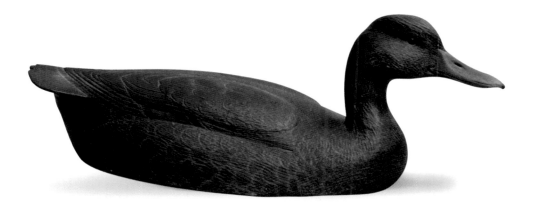

Black Duck. **Peter M. Pringle. 1944. Toronto and Dunnville, Ontario. Private collection.** Pringle so greatly admired the wariness of black ducks that he spent nearly three years crafting two "super decoys" that he felt were realistic enough to fool the birds. He declared them the best decoys he ever made and kept this one for his own gunning rig. Only four other hollow Pringles are known. This "super black" has far more relief carving than Pringle's standard models, with clearly defined scapular, secondary, and primary feathers, a flared tail, and an inset bottom board. The highly realistic head is carved from willow heartwood for added strength, as was Pringle's practice.

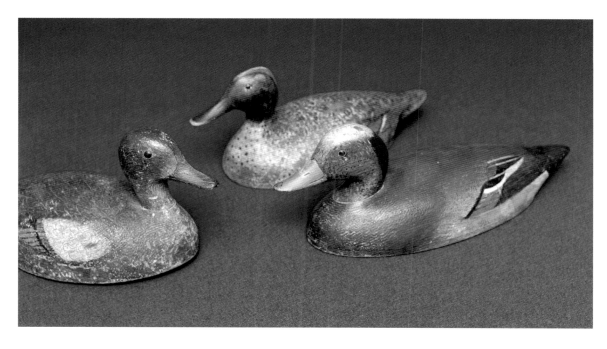

LEFT TO RIGHT: *Green-winged Teal Hen, Green-winged Teal Drake, Wigeon Drake.* **James Frederick Harper. c. 1900. Hamilton, Ontario. The Brisco Family Collection.** Harper (1857–1948) was a carriage and sign painter as a young man and then worked as a postmaster until he retired in 1907. He carved only one rig of decoys, but there is a considerable variety of species and form within it. His painting is known to have been influenced by the renowned American bird painter and carver Alexander Pope, and he, in turn, probably influenced Ivar Fernlund, who was a generation younger. The teal hen is solid bodied and the other two birds are hollow. All have "H" stamped on their breasts and under their tails and were collected directly from the widow of Harper's grandson.

highly textured, nonreflective surfaces. Few makers on either side of the border lavished as much time on their work as Pringle.

Ivar Gustav Fernlund (1881–1933) was born in Sweden and came to Grand Rapids, Michigan, with his family when he was four. He worked as a pattern maker for Westinghouse in Pittsburgh and was transferred to Hamilton, Ontario, on the west end of Lake Ontario, in 1906. Fernlund carved only for his own use, but his limited production of impeccably carved and painted birds rank with the finest made in North America. His birds are hollow carved in the Hamilton style, with powerful, sculptural lines and volumes and equally masterful paint applied with artist's oil colors.

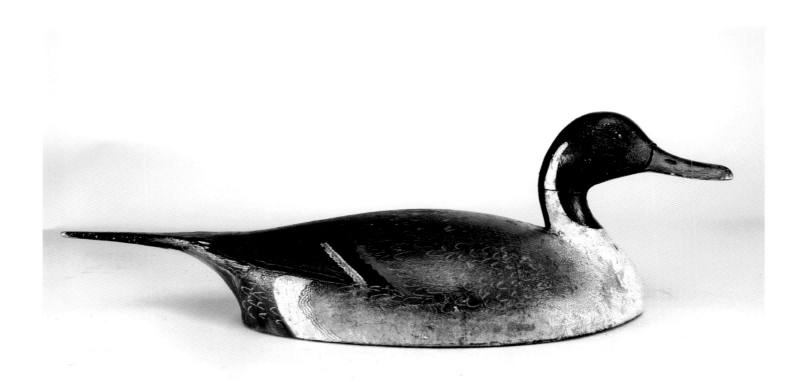

The Morris family ran Hamilton's most prominent boatbuilding company, the Morris Boatworks, for four generations, and a number of family members also crafted high-quality decoys, primarily for their own use from the scrap ends of cedar boat planking. The use of this material required ingenious structural approaches: The bodies were often made from four pieces of wood, and the heads sometimes had an added neck section. Like Fernlund and other regional carvers, the Morrises hollowed their decoys to a thin shell. The finely carved heads of Morris decoys have pronounced cheeks and detailed bill carvings, and wings are carved in low relief on many of the bodies.

Nate Quillen (1839–1908) of Pointe Mouille, Michigan, located south of Detroit at the marshy confluence of the Huron River and Lake Erie, was a cabinetmaker, locksmith, and boatbuilder whose precisely crafted hollow decoys are the work of a perfectionist. He made two forms, both of which have one-piece heads that are carefully inlet into the bodies. The bodies of both his standard-headed decoys and his decidedly boat-shaped, slope-sided low heads are hollowed to thin shells, while the heads of the compact low heads are hollow as well. The low heads also have a distinctive grooved helmet shape to the heads, which made them easy for hunters to pick up. Quillen sold many of his best carvings to the elite members of the Pointe Mouille Shooting Club, Michigan's premier gunning club of the era, for a $1 each, a substantial sum at the time. Founded by a consortium of prominent Detroit businessmen in 1875, the Pointe Mouille club owned 2,600 acres of

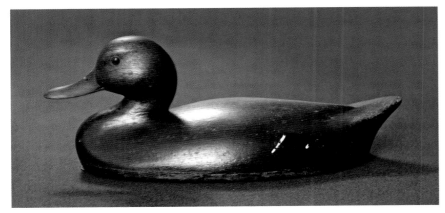

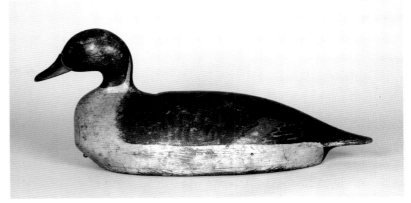

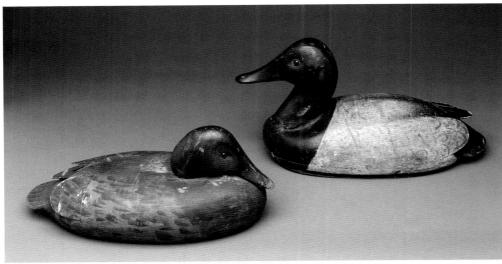

prime hunting land that remained in its control until it was purchased by the state of Michigan in 1945 and turned over to public use.

John Schweikardt (1870–1954), Benjamin Schmidt (1884–1968), and Ferdinand Bach (1888–1967) were Michigan's preeminent twentieth-century decoy makers. Schweikardt, a Detroit boatbuilder and champion yacht racer who owned a camp and gunned on Strawberry Island at the northeast corner of Lake St. Clair, was an inventive craftsman who hit on the idea of cutting winglike shapes from sheets of aluminum and applying them to the backs of his canvasback decoys. He nailed the pieces of aluminum to the backs of the birds, added a bit of fill, and then primed and painted them along with the rest of the decoy. Like other Flats decoys, Schweikardt's are hollow with thin bottom boards, and, like Nate Quillen, he sometimes hollowed out his heads as well to reduce weight. Schweikardt, who carved only for his own use, set the thick, tubular necks of his cans in three different positions: upright sentinels, standard straight heads, and resting tucked heads.

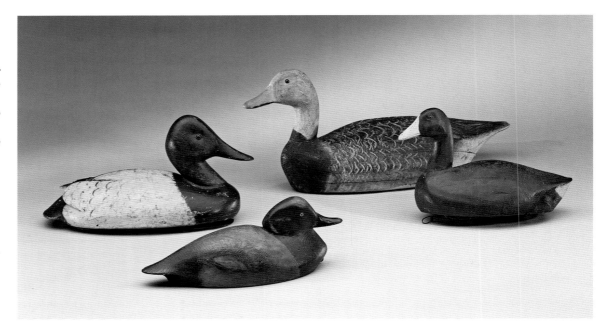

Unlike most other regional carvers, Ben Schmidt cut detailed feather patterns into the backs of his birds. He carved wing outlines and long flight feathers with a penknife and then used a set of handmade metal stamping tools to imprint feathers of different sizes and shapes. Each of the tools was made to imitate a particular feather shape; they were placed flush against the body and tapped with a hammer to make the imprints that covered the entire surface of a typical Schmidt decoy. Over the course of his long professional career as a decoy maker, he carved virtually every species of duck, goose, and swan found in North America, including a number of outstanding snow geese in both their normal and blue morph plumages.

Ferdinand Bach worked as a designer and draftsman for several Detroit automakers, and his powerfully stylized, broad-backed decoys reflect his design skills. Like Ben Schmidt, Bach often carved detailed feather patterns into the backs of his birds with a penknife and made decoys in a wide variety of head positions. The last rig he carved employed forty-four different head patterns.

Detroit was home to a succession of decoy "factories" that sold their products by mail order in the late nineteenth and early twentieth centuries. George Peterson founded the first in 1873 and sold his company in 1883 to Jasper Dodge, who remained in business until 1905. Mason's Decoy Factory, the last and by far the most successful of the Detroit-based commercial decoy making operations, was founded by William James Mason in 1896 and remained in business until 1924. Although they called themselves factories and manufacturers, all three operations were really cottage industries that divided the various steps of making a decoy among their workers to facilitate uniformity and ramp

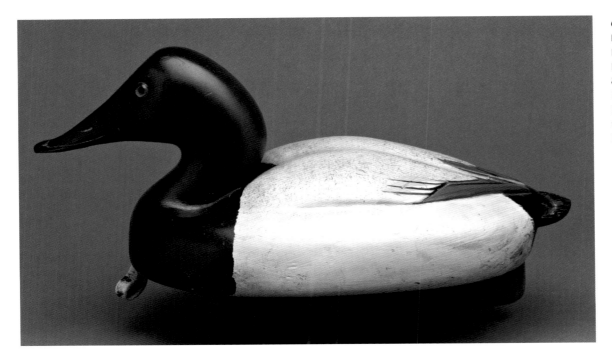

up production. Basic body forms were roughed out on a turning lathe, master craftsmen hand-carved heads and finished body details, painters added decoration to the smoothly sanded surfaces, and finally the decoys were weighted and packed in crates by the dozen, ready for shipment. Each crate of ducks held eight hens and four drakes.

Mason Decoy Factory offered hunters a full variety of duck and shorebird species, as well as geese, swans, brant, crows, passenger pigeons, and doves. The company's duck decoys were available in five ascending grades, with prices matching the degree of carving and painting detail and the type of eyes used. The relatively inexpensive bottom grade had comparatively small, narrow solid bodies with little detail and painted eyes, while the next two grades, also solid-bodied, had tack eyes and glass eyes, respectively. The top two grades, called Challenge and Premier, had glass eyes, detailed bill carving, and swirling, stylized paint patterns. Top-of-the-line Premiers had hollow, two-piece bodies with flat bottoms and deeply notched carving on the top of the bill where it meets the body. Challenge-grade decoys were available with either solid or hollow bodies and were smaller than Premiers, with round bodies and bottoms. Low heads were also offered in the top grades. A dozen Mason painted-eye ducks set a hunter back $4 in the early years of the twentieth century, while Premiers were $1 each. The Mason company shipped tens of thousands of decoys to hunters in every corner of North America. Masons are by far the most commonly encountered of all decoys, and their ubiquity speaks to their durability and quality as well as to the company's considerable commercial success in the first two decades of the twentieth century.

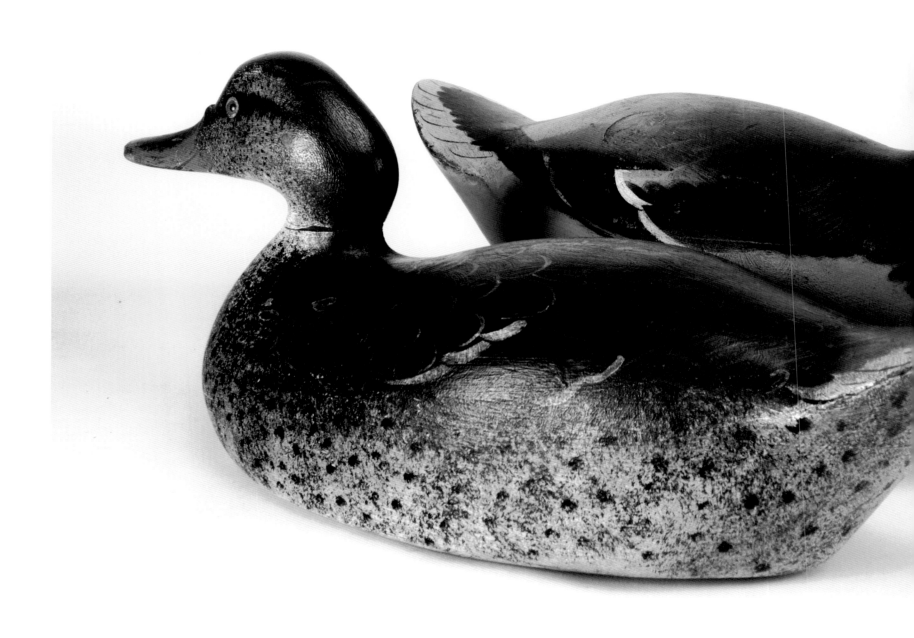

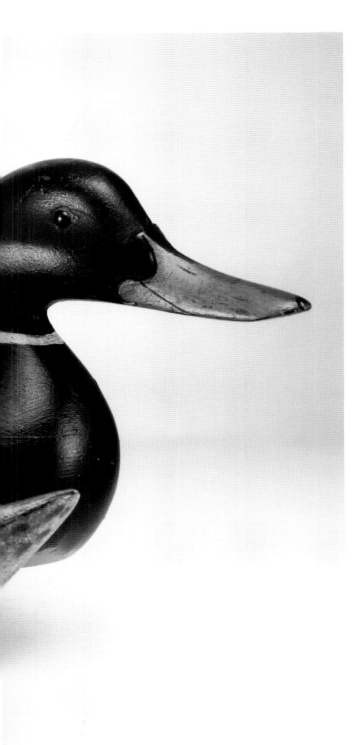

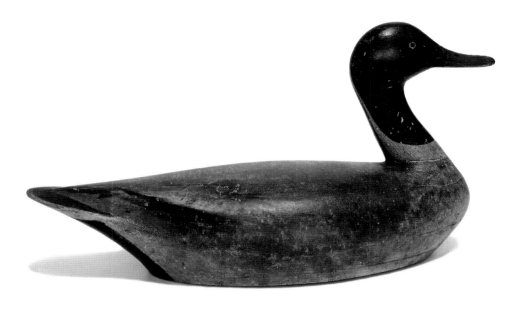

LEFT: *Pair of Mallards.*
Mason Decoy Factory.
c. 1910. Detroit, Michigan.
Collection of Russ and Karen
Goldberger, RJG Antiques.
This pair embodies the many
virtues of Mason's top-of-the-
line hollow-bodied Premier
models.

ABOVE: *Pintail Drake.*
Maker unknown. c. 1866.
Port Rowan, Ontario. The
Malcomb Family Collection.
This noble bird was originally
owned by Col. David Tisdale
of Simcoe, Ontario, and is
branded "D.T." Tisdale was
a founding member of the
Long Point Company, to
which he belonged from 1866
to 1891.

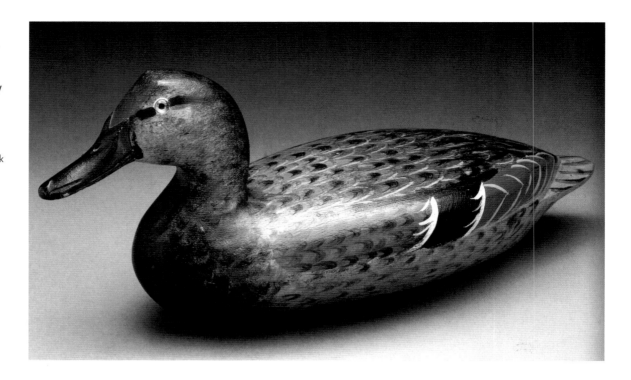

Mallard Hen. **Robert and Catherine Elliston. c. 1900. Bureau Junction, Illinois. Collection of Thomas K. Figge. Photograph courtesy Stephen O'Brien Jr. Fine Arts, LLC.**
This rare mallard hen demonstrates Catherine Elliston's superb brushwork at its best.

The Illinois River

The Illinois River is a principal tributary of the Mississippi, which runs more than 270 miles across the state it is named for and drains a substantial portion of central Illinois. During the nineteenth and early twentieth centuries, the Illinois River valley supported large populations of dabbling ducks, especially mallards, pintails, teal, wigeons, and black ducks, which could be found on the river and the many lakes and marshes that surround it. Dozens of hunting clubs operated in the Illinois River valley and were frequented by wealthy businessmen from Chicago and other Midwest cities.

Illinois River decoys were typically boatlike in form, with hollow, two-piece bodies and V-shaped bottom hulls. They were painted more elaborately than lures in most other regions of the country, with highly detailed comb and feather paint, and because they were used in freshwater, a large percentage have

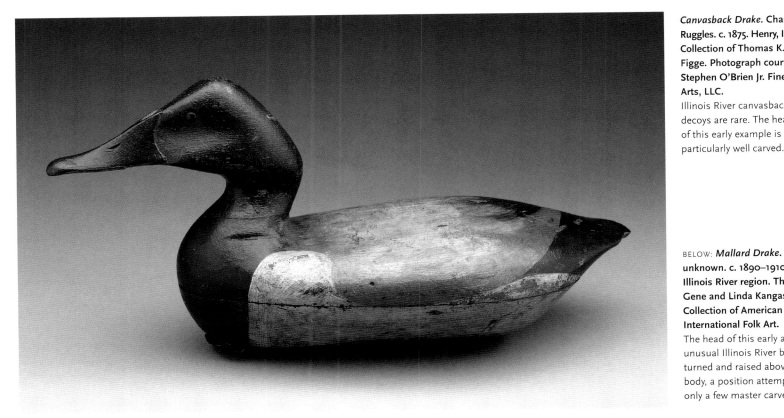

BELOW: *Mallard Drake.* Maker unknown. c. 1890–1910. Illinois River region. The Gene and Linda Kangas Collection of American and International Folk Art.
The head of this early and unusual Illinois River bird is turned and raised above its body, a position attempted by only a few master carvers.

survived in original paint. Prior to the banning of spring shooting, species made for use in that season, when the river was high and muddy with snowmelt, were often painted more brightly than those hunted later in the year. The majority of decoy makers carved nostrils, mandible separations, and nails on their bills and clearly delineated the meeting of head and bill. Most also fitted their decoys with high-quality glass eyes that further enhanced their birds' bright, alert, and realistic look.

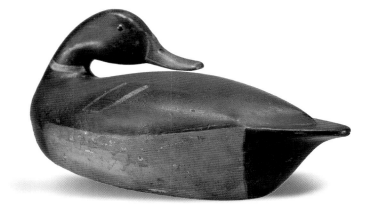

Henry Ruggles (1830–97), one of the earliest Illinois River carvers, worked as a house and sign painter in Henry, a small community on the river north of Peoria and equidistant from there and LaSalle. Ruggles made relatively few decoys, all for his own use, but his work influenced a number of younger carvers, most notably his son Charles (1864–1920) and Charles Perdew, who was born in Henry in 1874 and worked with Charles Ruggles for a time. Henry Ruggles carved robust, full-bodied decoys, with distinctly V-shaped bottoms, lightweight, hollow bodies, elongated, full-cheeked heads set on prominent neck seats, and square tails. Not surprisingly, given Ruggles's trade, they were completed with well-executed paint patterns.

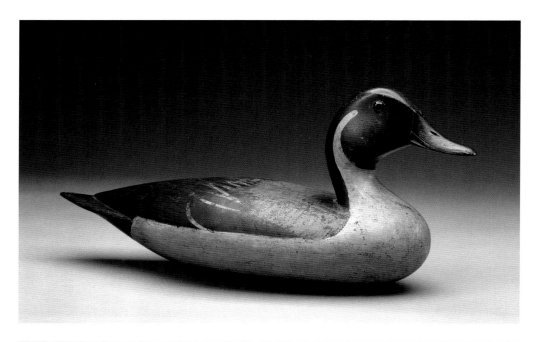

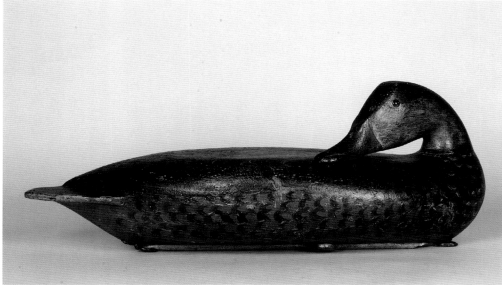

Stephen Lane (1843–1900) of Lacon, a small city on the river about twenty-five miles north of Peoria, was a market gunner and master carpenter who, in addition to the decoys he carved for his own use, also built houses, carriages, and furniture. His hollow-carved decoys are more refined and realistic than Henry Ruggles's work, with flowing lines and long, pointed tails. His woodworking skills made it possible for him to fit the halves of his bodies so precisely that they could be joined only with cement and needed no nails. He was also a masterful painter who used a metal comb to scratch feathery swirls in wet paint, a technique that may have influenced Catherine Elliston. A passionate hunter who killed so many ducks that he reportedly shot the choke out of a 10-gauge shotgun each year, Lane knew his birds, and he not only accurately painted the different plumages for drakes and hens but also made the females proportionately smaller, as they are in life. Lane also carved his bills with considerable detail, precisely delineating the nostrils, the line separating the mandibles, and the nail at the tip of the bill.

Robert Elliston (1849–1915) worked as a carriage builder before turning to full-time boatbuilding and decoy carving. He was one of the first professional carvers in the Midwest and by far the most successful professional Illinois River carver of his time, and his well-carved and well-painted work set a high early standard among other regional craftsmen. All of Elliston's decoys were painted by his wife, Catherine (1858–1953), whose detailed grain and feather painting was as

TOP: *Pintail Drake.* Stephen Lane. c. 1890. Lacon, Illinois. Collection of Thomas K. Figge. Photograph courtesy Stephen O'Brien Jr. Fine Arts, LLC.
To add realism to his decoys, Lane fitted them all with glass eyes made for taxidermists' mounts. Unlike most other carvers, he did not use nails to attach the two halves of his hollow-bodied birds, sealing them only with glue. As this splendid example of his work attests, his method left the normally apparent seam line between body halves almost invisible.

BOTTOM: *Black Duck.* Robert and Catherine Elliston. c. 1890. Henry, Illinois. Collection of Alan and Elaine Haid.
This unique, oversized bird represents a species the Ellistons rarely made. It was found in Massachusetts and was probably created as a special order.

influential as her husband's carving. Catherine developed her highly accurate patterns by observing ducks Robert had brought home for the family table, carefully studying the colors and textures of their feathers before plucking them for dinner. She was among the first decoy painters to employ a wet-on-wet technique, blending new colors with tacky, partially dried paint to achieve a soft, feathery look.

Robert Elliston moved several times during his professional career; an 1890 letter on his own printed stationery describes him as a "manufacturer of fine decoys and hunting boats," with a "factory at Henry, Illinois. Formerly at Putnam, Illinois" (Putnam is the next town north of Henry). At the time, he and Catherine were living near Putnam in the Undercliff Hotel on Lake Senachwine, a backwater of the Illinois River and a major destination for regional hunters. Elliston eventually built a house on land between the river and Goose Lake, about two and a half miles south of Bureau Junction, and there supplemented his income from building decoys and duck boats by producing honey from an apiary of more than 240 hives.

Elliston carved the relatively thin, flat-backed bodies of his ducks with V-shaped bottoms, not unlike the forms of the duck boats he made. His letterhead claimed his decoys were "glued firmly with choice glue and also nailed together with fourteen fasteners," with "bills of straight grained wood. Warranted in all respects." The decoys were weighted with a narrow strip of cast lead, imprinted with "THE ELLISTON DECOY." His narrow and somewhat pointed heads have flattened foreheads, and their high-set taxidermist's eyes give them a distinct, somewhat amphibious look. Elliston carved a deep V at the top of the bill, and, like Lane, added distinctly carved nostrils, mandibles, and nails. Elliston was the first Illinois River carver to craft birds with heads turned back over their bodies as if they were sleeping or preening. Almost all of his turned-head birds were mallard hens; one is accurately depicted on his 1890 letterhead. Although Elliston abandoned the sleeping form as his business grew because it was too time-consuming to produce, it was copied by many later carvers in the region, most notably Charles Perdew, who successfully applied it to a variety of species.

George M. Sibley (d. 1938), a prominent Chicago businessman and original member of the Hennepin Shooting Club, across the Illinois River from Henry, briefly manufactured decoys in Minnesota that were used at the club and many other locations on the Illinois River. He advertised his decoys as "being modeled and painted from specimens furnished us by the best taxidermist in Chicago" and sold them for $1 a dozen. Their boatlike, V-shaped bodies were hollow-carved and had interior weights, and they had inserted hardwood bills, an innovation for which Sibley applied for a patent. Sibley apparently operated his decoy company for only two years, from 1899, when he applied for the patent on his bills, to 1901, when he pulled up stakes and moved to Colorado, where he spent the rest of his life.

Decoy historians Joe and Donna Tonelli, who first documented the Sibley Co., believe that the operation was a production line similar to Mason Decoy Factory in Detroit. "The parts were turned on a lathe,

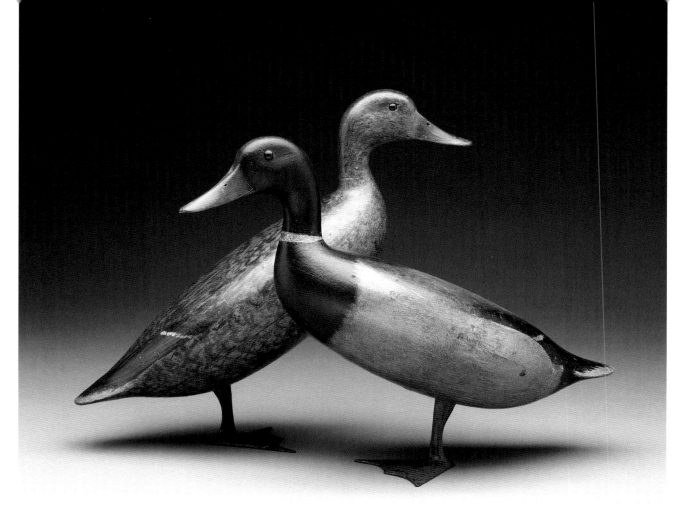

The bodies of Shoenheider's standing ice decoys are very similar to those of his floating lures. Notice how the placement of the painted cast iron legs set these birds at different angles. Legend has it that hunters heated the carefully cast metal feet so they would melt into the ice and stand hold the decoys firmly upright.

hand-finished, assembled and painted. The Sibley Co. produced mallard, canvasback, redhead, bluebill, ringbill, pintail, widgeon, blue-winged and green-winged teal decoys. . . . All of the bottoms were coated with a heavy layer of white lead paint and 'PATENT APPLIED FOR 1899' was stamped on them in ink."

Charles Schoenheider Sr. (1856–1924) of Peoria was a carpenter and market gunner who made decoys primarily for his own use. While he also made accomplished floating lures of a wide variety of the species he hunted, Schoenheider's most distinctive works are his standing mallards, pintails, and geese, which were made for winter shooting near air holes in frozen lakes and rivers. Crafted with the same elongated body forms as his floaters, Schoenheider's standing mallards and pintails were ingeniously balanced on a single cast-iron leg and wide-webbed foot. Impressed by Schoenheider's invention, a Peoria sportsman named Donald Voorhees commissioned him to carve a rig of geese consisting of two floating decoys and ten standers similar to the mallards and pintails he had made for himself. Schoenheider crafted full-bodied birds light enough to stand on a single foot by laminating pieces of

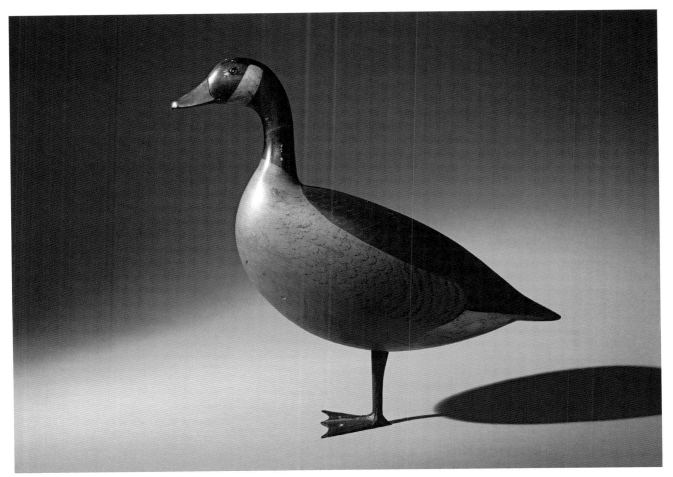

carved pine together horizontally to create a hollow body and hired Jack Franks, a Peoria decorator, to paint them. He worked on the rig for a year, but when he delivered it in 1918, Voorhees refused to pay what he considered an exorbitant asking price of $125. Schoenheider was furious; he hid the geese away in his attic, and they were never used.

Charles Perdew (1874–1963) was Illinois's most prolific and versatile professional carver. Like Robert Elliston, Perdew worked in partnership with his wife, Edna (1882–1974), who was a far more skilled painter than he. Charlie did paint some of his work, especially before their marriage in 1902 and starting again in the 1940s, after Edna's constant exposure to lead paint made her too ill to continue working. In addition to duck decoys, full-size ornamentals, and a variety of miniatures and novelties, Perdew also carved highly regarded duck and crow calls and was well known for his crow decoys.

Perdew was a born inventor, tinkerer, and handcraftsman who also made his own false teeth and eyeglasses and built a cabin cruiser, a two-person bicycle, the lathes he used to make his duck calls, and the house he lived and worked in. The house, which sits on a hill overlooking the Illinois River and has a foundation and chimney Perdew built from river rock, has been preserved as a museum. Before turning

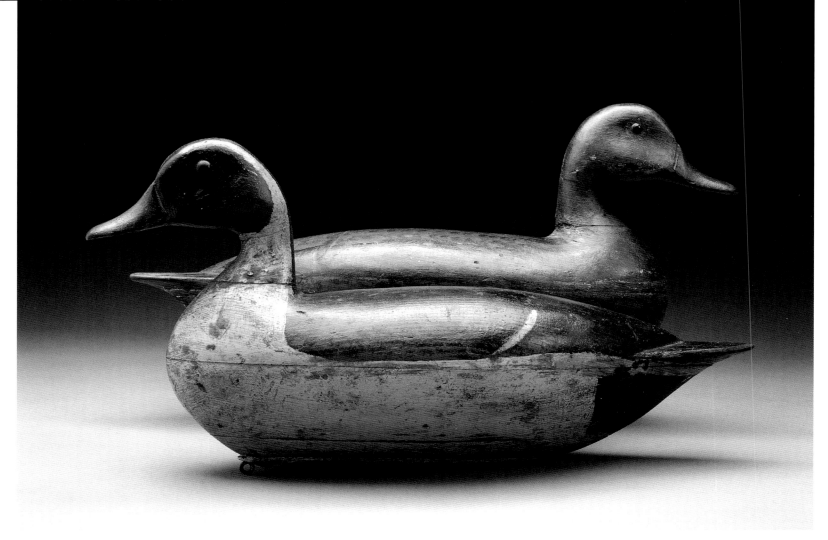

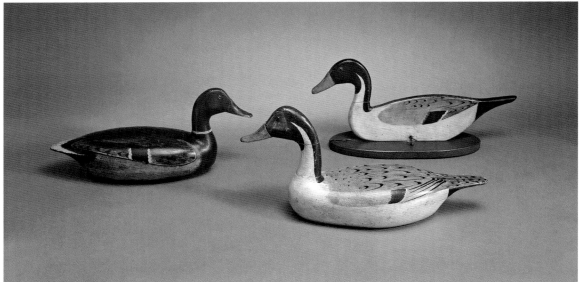

ABOVE: *Pair of Pintails.* Charles and Edna Perdew. c. 1910. Henry, Illinois. Collection of Thomas K. Figge. Photograph courtesy Stephen O'Brien Jr. Fine Arts, LLC.

These are examples of the Perdews' earliest work, with high heads and deep, three-piece hollow bodies that are complemented by Edna's skillful painting.

to decoy carving full time in the early years of the twentieth century, Perdew also worked as a market gunner and gunsmith, ran a bicycle shop, and sold his own handmade brooms.

Perdew knew Robert Elliston, who lived and worked nearby, and spent time in his shop in the late 1800s studying his methods and probably working as an assistant in some capacity. His earliest decoys have deep, three-piece bodies with V-shaped bottoms, but he eventually switched to a thinner two-piece body similar to Elliston's but with a more rounded bottom. The decoys that he and Edna made between the time of their marriage and the 1940s are remarkably consistent in quality, with an easy, relaxed look that was apparently very successful in deceiving wary Illinois River wildfowl. Perdew carved a wider variety of species than any other Illinois River maker and changed his forms a number of times, adding raised carved wings to some of his work in the 1940s, for example. He continued to produce prolifically right up to his death in 1963, painting later birds with his own highly stylized if somewhat stiff patterns.

Charles Walker (1876–1954) of Princeton, about twenty-five miles northwest of Henry, was a professional house and sign painter who turned to carving fairly late in life. His decoys were commissioned by well-to-do members of the Princeton Game and Fish Club, one of the most exclusive in the state. Club members shot on ponds and marshes, so, unlike decoys made for use on the Illinois River, the majority of Walker's lures had flat bottoms. Many had relief-carved wings, and most have high, straight heads, although he did carve a few with their heads turned back over their bodies. Walker bought professional decoy painting kits from Herter's, a decoy manufacturer in Minnesota, and followed their basic patterns, adding swirling feathering and combing details of his own invention to the blocks of solid-colored plumage. In addition to mallards, his primary species, he carved a dozen canvasbacks and two dozen pintails, and he also made a few folding silhouettes of mallards and pintails that were intended for use on winter ice. His regal, long-necked pintail drakes are considered his most aesthetically successful creations.

G. Bert Graves (1887–1956) of Peoria made decoys in a shed behind his house in the 1930s and early 1940s, sometimes working with the assistance of his wife, Millie, and brother Orville. Billing himself as the G. B. Graves Decoy Co., Graves modeled all but his canvasback decoys on Robert Elliston's work and sent many of his carvings to Robert's widow, Catherine, who was then living with her daughter in Batavia, outside Chicago, to be painted. She eventually taught Millie Graves how to paint in her style and passed most of her husband's tools and patterns on to Bert. He made a few pairs of enormously oversized mallards intended to attract the attention of high-flying birds and also made some mallard hen sleepers in the Elliston style. The combination of his interpretation of the Elliston form and Catherine Elliston's paint on these sleepers is particularly felicitous.

OPPOSITE BOTTOM LEFT TO RIGHT: *Mallard Drake.* c. 1940. *Pintail Drake.* c. 1932. *Pintail Drake.* c. 1932. Charles Walker. Princeton, Illinois. Ex-collection James M. McCleery, M.D. Photograph courtesy the Houston Museum of Natural Science, Houston, Texas. Walker belonged to the Princeton Fish & Game Club and made most of his decoys for other club members. The high-headed pintail was originally made for Merle Brown, the secretary and treasurer of the club, and was part of the famed E. C. Vance rig there. The number 28, which identified birds in the Vance rig, is stenciled on its bottom. Unlike most silhouette decoys, the flat-bodied pintail at right is beautifully painted and also has glass eyes and a carved bill. The lightweight bird folded so it could be easily carried.

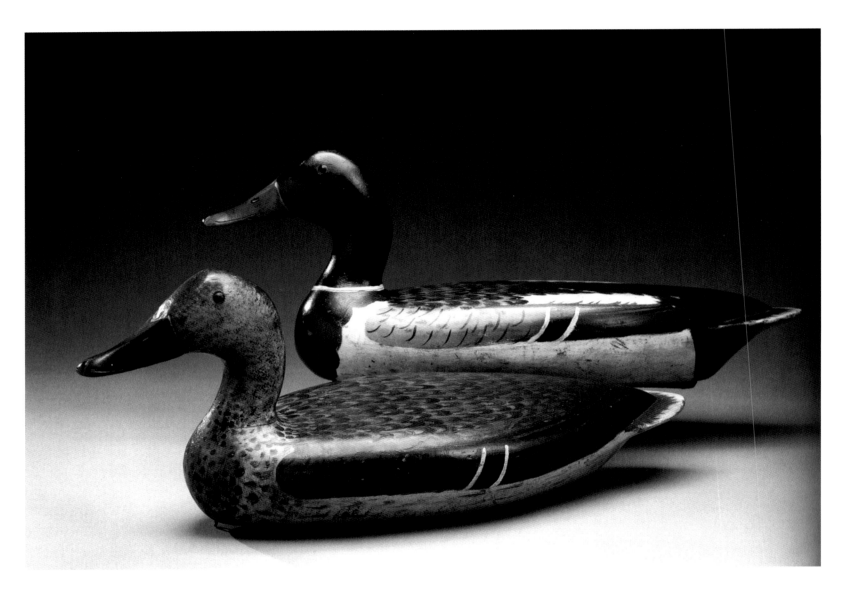

Pair of Mallards. Carved by
G. Bert Graves. Peoria,
Illinois. Painted by Catherine
Elliston. c. 1935. Batavia,
Illinois. Collection of Thomas
K. Figge. Photograph courtesy
Stephen O'Brien Jr. Fine Arts,
LLC.

Graves carved only a few
pairs of these oversized
mallards, which are twice the
size of his normal decoys.
Catherine Elliston continued
to paint decoys by other
carvers after her husband's
death in 1925.

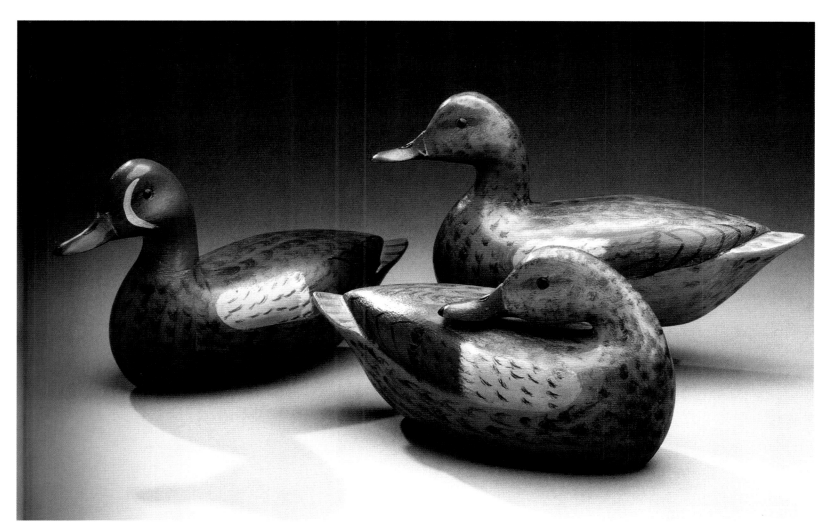

Blue-winged Teal Drake and Hens. **Charles and Edna Perdew. c. 1920. Henry, Illinois. Collection of Thomas K. Figge. Photograph courtesy Stephen O'Brien Jr. Fine Arts, LLC.**

These beautifully crafted little birds were part of a large and varied group ordered by a Rockford, Illinois, banker named G. K. Schmidt, for whom the Perdews pulled out all the stops. Like most of the other birds that they made for Schmidt, these remain in pristine, unused condition, virtually the same as the day they left the Perdews' shop.

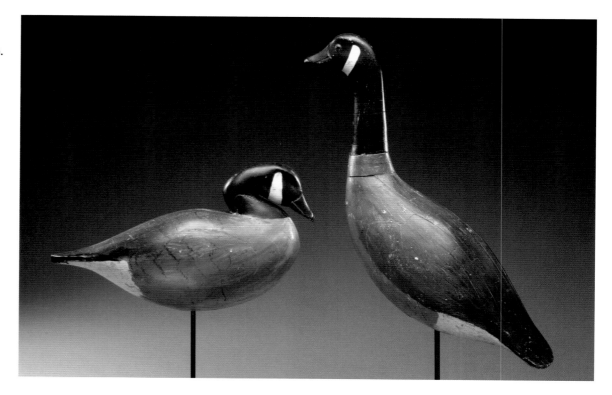

Pair of Canada Geese. John Tax. c. 1917. West Union, Minnesota. Private collection. Photograph courtesy Copley Fine Art Auctions, LLC.
The goose at right is poised in an alert sentinel position, keeping watch while its rigmate rests with its head tucked into its breast.

CHAPTER 24

The Upper Midwest:
Minnesota and Wisconsin

Minnesota and Wisconsin are defined by water. Both touch Lake Superior, the largest of the Great Lakes and the largest body of freshwater by surface area in the world, and both are dotted with thousands of smaller lakes, ponds, rivers, streams, and seasonal potholes that have provided habitat for breeding and migrating wildfowl since time immemorial. Minnesota, the northernmost of the lower forty-eight states, is known as the Land of 10,000 Lakes; it actually contains 11,842 lakes that each measure more than ten acres in size, one of which, Lake Itasca, is the source of the Mississippi River. The state's name comes from Mnisota, the Dakota Indian name for the Minnesota River. The word *mni* means "water" in the Dakota language. In addition to the Mississippi, which forms part of the border between Minnesota and Wisconsin, there are more than 6,500 other rivers and streams within the state. Wisconsin, to the east of Minnesota, is equally watery, with nearly

9,000 lakes that are each more than twenty acres in size. Its eastern border is Lake Michigan, the third largest of the Great Lakes.

Minnesota's most important carver, John Tax (1894–1967), lived in West Union and worked in Okasis, on the lake of the same name about 125 miles northwest of Minneapolis. Tax was a harness maker and shoe repairman by trade who made a variety of floating and standing decoys, primarily for his own use. His standing decoys include mallards and Canada, cackling, and snow geese. These were made for use in the fall, after the cornfields had been harvested and were drawing migrating wildfowl in search of food.

The dynamic, muscular standing geese that Tax carved for his own field-gunning rig are his best work. The rig, which included at least six snow geese and a dozen Canada geese, is distinguished by its pure strength of form. The decoys were made of laminated pine, hollowed to reduce carrying weight, and each was fitted with a leather carrying strap. In the field, they perched on heavy cast-iron stakes that could be forced into the frozen ground. Each bird in the rig had a slightly different attitude, adding variety and realism to the grouping: There are alert watch ganders, sentinels with their necks stretched high in the air to keep a lookout for danger; standers with their heads cocked in various directions; feeders with their necks arched and bending toward the ground; and resting birds with their heads tucked close into their chests. No two are exactly alike. As they must have been when in use, Tax's

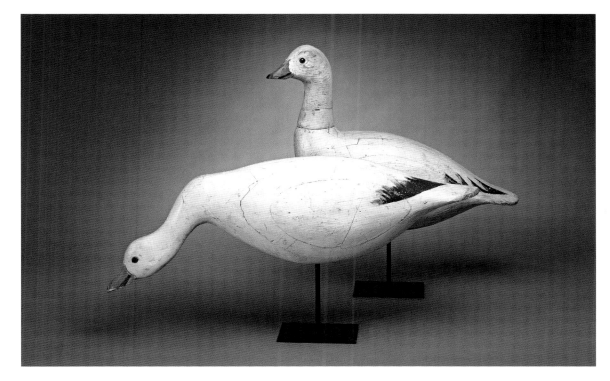

Snow Geese. John Tax. c. 1917. West Union, Minnesota. Ex-collection James M. McCleery, M.D. Photograph courtesy the Houston Museum of Natural Science, Houston, Texas. These snow geese, one with an upright alert head and the other posed as a feeder, are from Tax's own gunning rig.

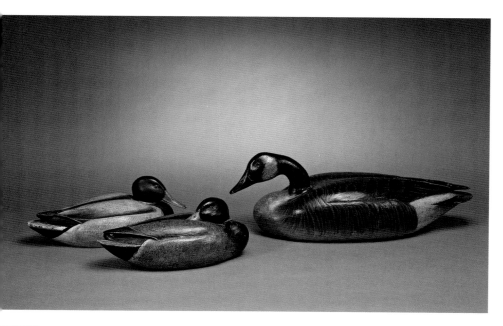

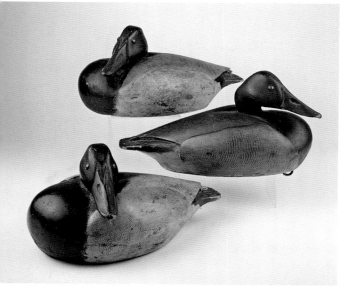

TOP, LEFT TO RIGHT: *Mallard Drake.* Ferdinand Homme. c. 1950. Stoughton, Wisconsin. *Mallard Drake.* Enoch Reindahl. c. 1940. Stoughton, Wisconsin. *Canada Goose.* Enoch Reindahl. c. 1940. Stoughton, Wisconsin. Ex-collection James M. McCleery, M.D. Photograph courtesy the Houston Museum of Natural Science, Houston, Texas. Both Homme and Reindahl worked slowly and meticulously, so their outputs were small. Reindahl is known to have carved only six geese. All three of these birds are hollow, and both carvers stenciled their names on the bottoms of their creations.

ABOVE: *Canvasbacks.* Mandt Homme. c. 1940. Madison, Wisconsin. Collection of Joe and Donna Tonelli. Like his brother Ferd, Mandt Homme was a perfectionist who studied wild birds carefully and carved and painted his decoys accordingly.

decoys are most effective when grouped, each complementing and adding to the impact of the next. The work of only a few makers has a similarly cumulative and complementary effect: Nathan Cobb certainly comes first to mind, followed by such masters as Albert Laing, Elmer Crowell, and Steve and Lem Ward. Tax's birds must have been an impressive sight in the Minnesota cornfields where they were first "exhibited."

Tax, who was clearly an inventive man, also carved superb fish-spearing decoys and was granted a patent in 1941 for a decoy made of "five pieces of fabric secured together by stitching" and intended to be stuffed with ground cork. This would, according to Tax's patent application, "provide a novel and improved light weight water bird decoy of cheap and simple construction."

Enoch Reindahl (1904–2000) of Stoughton, Wisconsin, just south of Madison and Lake Kegonsa, was the state's most influential twentieth-century decoy maker. Reindahl did most of his carving in the 1930s and '40s. A semiprofessional photographer who loved to take pictures of the natural world, Reindahl also snapped photos of every step of his decoy-making process, which were used to illustrate his 1949 *Field and Stream* magazine article, "How to Make Decoys." Reindahl was also a dedicated amateur musician and is known to have made a mandolin for himself with its headstock carved into the shape of an open-mouthed gorilla's head.

Reindahl was a perfectionist who made exactly realistic decoys; he even carved and painted the eyes of his decoys because he could not find glass eyes that he felt were realistic enough. He carefully carved body and head contours and raised primary feathers, set the heads of his birds in reaching, sleeping, and turned positions, and finished his work with accurately detailed comb and feather paint. Reindahl was friends with his Stoughton contemporaries, the brothers Ferdinand (1900–63) and Mandt

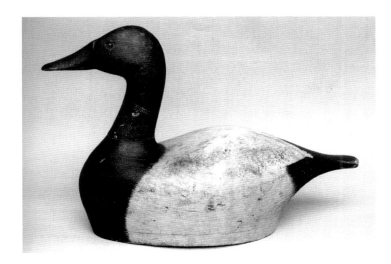

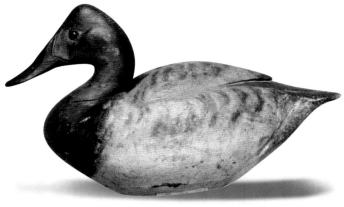

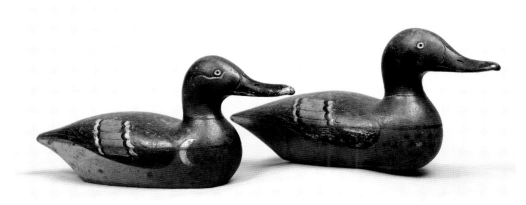

(1905–64) Homme, who shared his passions for duck hunting and bird carving. Not surprisingly, the three men shared carving tips with one another, and Reindahl told decoy historian Donna Tonelli that Ferd taught him some of the tricks of decoy making. "For example," Tonelli reports, "Ferd would use a heavy piece of paper glued between the two pieces of pine that would form the body of his decoys. This way he could shape his decoy body and then break the seal easily, allowing him to hollow out the carved body." Mandt Homme hunted with Reindahl at Big Marsh, a favorite haunt of Stoughton and Madison gunners on the nearby Yahara River, and, according to his wife, the two men often drew patterns and carved together in Homme's basement workshop. Like Reindahl, the Homme brothers were interested in creating the most realistic-looking decoys possible. Mandt also carved the eyes of his decoys, and both men shared their friend's preference for turned head positions and highly detailed paint.

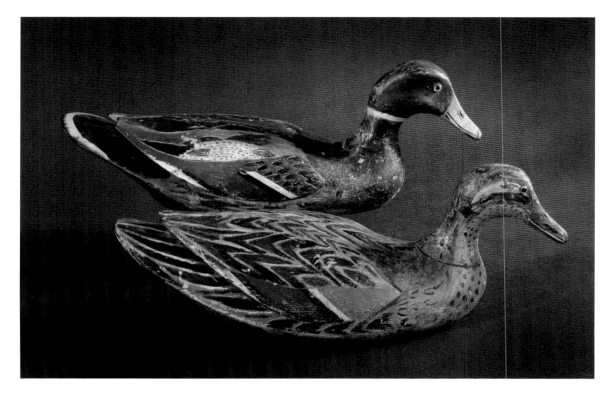

Pair of Mallards. **Adam Ansardi. c. 1920. Davant, Louisiana. Private collection.** Ansardi (1885–1953) was a well-to-do gentleman sport who crafted a small number of decoys for his own use. His flat-bottomed birds, all of which have raised wings, carved mandibles and nostrils, high-quality glass eyes, and carefully detailed paint, are among the most sophisticated decoys ever made in Louisiana. This handsome early pair conveys a strong sense of forward motion.

Bayou Country

Louisiana's Gulf Coast is unlike any other part of North America, and decoys made in the region are equally distinctive. The Mississippi River, which demarcates the state's eastern border and meets the Gulf of Mexico south of New Orleans, is North America's mightiest river; its immense drainage basin, which encompasses more than 1.2 million square miles and all or part of thirty-one states, is exceeded in size only by the watersheds of the Amazon and Congo rivers. The river slows and widens as it nears the Gulf of Mexico, where thousands of years of alluvial deposits have diverted its waters into an ever-changing welter of side channels, slow-moving bayous, swamps, fresh- and saltwater marshes, lakes, barrier islands, and tidal flats. The makeup of the Gulf Coast has also been shaped by the region's frequent hurricanes and by dredging and levee building aimed at controlling water flow and mitigating storm damage.

The artist Lynn Bogue Hunt, who hunted in Gulf Coast Louisiana in the 1940s, painted this vivid picture of the region in Eugene Connett's *Duck Hunting Along the Atlantic Tidewater*:

> The Louisiana marshes are a huge area of mudlands laced with bayous, canals and narrow waterways and dotted with ponds and little lakes. The vegetation of the mud flats is a jungle . . . of hog cane, phragmites and many other of the reed family. The open water is lined and choked with alligator grass and water plants of all sorts. Water lilies grow in profusion. In many places it is impossible to push a boat through the reeds, narrow as the pirogues are. This almost sub-tropical region is from fifteen to thirty miles wide and stretches all along the Gulf of Mexico to eastern Texas from New Orleans, so vast it is . . . the mainland edge of this wilderness is . . . miles of sheer beauty and romance [with] old plantation houses, tremendous live oaks bearded with eight- and ten-foot streamers of Spanish moss, fields of sugar cane standing and being harvested, streams, ponds, lakes and picturesque little towns all the way.

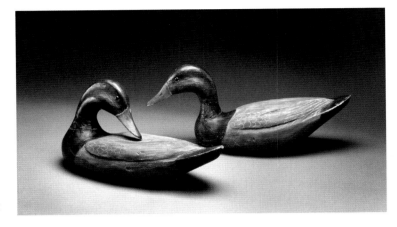

Canvasback Drakes. **Mitchel LaFrance, Charles Numa Joefrau, and George Frederick Jr. c. 1941. New Orleans, Louisiana. Collection of Barry Sallinger.**
These drake rig mates, with different head poses, show how refined the LaFrance team's carving could be. The paint on these birds is quite understated compared with other decoys they made.

The Gulf Coast has always provided a rich and varied habitat for game animals, alligators, fish, shrimp, oysters, and both native and migratory birds. As the southernmost stop in North America for wintering birds, the mild, essentially frost-free climate and abundant food sources attracted a wide variety of game species in the nineteenth and early twentieth centuries, especially pintails, mallards, teal, and other freshwater dabblers. The huge populations of wildfowl supported market gunners, feather hunters, and sportsmen as well as many who shot simply to put food on the family table or acted as guides to visiting sports.

As in other regions, Louisiana decoys were carved from native wood species, in this case the bald cypress and tupelo gum trees found throughout the swamps and bayous of the Gulf Coast. The majority of Louisiana carvers favored cypress root, while some carvers chose to carve cypress "knees," craggy outgrowths of the root system that project above the waterline. These are difficult to work with, but their suggestive forms often led to unusually expressive body and head shapes when carved. Tupelo gum, a dense-grained hardwood similar to ash and basswood, was used by many Southern furniture makers and a few carvers. Both cypress and tupelo are extremely durable and resistant to rot, a big plus in such a warm, moist climate. They also are lightweight; dried blocks of cypress root can be almost as light as balsa when dry, but they are still dense enough to carve well. Every ounce counted for hunters who had to carry rigs of decoys into the marshes, but the lightness of the native woods meant that area craftsmen did not have to hollow out their decoys to reduce weight, as was the case in other parts of North America. Thus Louisiana decoys are almost without exception solid-bodied, with separately carved heads that are most commonly attached with nails or wooden pegs.

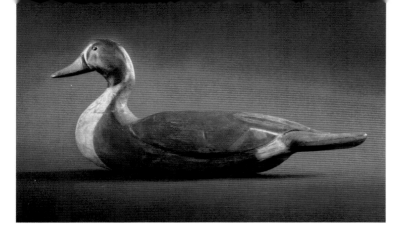

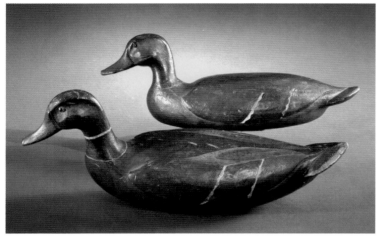

Pintail Drake. Nicole Vidacovitch. c. 1890. Sunrise, Louisiana. Private collection. This mighty bird is a prime example of Vidacovitch's earliest and least common style, with a fatter and more rounded body than the birds he is best known for. Many of his early works were lost to the hurricanes that wreaked havoc on the lower reaches of the Mississippi Delta, where Vidacovitch lived and guided until 1915.

Pair of Mallards. Nicole Vidacovitch. c. 1900. Sunrise, Louisiana. Private collection. A classic pair by the man considered by many to be Louisiana's greatest carver. Vidacovitch's long, low, elegant birds influenced generations of later craftsman.

Southern Louisiana was settled by people from many cultures, most notably French Canadians, who came to be known as Cajuns, but also former slaves, free blacks, and Creoles—people of mixed race from the southeast United States and Caribbean—as well as sizable numbers of immigrants from France, Germany, Yugoslavia, and Italy. This complex and unlikely mix of cultures and traditions is unique to southern Louisiana, and it has informed and enriched every aspect of life in the region, from its inimitable food, music, and street pageants to its folk arts. Not surprisingly, many Louisiana carvers brought influences from their native cultures to the art of the decoy.

Nicole Vidacovitch (1853–1945), who is widely considered Louisiana's greatest carver, lived in the town of Sunrise, far down the delta close to the mouth of the Mississippi. The son of Yugoslavian immigrants, Vidacovitch worked as a market gunner and also guided at the exclusive Delta Duck Club, which had been established by wealthy sportsmen from New Orleans. He sold decoys to both the club and the Chateau Canard (French for "duck house"), which had been built by Joseph Leiter, the son of one of the founders of Chicago's famed Marshall Field's department stores, and also carved for John Waterman, who owned the Waterman Steamship Company. In 1915, when Vidacovitch was in his early sixties, a major hurricane wiped Sunrise and the Delta Duck Club off the map. Vidacovitch lost everything in the storm and relocated to New Orleans, where he successfully supported himself and his family in his later years by selling his carvings. He carved his solid-bodied decoys from cypress roots, creating long, low, and narrow forms with upswept tails, prominent relief-carved wings that extend the length of the back, pronounced cheeks, and dynamic head positions. His painting is more subtle and realistic than that of most other Louisiana decoy makers, with well-blended colors and plumage patterns. He had enormous influence on later New Orleans carvers, many of whom emulated his racy, elongated carving style in their own work.

Sidney Duplessis (1870–1950), Gaston Isadore (1871–1948), and Jules Frederick Sr. (1876–1954), who lived near one another in the Phoenix/Davant area on the east bank of the Mississippi south of New Orleans, helped define that region's style in the early years of the twentieth century. Like many others who lived in the hardscrabble river hamlets of northern Plaquemines Parish, they were Creoles, descendants of free "people of color," the

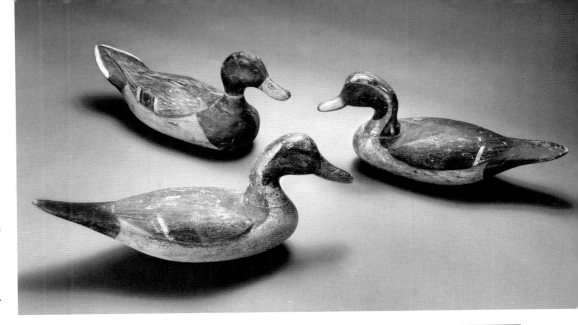

mixed racial offspring of white plantation owners in antebellum times. They lived off the land and water, hunting, trapping, and fishing, and Duplessis and Frederick also grew rice and other crops. All three created streamlined cypress wood decoys with rounded chests and sides, long tails, and smooth, flowing lines. They carved wing outlines in relief, with particular emphasis at the base of the wings behind the neck, which they carved deeply in a heartlike shape, and they scratched feather patterns into wet paint with the tips of their brushes. Duplessis's work is less sophisticated than Isadore's and Frederick's, but all three men made bold, robust, brightly feathered birds. Both Isadore and Frederick are known to have sold birds through hardware stores in New Orleans.

The influence of Duplessis, Isadore, and Frederick was strongly felt by the famous trio of Mitchel Lafrance, George Frederick Jr., and Charles Joefrau, who carried the memory of the older men's forms and painting style upriver to New Orleans, where they added elements of their own to the mix. Lafrance (1882–1979) spent the first half of his long life in the Davant area, but he moved to New Orleans sometime after the great flood of 1927, which inundated much of Plaquemines Parish. He was joined there around 1932 by fellow Davant natives Frederick (1907–77), who was his nephew, and Joefrau (1913–83), a volatile and enigmatic figure about whom little is known. In the city, the two younger men worked under Lafrance in a cottage industry he had founded and supervised. Working collectively, they created decoys with radically turned heads and high, upswept tails, carved wing and tail feathers, and vivid, brightly colored paint in which they often scratched scalloped feather patterns with the ends of their brushes. Lafrance, a larger-than-life character and born salesman, oversaw the operation and peddled the birds the three men crafted through sporting goods stores and other outlets in New Orleans. Current research suggests that Lafrance actually carved and painted few complete decoys himself, but sorting out who

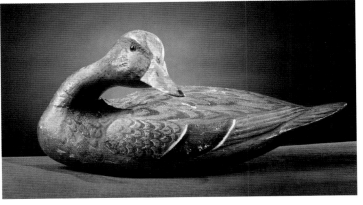

CLOCKWISE FROM UPPER LEFT: *Mallard Drake.* Sidney Duplessis. c. 1920. Davant, Louisiana. Collection of Torrey Riley. *Pintail Drake.* Gaston Isadore. c. 1905. Phoenix, Louisiana. Collection of Clyde Catha. *Pintail Drake.* Jules Frederick Sr. c. 1925. Davant, Louisiana. Collection of Clyde Catha.
This trio of dabblers is the work of three talented Creole carvers from the Davant-Phoenix area in upper Plaquemines Parish. Their work strongly influenced Mitchel Lafrance, George Frederick Jr., and Charles Joefrau. (Though they shared a common last name, Jules and George Frederick were not closely related.) Note the nostrils and nail Duplessis painted on his mallard's bill.

ABOVE: *Mallard Hen.* Mitchel Lafrance, Charles Numa Joefrau, and George Frederick Jr. c. 1938. New Orleans. Collection of Clyde Catha.
This bird could have been carved and painted by either Joefrau or Frederick, or both could have had a hand in its creation. Whoever made it, this is one of the finest and most expressive productions of the cottage industry run by Mitchel Lafrance.

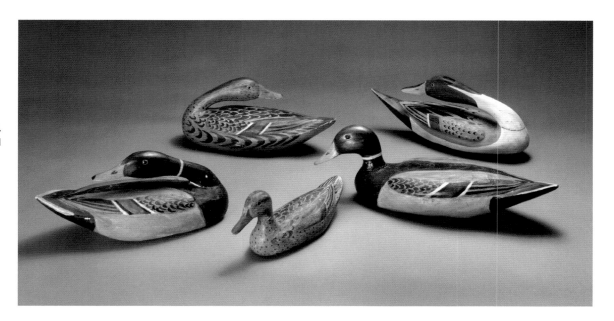

carved and painted which bird remains largely guesswork and is somewhat beside the point. Since the two younger men worked for Mitchel Lafrance, all the birds created by the partnership are technically Lafrance decoys. The trio worked closely together until 1949, when Frederick moved back to Davant to get married. They stayed in contact, however, and Lafrance continued to market their decoys into the 1950s, although the quality of the carving declined somewhat in later years.

Other New Orleans craftsmen produced lures in a variety of styles. Flat-bottomed decoys became popular in the city because their low, relatively wide bodies "stuck to the water" in the small marsh potholes where so many New Orleans sportsmen hunted. Craftsmen favored them as well because flat-bottomed forms required less wood than rounded bodies and could be easily cut out on mechanical band saws. Among the first city carvers to make flat-bottomed lures was Warren Seebt (1896–1972), who worked as a clerk for the Lykes Brothers Steamship Line and made decoys as early as 1925. Some of his pre–World War II decoys had balsa wood bodies, and all his work, which continued into the 1950s, was painted in brightly colored abstract patterns. Jim Mossmeier (1897–1969) made high-quality birds that are long and low, with raised wing carving, flat bottoms, and detailed paint. Mossmeier was a friend of Jack Couret's, another early carver of flat-bottomed decoys, and seems to have been influenced by Couret's body forms and insistence on quality. In turn, both Couret and Mossmeier influenced Couret's son Robert, whose aptly named Lifelike Lures, made after World War II, had flat-bodied, machine-duplicated bodies decorated with extremely realistic stenciled paint patterns.

Like Mossmeier, Al Beyl (1900–57), who worked as a machinist for the American Can Company, made few decoys, focusing on quality, not quantity. His birds have rounded, flat-bottomed bodies

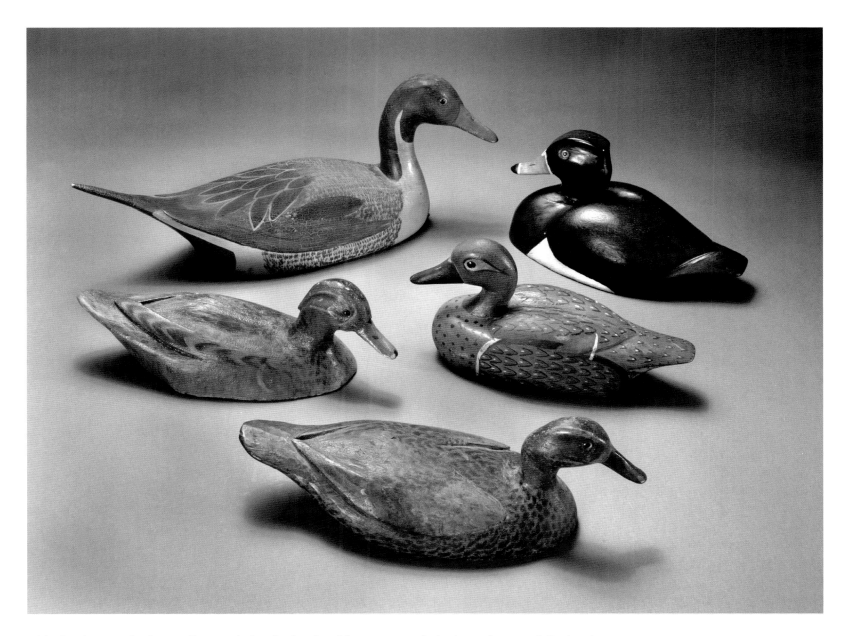

with deeply carved wing outlines and chunky heads with pronounced cheeks and grooved foreheads. Mike Frady (1912–93) was a commercial art teacher at Delgado Community College, Louisiana's oldest community college and trade school. Frady began carving in 1939 and continued throughout his life, influencing many younger carvers who have carried on the tradition. Frady was a masterful painter who added carved wing tips and detailed hand painting to flat-bottomed body forms that show the influence of Jack Couret. He also made many decoys with bodies made from readily available World War II–surplus balsa wood, to which he added cypress heads. Not much is known about John Scott Young

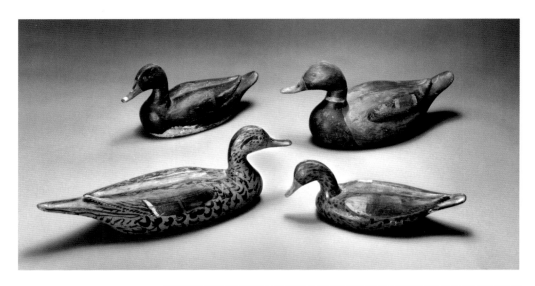

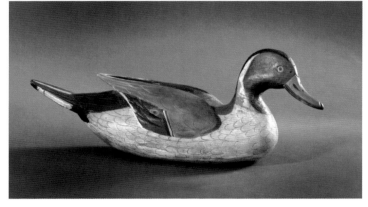

(1911–82), another skilled professional carver at work in the city during and after World War II. He sold his well-crafted, smooth-bodied decoys through Sears, Roebuck and Co. and other stores that carried sporting goods.

The small towns along Bayou LaFourche (pronounced *la-FOOSH*), which roughly parallels the meandering course of the Mississippi southwest of New Orleans, are dominated by Cajun history and culture. The bayou, once a distributary of the Mississippi, was dammed at Donaldsonville in 1905, cutting off the flow of freshwater from the great river and turning it muddy and stagnant. Area residents have always made their living from the water that literally permeates the region between Donaldsonville and the Gulf of Mexico, fishing, shrimping, and hunting the abundant wildfowl. Cajun carvers who lived along the bayou brought elements of their flamboyant culture to their work, decorating the surfaces of their birds with distinctive carving and paint details.

Xavier Eloi Bourg (1901–84) of Larose, just west of Lake Salvdore, worked as a bridge tender on Bayou LaFourche for a number of years. He was also a shoemaker and used shop tools to serrate the outside edges of his birds' raised wings. Between the wings, he carved a distinct groove that extended from the base of the neck to the wing tips, which rest on the tail. He also varied head positions, turning some to one side and extending others forward as if feeding. His earliest decoys have painted eyes, while later carvings have tack eyes. Clovis "Cadice" Vizier (1879–1976) lived in Galliano, eleven miles south of Larose, where he carved professionally for more than fifty years. In a 1941 interview, Vizier told a reporter from the *Mt. Adams Sun*, "At the end of one hunting season, I usually have enough decoys ordered to keep me busy until the following year." The article noted, "Vizier's friends and neighbors—fishermen mostly—know the type of wood he needs for his decoys. Wherever they are, in the swamps or shrimping on the Gulf Coast, they pick up pieces of wood they think he can use." Working with this stash of cypress, Vizier spent his summers carving rounded, full-bodied birds with broad, fan-shaped tails, wings that were raised well off the body,

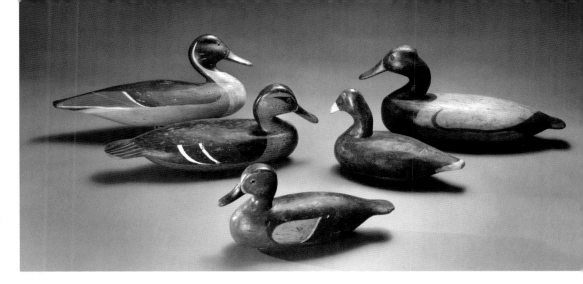

Whipple was a prolific craftsman who carved virtually every species hunted in Louisiana. Although his output spans fifty years, it is remarkably consistent in quality. For some reason, he painted the eyes of his coots and ring necks, but all of his other birds here have glass eyes. Coot were locally known as *poul d'eau*, Cajun for "water chicken."

and curved feather shapes that were incised or stamped. He further embellished the surfaces of his decoys with elaborate paint patterns that echo or amplify the semicircles of his feather carving. His father, Beauregard (1845–1934), and brother Odee (1892–1969), known as "Bee," were also professional carvers who worked in similar but less complex styles.

Mark McCool Whipple (1884–1961) worked as a Mississippi River tugboat captain before growing deafness forced him to seek other work. After giving up life on the river, he moved to Bourg, about fifteen miles west of Larose, where he and his brother Walter hunted and guided on nearby Lake Long. Whipple, who made decoys professionally for about fifty years, carved some of his birds from cypress knees cut below the waterline when root was not available, a choice that resulted in particularly sturdy and long-lasting lures. He was a meticulous craftsman whose tight-fitting neck seats provided extra stability and strength to his heads, which are pulled back in a restful position with lines that flow directly from the throats into rounded, protruding chests. The backs of his smooth-bodied birds are relatively flat, ending in paddle tails.

Nick Trahan (d. 1969) of Lake Arthur was the most influential carver in the Chenier Plain region of southwest Louisiana, a 2,200-square-mile expanse of marshes, sizable inland lakes, and oak-covered ridges (locally known as *cheniers*) that runs along the Gulf of Mexico from Sabine Lake, near the Texas border, to Vermilion Bay, about 150 miles to the east. Trahan, a professional guide and decoy maker, set the style in the region. He was one of the most prolific carvers in the state, turning out thousands of birds, primarily mallards, over the years. He disdained the use of patterns, but the work he did prior to World War II is uniformly well carved, with smooth, flat bodies and heads set on long, angled seats.

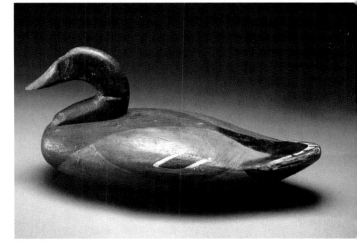

Mallard Drake. Nick Trahan. c. 1935. Lake Arthur, Louisiana. Collection of Barry Sallinger.
This simple, bold carving represents Trahan in his prime. Notice the knife marks that he left on the unsanded head, a choice that actually adds to the bird's power and vitality.

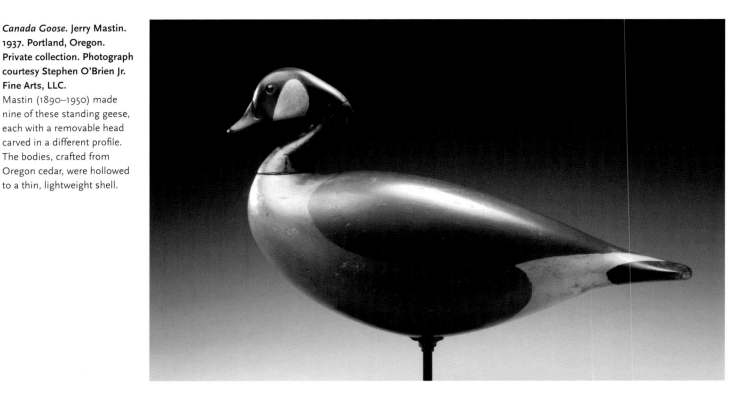

CHAPTER 26

The West Coast

Because the West Coast of the United States was settled so much later than the East Coast, hunting traditions were correspondingly late in developing there. Few decoys were made before 1900; diving and dabbling ducks, brant, swans, and geese were so abundant that hunters simply did not need them in the early years of settlement. However, as populations grew and competition for game increased, decoys became the necessity that they had long been in other parts of North America. A number of West Coast hunters began to make decoys for their own use in the late nineteenth and early twentieth centuries, and, by the 1920s, a few of the most skilled of these men were working as professional carvers, selling their birds to local hunters and the many sportsmen who were traveling to the region to shoot at the exclusive clubs that had been established to take advantage of the profusion of wildfowl.

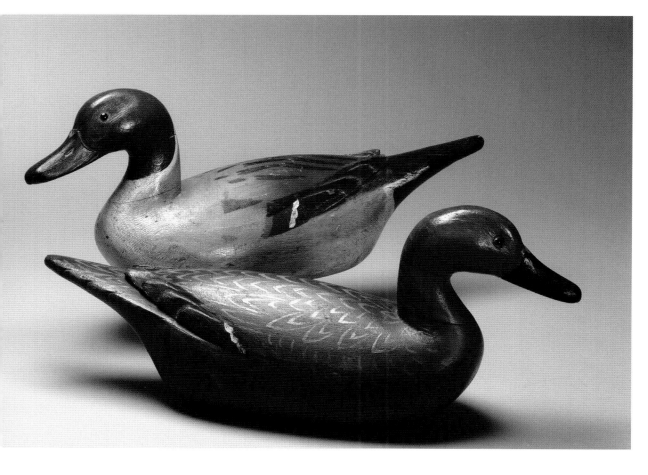

Pair of Pintails. **Richard Ludwig Janson. c. 1930. Sear's Point, California. Collection of Micah Brosnan.** Janson, who carved thousands of decoys between the early 1920s and the late 1940s, was the most prolific and influential carver on the West Coast. This early pintail pair exemplifies his outstanding work, which is readily distinguished by deeply carved wings and tails and well-crafted heads that reveal detailed bill carving and pronounced cheeks.

The West Coast's most influential decoy maker was William Ludwig Janson (1872–1951), known as Fresh Air Dick for his habit of sleeping on the decks of the Alaskan salmon fishing boats he worked on no matter the temperature and weather. Janson, who also worked as a ship's carpenter and market gunner before turning to carving full time, was born in Estonia. After immigrating to the United States, he settled in Sears Point on Sonoma Creek, close to San Pablo Bay, a northern extension of San Francisco Bay. He and his dozens of cats lived on a ramshackle, arklike houseboat of his making, and he hunted over his own handmade decoys in the immense Napa Sonoma Marsh that surrounded his floating home.

Janson began selling his decoys in the early 1920s and continued to carve pintails, mallards, canvasbacks, bluebills, green-winged teal, and an occasional brant into the 1940s. Although a number of hollow-bodied examples are known, most of his decoys are solid-bodied and carved from redwood, with pine heads attached with dowels he made himself by jamming pieces of pine into a small metal pipe. Many of his diving ducks—canvasbacks and bluebills—and brant have at their rears a unique carved

Whistling Swan. Charles Bergman. c. 1905. Astoria, Oregon. Private collection. Photograph courtesy the Houston Museum of Natural Science Houston, Texas. Only three Bergman swans survive.

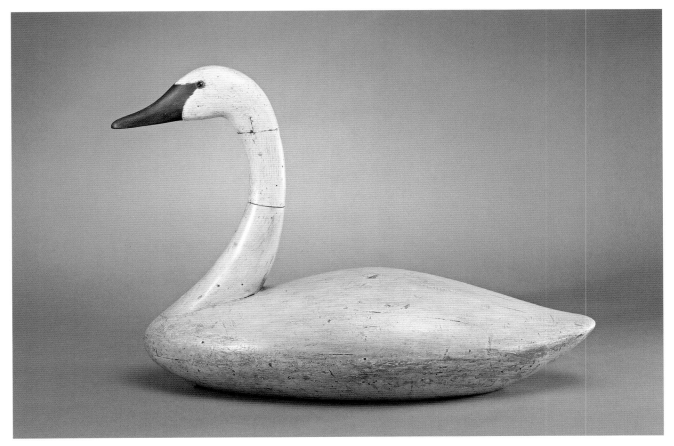

BOTTOM LEFT: *Pintail Drake* (feeding position). John G. Tornberg. c. 1948. Mill Valley, California. RIGHT: *Pair of Green-winged Teal*. Horace Crandall. c. 1935. Westwood, California. Ex-collection James M. McCleery, M.D. Photograph courtesy the Houston Museum of Natural Science, Houston.Texas. Tornberg (1902–1971) was a yachtsman who carved the surfaces of his hollow redwood decoys with gouges and chisels. This highly realistic pintail, which has detailed primary feather and bill carving, is one of five that Tornberg carved with their heads tipped down and forward as if reaching to the surface to feed. Mill Valley is about fifteen miles north of San Francisco.

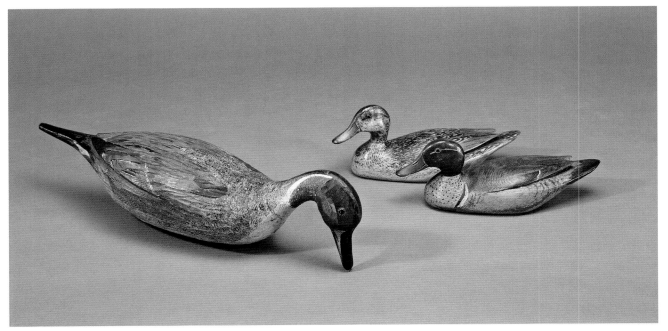

vertical skeg, a keel extending from the back centerline that helped balance them in swift currents and rough water. Janson also deeply carved primary and tail feathers on the backs of his decoys. He primed his birds by immersing them in linseed oil and then applied skillfully blended plumage patterns with oil paints. In the 1930s, at the height of his production, he priced his decoys at $28 a dozen if the customer supplied the wood, charging an additional $4 if he had to tap his own supply. He was the best-known and most prolific carver of his time, and his sturdy, forthright designs were imitated and, in some cases, outright copied by many other decoy makers in the region during and after his lifetime.

Charles Magnus Bergman (1856–1946) was a Finnish-born commercial fisherman who, like Dick Janson, left his native country as a young man. After working at sea for several years, he settled first in San Francisco before moving to Astoria, Oregon, at the mouth of the Columbia River. Bergman was an avid hunter who carved decoys for his own use, including a rig of twelve whistling swans made early in the twentieth century, before swan shooting was outlawed in 1918. Only two of the swans survive; they have hollow, two-piece bodies carved of western red cedar, with elegantly shaped, two-piece necks that are topped with separately carved heads.

Bergman did not carve professionally until 1929, after he had retired from fishing. Unlike his swans, Bergman's duck decoys appear to have been strongly influenced by the form and paint styles of the Mason Decoy Factory's top-grade products. They are hollow carved from red cedar, with smooth, boatlike bodies, upswept tails, and highly stylized abstract paint patterns. Like Janson, Bergman was a prolific and remarkably consistent carver who is believed to have crafted more than five thousand decoys before his death at age ninety.

California's other major professional carver was Horace Lewis "Hie" Crandall (1892–1969), an amateur taxidermist and painter who carved delicate, solid-bodied redwood decoys with raised wings and highly detailed plumage painting. Crandall was born in Rhode Island but moved to Benicia, Cali-

fornia, about thirty miles northeast of Oakland, during World War I, where he worked as a ferryboat engineer. He also found time to fish and hunt in the extensive marshes around Suisan Bay, which teemed with wildfowl in the early years of the twentieth century.

Drawing on his taxidermist's knowledge of wild birds, he began to carve and paint decoys for his own use not long after arriving in Benicia. In 1934, he moved to Westwood, in the Sierra Nevada mountains of north-central California, where he worked for a lumber company, a position that gave him access to all the redwood he needed for carving. He began selling his work through sporting

Swan. **Maker unknown. c. 1880. Oregon. Private collection. Photograph courtesy Guyette & Schmidt, Inc.**
This alert swan is one of the earliest known West Coast decoys.

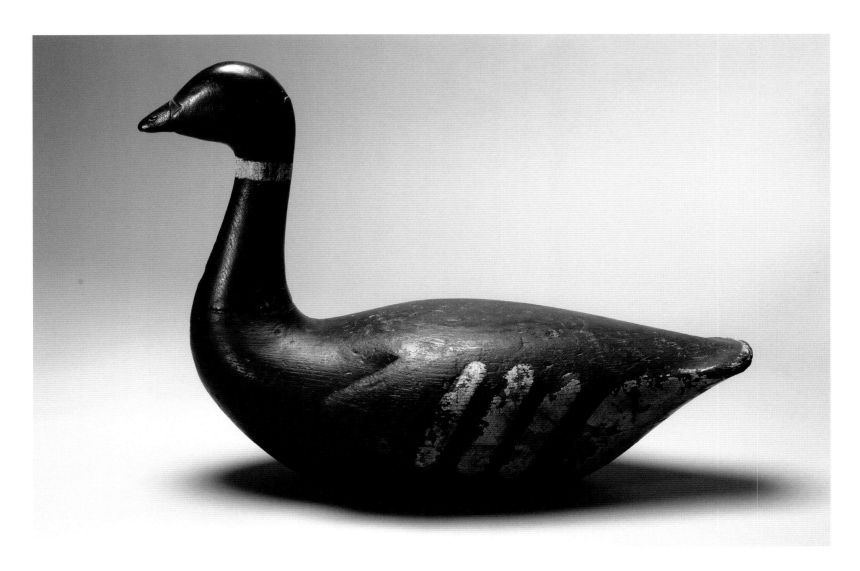

goods stores in nearby Chester, on Lake Almanor, as well as in San Francisco, and he found immediate success. He continued to craft working decoys until he relocated again in 1942, this time to work in the war effort with Douglas Aircraft in Los Angeles. By the time the war was over, interest in wooden decoys was waning, and Crandall's own artistic leanings led him to focus on miniatures and ornamental mantelpiece carvings rather than working birds.

Humboldt Bay, near Eureka in far northern California, about 225 miles north of San Francisco, has long hosted huge concentrations of migratory brant and has been a particularly important staging area on their spring journey to breeding grounds in Alaska. The brant are attracted by the bay's considerable beds of eelgrass, their favorite food. Brant hunting in Humboldt Bay began soon after the founding of Eureka in 1850. The city became a bustling center of commercial lumbering, shipping,

boatbuilding, and fishing, and prosperous lumber barons and other entrepreneurs built some of the finest Victorian homes in the nation there in the late nineteenth century.

Not surprisingly, Humboldt Bay carvers produced the West Coast's best brant decoys. One of the earliest documented California carvers was a Captain Olsen of Eureka, who piloted a small freighter in local waters and carved a rig of thirty-six brant around 1890. The simply painted but well-crafted birds were hollow-carved from redwood, the most prevalent local wood and the tree upon which the lumbering industry was built. They had carved shoulders and hardwood bills with dowels at the back so that they could be inserted into the heads. The neck seat was dovetailed and the base of the neck had a dovetail joint that would slide into place. Olsen's brant are now thought to have been made during three different periods, which are defined by the head type—those with upright heads are the earliest, followed by intermediate heads and swimmers. Only seven of the original thirty-six are known to survive.

In 1941, William McClellan (1897–1987), also of Eureka, worked with his wife, Olga, on a large rig of brant for use on Humboldt Bay. Comprising sixty floaters and nine flying birds, all the decoys were crafted from redwood chopped from salvaged telephone poles. According to Michael R. Miller and Frederick W. Hanson's *Wildfowl Decoys of the Pacific Coast: Carving Traditions of British Columbia, Washington, Oregon, and California*, the wings of the ingeniously designed flying birds were constructed in much the same manner as those on high-quality model airplanes. The wing frames

OPPOSITE: *Brant.* **Captain Olsen. c. 1880–90. Eureka, California. The Gene & Linda Kangas Collection of American & International Folk Art. Photograph courtesy Westcoast Decoys.**
This hollow redwood brant, an example of Olsen's earliest style, retains its original weight and much of its original paint (the paint is quite thin, and there may have been two coats of black). Olsen's earliest birds are larger than his later work and have higher backs. Eureka, located on Humboldt Bay, 283 miles north of San Francisco, was a major commercial port in the late nineteenth and early twentieth centuries and the center of the redwood logging trade.

LEFT: *Pintail Drake* **(top and side view). Harold W. "Pappy" Kidwell. c. 1945. Berkeley, California. The Gene & Linda Kangas Collection of American & International Folk Art.**
Pappy Kidwell (1895–1982) claimed to have made 100,000 decoys over a fifty-year period, many of them carved from palm fronds. This example of his imaginative work is purposely headless, suggesting a feeding duck with its head submerged. The body is of cork set on a bottom board, with inserted hardwood tail and wing feathers. The irascible Kidwell told one interviewer, "I make decoys for the ducks, not the damned collectors."

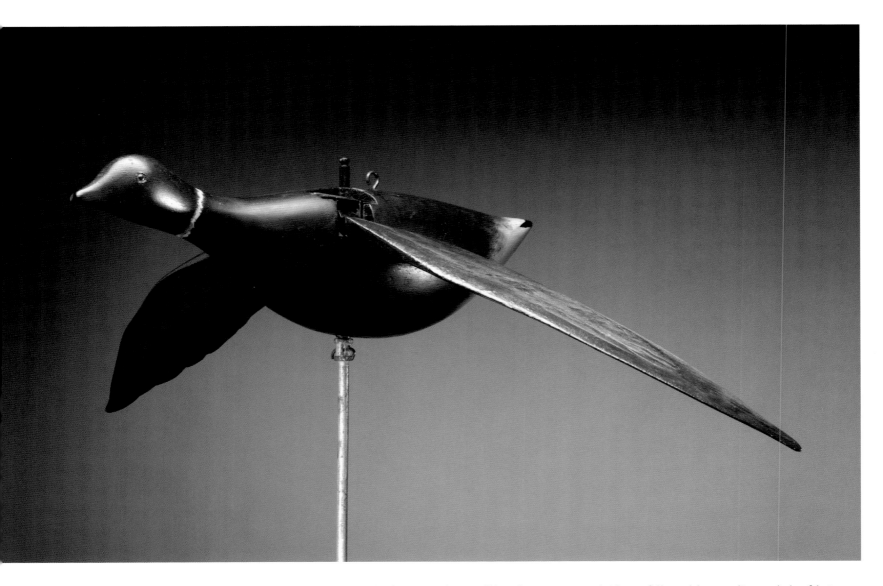

were constructed of spruce, then stiff butcher paper was laid on, followed by muslin, and the fabric was coated with airplane dope. "The wing patterns were taken from the tracing of an actual brant wing—'a big fella,' according to McClellan. Each of the nine flying brant was numbered on the body and matching wings. The latter fit into the bodies with intricate brass wing-locking mechanisms that allowed for quick removal or attachment. The wing lock was hinged to allow the wings, rigged with heavy rubber bands, to waver in the wind. A copper pin secured the wings to the hinges." In the field, the flyers were mounted on telescoping steel poles that could be set at different heights. All nine were attached to a floating wooden frame that McClellan could "pull over the sand into the water as the tide rose and fell" on the bay.

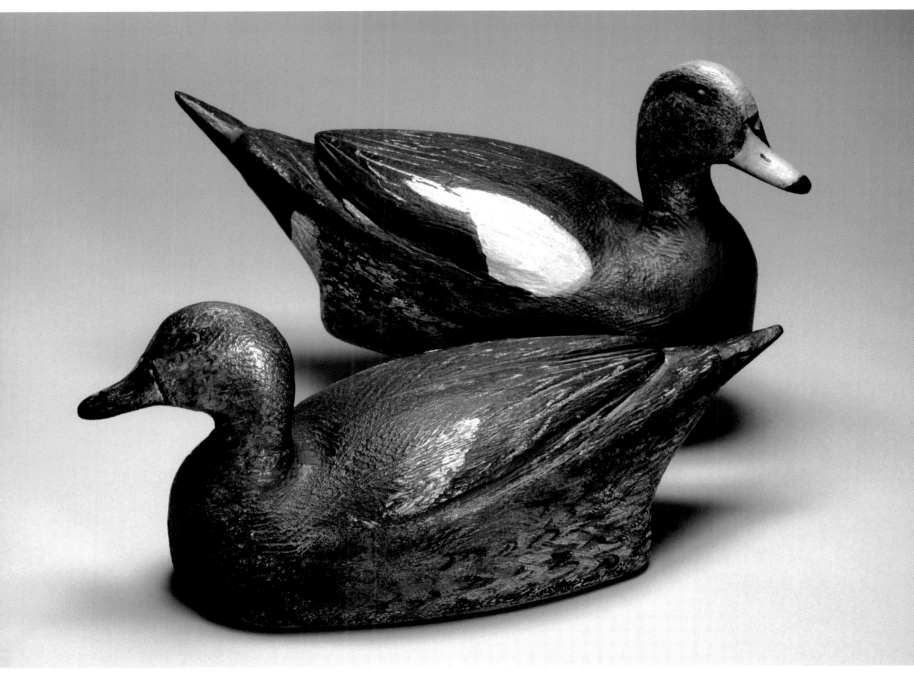

Pair of Wigeon. **Luigi Andreucetti. c. 1930. Sacramento, California. Collection of Mike Cole. Photograph courtesy Westcoast Decoys.**

Andreucetti (1898–1978) hunted in the Meadows, a part of the Sacramento–San Joaquin River Delta, south of Walnut Grove, which teemed with wildlife. Now preserved as Delta Meadows River Park, the area remains largely undisturbed by the effects of civilization and development. Andreucetti, who carved decoys for his own use for nearly sixty years, varied his style constantly. These early wigeon show off his considerable carving and painting skills.

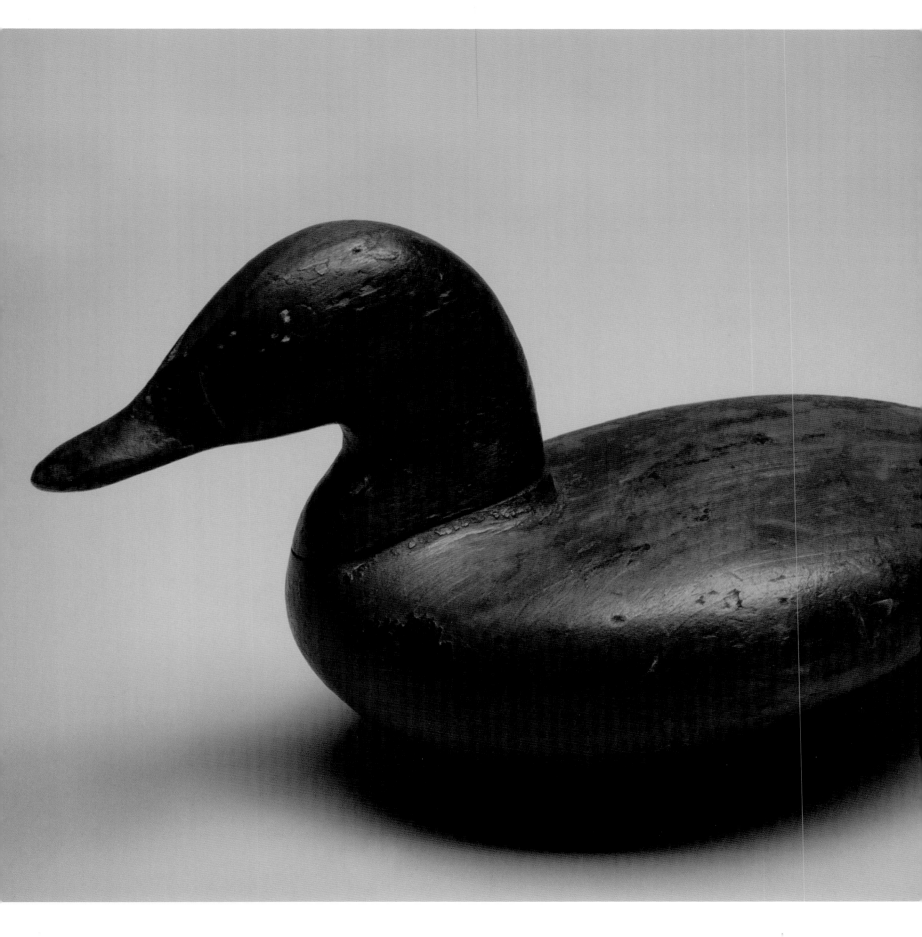

Beauty and Wonder

N orth American bird decoys represent an extraordinary response to a simple need. Made as tools to lure wild birds within range of hunters' weapons, decoys embody an explosion of creativity, variation, inspiration, and innovation that is rare among functional objects. The masters of the decoy were keen observers of the birds they sought to deceive. They knew their prey well, and the images of wildfowl they created conjure the natural world that they experienced, bringing it into focus before our eyes. Decoys reflect the respect and awe that their makers and users felt as they interacted with this continent's varied and abundant populations of wild birds. The world they were made and used in no longer exists, but the best surviving decoys pay tribute to the magnificence of American birds and their continuing ability to bring beauty and wonder to our lives.

Ruddy Duck. Benjamin Dye.
c. 1880. Perryville, Maryland.
Collection of Ron Gard.

Acknowledgments

Like any project of this magnitude, this book has a long background and would not have been possible or worthy without the generosity and assistance of many other people.

Many dealers, auction houses, and museums contributed photographs and information. My thanks to: Anne Juergensen of the Canadian Museum of Civilization; Nancy Druckman and Sotheby's; Ellen Sandberg and the Granger Collection; Gary Guyette, Frank Schmidt, and Jaime Sayers of Guyette & Schmidt, Inc.; Ted Harmon and Decoys Unlimited Inc.; Lisa Rebori and Beth Copeland of the Houston Museum of Natural Science; Joshua Ruff and Christa Zaros of the Long Island Museum; Stephanie Hansen of the Milwaukee Art Museum; Andrew Davis and Northeast Auctions; Stephen and Cinnie O'Brien Jr.; David Schorsch; Skinner, Inc.; and Stephan Jost and Julie Sopher of the Shelburne Museum.

A number of intrepid souls assisted with new photographs of birds in their own and others' collections, and the results are among the highlights of this book. Special thanks to Paul Brisco, Micah Brosnan, Ron Gard, Bernie Gates, Russ Goldberger, Jim Grochowski, Alan Haid, Gene Kangas, Bruce Malcomb, Dick McIntyre, Peter and Peggy Muller, and Jamie Stalker for all their efforts. Gary Lipham and Wade Hanks spent many long days organizing and arranging shots of outstanding Louisiana decoys and helping me get things right about their state's still underappreciated decoy heritage. My hat is off to them both. Bill Reeve helped me understand the art of Peter Pringle and supplied a photo of his masterpiece. Thanks are also due to the Brisco family, Clyde Catha, Jonathan and Virginia Chua, Mike Cole, Tom Figge, Gary and Dale Guyette, Ted and Judy Harmon, Max Hoyos, Paul Tudor Jones II, the Malcomb family, Wendel Nunez, Torrey Riley, Gerard Ruth, Larry Ruth, Barry Sallinger, David Teiger, Joe and Donna Tonelli, Cap and Paige Vinal, and Roger Young, whose birds are among those included in the pages of this book, and to the host of private collectors who chose to remain anonymous and let their birds take all the credit.

I am profoundly grateful to my mentors in the decoy field, so many of whom are now gone and all of whom offered open-hearted support when I began this quest nearly thirty years ago, as a young curator at the Shelburne Museum. I feel blessed to have counted the late Harold Corbin, Somers Headley, Jim McCleery, Jackson Parker, C. G. Rice, George Thompson, and Bud Ward among my friends and to have had the opportunity to spend time with the likes of Russell B. Aitken, Fred

Anderson, Joe Barber, Mary Barber, Evie Chace, Henry Chitwood, Captain George Combs Sr. and George Combs Jr., Barnie Crandall, Adele Earnest, Joe French, Ken Gosner, Robyn Hardy, Johnny Hillman, Hal and Barbara Sorenson, Doc and Robin Starr, and George and Hope Wick. Thanks also to those who still are very much among us, including John Dinan, Tim Eastland, Henry Fleckenstein, Dixon Merkt, Donal O'Brien Jr., Bill Purnell, Bobby Richardson, and Ron Swanson, all of whom were introduced to me one memorable April weekend in Shelburne, when they gathered to help assess and catalog the museum's collection. Thanks also to Dick Brust, Dick Carlson, Dick Coen, Grove Conrad, Brian Cullity, Sam Dyke, Patsy Fleming, Bob and Wilma Gerard, Merle Glick, Lloyd Griffith, Ron and Micki Heubsch, Kitty Mackey, Ron McGrath, D. C. North, Van Smith, Pete and Janet Van Tright, Jeff Waingrow, Bruce Williams, and dozens of other collectors and researchers who have shared their passion for the old birds with me over the years. Directly or indirectly, all of them have informed the pages of this book.

Special thanks to my old friend and fellow bird lover, Gigi Hopkins, who dropped everything to share the fruits of her research on John Dilley, Lothrop Holmes, Fred Nichols, Clarence Gardner, Newton Dexter, and other shorebird masters and e-mailed me daily updates from her post at the local library.

Thanks to my agent, Jeanne Fredericks, who made this book a reality, and to my unfailingly supportive editor at Sterling Publishing, Barbara Berger, who shared and championed my vision for it's content and look. It was pure pleasure to work once again with my old friend and colleague, Ellin Yassky, who nimbly edited the manuscript and tightened and improved it in a thousand ways. Thanks also to Rachel Maloney and Amy Henderson, who provided the book's beautiful design, and Karen Nelson and Elizabeth Mihaltse, who designed the jacket. Finally, thanks to my long suffering wife, Nancy, who knows far more about wooden birds than she ever intended, and to my daughters, Emma and Georgia, who somehow forgave me the endless hours I spent at my computer over the course of this project.

—Robert Shaw, Shelburne, Vermont

Selected Resources

WHERE TO SEE DECOYS: MUSEUMS WITH DECOY COLLECTIONS

Only a handful of museums have decoys on permanent exhibition, so be sure to check ahead. If a museum's birds are in storage, you may be able to make an appointment with a curator who can show them to you.

Abby Aldrich Rockefeller Folk Art Museum, Williamsburg, Virginia

www.history.org/History/museums/abby_art.cfm
This outstanding collection of American folk art includes decoys and ornamental carvings by Shang Wheeler, Gus Wilson, and others.

American Folk Art Museum, New York, New York

www.folkartmuseum.org
Decoys by Nathan Cobb, Elmer Crowell, Lothrop Holmes, Charles Osgood, Gus Wilson, and many other masters, are among the highlights of this excellent collection.

Boston Museum of Fine Arts, Boston, Massachusetts

www.mfa.org
This small collection includes works by Elmer Crowell, Albert Laing, and Gus Wilson.

Canadian Museum of Civilization, Ottawa, Ontario

www.civilization.ca
More than 500 Canadian decoys are showcased here.

Chesapeake Bay Maritime Museum, St. Michaels, Maryland

www.cbmm.org

Cleveland Museum of Natural History, Cleveland, Ohio

www.cmnh.org
This is a small but varied collection.

Havre de Grace Decoy Museum, Havre de Grace, Maryland

www.decoymuseum.com
Decoys by Susquehanna Flats carvers are featured.

Heritage Museum & Gardens, Sandwich, Massachusetts

www.heritagemuseumsandgardens.org
This museum's holdings include a large collection of decoys and bird carvings by Elmer and Cleon Crowell, as well as hundreds of their patterns.

Illinois State Museum, Springfield, Illinois

www.museum.state.il.us
Illinois decoys are featured.

Lakeview Museum of Art and Sciences, Peoria, Illinois

www.lakeview-museum.org
Illinois decoys, including works by Robert and Catherine Elliston, Bert Graves, Charles and Edna Perdew, and Charles Schoenheider, are housed here.

Long Island Museum, Stony Brook, New York

www.longislandmuseum.org
A permanent exhibit highlights primarily Long Island decoys, including masterpieces attributed to Bill Bowman, Thomas Gelston, and Obediah Verity.

Milwaukee Art Museum, Milwaukee, Wisconsin

www.mam.org
The Michael and Julie Hall Collection includes outstanding examples by Bill Bowman, Nathan Cobb, Elmer Crowell, Robert and Catherine Elliston, Lothrop Holmes, John Schweikardt, the Ward brothers, and Shang Wheeler.

Milwaukee Public Museum

www.mpm.edu
This is a small collection of decoys purchased from William Mackey Jr., including several birds pictured in his book, *American Bird Decoys*.

Noyes Museum of Art, Oceanville, New Jersey

www.noyesmuseum.org
More than 350 historic New Jersey decoys and contemporary decorative bird carvings are featured.

Peabody/Essex Museum, Salem, Massachusetts

www.pem.org
The museum owns an outstanding collection of Massachusetts decoys by Elmer Crowell, Samuel Fabens, Joe Lincoln, Fred Nichols, and other masters.

Charles Perdew Museum Association, Henry, Illinois

www.charlesperdew.com
The home that Perdew built in Henry is preserved here.

Shelburne Museum, Shelburne, Vermont

www.shelburnemuseum.org
This is the largest, finest, and most comprehensive decoy collection on public exhibition, including the Joel Barber Collection. Masterworks from all regions, as well as a large selection of decorative and miniature carvings by Crowell, Lincoln, and others, are on view from mid-May to mid-October in the Dorset House. More than forty other buildings house extraordinary collections of fine, folk, and decorative arts.

Tuckerton Seaport, Tuckerton, New Jersey

www.tuckertonseaport.org
This maritime village encompasses seventeen historic and re-created buildings, including a gallery of New Jersey coast decoys.

Ward Museum of Wildfowl Art, Salisbury, Maryland

www.wardmuseum.org
Historic decoys and contemporary decorative bird carvings are featured here.

COLLECTORS' GROUPS AND SHOWS

Canadian Decoy and Outdoor Collectibles Association

www.canadiandecoy.com
This group hosts an annual show and publishes a quarterly newsletter.

Long Island Decoy Collectors Association

www.lidecoycollectors.org

Midwest Decoy Collectors Association

www.midwestdecoy.org
This national group of 1,100 members hosts an annual North American Antique Decoy and Sporting Collectible Convention Week at Pheasant Run Resort in St. Charles, Illinois, which includes a Guyette & Schmidt auction and the Midwest Decoy Collectors Show, the "granddaddy" of all shows, with more than 400 tables of decoys and sporting art.

Minnesota Decoy Collectors Association

www.mndecoycollectors.com
This group holds an annual antique decoy and collectibles show at the Thunderbird in Bloomington the first weekend of February.

Ohio Decoy Collectors and Carvers Association

www.facebook.com/group.php?gid=67884184400&v=info
Annual show held the third weekend in March at the Holiday Inn West, Westlake, Ohio.

WHERE TO BUY DECOYS:
AUCTION HOUSES AND DEALERS

Paul Brisco

rpb@sympatico.ca
Author of *Decoys of Southwest Ontario.* Specialist in Canadian decoys.

Micah Brosnan

www.westcoast-decoys.com
Specialist in West Coast decoys.

Christie's

www.christies.com
Occasionally sells decoys in association with Guyette & Schmidt, Inc.

Decoys Unlimited, Inc.

www.decoysunlimitedinc.com
Ted and Judy Harmon are a dealer, broker, and auction team with decoys from all regions and a large annual summer sale.

Russ Goldberger, RJG Antiques

www.rjgantiques.com

Goldberger is the co-author of *Mason Decoys: A Complete Pictorial Guide* and specializes in decoys and folk art from all regions, with a focus on Mason Decoy Factory.

Guyette & Schmidt, Inc.

www.guyetteandschmidt.com

The leading decoy auction firm, which holds four auctions each year.

Alan Haid, Classic Decoys

www.decoymag.com/haid

Haid, co-author of *Mason Decoys: A Complete Pictorial Guide*, features decoys from all regions, with an emphasis on Illinois River and Mason Decoy Factory.

Gene and Linda Kangas, Creekside Gallery

www.creeksideartgallery.com

The Kangases collect, research, and sell an eclectic variety of contemporary art, folk art, decoys, and antiques.

Dick McIntyre, Collectable Old Decoys

decoyczar@hughes.net

McIntyre is a broker/dealer specializing in Southern decoys.

Northeast Auctions

www.northeastauctions.com

Outstanding Americana and sporting art sales that often include decoys.

Stephen O'Brien Jr. Fine Arts, LLC

www.americansportingart.com

Dealer and broker specializing in decoys and sporting art. Holds large annual summer auction, info at www.copleyart.com

Sotheby's

www.sothebys.com

Nancy Druckman heads the American folk art department, and decoys are often at auction.

Joe Tonelli

www.edecoy.com
Illinois River and Midwest decoys are specialties.

DECOYS ON THE WEB

Decoy Magazine

www.decoymag.com

eDecoy Online Magazine

www.edecoy.org
Joe and Donna Tonelli's extensive site.

Hunting & Fishing Collectibles Magazine

www.hfcollectibles.com

Robert Shaw

www.roberteshaw.com/decoys.html
This site includes a number of articles written by the author of this book.

Selected Annotated Bibliography

Audubon, John James. *The Birds of America*. London: 1826–38.
_____. *Writings and Drawings*. New York: The Library of America, 1999.

Barber, Joel D. *Wild Fowl Decoys*. New York: Derrydale Press, 1934.
The first, best-written, and most charming book on decoys, with many important insights into what the pioneer collector and artist called "floating sculpture." Barber's collection was acquired by the Shelburne Museum and is exhibited in the museum's Dorset House.

Bent, Arthur Cleveland. *Life Histories of North American Wild Fowl*. New York: Dover Publications, 1962.
_____. *Life Histories of North American Shorebirds*. New York: Dover Publications, 1962.
These wonderfully detailed studies were originally published by *Smithsonian* magazine in the late 1920s.

Bowman, Russell, ed. *Common Ground, Uncommon Vision: The Michael and Julie Hall Collection of American Folk Art*. Milwaukee: Milwaukee Art Museum, 2005.

Brisco, Paul. *Waterfowl Decoys of Southwestern Ontario*. Erin, Ontario: Boston Mills Press, 1986.

Carter, Win and Ray Egan. *George Boyd: The Shorebird Decoy—An American Folk Art*. Fayetteville, New York: Tenant House Press, 1978.

Chandler, Richard J. *The Facts On File Guide to North American Shorebirds*. New York: Facts On File, 1989.

Chitwood, Henry C., with Thomas C. Marshall and Doug Knight. *Connecticut Decoys: Carvers and Gunners*. West Chester, PA: Schiffer Publications, 1987.

Colio, Quintina. *American Decoys*. Ephrata, PA: Science Press, 1972.
Valuable photographic record of William J. Mackey Jr.'s collection at the time of his death; an adjunct to his own book.

Connett, Eugene V., ed. *Duck Shooting Along the Atlantic Tidewater*. New York: William Morrow & Company, 1947.

Crandell, Bernard W. *Decoying: St. Clair to the St. Lawrence*. Erin, Ontario: Boston Mills Press, 1988.

Cullity, Brian, ed. *The Songless Aviary: The World of A. E. Crowell & Son*. Sandwich, MA: Heritage Plantation, 1992.
By far the deepest look into the work of the Crowells.

Dudley, Jack. "Carteret Waterfowl Heritage." *Decoy Magazine*, 1993.

Earnest, Adele. *The Art of the Decoy: American Bird Carvings*. New York: Clarkson N. Potter, 1965.
Insightful study by one of the great early folk art dealer/collectors.

Engers, Joe, ed. *The Great Book of Wildfowl Decoys*. San Diego: Thunder Bay Press, Inc., 1990.

Farrand, John Jr., ed. *The Audubon Society Master Guide to Birding: Loons to Sandpipers*. New York: Alfred A. Knopf, 1983.

Fleckenstein, Henry. *Decoys of the Mid-Atlantic Region*. Exton, PA: Schiffer Publishing, 1979.
_____. *New Jersey Decoys*. Exton, PA: Schiffer Publishing, 1983.
_____. *Southern Decoys of Virginia and the Carolinas*. Exton, PA: Schiffer Publishing, 1983.
All of Henry's books are well researched and useful.

Fleming, Patricia, with Thomas Carpenter, ed. *Traditions in Wood: A History of Wildfowl Decoys in Canada*. Camden East, Ontario: Camden House Publishing, 1987.
The definitive study of Canadian decoys and their makers, with input from many Canadian authorities.

Forbush, Edward Howe. *A History of the Game Birds, Wild-fowl and Shore Birds of Massachusetts and Adjacent States.* Boston: Massachusetts State Board of Agriculture, 1912.

A deep study of the state of wild birds just before conservation laws were enacted, "including those used for food which have disappeared since the settlement of the country, and those which are now hunted for food or sport, with observations on their former abundance and recent decrease in numbers, also the means for conserving those still in existence."

Gard, Ronald J. and Brian J. McGrath. *The Ward Brothers' Decoys: A Collector's Guide.* Plano, TX: Thomas B. Reel Company, 1990.

Gates, Bernie. *Ontario Decoys.* Kingston, Ontario: The Upper Canadian, 1982.
_____. *Ontario Decoys II.* Kingston, Ontario: The Upper Canadian, 1986.
_____, Jeff Newburn, and William Reeve. *Nichol Decoys: The Smiths Falls School of Carving.* Kingston, Ontario: Quarry Press, Inc., 2009.

Gosner, Kenneth. *Working Decoys of the Jersey Coast and Delaware Valley.* Philadelphia: Art Alliance Press, 1985.

Gosner was the curator of zoology at the Newark Museum in New Jersey, and this atypical book reflects his deep knowledge and unusual perspective.

Grinnell, George Bird. *American Duck Shooting.* New York: Field and Stream Publishing, 1901.

Guyette, Gary and Dale. *Decoys of Maritime Canada.* Exton, PA: Schiffer Publishing, 1983.

Guyette, Gary and Frank Schmidt. *The Art of Deception: Waterfowl Decoys from the Collection of Paul Tudor Jones II.* St. Michaels, MD: Guyette & Schmidt, Inc., 2006.

Haid, Alan G. *Decoys of the Mississippi Flyway.* Exton, PA: Schiffer Publishing, 1983.
_____ and Russ J. Goldberger. "Mason Decoys: A Complete Pictorial Guide." *Decoy Magazine,* 1993.

Hall, Michael and Ronald Swanson. *The Decoy as Folk Sculpture: An Exhibition of Waterfowl and Fish Decoys.* Bloomfield Hills, MI: Cranbrook Academy of Art Museum, 1986.

Hard-to-find catalog of exhibition combining two great collections. Hall's essay "Marsh Trek: The Dilemma of Decoys" is worth the price of admission alone.

Hallock, Charles. *The Sportsman's Gazeteer and General Guide*. New York: Forest and Stream Publishing Company, 1877.

Harrington, Brian, with Charles Flowers. *The Flight of the Red Knot*. New York: W.W. Norton & Company, 1996.
An incredible saga, well told.

Johnsgard, Paul A. *The Bird Decoy: An American Art Form*. Lincoln, NE: University of Nebraska Press, 1976.

Kangas, Gene and Linda. *Decoys: A North America Survey*. Salt Lake City: Hillcrest Publications, 1983.
The most comprehensive and useful survey, encompassing all of North America. An essential reference.
_____. *Decoys*. Paducah, KY: Collector Books, 1992.

Lacey, Tandy. *The Wooden Bird: Heritage Bird Carvers of the Upper Illinois River Valley*. Washburn, IL: Sun Foundation, 1989.

Mackey Jr., William J. *American Bird Decoys*. New York: E.P. Dutton, 1965.
Classic survey by the most influential collector and authority of his generation. The sale of Mackey's immense collection in the early 1970s was a signal event.

Matthiessen, Peter. *Wildlife in America*. New York: Viking Penguin, Inc., 1959.
_____. *The Wind Birds*. New York: Viking Press, 1973.
Passionate and brilliantly written books by one of America's greatest naturalists, conservationists, and novelists.

Merkt, Dixon MacDonald, Mark H. Lytle, and Richard M. Grave. *Shang: A Biography of Charles E. Wheeler*. Salt Lake City: Hillcrest Publications, 1984.

Muir, John. *Nature Writings: The Story of My Boyhood and Youth; My First Summer in the Sierra; The Mountains of California; Stickeen; Essays*. New York: Library of America, 1997.

Muller, Dr. Peter J. and Peggy L. "The Stevens Brothers: Their Lives, Their Times and Their Decoys." *Decoy Magazine*, 2008.

The definition of an in-depth study.

Murphy, Stanley. *Martha's Vineyard Decoys*. Boston: David R. Godine, 1978.

A superb regional study, the best of its kind.

O'Brien Jr., Stephen and Julie Carlson. *Masterworks of the Illinois River: Decoys from the Collection of Thomas K. Figge*. Boston: Stephen O'Brien Jr. Fine Arts, LLC, 2005.

Parmalee, Paul Woodburn, and Forrest D. Loomis. *Decoys and Decoy Carvers of Illinois*. Dekalb, IL: Northern Illinois University Press, 1969.

Peterson, Roger Tory. *A Field Guide to the Birds of Eastern and Central North America*. Boston: Houghton Mifflin, 1980.
_____ with Virginia Marie Peterson. *Audubon's Birds of America (The Audubon Society Baby Elephant Folio)*. New York: Artabras/Cross River Press, 1981.

Reed, Henry M. *The A.B. Frost Book*. Charleston, SC: Wyrick & Company, 1993.

Reiger, George. *The Wings of Dawn*. New York: Stein and Day, 1980.
_____ and Kenneth Garrett. *Floaters and Stickups: A Personal Survey of Wildfowl Decoys*. Boston: David R. Godine, 1986.

Richardson, Robert H. *Chesapeake Bay Decoys: The Men Who Made and Used Them*. Cambridge, MD: Crow Haven Publishers, 1973.

Shaw, Robert. *America's Traditional Crafts*. Southport, CT: Hugh Lauter Levin Associates, 1993.
_____. *Call to the Sky: The Decoy Collection of James M. McCleery, MD*. Houston: Gulf Publishing, in association with Houston Museum of Natural Science, 1992.
_____ and Ron Gard, ed. *The McCleery Auction*. Dallas: Lake Emma Press, 2001.

Sibley, David Allen. *The Sibley Guide to Birds*. New York: Alfred A. Knopf, 2000.
_____. *The Sibley Guide to Bird Life & Behavior*. New York: Alfred A. Knopf, 2000.

Sorenson, Harold D. *The Decoy Collector's Guide*. Burlington, IA: 1963–1978.

Starr, George Ross Jr. *Decoys of the Atlantic Flyway*. New York: Winchester Press, 1974.

A raconteur's tour of his great early collection.

Stewart, Jim. *The County Decoys: The Fine Old Decoys of Prince Edward County, Ontario*. Erin, Ontario: Boston Mills Press, 2004.

Sullivan, C. John. *Waterfowling on the Chesapeake, 1819–1936*. Baltimore: Johns Hopkins University Press, 2003.

Townsend, E. Jane. *Gunner's Paradise: Wildfowling and Decoys on Long Island*. Stony Brook, NY: The Museums at Stony Brook, 1979.

Catalog of the collection of the Long Island Museum.

Waingrow, Jeff. *American Wildfowl Decoys*. New York: E.P. Dutton in association with Museum of American Folk Art, 1985.

Well-written catalog of the museum's collection.

Walsh, Clune Jr., and Lowell G. Jackson. *Waterfowl Decoys of Michigan and the Lake St. Clair Region*. Detroit: Gale Graphics, 1983.

Walsh, Harry M. *The Outlaw Gunner*. Centreville, MD: Tidewater Publishers, 1971.

Webster, David, and William Kehoe. *Decoys at Shelburne Museum*. Shelburne, VT: The Shelburne Museum, 1961.

Weidensaul, Scott. *Living on the Wind: Across the Hemisphere with Migratory Birds*. New York: North Point Press, 1999.

Yakush, Mary, ed. *An American Sampler: Folk Art from the Shelburne Museum*. Washington: National Gallery of Art, 1987.

Index

Note: Page references in *italics* include illustrations and/or captions.

Picture Credits

Note: Please see captions for additional credits.

Courtesy of the Library of Congress Prints and Photographs Division:

viii: LC-USZ62-46999; 9: LC-DIG-pga-01748; 10; 19: LC-USZC2-2560; 20: LC-USZC2-3173; 22: LC-USZ62-62712; 106–7: LC-USZ62-51089, 109; 120: LC-USZ62-62713; 121: LC-USZ62-115773; 126: LC-USZ62-125425; 128l: LC-DIG-ppmsca-02905; 128tr: LC-USZ62-74343; 129: LC-USZ62-61248; 132: LC-USZ62-113508; 133t: LC-USZ62-107389; 133b: LC-USZ62-72116

Public domain/Courtesy of the author:

6, 11, 110, 111, 112, 119, 123, 124, 125, 128br, 135, 159, 174, 186, 194, 197, 204, 213, 219

Robert Havell Jr. after John James Audubon, for *The Birds of America*, 1827–38. London:

18, 25, 26, 29, 34, 40, 42, 44, 57, 61, 64, 66, 68, 70, 73, 75, 83, 90, 93, 95, 97, 99, 101t, 103, 136

John T. Bowen after John James Audubon for *The Birds of America,* First Octavo edition. 1840–44. Philadelphia:

21, 30, 32, 36, 38, 48, 51, 53, 55, 59, 63, 76, 78, 79b, 81, 85, 87, 88

The Granger Collection, New York:

108, 115, 116, 134